EMPRESS OF FASHION

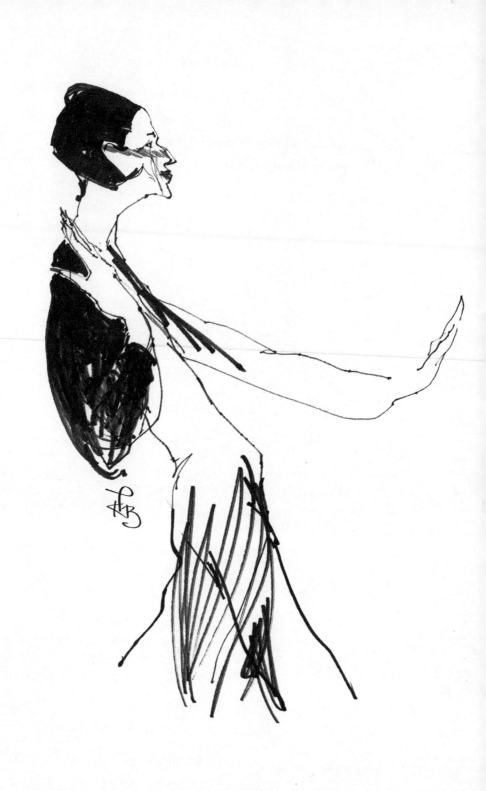

Empress

A LIFE

OF

DIANA

VREELAND

Amanda Mackenzie Stuart

HARPER PERENNIAL

NEW YORK • LONDON • TORONTO • SYDNEY • NEW DELHI • AUCKLAND

HARPER ● PERENNIAL

An extension of this copyright page appears on pages 391 to 393.

FIRST HARPER PERENNIAL EDITION PUBLISHED 2013.

*Frontispiece illustration by Kenneth Paul Block,
printed with permission by Morton Ribyat*

Designed by Fritz Metsch

Library of Congress Cataloging-in-Publication Data
has been applied for.

ISBN 978-0-06-169175-1 (pbk.)

13 14 15 16 17 OV/RRD 10 9 8 7 6 5 4 3 2 1

To Michael

CONTENTS

EMPRESS OF FASHION

INTRODUCTION

My maid here at the Crillon is driving me crazy.... I've been having
fittings in the morning all week long and Betty, my maid, is down on
her knees sticking pins in my hem—but she won't look in the mirror.
 "Ah madame," *she'll say,* "Quelle belle robe."
 "Betty," I'll say, "Don't look at me, look in the mirror."
 "Mais madame, comme c'est jolie."
 "Betty!" I said, "Look in the mirror! What I want is in the mir-
ror. What you want, you can't see because you won't look at it."

DIANA VREELAND (1903–89) believed in the power of the re-
flected image with something close to religious fervor. She once
observed that without a mirror, "you lose your face, you lose your
self-image. When that is gone, that is hell." Her faith in the magic
of the looking glass propelled her through a long life, and into a dis-
tinguished career at a time when it was unusual for a woman from
her background to work at all. She joined *Harper's Bazaar* in 1936,
officially becoming its fashion editor for twenty-three years from
1939; she was editor in chief of American *Vogue* from 1963 until
1971; and from 1972 she was special consultant to the Costume In-
stitute at the Metropolitan Museum of Art in New York, where she
launched fifteen groundbreaking costume exhibitions. She was re-
garded, at her peak, as the empress of American fashion, or as one
admirer put it: "the High Druidess of fashion, the Supreme Pon-
tiff, Perpetual Curate, and Archpresbyter of elegance, the Vicaress
of Style." She is thought—by some—to be the cloth from which
twenty-first-century editors in chief of fashion magazines are cut.

However, Diana often insisted that she was really an amateur at heart. Her resistance to being defined by her working life was noted by the British photographer Cecil Beaton while she was still at *Harper's Bazaar* in the 1950s: "She is indeed such a powerful personality in her own right, and so little dependent on the fashion world for her terms of appeal, that many of her friends never think of her in connection with printer's ink," he wrote. Growing up as cubism emerged at the beginning of the twentieth century, Diana had the appearance of a multifaceted artifact herself, a creature of planes, angles, and polished surfaces, interpretable from multiple viewpoints, frequently in motion and in vivid color. She may have favored her reflection in the mirror; but she was remembered by many in vibrant three-dimensional reality as she erupted into a room. "She didn't merely enter a room, she exhilarated it," wrote Nicholas Haslam, who worked in the art department of *Vogue* in the early 1960s. "And all eyes immediately locked on her, hypnotised. . . . Her actual presence was like a sock on the jaw. You knew you were seeing a supernova."

Her face was the most famous part of her. "Mrs. Vreeland's head sits independently on top of a narrow neck and smiles at you. Everything about her features is animated by amused interest," wrote Beaton. Provided she was engaged or charmed, the overwhelming impression was of a brilliant glint that spread outward from narrow brown eyes, beneath Vaselined eyelids, across high cheekbones exaggerated with great streaks of rouge, with which she also powdered her ears, turning them a shade of terra-cotta. The centerpiece of this face was a very large beaky nose above a huge, wide crimson mouth and a pointed aggressive jaw. The effect was framed by jet black hair, sometimes in a snood, veneered into place from her hairline with such a high metallic sheen that it is said to have clinked when a waiter bumped it with a tin tray. Beneath her head Diana maintained the slender, supple body of a dancer until the end of her life, but she held it in a curious sloping posture. When she moved, her pelvis thrust forward and her upper body sloped backward as she glided ahead. Once she gained

momentum she assumed the lolloping gait of a dromedary, topped with a light sashay, a walk she said she copied from the showgirls of the *Ziegfeld Follies*. Even when seated she was animated: jabbing, pointing, prodding, and kneading the air, the fingers of one hand spread outward, a cigarette clasped in the other, displaying to advantage long, red, perfectly manicured talons. "Like everyone else, I was not introduced to her but to her index finger, extended as a kind of barrier to trade," wrote Jonathan Lieberson, who met her in the 1960s when Diana was in her sixties too. "She was improbable in the extreme: a strange figure, sitting closed cross-legged, with erect spine, stroking the arch of an extended foot, her fingers stretching . . . her mouth and out-thrust jaw in constant motion."

Those trying to describe her often reached for avian imagery. "An authoritative crane," said Cecil Beaton. "Some extraordinary parrot—a wild thing that's flung itself out of the jungle," thought Truman Capote. "An Aztec bird woman," suggested *Vogue* feature writer Polly Devlin, though she also proposed a Kabuki runaway. Diana's appearance could cause confusion. On a trip to Kyoto, it was said that her Japanese hairdressers thought she was a man before they decided she was Chinese. ("As you know, that's not the *most* popular thing you can be in Japan . . . but they were very polite. And once you get a person totally wet with half their make-up off, you *see* something.") It is less often remarked that Diana Vreeland was actually ugly, an ugliness made worse by having mild astigmatism which could make her squint. Polly Devlin was forcefully struck by Diana's unattractiveness on their first meeting, and equally amazed by how quickly the ugliness seemed to melt away. "There's a word not much used nowadays, 'limned,' which is to illuminate, to edge in color," she wrote. "She was always limned, set in shock against her background."

One reason Diana had such a mesmerizing effect was the sound, as well as the sight, of her. "When she laughed, she slowly and deliberately intoned each 'ha' of 'ha-ha-ha,' much, I imagined, as one of the denizens of Hogarth's Gin Lane might have done," wrote Lieberson. Bystanders were rooted to the spot by the peculiar swooping

cadences of her gravelly bass voice, which could rise to a booming bark and fall back down to a whisper in the course of one sentence, its colors darkened by years of smoking. The rhythm of her speech was unpredictably emphatic, punctuated by the throaty laugh, a descending scale that went *M-m-m*, and (since she took a positive view), the word "duh-vine." She could generally be relied on to light upon at least one italicized word every few seconds, more often when telling a story. She had a predilection for rolling her *r*s as in "*rrr*ighto"; and faux French pronunciation, so that "corduroy" became "cord-du-*roi*," "tiger" became "*tee*-gray," and "video" was pronounced as in "Montevideo." Though she could bridle (or worse) at unrefined language, she had an acute ear for gamey slang and reminded Beaton of Falstaff, a very different physical type. But even her manner of speech was less interesting than what she actually said.

By the time she joined *Harper's Bazaar*, Diana had cultivated a verbal brilliance that was all her own, her talk interspersed with Delphic remarks that were captured by listeners like butterflies, only to flutter weakly on the page. "Pink *is* the navy blue of India" was one much-quoted aperçu with which she became bored. "Blue jeans are the most beautiful thing since the gondola," was another, and there were thousands more in the manner of "One thing I hold against Americans is that they have no flair for the rain. They seem unsettled by it; it's against them: they take it as an assault." She attributed her oblique point of view to the astigmatism:

> *I have astigmatism, like El Greco. I'm not comparing myself with El Greco for a minute, except that we both have the same physical disability. Partly because of his disability he saw things that most people don't see. I see all sorts of things that you don't see. I see girls and I see the way their feet fall off the sidewalk when they're getting ready to cross the street but they're waiting for the light, with their marvelous hair blowing in the wind and their fatigued eyes. . . .*

Not everyone admired her. Some people thought she was frightening, abrasive, disagreeable, a bully, and even a freak. Others did

not forgive her for her social life in her seventies, when she was photographed with Andy Warhol, Mick Jagger, and Jack Nicholson. Coco Chanel said she was the most affected woman she had ever met. Salvador Dalí maintained that she lied all the time, a charge echoed less fiercely but nonetheless insistently by others who knew her better than he did. Polly Devlin thought that her "slanting knowing eyes" missed much about the soul but "nothing, nothing to do with the body." The designer Charles James, whose work she overlooked, excoriated her. The first time he met her Jonathan Lieberson thought she was not exactly fake but artificial in the extreme: "At the time, though, I recalled a remark made about Max Beerbohm: 'For God's sake, take off your face and reveal the mask underneath.' " Many more people thought she was plain eccentric, though this was one charge she rebutted. "I have not one eccentricity—that I *know* of. . . . I think most eccentrics are just go-ahead kids, like Hank the Yank, Henry Bath, the Marquess of Bath and owner of Longleat, who went through the whole War with a duck on a chain . . . *praying* for bombs to fall so that his duck would have a pond. To me, that's not eccentricity—that's how he felt about his *duck*."

Others adored her and thought she was extremely funny. Cecil Beaton described her as having the humane wit of Madame de Sévigné. The art historian John Richardson loved her for her worldly tolerance, her powers of perception, and her engaged friendship. Nicholas Haslam did not take long to discover that behind her astounding exterior "lay a much-heralded mind not only of dazzling fantasies . . . but of originality of thought, and a carefully shrouded or, rather, disguised loving tenderness." At Diana's memorial service in 1989, it was observed that Jacqueline Kennedy Onassis sobbed from beginning to end. *Vogue* Contributing Editor André Leon Talley regarded Diana as one of the two most important women in his entire life. A host of creative and talented people in the world of fashion, including models, photographers, designers, and some actors, not only credit her with launching their careers but have said they felt better for having known her. Ferle

Bramson, Diana's secretary during her tenure at the Costume In-
stitute, echoed the feeling of many when she said that her boss was
so creative and original that liking or disliking her was, in the end,
irrelevant.

Diana Vreeland was such a substantial presence while she was
alive that there is a perception that much has been written about
her since her death. Surprisingly, however, she has never been the
subject of a full-length biography. There have been many pro-
files, articles, and one highly critical book. In 1982 she published a
memoir, *D.V.*, which she happily described as "faction," developed
from her earlier photo essay, *Allure*. After her death in 1989, the
Costume Institute mounted a brilliant and illuminating exhibi-
tion about her, accompanied by a publication that included many
reminiscences by friends and colleagues and an essay that focused
on her work at the Metropolitan Museum of Art. Lisa Immordino
Vreeland's book, *Diana Vreeland: The Eye Has to Travel*, is a beau-
tiful evocation of images from *Harper's Bazaar, Vogue*, and her
exhibitions at the Costume Institute, a timely reminder of the ex-
traordinary work Diana stimulated as well as her own; and Lisa's
documentary of the same title captures Diana with great verve
and nuance with the help of those who still remember her. Eleanor
Dwight's superbly illustrated *Diana Vreeland* revealed new mate-
rial about her upbringing and marriage, but its text was of neces-
sity short and its focus external.

There is therefore a case for a longer account, partly because
fashion itself has changed. It has vastly expanded its reach, insinu-
ating itself into places unthinkable half a century ago. There has
also been much fresh thinking about it as a phenomenon in aca-
demic circles, across several disciplines. Where fashion was once
regarded by academics as too trivial for serious examination, or too
mired in false consciousness for feminist scholars, it is now being
reinterpreted more subtly. This is leading to a reevaluation of those
involved in its making. The job of editor in chief of a fashion maga-
zine is a century old; the women who have done it successfully have
exercised enormous power at the center of a vast web of production

and consumption, and the scale of their power is unusual even to-
day. Quite as important, there is reassessment of fashion as *the* phe-
nomenon that encapsulates what Baudelaire called "the ephemeral,
the fugitive, the contingent" nature of modern life. If this is true, it
raises a question about Diana herself: is it possible that her achieve-
ments have been seriously underestimated? Some friends and col-
leagues certainly thought so. One of them was the Hollywood agent
Irving "Swifty" Lazar, as Diana later recalled:

> *Swifty Lazar took me with him to buy something in Bloomingdale's*
> *basement. And at every counter, he said, "This is one of the greatest*
> *women of the century! This is Diana Vreeland!"*
>
> *"Who could this be that we've missed?" I could see people think-*
> *ing, "It's not Chanel, it's not Garbo, it's not Monroe."*

The puzzled reaction of the Bloomingdale's shoppers was under-
standable. A long career on fashion magazines, a series of innova-
tive costume exhibitions, and a trail of Sphinx-like remarks do not
explain Swifty Lazar's assertion that Diana was one of the greatest
women of the twentieth century, and Diana herself thought it was
nonsense. "Look, nothing I've ever done is extraordinary," she said
to one interviewer. Truman Capote, however, also thought she was
a genius. Mrs. Vreeland, he wrote, was one of the great Americans
who had contributed more than anyone to improving the level of
taste of the American woman. This was not an assessment of the
American woman with which Diana agreed. "Alas, I am afraid she
looks worse than ever," she wrote to an old colleague in 1972. But
Capote was adamant (if self-serving): "She's a genius but she's the
kind of genius that very few people will ever recognize because
you have to have genius yourself to recognize it. Otherwise you just
think she's a rather foolish woman."

This book is for nongeniuses interested in the nature of Diana
Vreeland's talent and achievements. For all the fanfare of her ap-
pearance and her personality, her gifts were elliptical. Yet they
were real. They were consistent. They were visible early in her life,

and what happened to her in her early years, and as a young married woman, lent them a particular intensity, giving her what the make-up artist Pablo Manzoni called a "leitmotif, a continuity" that lasted throughout her professional career and until she died. Diana regarded a chronological approach to anything as consummately tedious, but hers was a life in which chronology counted for a great deal. Far from agreeing that she constantly reinvented herself, as some have maintained, this book contends that her later achievements can better be understood by looking at those early years, by paying close attention to her omissions and evasions about her past, and by peering into the interstices between the facts of her life and her later fictions. It does not pretend to be an exhaustive account of her fashion enthusiasms, or her friendships, which would run to several volumes.

It is not clear whether she would have welcomed much probing beneath her dazzling lacquered surface, for Diana Vreeland was a very private person. "Keep your secret," she once said. "That's your power over others." On the other hand she greatly enjoyed recognition when it finally came to her, particularly if it arrived unexpectedly. It was sweetest of all when it enabled her to get the better of her most critical friend, Jerome Zipkin. Jerry Zipkin was a celebrated man-about-town in New York in the 1970s and 1980s, best known for being Nancy Reagan's "walker" after she became first lady in 1981. He was famous for his ability to undermine his fragile society-lady friends and reduce them to tears. But he underestimated Diana's standing in the world of fashion, not to mention one of her abiding characteristics: the ability to jump, in just a few seconds, from the negative to the positive while keeping an open mind about the latest trend, before swooping triumphantly to a perspective that was all her own:

> *I want to tell you that a few years ago Jerry took me down to Palm Beach, which at that point, I knew about as well as I know Bloomingdale's, not having been there in 40 years, and the first thing we do is tour Worth Avenue. . . .*

"You haven't seen anything yet," he said. *"I'm going to take you to a place where I* doubt *you'll get in."*

So *we go to a place called Mitzner Court, I think it's called, and Jerry said, "Let me explain it to you—you have to be a member."*

"But Jerry," I said, *"I thought you were taking me to a shop."*

"It is a shop," he said. *"But the* chances *are—don't be offended— that you won't get in. We'll just have to see what we can arrange. . . ."*

Then . . . *we ring a bell and a man comes out. "Oh Madame Vreeland,"* he said—*it couldn't be more American, the "Madame Vreeland" . . . well, I'm In Like Flynn. He gave me a year's free membership.*

I couldn't believe it—you have to pay *to* buy?

This, *I have to say—is new.*

PARIS OPENING

There is no doubt that Diana Vreeland disdained an inconvenient truth in a manner that could be startling. She once ejected a friend from her apartment, the jewelry designer Kenneth Jay Lane, for suggesting that her beloved England had been invaded by the Normans; and she enjoyed polishing up birth moments when she thought they needed it, a compliment extended even to the most exotic of her acquaintances. In the 1960s the model and actress Vera von Lehndorff, known as Veruschka, told a story at a New York party about noticing the time as she was born. "I said, 'The first image I saw of this world was an enormous round watch with a black frame, black numbers, and black pointers. It was 6 o'clock and 10. I was born at the hospital in Königsberg, East Prussia, now called Kaliningrad.'" Everyone laughed. But a little while later Diana took Veruschka aside and gave her some advice in a low whisper. "Veruschka darling . . . when asked where you are born, never say East Germany, Prussia, Königsberg, or Kaliningrad, that's boring, just say 'I am born on the border, right on the border, between Germany and Poland, in the swamps of the Masurian lakes.'"

Diana liked to spread a little mystery about her own arrival in the world too. She was coy about her age, and genuinely perplexed in later life by the discovery of an apparent discrepancy between the dates of her birth on two official documents, her French *bulletin de naissance* and her actual birth certificate. However, Diana was indisputably born on September 29, 1903. She was born in Paris; and apart from moments when it amused her to outline more extreme birth scenarios, such as appearing to the sound of Berber

ululations in the Atlas Mountains, she liked to maintain that her French beginnings set her apart. People born in Paris were different from other people, she once said. The event was registered at the British consulate in Paris because Diana was the daughter of a British father, Frederick Young Dalziel. Dalziel is a Scots name, with a range of spellings that derives from the barony of Dalziel, in Lanarkshire, and pronounced *dee-ell*. "People used to say to me, why don't you cut out all that and just put the 'D' and the 'L'?" said Diana. "I'd say—do it yourself. For me, it's the whole way because I *love* the spelling. I *love* Zs." She delighted in her "medieval" Scottish clan origins throughout her life. As a girl she took the clan motto, "I Dare," seriously. As an adult she owned a print of the Dalziel coat of arms and sported the Dalziel tartan at the right sort of parties.

Her father, Frederick Young Dalziel, however, was not quite what he appeared to be. He was not very Scots—his line of Dalziels came from England—and his background was much more modest than he found socially convenient. His family lived in Haringey in North London, where he was brought up by a stepmother and a father who worked for the General Post Office, alongside a younger half brother named Edelsten. This was a family in which even middle-class status hung in the balance. Frederick and his half brother were sent to Highgate School, a school educating young gentlemen from North London, but they went there late and all the evidence suggests that money was extremely tight. Though Frederick gained a place at Oxford University and started at Brasenose College in 1888, he left just a year later at the end of 1889, probably because that was as long as his family could afford. A year at Oxford was enough to give him a marked fondness for aristocratic tone. It also allowed him to describe himself as "Oxford educated" forever more, sidestepping the fact that he never actually obtained an Oxford degree.

Diana's father was tall—over six and a half feet—strikingly handsome, and she loved him. "He was so wonderful looking—so charming. For every daughter, the first love of her life is her father.

To this day I just adore him. He was wonderfully affectionate. . . .
A great beauty; and really nothing to do with the modern world
at all. Totally Edwardian, you know." In 1890 the obvious destina-
tion for an "Oxford educated" young man with good looks, energy,
charm, no private income, and a socially undistinguished family
was some part of the British Empire where lack of pedigree was not
an impediment and there was no prejudice against earning money.
Frederick Dalziel was so evasive about the five years that followed
his departure from Oxford that it started a family myth that he
became a spy. It is more certain that from 1895 he worked as a
representative for South African gold-mining interests and lived in
Paris. Speculation in the discovery of gold and diamonds was ex-
tremely risky and was only for the spectacularly rich. In the 1890s
some of the wealthiest people in the world were rich Americans
of the Gilded Age who regarded Paris as both their playground
and their second home. These were his clients, and eventually his
friends too.

By 1901 Frederick Dalziel was mixing with American million-
aires in Paris in a manner that suggests he was already migrating
from a suburban middle-class to an upper-class persona. Those who
remember Frederick Dalziel in old age confirm Diana's description
of her father as the model of an Edwardian English gentleman;
but he projected this image quite self-consciously, cultivated smart
acquaintances, and masked his background with a grand mien,
having himself photographed at this period in hunting pink by
French society photographer Numa Blanc. "There's only one very
good life and that's the life that you know you want and you make
it yourself," said Diana later. It was an attitude she inherited from
her father; and in 1901, the solution to the gap between Frederick
Dalziel's background and the life he knew he wanted presented
itself in Paris in the form of Diana's American mother, Miss Emily
Key Hoffman.

DIANA'S MOTHER ARRIVED in Paris by a very different route.
Born in 1877, she was the daughter of George Hoffman, a lawyer

from a prominent Southern family. The surname has led to claims that this side of Diana's family was Jewish, but Hoffman is also a non-Jewish name, and there is no record of Judaism in the family tree. Diana's Hoffman forebears were gentlemen farmers in Virginia, and at least one of her Southern great-grandmothers was socially distinguished. "We're top drawer from Baltimore," went a family expression, and "Key holds the key" was another. The "Key" was George Hoffman's mother, Emily Key, a member of a well-known family of the American South whose lineage connected Diana to Francis Scott Key, composer of "The Star-Spangled Banner." The only thing that Diana knew about her Baltimore great-grandmother was that she and her sister went to law over a dining-room table, so exasperating the judge that he Solomonically ordered a carpenter to cut it in two and give each of them a half. Judged by bloodline rather than passion or pigheadedness, however, Diana Vreeland's colonial antecedents on her mother's side were impeccable.

In New York society this kind of pedigree mattered, and after the Civil War ended in 1865, it was also essential to have riches. In Diana's case the family money came from her maternal grandfather, John Washington Ellis, who made his first fortune as partner of a wholesale dry goods firm in Cincinnati before helping to found the First National Bank of Cincinnati and then moving to New York, where he ran a private investment bank. As New York became America's financial and cultural capital after the Civil War, the city drew in hundreds of families made newly rich by the extraordinarily rapid postwar boom that soon came to be termed the Gilded Age. New York's finest reacted by becoming much more self-consciously elitist, with resistance led by Mrs. William Backhouse Astor, who could famously fit only "Four Hundred" top people into her ballroom, a notion that then became shorthand for New York's most exclusive clique. However, Mrs. Astor welcomed those with money of whom she approved, to the extent that after 1865 a large fortune became the sine qua non for joining her circle. On arriving in New York, the well-to-do Ellis family were among

the lucky ones, quickly joining the "Four Hundred." The family rode to hounds and hunted with the right packs. The New York family home was just off Fifth Avenue, and John Washington Ellis helped by building a huge Shingle-style summer "cottage" called Stone Acre on Bellevue Avenue in Newport, Rhode Island, in 1882. Newport was well on its way to becoming New-York-Society-by-the-Sea in the 1880s. The Ellises became closely identified with Newport's growing exclusivity; and they were listed in the first edition of the social bible, *The Social Register*, in 1886.

Diana's mother, Emily Key Hoffman, was therefore brought up at the heart of the New York world of Mrs. Astor's "Four Hundred." Her father died young in 1885, and thereafter Emily was raised by her widowed mother in a house on West Fiftieth Street, just off Fifth Avenue. Between the ages of sixteen and eighteen, she was sent to the highly academic Brearley School, soon after it was founded. But that was as far as her education went, and in 1896 Emily's mother launched her into New York society. The 1890s marked an era of great transatlantic marriages, when hundreds of daughters of well-to-do Americans married impoverished European aristocrats, enriching noble families in Europe and ennobling the plutocrats back home. Young women from New York's *gratin* who did not marry European nobility were expected to make good matches with scions of American dynasties. Their stories were lapped up by press and public alike, with the result that any attractive young society woman in New York was minutely scrutinized by even respectable newspapers, which ranked a debutante in terms of appearance, family connections, and likely dowry.

The newspaper columnists were enchanted when Miss Emily Hoffman became a debutante. They waxed lyrical about her dark brown eyes, fine features, chestnut hair, charming conversation, and exceptional elegance. Even before her formal debut, she was regarded as "the most beautiful young lady on the floor" at the Newport ball given by Alva Vanderbilt for the Duke of Marlborough when he came courting Consuelo Vanderbilt in 1895; and she was frequently referred to as the most beautiful of the belles of

Newport once she was out in society. Throughout the second half of the 1890s, Emily appeared with her mother on the guest lists of every important "Four Hundred" event of the late 1890s. She was one of three hundred guests at Mrs. Astor's annual ball. She had her portrait painted by the very fashionable Adolfo Müller-Ury, who was so overcome by her pulchritude that he was inspired to paint her as the Virgin Mary, leading to dazzled descriptions of her as "the Madonna of the 400." In 1898 Emily was reported to have been the success of the season in Rome, too. She loved hunting, riding out with the Monmouth County hounds. She was sportif, playing her way to victory in tennis tournaments, and she was often to be found leading high jinks from the front. "A merry party of Mrs. Stuyvesant Fish's guests took a midnight bath at Bailey's Beach last night led by Mr. and Mrs. Whitney Warren and Miss Emily Hoffman," read the *News of Newport* in 1900.

What really set Emily apart from other socialites of the day, however, was the way she danced, a natural talent that would later have a great impact on Diana and an indirect influence on twentieth-century American fashion. Had she been born two generations later, Emily might well have succeeded in a professional career. As it was, she was celebrated as the "society exponent of Spanish dances," which she performed with "grace and fire," a talent that was regarded as all of a piece with her dark Spanish coloring. She had a pronounced theatrical streak. Dubbed the Carmencita of New York society by the press, her star turn as an amateur was a dance called the *cachucha*. This involved Emily in much clicking of castanets and flashings of ankle in public. The high point of her dancing career was a performance of the *cachucha* for charity in January 1900 at the Waldorf-Astoria, which earned her a standing ovation, fan letters, and rave reviews in New York's newspapers. One critic noted that "although it was near midnight when she came on the masculine enthusiasm that she aroused was of the most unmistakable sort." It was reported afterward that the great vaudeville impresarios Weber and Fields offered her hundreds of dollars to perform her Spanish dances

at their music hall on Broadway—an offer that caused her circle much hilarity and that she naturally had to refuse.

There was no pressure on Emily to make a grand European marriage. But with colonial ancestry on one side, Gilded Age riches on the other, and great beauty and vivacity into the bargain, she should have been wed within a year or two to a young man from a distinguished American family; and her name was often linked by gossips to New York society's more eligible bachelors. Four years after Emily's debut, however, the smart marriage plan seems to have gone offtrack. By 1899 Emily had drifted toward a group of louche society bohemians who called themselves the Carbonites. Their leader was the handsome James Lawrence Breese, a man who developed a new photographic carbon-printing process at the Carbon Studio downtown at 5 West Sixteenth Street. He was well known for his effect on impressionable young ladies. Another figure in the Carbonite group was the architect Stanford White, whose sensational murder by Harry Thaw a few years later would expose him as a serial womanizer and the owner of a red velvet swing on which semi-dressed young women, including Thaw's wife, entertained him. Before this came to light, the press loved the Carbonites for being a little wild and for holding what were described as weird midnight suppers. There was a "budget of fun for every second spent in the studio," said one newspaper and Emily was at the heart of it, dancing the *cachucha*.

It seems likely that Emily's predilection for Carbonite company and her refusal to get on and marry the right sort of husband caused considerable tension with her widowed mother; but during the Newport summer season of 1900, a candidate for Emily's hand appeared who fulfilled every maternal dream. Eugene Higgins was one of the world's most eligible bachelors. Higgins had sold his father's carpet-manufacturing business for an estimated fifty million dollars, leaving him free to pursue life as a sought-after gentleman of leisure. (One New York newspaper gave him precedence in the eligible bachelor ranking over George Vanderbilt and a brother of the khedive of Egypt.) The budding relationship

was closely watched, and tongues wagged even harder when Emily, chaperoned by married friends, was one of the party aboard Higgins's enormous yacht the *Varuna* when it set sail for the Mediterranean on November 14, 1900.

At the same time there were rumors that the true reason for Emily's sudden departure from New York was a serious rift with her mother. It was whispered that the upset was about potential husbands but in this instance the gentleman in question was not Emily's but Mrs. Hoffman's. In 1900 Mary Hoffman finally ran out of patience with Emily's obstinate behavior and announced to her stunned family that she was planning to marry again herself. It was said that the news came as a great shock to Emily and her brother, Ellis, neither of whom could stand their stepfather-to-be, Charles Gouverneur Weir, the implication being that the man had his eye on Mrs. Hoffman's considerable private income and luxurious style of life. Looking back on what happened a few months later, the gossip sheet *Town Topics* opined: "Miss Hoffman did not approve of her mother's marriage to Mr. Charles Gouverneur Weir, and she went abroad consulting her own wishes solely. On the evening before she sailed she told an intimate that she wanted never to come back."

WHATEVER THE TRUE reason for her departure from America, Emily arrived in Nice aboard the *Varuna* in March 1901 and made her way to Paris with Higgins and his other guests. But at that point the idea of an engagement between Emily and Eugene Higgins faded away. Emily may never have had the slightest intention of marrying Higgins. It is also possible that even if she entertained the idea at first, a long cruise with him on the *Varuna* changed her mind. At close range, said *Town Topics*, Higgins was such an intolerable fusspot that he robbed life aboard his yacht of much of its charm. However, the end of the much-vaunted romance meant that in the spring of 1901, the dazzling Miss Emily Hoffman found herself in Paris in an unexpected position. She was essentially on her own, back on the marriage market in her midtwenties in a

world where a woman was thought to be "on the shelf" at twenty-five. She seems to have had no wish to return home to live with a new stepfather whom she found uncongenial. Whether she liked it or not, Emily was under pressure to find a husband. She did not return to New York or Newport during the summer of 1901 but stayed on in Europe.

In September 1901, just six months after the *Varuna* docked in Nice, it filtered through to the society press in New York that the beautiful Miss Emily Hoffman was to marry a dashing Englishman, whom no one knew anything about, called Frederick Young Dalziel. Diana was certain that high-voltage physical attraction played its part. Frederick Dalziel was "Oxford educated," handsome, kindly, and adoring. He not only solved Emily's marriage problem but held out the possibility of an extended stay in Belle Epoque Paris. Subtle class differences that might have been important in a different city mattered less in its expatriate community. Even if Emily's mother, Mary Weir, was appalled by her daughter's engagement, she was unable to act, grounded in New York by her own recent marriage. It may also be that Frederick Young Dalziel's lack of a grand pedigree was part of his charm as far as Emily was concerned, allowing her to checkmate her mother in a tussle about wedlock.

They married in London, in the presence of Emily's brother and his wife rather than her mother, who appears to have been absent. Although the Dalziel family was in evidence, and Frederick's father signed the marriage certificate, there was no question of a ceremony anywhere near Haringey. Frederick Dalziel rented a room in Mayfair, and the wedding took place by special license on September 28, 1901, in one of London's richest areas, and at one of its smartest and most fashionable churches, Saint Peter's Eaton Square. After a honeymoon in the South of France, the newly married Mr. and Mrs. Dalziel set up home in Paris at 5 avenue du Bois de Boulogne. The following year, in 1902, Emily and her new husband went to New York on a visit that lasted well into the autumn.

They stayed with Emily's grandfather John Washington Ellis

at Stone Acre during the Newport season and appear to have been considering a move from Paris to New York even then. Up to the time of the Boer War (1899–1902), Frederick Dalziel earned a good living in Paris ("Mr. Dalziel has plenty of money," pronounced one gossip columnist). But the war in South Africa dragged on unexpectedly, which could have made life difficult for a man charged with attracting investment to the Transvaal's gold mines. The style of life on display that summer in New York and Newport was attractive and amusing; many of the Dalziels' friends already had houses on both sides of the Atlantic; and although the young couple might have preferred not to articulate it thus, there were arguments in favor of moving closer to Emily's powerful family, who could open doors in New York in a way that was impossible elsewhere. If marrying a socially undistinguished Briton in 1901 offered Emily a way of hitting back at her mother and a route out of a predicament, marrying the beautiful, well-bred Emily Key Hoffman marked an extraordinary change of fortune for Frederick Young Dalziel—a straight pass to the heart of one of the world's most exclusive elites, the New York "Four Hundred."

However, the newlyweds seem to have been in no great hurry to make the move from France. When Diana called her parents "racy, pleasure-loving, gala, good-looking Parisians who were part of the whole transition between the Edwardian era and the modern world," she lit on a poetic truth. The Dalziels—and particularly Emily—were indeed Parisians in the sense that Paris was their spiritual home. It was a feeling that affected many rich Americans so profoundly from the late nineteenth century onward that to quote one of their number, it was possible to feel "homesick on both continents." Provided one averted one's gaze from its dark underbelly, Paris at the turn of the century was a difficult place to leave—the Paris of Maxim's and the Opéra Garnier; of the couture of Worth, Doucet, and Paquin; of grand dukes and demimondaines; and of children in sailor suits sailing toy boats in the Jardin du Luxembourg.

Shortly after Emily and Frederick Dalziel returned to Paris

from the United States in late 1902, Emily became pregnant with her first baby. It is possible that this became a further excuse for lingering on. Diana's was a breech birth, but in spite of the risks she was born at home at 5 avenue du Bois de Boulogne. The name she was given was fashionable at the time. It recalled the goddess of hunting, an activity close to the heart of both her parents, though Diana preferred to believe she was named after Diane de Poitiers, the hunting beauty who was mistress to Henri II of France. If there had been a rift between Emily and her mother, it had now healed enough for Mary Weir to come to Paris to be on hand. Frederick Dalziel noted proudly in Diana's childhood album that her first visitor was one of his most aristocratic friends: Douglas Walter Campbell, heir to the 10th duke of Argyll, who brought a gift of a silver cup on behalf of his four-month-old son Ian, eventually the 11th duke. On October 25 Diana was christened at home by the vicar of Saint Luke's Chapel in the Quartier Latin. Her godmothers were her grandmother and a relation of Emily's, Anna Key Thompson. Her godfather was her uncle Edelsten, but since he was unable to be present one of New York's aristocrats, Henry Clews, Jr., stood in for him.

The Dalziels spent some time in San Remo that winter with their baby daughter. When they returned to Paris in March 1904, they stayed with friends for a few weeks before they finally gave up living permanently in Europe. On March 31, 1904, Frederick Dalziel's father and Edelsten went ahead to Boulogne so that they would be there to see the party off. From then onward a gap opened up between Frederick Dalziel and his suburban background. (Diana paid at least one visit to her uncle Edelsten—in Pangbourne, England—many years later, but she never mentioned his existence to her own children.) In 1904 Frederick Dalziel, who could not have been included in *Burke's Peerage* or *Debrett's* in England, was listed in the American *Social Register* for the first time; and on April 2 of that year, seven-month-old Diana Dalziel sailed on the SS *Ryndam* with her mother and father to begin a New York childhood.

..

WHEN SHE TALKED about her upbringing later, Diana invariably maintained that her family left Paris for New York only in April 1914, shortly before the outbreak of the First World War. In this oft-repeated version of her early years, she took daily walks in the Bois de Boulogne in the company of a nursemaid called Pink; she was taken to see the *Mona Lisa* at the Louvre ad nauseam and was one of the last visitors to see the painting before it was stolen in 1911; Nijinsky came to the house and sat around like a pet griffin ("he had nothing to say"); and the great demimondaines of Paris swished past her in the Bois, inspiring a lifelong love of footwear. "Their *shoes* were so beautiful! Children, naturally, are terribly aware of feet. They're closer to them."

But Diana did not grow up in Paris. She grew up in New York. Frederick Dalziel became a Wall Street broker, running the foreign securities desk of Post & Flagg; and the press noted the reappearance of the "bewitching" Emily soon after the family arrived back in 1904. The Dalziels proceeded to occupy a number of houses before finally settling in an agreeable Upper East Side town house at 15 East Seventy-Seventh Street in 1910; and Diana lived on the Upper East Side of Manhattan until she married. In 1907, the Dalziels had a second child, a daughter named Alexandra, who was known in the family as Teenie, and whom Diana called "Sister." Diana and Alexandra enjoyed an upper-class New York upbringing that was similar to Emily's: a world of governesses, walks in Central Park, skating clubs, dancing classes, and children's parties. A costume party at 15 East Seventy-Seventh Street was attended by the offspring of grand families including the Van Rensselaers, Livingstons, Potters, and Goulds. There were summers in houses in the Hudson Valley, and holidays with their grandmother Mary Weir in Southampton and on her farm in Katonah, New York.

In common with other children from New York's plutocracy, the two little Dalziel girls with their beautiful mother appeared from time to time in studio photographs in the society pages of the better parts of the press. There are several photographs of Diana herself before her twelfth birthday, marking her as a child who, like

her mother, lived at the heart of New York's social elite. She starred as the leading lady in a widely reported colonial pageant enacted by two hundred society children, a somewhat obnoxious event ostensibly organized by the Lafayette Fund to help wounded soldiers in France but mainly designed to let social interlopers know where they stood, since casting was by pedigree. (Diana headed the cast as Martha Washington because she was thought to be a collateral descendant of George through the Key connection.) Diana's insistence that she was brought up in Paris was also sharply contradicted by an album recording her New York childhood, assembled by her father as a wedding present, and confirmed by entries in *The Social Register* from 1904 onward. *The Social Register* suggests that the Dalziels may have held on to their Paris house at 5 avenue du Bois de Boulogne for two years after they moved to New York in 1904, but no longer. Alexandra would later say categorically that she and Diana grew up entirely in New York—but that it seemed to matter very much to Diana to believe otherwise. In public Alexandra loyally refused to discuss the whereabouts of their upbringing. "I'd better leave memories of childhood to Diana," she said later. "Sisters remember things differently."

ONE POINT ON which both sisters did agree was that behind the facade of their pleasant house on East Seventy-Seventh Street the atmosphere was often strained; and that the problems revolved entirely around the moods of their ever-more-volatile mother. The decision to move from Paris to New York in 1904 affected Frederick and Emily Dalziel quite differently. In an unusual version of the American dream, America gave Frederick Dalziel the freedom to live as the upper-class Englishman he wanted to be, though he talked up his wife's family connections while keeping quiet about his own. "My father," Alexandra said, "was a tremendous snob about my mother's relations." His income from Post & Flagg and Emily's trusts from the Ellis family combined to give them a life on the Upper East Side of which he could only have dreamed as a boy in Haringey. For its part, New York society took Frederick

Dalziel at face value. By 1910 he was a member of the invitation-only Brook Club, said to be the most exclusive gentleman's club in the United States, let alone New York.

For Emily, however, the move back to New York from Paris came at some personal cost, returning her to the world of her mother and the claustrophobic, gossipy, even vicious social elite in which she had grown up. To make things worse, there was now a certain degree of slippage in Mrs. Frederick Dalziel's status and position. While she was growing up Emily was associated with the social power that came from money. By the time she returned from Paris in 1904, riches mattered even more, and many of her friends had either married into great means or inherited vast fortunes. (The Dalziels' friends included rich bohemians such as Diana's stand-in godfather, the sculptor Henry Clews, Jr., the painter Robert Winthrop Chanler, and the former actress Mrs. George Gould.) Emily, meanwhile, had married an impecunious Englishman. It was a loss of power with which she struggled. Emily felt poor compared to their wealthy friends. Living in a world where making any money herself was out of the question, she worried about it all the time. "He never had any money," Diana later said. "Never made any money, never thought about money; it killed my mother, who was American, though she was very European. She saw things rather square, which most women do."

Another reason for Emily's unhappiness was that she suffered as her youthful bloom began to fade, a loss that was all the more potent in the inward-looking world of New York's elite, where great importance was placed on appearance and display. She became increasingly neurotic about her power to attract, compensating with extravagant makeup that caused her daughter much embarrassment at school. "Whispers would go around: 'Look, she's painted,'" said Diana. "She was *very* made up for those days." This anxiety manifested itself in a constant need to be the center of attention, and some very uninhibited flirting. "I remember this: my mother wouldn't have a chauffeur or a footman unless he was infatuated with her—he had to show enormous *dazzle* for her. Everyone had

to or she wasn't interested." This attitude would later extend to Diana's own boyfriends: "She had to be on stage, often making a show of herself." Diana sensed that of the two of them, her mother was by far the more fragile character: "I think she was someone who was possessed by a great fear."

It is not clear exactly when Emily tipped from a flirtatious manner into taking lovers. Having created a delightful new reality for himself in New York, Frederick Dalziel resolutely refused to spoil it by facing up to the fact he was being cuckolded, and Diana had difficulty coming to terms with the idea later too, maintaining that the worst her mother did was to travel everywhere with a good-looking Turk. "My father was rather amused by her flirtations—it was all part of the scene," said Diana. "Flirtations are part of life, part of society—if one didn't have these little flings, where would one be? I think my father realized this. He was devoted to my mother. She was in the arms of a strong man who saw to everything because he knew that she wasn't strong." It was Alexandra who faced Emily's adultery squarely and acknowledged that in retrospect she was certain her mother had often been unfaithful to her father. "She had a great many men," said Alexandra. "My father had to put up with a very great deal."

Emily also dealt with the unhappiness that gnawed at her by escaping from New York. Until the outbreak of war in 1914 she returned to Europe frequently, and from the age of eight Diana went with her. Diana's memories of a childhood in Paris were not, therefore, purely imaginary: they did draw on real experience. Between 1911 and 1913 she traveled with her family to England, Scotland, and France. Her grandmother Mary Weir went to Paris too, establishing her own household with servants and a secretary. These expeditions lasted for several months each summer, and there is no reason to doubt the impact of Paris on a sensitive child whose parents loved the city and impressed upon her the fact that she had been born there. Given her age at the time, some later confusion is understandable. Nonetheless, it is also the case that once an idea gripped Diana's imagination, it became true even if it was

not. "So many of the things in life that interest me the most I to-
tally forget," she once remarked. "They're so intense they . . . burn
off. Then, when I do remember them, they become stronger than
memory—stronger, even, than reality."

One example is her story that in 1909 Diaghilev brought the
ballerina and Belle Epoque figure Ida Rubinstein to her parents'
house on the avenue du Bois de Boulogne, whereupon six-year-old
Diana hid behind a screen and took in every detail of what Rubin-
stein was wearing. "She was all in black—a straight black coat to
the ground. . . . Under the coat she wore high black suede Russian
boots. And her *hair* was like Medusa's—these great big black curls,
draped in black tulle, which kept them in place and *just* veiled
her eyes. Then her *eyes*, through the veil. . . . If you've never seen
kohl before, brother, was that a time to *see* it!" And then there was
Rubinstein's shape: "She was long, lithesome, sensuous, sinuous . . .
it was all line, line, *line.*" Leaving aside the detail that Diana's
parents were not living in the avenue du Bois de Boulogne in 1909,
parts of this story are credible for the prosaic reason that Diaghilev
was searching Paris for money that year to launch the first season
of his Ballets Russes; and he often touted Ida Rubinstein around
rich people in the hope that they would back his productions of
Cléopatre and *Schéhérazade* in which Rubinstein would star.

It is plausible that Diaghilev heard about Emily's talent as an
amateur dancer, sought her out, introduced her to both Rubinstein
and the great Nijinsky, and treated her as a person of informed
taste in the mistaken belief that she was in a position to write a
large check. But given that Diana was only six in 1909 and that
there is no record of her traveling outside the United States before
1911, it is much less plausible that she met Ida Rubinstein herself
or that she hid behind a screen while her mother chatted with Di-
aghilev. It is more probable that Diana met or saw Ida Rubinstein
when she was older, or heard the story from her mother later, for
from the evidence Emily had a narrative gift. Diana's vision of
demimondaines parading in the Bois de Boulogne in the colors of
the new century may well have been her mother's description, at

least in part: "red red, *violent* violet, orange—when I say 'orange' I mean *red* orange, not yellow orange—jade green and cobalt blue." Diana's story about visiting London for the coronation of King George V is another case in point. The coronation took place in June 1911 when the Dalziels were in Europe, and it is quite possible that the eight-year-old Diana was taken to stand in the crowds. But she later confessed to Jacqueline Kennedy Onassis that most of what she remembered came from gazing intently at photographs for hours on end much later. In reminiscing about Diaghilev, Diana left herself an escape route too. "That's where everything happened, and 1909, that's the year it happened, *and they say that's* how *it happened.*"

It is also perhaps not surprising that memories of long sojourns in Paris, however confused or improved upon later, burned brighter than the mundane routine of New York childhood. The Belle Epoque Paris that displaced her Manhattan upbringing before 1914 certainly positioned Diana later as more romantic, more exotic, more "other" than she really was, and made her parents sound richer and more fashionable. In years to come this would become more, not less, important. By the time she was in her sixties, Diana placed such a high premium on imaginative power that she believed the romantic way she remembered her childhood was more significant than reality. Images of a Paris childhood nourished her imagination to such an extent that she almost came to believe her own stories while holding out the possibility that it was all "faction." But there was more to blotting out her early years than this.

FROM AN EARLY age Diana's American childhood was made miserable by beauty. She felt herself to be her beautiful mother's unloved, ugly child, causing her great pain. She internalized a sense of herself as ugly when she was very young, though photographs suggest that she was not nearly as plain as she felt herself to be. She inherited attractive dark coloring from Emily but a big nose and jaw from Frederick Dalziel, features that worked less well on a little girl with slight astigmatism than they did on a large man.

But it was also Diana's misfortune that her younger sister, Alexandra, was enchantingly pretty. Alexandra had a fine bone structure, a petite nose, and extraordinary violet eyes. According to Diana, "Sister" was a sensation even when taken out in her pram to Central Park:

> *I can remember she was The Most Beautiful Child in Central Park. In those days it was a very small world, and there were all sorts of little titles like that. She'd sit in her pram—she was terribly dressed up, you understand—and people would stop just to look at her. As soon as I'd see people looking, I'd run over to the pram, because I was so proud of her.*
>
> *"Oh what a beautiful child!" they'd say.*
> *"Yes," I'd always say, "and she has violet eyes."*

But in an incident that seared itself forever on Diana's memory, pride in her little sister's beauty became entangled with crushing blows to her self-confidence:

> *Then there was the most terrible scene between my mother and me. One day she said to me, "It's too bad that you have such a beautiful sister and that you are so extremely ugly and so terribly jealous of her. This, of course, is why you are so impossible to deal with." It didn't offend me that much. I simply walked out of the room. I never bothered to explain that I loved my sister and was more proud of her than of anything in the world, that I absolutely adored her. . . . Parents, you know, can be terrible.*

As a small girl, Diana could not possibly have understood why her mother lashed out in this malign way. In the years between 1904 and 1914, Emily Dalziel pitched between restless unhappiness and exuberance and finally tipped into a depressive state that she later described as "wretched health . . . nothing definite you know, just a nervous miserable condition." Poorly understood in the years before World War I, and compounded by acute anxiety

about her fading beauty and appeal, Emily's "nerves" resulted in histrionic and delinquent behavior toward her two daughters, with effects that stayed with both of them for years. Diana would later rationalize this by saying that mothers and daughters rarely got on well. But the truth, in the Dalziel family, was that the mother adored one daughter and not the other.

"You ask 'do I love you,'" Emily once wrote to Alexandra. "My precious baby girl, I love you with all my heart & soul & body. . . . I love *you*, the air you breath [*sic*], the things you touch, the ground you walk on. Every little bit of me loves every bit of you. I love you so it hurts, so it frightens me." At the same time Emily developed an antipathy toward Diana, who committed the cardinal sin of refusing to show her mother the unconditional love she demanded from everyone else. Diana probably did become exceedingly difficult, for she possessed a fierce temper that never quite went away. In childhood, however, Diana was convinced that the root cause of Emily's incontinent antagonism was her ugliness. While her mother reveled in Alexandra's beauty, Diana's looks were an embarrassment. "All I knew then was that my mother wasn't proud of me," said Diana. "I was always her ugly little monster."

Had Diana been luckier, an affectionate nanny might have compensated for her mother's hostility. But in this instance she was truly unfortunate, for the Dalziel children grew up with a nanny who also found Diana difficult and made the dysfunctional family dynamics even worse. This was not, as Diana claimed in her memoirs, the nurse called Pink who took her for daily walks in the Bois de Boulogne. (Though there was a nurse of that name, she left the Dalziel household when Diana was about a year old.) The nanny in question was Katherine (or "Kay") Carroll, who appeared in the New York household in 1908, about a year after Alexandra was born. She was no passing nursemaid. Because Emily was often out or away, she left Kay Carroll in charge and ceded control to her. Nanny Kay acquired a great deal of power. She became the person who held the Dalziel household together, and she stayed for decades, becoming, in effect, another member of the family.

Kay Carroll adored her "baby" Alexandra, and Alexandra—and Emily—loved Nanny Kay. As far as Alexandra was concerned, Kay Carroll was the warm substitute mother who compensated for Emily's increasingly frequent absences. Yet Alexandra was also the first to say that Nanny Kay's attitude to Diana was completely different. "She didn't like Diana," she declared. "Diana and she didn't get on." Nanny Kay copied Emily by constantly comparing Diana unfavorably with her younger sister. Understandably Diana loathed Kay Carroll. "My nurse was appalling. Naturally, nurses are always frustrated. They may love the children but they're not theirs and the time will come when they will have to leave them. . . . I couldn't stand her. She was the *worst*." Remarkably the loved and the unloved sisters remained fond of each other though they were very different, one bond in an otherwise fissile household.

IN DIANA'S EARLY adolescence, matters came to a head. Diana spoke of this fleetingly much later, though she generally only dropped hints, leaving the listener to put the constituent parts together. She told Christopher Hemphill, a New York writer who was custodian of Andy Warhol's tapes, that she had a terrible nightmare as a child about being obliterated, one that stayed with her for years. "It was a wall of water coming curling over me when I was alone in the water—this body of water moving, moving, moving, moving. . . . It was like *teeth* almost—*totally* consuming. . . . I was terrified of the Atlantic but I couldn't stay out of it. . . . It was always the same all-consuming war." There are very few photographs of Diana in her early teens, so it is difficult to tell whether puberty wrought real damage to her looks. What is clear is that once she reached the age of self-consciousness and looked in the mirror, she hated what she saw; and what seems to have happened is that relentless labeling as ugly, and the denigration that went with it from the two female adults in the Dalziel household, conspired to reduce a fragile child to such a low emotional state that Diana later preferred to excise and rearrange much of the narrative about this part of her life, rather than remember that it nearly broke her.

..

IN DIANA'S VERSION of what happened, the problems began when
the family returned from Paris to New York in 1914. In this account
she could speak only French and was unable to understand what
was said to her. "Actually, when I was brought to America from
France in 1914, I didn't know any English. But what was worse, I
didn't *hear* it. I was the most frustrated little girl." She was cer-
tainly frustrated and miserable, but for a different reason. In 1914
(having actually moved to New York ten years earlier) both Diana
and Alexandra followed their mother to the Brearley School, then
as now a top private girls' school. As an adult Diana consistently
maintained that she and her sister were barely educated, but this
was wrong. Their education was taken seriously. Brearley aimed
to give young ladies an intellectual education comparable to that
of their brothers, and when Diana was there its head, James G.
Croswell, was a professor of Greek from Harvard. But once again
the beautiful Alexandra, who was blessed with brains and sport-
ing ability as well as beauty and an even temperament, thrived
in the atmosphere of Brearley and stayed there for thirteen years.
She went on to study mathematics at Bryn Mawr, and finished her
degree at Barnard.

Diana, on the other hand, hated Brearley and its academic ethos
so much that she almost wrote it out of her life story. She loathed
the school's rigid authoritarianism, felt isolated from her more
teachable classmates, and learned nothing. "It's one time in my life
I've always regretted—fighting my way through the place. . . . And
those goddamn *gongs*! Everyone knew where to go when the gong
went off except me, but I didn't know whom to ask. I didn't know
anybody. I didn't know anything—I couldn't *speak*." Talking to
the New York curator and art critic Henry Geldzahler years later,
she described her time at Brearley thus: "I lasted three weeks at the
Brearley School . . . three *months* . . . three *months*. And really, they
kept me there out of sort of kindness to my parents who obviously
didn't know what to do with me because I didn't speak English, I'd
never had time to learn English, wasn't allowed to speak French

and I'd no one to talk to." Misery at Brearley may have led to an outbreak of stuttering. "English was decided on, which is why I speak such terrible French to this day." This nonsense is best read as a metaphor for a time when Diana was so isolated and adrift that she could barely communicate. Her school records show that she was in fact at Brearley for three full years.

To make matters worse, Emily found a new way of passing the time during the vacations that Diana truly hated. The outbreak of war in Europe put an end to family trips to Paris after 1914. Faced with being trapped in the United States during the long summer months, Emily turned to big-game hunting. She had long ridden to hounds, but from around 1916, when Diana was thirteen, Emily developed a passion for a sport in which upper-class women were slowly being allowed to participate. Although it was unusual for a woman to take up big game-hunting in North America, it gave those that did a rare opportunity to escape from society's concerns and petty domesticity while remaining within the outer limits of social convention. It also gave women who could afford it a chance to develop a level of expertise and degree of focus that was uniquely exhilarating.

Emily told a newspaper that she first went to the Rockies as a cure for her nervous debilitation. It worked. Photographs show her communing happily with a mountain lion and posing with a patient elk. A fascination with open spaces, wild animals, and the hunt "took possession of her." It all did her so much good, she said, that she sent for her daughters to join her, and at least one photograph shows that Nanny Kay went too, riding in the Rockies with her charges and Emily. Inevitably Diana's claim that she was taught to ride by Buffalo Bill Cody has been regarded as one of her more outré assertions. However, this was true: like Diaghilev, Buffalo Bill entered Diana's life because of Emily, though in this instance Emily was one of Cody's patrons. If a woman from Emily's background wanted to learn to track and shoot big game, Buffalo Bill's establishment in Wyoming was the obvious destination. Buffalo Bill was part showman, part impostor, but he started

out as a guide to European aristocrats and American millionaires on buffalo hunts. He traveled so widely that Emily and her daughters could have met him—and had an occasional riding lesson—at almost any time. However, it is most likely that Diana and Alexandra remembered him from the very end of his life, when they stayed at his Hotel Irma in Cody, Wyoming, in 1916.

An epidemic of infantile paralysis swept through New York and its surroundings in the summer of 1916, causing panic. This tallies with Diana's memory of being sent out of the city with Alexandra and a hysterical French maid (Kay Carroll was probably on holiday). In common with children from thousands of other families, they found themselves on a train at very short notice, though Diana's account of watching drunken cowboys shoot each other dead from the train window as they traveled west should be taken with a large pinch of salt. Like many other children, the sisters were kept away from New York until long after the start of the new school year, when all danger of polio had passed. According to his biographers, Buffalo Bill did make a brief visit to his beloved Cody in November 1916, just before he died in Denver in January 1917. Ill and almost bankrupt, he could well have taken a liking to Emily's daughters, found them two little Indian ponies to try, and whiled away the time by teaching them to ride. If so, he probably came to see them off too. "The last time I saw him was when he came to see us off on the train that was to take us back to New York. I can remember standing with my sister at the back of the train with tears pouring down our faces, waving."

She may have loved Buffalo Bill and his fringed jackets, but Diana hated everything else to do with this new world in which she found herself. She hated her mother's enthusiasm for the wild. She hated Wyoming. She hated cowboys. She hated the great open spaces that ached of loneliness. "We were there in the wilds with the moose and the bears and the elks and . . . my *word*! It was so *lonely*. I remember lonely men, lonely spaces. . . . I couldn't stand the loneliness of those cowboys." Most of all she hated shooting and she loathed wild animals. In the grip of this new interest, which

Alexandra shared enthusiastically, Emily ignored the reaction of her tiresome elder daughter. "I was just a nut. And a bore. But I didn't declaim. I was very young. No one listened."

Then there came a body blow. In the summer of 1917 the headmaster of Brearley wrote to the Dalziels asking them to remove Diana, saying that she was not considered to be Brearley material. It is safe to assume that at the time Emily did not react sensitively; that she was angry and exasperated with Diana; that the effect on Diana of three very stressful years in the wrong school was never considered; and that "stupidity" was now added to Diana's growing list of failings. Years afterward Diana was fond of saying that she was looking for something that Brearley could not offer—allure. At the time the impact of expulsion was almost certainly terrible, coinciding as it did with so much else that was going wrong. In later life Diana dropped hints that in the summer of 1917 she was so miserable she was suicidal. She was most frank with the journalist Lally Weymouth in an interview for *Rolling Stone* in August 1977.

By the age of fourteen, she told Weymouth, "If I thought of myself, I wanted to kill myself." Her mother had christened her Diana after the goddess of hunting, a name freighted with expectation. She was manifestly no goddess. "I thought I was the most hideous thing in the world. Hideous," she said bleakly to Weymouth. She was isolated inside her own family, the only ugly child in a family of beauties; and her nanny's power to hurt was as great as her mother's. The top girls' school in New York, which celebrated her beautiful, sporty, clever younger sister, had rejected her, evidently proving her mother's point. It was a very low time. "But I think when you're young you should be a lot with yourself and your sufferings," said Diana years later. "Then one day you get out where the sun shines and the rain rains and the snow snows, and it all comes together.

"It all came together for me when I got back to New York."

THE GIRL

The first change was educational. In the autumn of 1917, Diana, who was now fourteen, started at a smaller, less academic school run by a Mrs. Randall McIver. The atmosphere was friendly; there were no more "goddamn gongs"; and when she forgot to do her homework, no one seemed to mind. Mrs. McIver held classes only in the mornings, making a second change possible since Diana was able to attend Louis Chalif's dancing school in the afternoons. In later life she made it sound as if she abandoned academic education altogether in favor of a ballet school run by the Russian dancer and choreographer Michel Fokine. This was not the case, not least because Fokine did not open his New York studio until 1921; but in dispatching Diana to Chalif's school two or three times a week, Emily did enroll her with New York's leading dance educator of the time. Chalif was a distinguished Russian figure in his own right, the former ballet master of the Government Theater in Odessa. He wrote books for dance teachers and is credited with developing simplified ballet instruction for American children.

"I am simply crazy over dancing and over Mr. Chalif," wrote Diana in a diary she started in January 1918. Chalif had the gift of creating an atmosphere that was both disciplined and encouraging. "He is so nice & never gets mad or anything and I wish I could do nothing but take a nice warm bath with loads of perfume & dance dance dance." His classes proved to be a powerful antidote to her problems at home: "Music can do something to me that nothing else can. It just makes me forget everything." Inspired by Chalif's classes, Diana longed to be a dancer when she grew up. By

1917 Isadora Duncan had opened up the idea of dance as an activity for noble, artistic women who hungered to connect the soul to spontaneous free expression of the body; and in her diary Diana wrote that she yearned to go to Duncan's school and become one of her semiadopted daughters, known as the "Isadorables."

Unsurprisingly the notion that Diana should run off and become an "Isadorable" was not encouraged by her family. Neither was the idea that she should become a professional dancer. Her diary suggests that Diana would in fact have settled for much less, in the form of a kind word from Emily about her dancing, but even this was not forthcoming: "I still don't think mother thinks I dance well and I guess I don't but I won't drop it," she wrote. Having put herself out to find a new school and enroll Diana in ballet classes, Emily seems to have left her to get on with it. There is no suggestion in Diana's diary that she came to watch her in class, although she was in New York at the time. Diana's grandmother Mary Weir, known to her granddaughters as "Ama," and her husband did put in an appearance, though even their reaction was distinctly qualified. "Ama and Daddy Weir went to saw me [*sic*] and they say I'm awfully good but that I don't kick out my feet enough & I don't thro my head back enough." In the end the daydream faded of its own accord when Diana was overcome by self-consciousness during Chalif's end-of-term shows in Carnegie Hall. "I suffered, as only the very young can suffer, the torture of being conspicuous," she said.

IN SPITE OF Emily's lack of interest in Diana's new craze, her own love of dancing had a great impact on her eldest daughter and on her view of fashion in the longer term. The Dalziels knew Irene and Vernon Castle, creators of the Castle Walk and a host of other ballroom dances adapted for polite society from raunchy South American originals, which became the rage from about 1912. The Castles came to 15 East Seventy-Seventh Street, probably to give Emily and Frederick Dalziel private lessons. Irene Castle was a fashion phenomenon, much fêted for the slim, uncorseted look she

developed so that she could dance unencumbered, and for her short haircut of 1915, known as the "Castle bob." Emily's enthusiasm for the Ballets Russes had an even greater influence on Diana's ideas about the "modern" female body and the way it should be dressed. Diana may or may not have encountered Diaghilev fleetingly before the First World War; what is more important is that she was taken to see his ballets as she grew up and her eyes were opened at a young age to the work of Léon Bakst, Alexandre Benois, and Nijinsky and the greatest artists and musicians of the period. Even as a child Diana was encouraged to admire the bold and brilliant colors, the rich textures, and the new silhouettes of Diaghilev's vision, and the dress designers he influenced, Paul Poiret above all; and it is possible to trace her lifelong fascination with Cleopatra and Scheherazade to Diaghilev's mock-Oriental conceptions of 1909 and 1910. Diana was not grateful to her mother for much, but she did appreciate being allowed to witness the first great revolution in style of the twentieth century at close range when she was very young: "I realize now I saw the whole beginning of our century . . . everything was new."

Emily also shared an outlook influenced by gymnastics, calisthenics, and the dress reform movement: aesthetic movements that emphasized healthy diets, fresh air, and exercise, as well, of course, as an attitude to sex that was anything but puritan. Paul Poiret claimed to have been the first to abandon the corset in 1905. In doing so, he captured a wider female mood that rejected restrictive clothes and embraced the pleasures of motion and rhythm. Diana sensed this when she tried to explore in her diary what dancing felt like: "I like dancing with lots of noise. I hate fluffy costumes. I like Spanish and gypsy costumes. I like diamond headed daggers and tambereens [sic]. I like it when you put your foot down hard on floor [sic] and the drum makes a boom." Her diary offers a glimpse of her pleasure in the physicality of dance and the way dancing strengthened her sense of herself.

Diana's lessons with Louis Chalif in 1918 set her on the road to recovery after much misery, but her mother's love of dancing

and her decision to enroll Diana with Chalif also marked the beginning of many long-standing passions: for rhythm and music; for ballet and ballet dancers; for leotards and ballet pumps; and for designs that worked with the natural body, rather than clothes that corseted and constrained it. Chalif's classes started Diana's preoccupation with posture, health, and fitness in a way that was years ahead of its time. Decades later, her delight in the attractiveness of the invigorated, well-stretched body and long, long limbs would resurface repeatedly on her fashion pages and in her photo-autobiography, *Allure*. But in 1918 the real importance of Chalif's classes lay elsewhere. "When I discovered dancing," said Diana, "I learned to dream."

ALTHOUGH LIFE IMPROVED after she left Brearley in 1917, Diana remained vulnerable to Emily's insensitivity, narcissism, and petty cruelties, and was often made very depressed by her. It is clear from her diary in January 1918 that her relationship with her mother was still dreadful. "Mother and I agree on practically nothing . . . I can't do anything but think & think about it." Her unhappiness was palpable. "I cried this morning. I feel like crying now. I don't know what to do. It really isn't fair toward mother. If only I knew what to do. I do nothing but argue & contradict mother & it must stop. It's awful but I can't help it." Not being able to talk to Emily made the problem far worse. "It's one of the big problems of my life today. I can't tell mother. I would not know what to tell her. If I went to her & told her that I was unhappy she'd never understand & say I was an ungratefull [sic] little wretch." She kept many things from her mother, she wrote, and it was all the more painful because Emily insisted that she and her eldest daughter were chums. Diana regarded this as pure hypocrisy. "Mother always says we are good friends. We are not. It seems to me we never were & if we ever will be I don't know."

However, the diary also reveals that Diana was learning to save herself from emotional evisceration by escaping to a world of her own. Boris Cyrulnik, a leading French expert on resilience

in childhood, observes that sensitive, imaginative children often survive bad childhoods better than the tough and unimaginative young, precisely because of their aptitude for escaping from bleak reality by transporting themselves over and over again to a fantasy parallel universe. "Freud thought that a happy man did not need to dream and that reality was enough to keep him satisfied," writes Cyrulnik, "[but] only children who can dream can save themselves."

By any standard Diana was an exceptionally imaginative child. At fourteen she felt this intuitively and tried to explore how it set her apart from other people. "I have always had a wonderful imagination. I have thought of things that never could be found," she wrote.

> *For instance I play the Polonaise. I feel the anger, the strife and pride myself with jealousy of a race of people that live in a cold barren country. It bring(s) before me the magnificence & glory of a great expanse of territory occupied only by peasants. A Spanish tango and any other Spanish music brings me strait [sic] to sunny warm Spain full of people in brilliant costumes . . . the music is full of coquetry as the girl that dances to it is flirting with a group of admirers.*

Diana needed only to focus inwardly for a moment to visualize a scene in which she hovered at the center, remarking years later to Chrisopher Hemphill: "I keep constructing tableaux in my mind. Usually, they're of these memories—if that's what you can call them. Usually, they're of conversation. And usually, they're of something somebody said at dinner." She was already doing this at fourteen, though in 1918 inspiration naturally came from the world around her rather than dinner parties. To take just one example, she flirted with the idea of becoming a Roman Catholic, like one of her friends at Mrs. McIver's, before deciding she was not sufficiently devout. Instead she settled for an image of herself saying her prayers before an ivory crucifix, a victory of style over substance for which she would later be much criticized: "There

is something so wonderfull [*sic*] about a girl just a girl in a fresh white nightdress kneeling before a pure white crucifix in the candle light—I shall really be like that I want to be heavenly."

Looking back, Diana thought she was also saved by a strength of character that her fragile mother lacked. "I was much stronger—with a stronger will and a stronger *character*—but I didn't realize it then." She was a determined fourteen-year-old, and she was determined to become great. Keeping a diary was, in fact, part of the greatness plan. "All great people kept diaries so I think I will keep mine very seriously henceforth," she wrote on January 10, 1918. Though she dreamed of becoming a ballet dancer, another potent daydream was, quite simply, showing everyone that they were wrong about her. If she could not be a dancer, she would be an actress or an interior decorator. But it was agony to think how long she would have to wait, and her diary was filled with daydreams of escape. As Diana said later, "Some children have people they want to be. I wanted to be anywhere *else*." In 1918, however, she was in no doubt that marriage was the most realistic evacuation route, and she weighed her options. A creative sort was one possibility: "I want sometimes an artist, wild and fantastic, that will fall in love with my small white feet etc oh but very, very, wild and horribly good looking." But a Wall Street chap was indubitably more sensible: "Then the next day I want a man with money, moustache, good looks . . . of course the latter variety is more practical but still I want a wild romance—wild, oh si, si wild—an Italian painter who will want to model me in marbl [*sic*] and paint me as the Bohemians did with a tambourine and a dagger."

It was not all fantasy, however. Emily had impressed on Diana that she would need to be self-supporting when she was older. It is unclear whether in saying this Emily was worried about Diana's chances of finding a husband because of her looks or her lack of private income, or was simply trying to make her do her homework. Whatever the reason, Diana took Emily's injunction very seriously and worried about money for the rest of her life. Her first recorded attempt to do something about her financial situation—and to earn

cash from a woman's magazine—appeared on January 23, 1918. She had written to the *Woman's Home Companion* "pin-money club" which offered readers the chance to earn a few dollars through the magazine. However, Diana then discovered that she would be required to sell subscriptions, which she did not think would be "quite correct." On the other hand, at fourteen she also unknowingly rehearsed being editor in chief of a fashion magazine in the most intriguing way, not just by endlessly constructing tableaux in her mind but by spending hours cutting out images from magazines and catalogs and rearranging them. "I am making a divine collection of pictures from the penny picture catalogue. . . . I spend hours a day but very interesting hours picking out and choosing and disciding [*sic*]."

It is clear from her diary at this time that Diana was gifted not just with a prodigious inner eye but a way of looking intently at the world beyond her family that was already becoming second nature. She frequently talked to herself about the houses she visited: "Mrs. McKeever has lots of taste & the whole apartment is sort of dark and rich in coloring." Ama, on the other hand, had no taste at all. "The house is terrible, it is so ugly. Ama knows a beautiful thing when she sees it but she can not create a beautiful thing." In her diary she transposed these observations into plans for her grown-up bedroom on the happy day when she was finally in control of her own destiny: "I would love a bedroom in French gray and turquoise blue & then a boudoir opening off it. I would line it in a dull grey [sic] and dull grey blue. I'd like to have painted furniture & bowls of fruit and flowers. Also transparent plum colored glass and dried rose petals. Also incense."

Those who knew and admired Diana later were often astounded by the way she was never on vacation from her eye. "She was perpetually scanning, monitoring, reaching for some idea, sensation, or tangible item—a fingernail, a color, an eyesocket, a squashed banana, a jewel—that would, in her words, 'thrill me to madness,'" wrote Jonathan Lieberson in the 1960s. One friend later described her love of a beautiful object (which frequently opened the eyes of

others to its beauty) as "almost fetishistic." Not everyone who scans
the world with such sustained concentration necessarily enjoys it;
but from childhood Diana was undoubtedly made happier by look-
ing, an act on which her misery bestowed a fierce intensity. In the
manner of many unhappy children Diana learned early the trick,
which stayed with her for life, of making herself less miserable by
gazing at beautiful things to the point of euphoria. "Some times
I feel as if I did not want anything but a wonderfull [*sic*] picture
to look at," she wrote in her diary. At the same time she started to
deploy her great imaginative gifts to construct a carapace, a pro-
tective sleeve—beginning with the Girl.

THE GIRL FIRST appeared in Diana's diary in early January 1918.
On January 12 she wrote: "You know for years I am and always
have been looking out for girls to idolize because they are things
to look up to because they are perfect. Never have I discovered
that girl or that woman. *I shall be that girl.*" Denied a female
role model, Diana elected to craft her own. She proceeded to list
some of the ways she was going to set about it: "Never to be rude
to mother sister or anybody. To improve my writing . . . I shall
always try terribly hard in everything I do. I shall do things all
the time (like make things etc). *Never be idle!* And so on. There
are loads and loads of others." In further diary entries the goal
of achieving perfection crystallized around three aims. First, she
had to battle her natural disadvantages and transform the way
she looked: "I have descoved [*sic*] I don't look pleasant & and if I
want to look as well as I do want to I must look pleasant and be
sweet and look charming and be 'the girl.'" Second, she would
improve her manner and the way she spoke: "I have decided that
my vocabulary is very small & poor so I am going to try and
broaden it." Third, she would work very hard, although such res-
olutions were generally subordinate to becoming more attractive:
"I shall please everyone in my appearance & my manner and
shall work my hardest in everything I do."

..

IN JUNE 1918, when she took her diary up again after a pause,
Diana (who was still only fourteen) had an even clearer idea about
who she wanted the Girl to be. Smoking, which was just becom-
ing fashionable for stylish young women, was crucial to the effect.
"Have smoked a cigarette & adored them. My ambition is to be a
dancer or actress have wonderfull clothes and no clothes that aren't
wonderfull, smoke and drink cocktails. Not drink hard of course
just for the chic of the thing. Yes, those cigarettes were great, mar-
vellous." She appreciated that this would require a painstaking ap-
proach: "I want to look after detail and I simply must be perfect."
It should be noted that learning French was part of the master
plan, another clue that Diana was not a Francophone in 1914 as she
later claimed. "I must learn French and be able to speak fluently. I
must be able to dance and be a belle everywhere I go."

Diana dreamed of winning the same kind of admiration and in-
tense attention that flowed toward her beautiful sister, Alexandra,
whenever she entered a room: "I am going to be able to sing at lib-
erty the song sister sings—'they are wild, simply wild over me.'"
But rather than compete on Alexandra's territory, she decided to
create an alternative, original identity, a different ego-ideal, so that
"they" would be "wild, simply wild," about her stylish appearance,
her command of French, her chic smoking technique, and her ex-
tensive vocabulary. The young Diana firmly believed she could
dream such admiration into existence: "I dreamt of many men
coming to me & asking me to take drives with them in their cars.
In other words it means that I was popular. I have heard it said that
dreams do not come true but I will make this one come *true*!" The
campaign would be directed at both sexes. "I shall make myself
the most popular girl among boys and girls," she wrote on January
20. "I'm going to make myself the most popular girl in the world. I
know I can succeed. If I don't . . . it will be betrayal of my own self."

Triumph over youthful adversity has been described as a pro-
cess, a successful reknitting together of a sense of oneself in stages.
Applying herself assiduously to the secret business of becoming
the Girl at Mrs. McIver's school turned out to be just as good for

Diana's self-esteem as doing well in Mr. Chalif's classes: "Sister's music teacher told me that one of the little girls in school said I was wonderful I'm going to try and make that impression on everyone. My skirt has been lengthened & my hair is held back with a comb and I feel new and fresh." Her self-conscious attempts to develop her vocabulary and the way she spoke contributed to her success. Her classmates at Mrs. McIver's thought she was entertaining. A new friend, Emily Billings, found Diana particularly funny. "Emily said I talked very well and am very amusing. I'm awfully glad because I love people to talk in an amusing way." It all led to the most gratifying success. By late January she felt able to write: "You know I'm vastly popular everybody wanted to walk near me & be with them. . . . Well that's just what I'm driving at. Popularity." By June 1918 it was even better. The plan was working. Her efforts *had* made her more sought-after. "Lots of things have happened since I last wrote in this book—I have become much more popular with everyone. Emily Billings & I are best friends forever, and all the girls at school the latter part of April and May were awfully nice to me—I'm going to make myself the most popular girl in the world. I know I can succeed."

By June 1918, Diana had her pick of friends, a heady experience after Brearley. Elizabeth Kaufman had asked her to stay; Anne had told Diana she was her best friend, a boost to the morale because Anne was sarcastic and fascinating; her friendship with Emily Billings soared as they exchanged weekly letters filled with mad plans for getting away from their parents and setting up home. "E Billings and I are going to get up a ballet and next winter we are going to have a studio somewhere and I'm going to dance and she is going to draw." Diana made the important discovery that friendship was a powerful cure for misery caused by one's mother. Boys appeared in her diary too. Like Emily, she was allowed to mix with the opposite sex, without chaperones. Hollis Hunnewell, for example, had nice manners until they were left alone. At that point "he lost them all & we had wonderful time using slang and discussing women's rights." (Hollis was against women having

rights, while she was in favor, a rare instance of Diana arguing the feminist case.) By June, Chanler Chapman was writing her letters, and following her around on his bicycle asking her to marry him.

"I fought for a long time to be like other people," Diana said later. However, it is clear from her diary that she had already decided to stop being like other people in 1918. Once tentative attempts to change the way the world saw her proved unexpectedly successful, she made up her mind to go one step further. She would finally fulfill the expectations that came with the name her mother had given her, and she would do it alone, for only she had the power to make her life as she wanted it to be.

At this point Diana wobbled back toward the idea of finding a great person on whom to model herself: "then by that I can become great." She was reading a life of George Sand, and there was much she could learn from the life of Sand, she felt, since they were so alike. She would become an artist like her latest idol. "I want art, pure art," wrote Diana. "I shall be as I what [*sic*] to be and no other. I am Diana Dalziel I am going to treat myself as a goddess, with respect and I am only for art and for the arts." Reading about Sand left her in no doubt that becoming a goddess not only meant being different and original, but having the courage and determination to see it through: "Diana was a goddess and I must live up to that name, Dalziel = I dare, therefore I dare, I dare change today & make myself exactly how I want to be. I dare do anything on this earth where there is a will there is a way."

It would be a mistake to read a sexual undertone into Diana's admiration for the cross-dressing, cigar-smoking George Sand, even if she did express warm feelings in her diary for her new friend Emily Billings. Any such undertow remained subterranean, sublimated in intense female friendships. Diana thought she might be in love with Chanler Chapman, she admired Sand for having many male lovers, and there is plenty of evidence of her interest in the opposite sex. The Girl was the goddess Diana wanted to be, rather than someone she longed to possess; and in 1918 she was an interesting and composite creature. She was bohemian and

dedicated to the arts. She liked society and parties. She had many lovers, and flamboyant, daring style. She was in many ways remarkably like Emily and it is not hard to see that at one level Diana wanted to be like her mother and win her approval. As far as Diana herself was concerned, however, the Girl/Goddess was also like no one else at all. She was an idealized girl of her own creation, with whom Diana intended to snuff out the unlovable imperfect version of herself. She was her own hidden source of power.

In summoning an idealized version of herself into being, Diana absorbed several ideas floating in the American ether in 1918. The fashion for the first great U.S. female prototype, the Gibson girl, had passed, but the idea of the perfect woman was surfacing again with the sirens of early Hollywood whose eyes, hair, makeup, and dress (or lack of it) could be scrutinized in close-up for the first time. Diana paid rapt attention to the new screen goddesses. In January 1918 it was the refined beauty of Elsie Ferguson in *The Rose of the World* that made the strongest impression. "It was the most tragic & harrowing thing I ever saw," she sighed to her diary. "There was only one moment of brightness in it and that was ruined by something happening." Though the book that popularized the idea of the American dream would not appear until 1931 (James Truslow Adams's *The Epic of America*), there were elements of this, too, in Diana's faith in the power of possibility, and in the connection she made between wish fulfillment and hard work; and there was more than a dash of New England puritanism in her determination to drive herself on through effort and meticulous attention to detail.

It is also possible to detect elements of positive thinking in Diana's adolescent philosophy. Positive thinking was an idea that flourished during this period in books for teenage girls like *Pollyanna* and *Rebecca of Sunnybrook Farm*. The cultural historian Ann Douglas suggests that the insistence in these highly influential books on accentuating the positive and turning one's gaze away from the "horrors of life" emerged from a uniquely American mixture of self-help attitudes and quasi-religious, late-nineteenth-century

movements such as Mind-cure, Spiritualism, and Christian Science. One common characteristic of these therapies, which were dominated by powerful women, was the assertion that the disciplined conscious mind could win the battle over the dark workings of the unconscious, and that doing so was the key to a happy and successful life. "It's not just nightmares I can't stand," Diana once said to Christopher Hemphill. "If you really want to know . . . I don't like waking up with an idea stronger than . . . than my own day." But for all that positive thinking was an American idea, it was also remarkably close to Frederick Dalziel's resolute denial of his wife's affairs, his definite preference for the bright side, and his very British insistence that "worse things happen at sea," when they were going very badly indeed.

AFTER DIANA'S DEATH in 1989, a view of her emerged as someone damaged early in life by a great "complex" about her looks, intensified by her sister's beauty and her mother's antipathy. In this interpretation Diana became "Diana Vreeland" because of emotional injury inflicted in childhood. "Changing herself covered up a deep wound," wrote Eleanor Dwight. Insecurity and pain about her ugliness was so great, ran Dwight's argument, that it induced a lifelong obsession with external appearances that eventually propelled Diana into a position of control where she punished the world by deciding what constituted beauty and ugliness. "In later life," wrote Dwight, "Diana's models, her magazine pages and her Costume Institute shows would all benefit from her deep need to wave her wand and transform the ordinary and the flawed into the mesmerizingly beautiful. And one day, rather than being the object of criticism by her classmates and her mother, Diana, the powerful fashion editor, would be the judge and decide who was and who wasn't beautiful."

There is, of course, an element of truth in this. But there is also a danger that this view of Diana unfairly pathologizes her as someone who was driven mainly by a profound and somewhat negative emotional flaw.

It is perhaps more fruitful to pose a different question and ask: What was it that allowed Diana to survive her mother's destructive treatment? An alternative answer is that Diana was a vulnerable child who was saved by the power of her imagination. She deployed it with great intelligence to defend herself against Emily's negative view of her, escaping over and over again to the parallel world of her inner eye in a way that became the basis for much of her later success, which would eventually enable her to challenge conventional ideas about female beauty.

In the meantime, in the six months between January and June 1918, Diana also discovered that when she took tentative steps to align her fantasies with the real, outer world, the real world saw her so differently that her perception of herself changed too.

Boris Cyrulnik and others have observed that one of the most common defense mechanisms in unhappy but resilient children is "splitting"—a dividing of the self into a socially acceptable part and a hidden, unacceptable part. "If I can change the way you see me, then I can change the way I feel about myself," writes Cyrulnik, describing this frame of mind. "I can prove to myself that I am once more in control of my past and I am not such a victim after all." In 1918 Diana seemed to understand that rather than transform herself, she needed to become the most perfect version of the highly original, imaginative self that she could be. At fourteen she already understood that this would require the courage to stand out, not to mention constant attention to detail and a philosophy of continuous improvement. "I simply must be more perfect. Although I am getting better every day I am not 'there' yet," she wrote. "The damn fool," she scribbled years later beneath the last entry in her diary, which, apart from one short sentence, fizzled out midsentence in June, incidentally suggesting that the long-haul literary endeavor was not for her. But in this instance Diana was wrong. Rather than a "fool," the diary suggests a creative, unhappy child whose resilience stemmed from a growing belief in the power of dreaming, harnessed to the determined effort of

the conscious mind. "It's very touching—the things that exist and come true if you believe and insist," she said years later. "If you just have an idea. . . . If you just have a dream."

THROUGHOUT THE PERIOD covered by the diary, Diana had two supporters. One of them was Frederick Dalziel. A rare note of encouragement came from her father on January 10, 1918: "Yesterday I painted my brackets black and today put a blue lampshade on it which makes it look too lovely against the bright blue wall. . . . Daddy says my room looks 'nifty' which encourages me greatly as I simply love interior decorations." (Years later "nifty" would reappear as one of Diana's favorite adjectives in *Vogue*.) Frederick Dalziel was clearly able to ease family tensions when he was at home. "He had that *thing* about him, having to do with a sense of humor, which is the most cleansing thing in the world," Diana remarked. "My father was so much easier and closer to us." Family photographs often showed Diana and her father together, while Alexandra and Emily were photographed elsewhere. "We weren't exactly what you'd call a tidy little group," said Diana. But Frederick Dalziel was an Edwardian father who had work to do at Post & Flagg and a male New York life. He was also devoted to Emily, so however much Diana loved him, the extent to which her father was really able to protect her from her mother is debatable.

The person who rescued Diana was Ama—her grandmother Mary Weir. It has already been noted that it was Mary Weir, not Emily, who came to watch Diana in ballet class. Throughout the period covered by the diary Diana went to see Ama so often in the afternoons that it is possible that Weir actively intervened on her behalf against Emily and Kay Carroll after Diana was expelled from Brearley. Mary Weir would certainly have had no compunction about interfering if she thought it necessary, for by 1918 she had turned into a ferocious elderly woman. "My grandmother could be appalling. . . . She was domineering. . . . The Victorian grandmother was the matriarch," said Diana. Cast in the mold of a

formidable generation of white middle-class women excluded from political power, Mary Weir was a founding member of the Colony Club, the first exclusive club for society women in New York; her servants did not stay long; she feuded with her relations; and she was perfectly capable of sending all six and a half feet of Frederick Dalziel from her table for unspecified offenses. ("He thought it was a riot," said Diana.)

Formidable or not, Ama gave Diana the kind of appreciative affection denied to her by Emily, and the bond grew stronger as Diana moved into her midteens. Weir seems to have been pleased by Diana's idiosyncratic intelligence, imagination, and strength of character. (Diana may have looked like Weir, too, for Frederick Dalziel once thanked Diana for a photograph remarking she was "a dead ringer for Ama.") Diana was alert and amusing, and she won her grandmother's respect, while the less confrontational Alexandra, in contrast, did not. The feeling was mutual. In an unusually bitter aside years later, Alexandra said that she really did not like her grandmother at all. This was a family of volcanic emotions; in another instance of the strong feelings that convulsed it, Weir named her house in Katonah Villa Diana. After the miserable summer of 1917, Diana spent vacations with her grandmother while Emily and Alexandra went back out West. Her grandmother's household at Katonah provided another source of comfort in the farm animals, especially the horses, which did not have the power to hurt, unlike human beings. "My grandmother had a huge farm horse in the country outside of Katonah. . . . After lunch I'd run off, get on the horse. . . . I'd sit there all afternoon, perfectly happy. It would get hot, the flies would buzz. . . . That's all I wanted—just to be with the *steam* and the *smell* of that divine horse. Horses smell much better than people—I can tell you *that*."

In 1920, when she was sixteen, Diana spent most of the summer with Weir before she died on September 8. There was another emotional upheaval when it emerged that Mary Weir had left Diana far more than all her other grandchildren, in the form

of the Villa Diana, its contents, and twenty thousand dollars for its upkeep. Given the brutal value system of the day, Weir may have felt that Diana needed a dowry in a way that the beautiful Alexandra did not, and that by leaving her some money she was making up for a poor hand dealt by nature. It is also possible that over the years Diana had confided in her grandmother about her need to become "self-supporting" and that Weir thought it wrong of Emily to insist on this, since to her such a notion was both inappropriate and implausible. There was certainly an implied rebuke to Emily about her handling of Diana in Weir's will; and Emily's indignation at the slight to Alexandra can be felt in the wording of her own will, in which she left Diana almost nothing in an attempt to even things out.

However, Mary Weir's bequest meant that when the Villa Diana was sold two years later Diana had some money of her own. Emily also inherited a trust from her mother that finally gave her a substantial independent income. This was followed by another legacy to Emily from Diana's godmother Anna Key Thompson in 1921, though the will was contested and the matter remained unsettled until 1923. In the late autumn of 1920, however, the Dalziel family finances were already less stretched. Soon after her grandmother died, seventeen-year-old Diana was dispatched to a liberal arts boarding school on Staten Island for a final year of education. Meanwhile Emily had enough money of her own to pursue what she most enjoyed on a much grander scale. In what would prove to be a fateful move, she departed a few weeks later on a hunting expedition to Africa with Sir Charles Henry Augustus Frederick Lockhart Ross, ninth Baronet of Balnagown, plunging her family into years of bewilderment about fact and fiction.

UNLIKE FREDERICK DALZIEL, Sir Charles Ross (1872–1942) was an authentic British aristocrat and a genuine British bounder. He was known as a "stinker" throughout his life by tenants, wives, and his own mother, whom he ejected from the family home, Balnagown Castle in Scotland, either by stopping up her bedroom

chimney and smoking her out, or by setting fire to her hair, depending on which account one prefers. Even this behavior paled into insignificance beside the matter of the Ross rifle. Invented by Sir Charles, the Ross rifle was ideal for sport but had lethal shortcomings in battle. Nonetheless Sir Charles pressed it on the Canadian government before and during the First World War, making a fortune by causing the unnecessary deaths of thousands of Canadian soldiers before Field Marshal Douglas Haig personally intervened. None of this deterred Emily. She and Sir Charles Ross first met in New York in 1896, around the time of her debut. There is no sign of any further communication between them till 1919–20, when Ross, by now a very rich man, was living for many months of the year in the United States to be close to his business interests. He was a renowned sportsman, and given Emily's enthusiasm for hunting and penchant for charismatic men it is not surprising that they struck up a friendship.

Two versions of what happened next later emerged. In one version the relationship between Sir Charles Ross and Emily was innocent, and the notion that they should go off hunting together was enthusiastically supported by Frederick Dalziel. The greatest of their expeditions was to East Africa in 1920, in a group that included a distinguished naturalist, a pioneer of wildlife photography, Emily's maid, Sir Charles's chauffeur, and Sir Charle's Rolls-Royce. The party sailed from New York to Marseille, and then from Marseille to Mombasa. After a period in Kenya they made their way south to what is now Tanzania. There they plunged into virgin territory for Europeans, the Ngorongoro Crater. The expedition eventually broke up in May 1921. By this time Emily was ill. She returned to New York and to her husband, who later deposed that her affectionate feeling toward him had in no respect abated. In an alternative version of the story, the attraction between Sir Charles and Mrs. Dalziel was blindingly obvious from 1920 onward, especially to Sir Charles's wife. Their behavior aboard the ship from Marseille to Mombasa, which included Mrs. Dalziel lounging *en déshabillé* in Sir Charles's cabin at breakfast

time, obliged the stewards to conclude that they were on unusually familiar terms. In this version of the story this sort of thing was but "a natural preliminary to the guilty use of opportunities such as awaited them in the solitude of an African forest," opportunities they put most energetically to use.

These stories did not circulate for some years, however. In the meantime Emily's return to New York from Africa in 1921 caused a mild sensation. The *New York Times* reported excitedly that her "bag" included one elephant, two rhinoceroses, one buffalo, seven lions, one leopard, one cheetah, and three hippopotamuses. On July 27, 1921, Emily gave an interview in the paper to a bedazzled Walter Duranty, of particular interest because it is the only record of the way Emily spoke, suggesting that Diana developed her eye and poetic turn of phrase by listening to her mother. Emily talked of watching, entranced, as a herd of elephants played in a narrow ravine, "squirting water from a stream over one another like schoolboys splashing in a swimming pool"; and of turning around to face a wounded elephant, who, "Like a shadow . . . drifted through the jungle without breaking a twig." In the bush there were "metallic beetles, whose whole being seemed made of beaten gold and silver or bronze." Diana's love of color is detectable in Emily's description of the great soda flats of Lake Manyara: "The dry season had dried up part of the water, leaving exposed the brilliant colored mineral and soda deposits—amethyst, ruby, yellow, green, crimson and snow white," and the language used by Emily when talking about safari catering is oddly reminiscent of Diana talking about the horse she loved at Katonah. "Elephant trunk didn't please me, though supposed to be a delicacy. To tell the truth, it tastes just like the circus smells."

UNAWARE OF ANYTHING that might or might not be happening in the Ngorongoro Crater, Diana spent her last year of formal education at Dongan Hall on Staten Island. (Her sister Alexandra remarked in an interview that Diana had to keep changing schools because, regardless of all her good intentions in her diary,

she never did any work.) Dongan Hall's records were destroyed in a fire in 1975, and all that survives from Diana's time there is a handful of compositions that again reveal her creative flair, and the development of an idiosyncratic way with words. By 1920 she had acquired a taste for the gothic. In "The Very Blackest Night" a boy dies outside in the cold as the sounds of the great organ fade away in the howling wind and the nuns pass slowly by across the cobblestones. In another story a Spanish child bride sits "tragically alone in her huge and magnificent bedchamber, listlessly watching the tame nightingales in the jewelled cage splash around in the little silver bathtub."

These female "types" of Diana's imagination were, in 1920, clearly influenced by the first screen siren, Theda Bara, who had launched herself on an unsuspecting world a few years earlier as the Vamp in *A Fool There Was* and spawned a host of imitators. In Diana's essays, vampish girls lounged, spoke with a sleepy drawl, and loved to have unsuspecting men confide in them about business difficulties. Lola, a vampire girl, "had long pale eyes. The kind that were sometimes green and sometimes blue, it depended on her frame of mind. She loved to slide these over you & then turn dreamily away and slide them over someone else." Diana's vamps, vampires, and other creations were not original, but these essays do convey the rich and precise detail of her gaze at seventeen, her sense of the zeitgeist, and her interest in the way clothes and *objets* projected a woman's persona. She submitted one essay for publication in the school's magazine, titled simply "A Type," about a woman she clearly longed to be, and whom she described largely in terms of fashionable shopping circa 1920. The Type's loves were

> *taffeta, telephone screens, round lace handkerchiefs, French silk stockings & squashy sofa cushions. . . . She was always discovering new specialty shops, and hated the big houses for her clothes, they were so wholesale. . . . And was always wanting to know where you got your darling blouse. Her favorite color for herself was gray blue, but she often mentioned that vermilion inspired her. . . . Pearls she*

considered her correct setting, bracelets and lingerie her passion and
Oscar Wilde her idol.

(Oscar Wilde, had, of course, proposed an aesthetic ideal of the supremacy of art in every aspect of daily life.) Diana's Type still bore traces of Theda Bara, by now an Egyptianized Vamp after a *succès-fou* as Cleopatra. "She was simply crazy for anything Egyptian," wrote Miss Dalziel of her creation. "In fact at times she saw herself only as Cleopatra, surrounded by leopards, black slaves & silver white peacocks. She seldom smoked . . . but could rarely resist a gold tip & always managed to have the trusty black enamel holder aloof."

Unlike Theda Bara and her screen sisters, who were silent, the manner in which Diana's Type spoke—or chose not to—was most important: "She had taught herself to have quite a facility for words, but she seldom used it." This Type "abhorred the woman who could not rely on herself to be smart & had to get their distinction by means of a Pekinese or chow chow." In fact, wrote Diana, if you thought she was a woman with a lapdog you had missed the Type completely. Writing in the margin, a tin-eared teacher responded, "It's your fault if anyone misses the type at this point." Yet again Diana received almost no encouragement for her efforts, and the essays came back with low marks and complaints about dashes, paragraph indentations, and monotonous sentence construction. However, a corrected version may have appeared in the school magazine as Diana's first published writing; and both Cleopatra and the "trusty black enamel holder" would reemerge later to great effect.

DIANA LEFT DONGAN HALL in June 1921, and Emily returned from Africa shortly afterward to preside over her debut, soon after Diana's eighteenth birthday on September 29. There was no question that finding a husband should not be Diana's next step; and the purpose of the debutante season was, of course, to bring together young women and men from the right background in a

marriage market. The season began out of town with an annual ball for one hundred debutantes at Tuxedo Park, at the Tuxedo Club founded by the tobacco magnate Pierre Lorillard IV for New York's bluebloods in the 1880s. The "debutantes' first bow in town" followed at the Junior Assemblies at the Ritz-Carlton on December 2. Throughout the autumn each debutante's mother gave at least one tea, dinner, or dance for her daughter at a fashionable venue: the Colony Club, the Cosmopolitan Club, the Ritz-Carlton, the Plaza, or Sherry's. In Diana's case Emily gave a luncheon at the Colony Club on December 1. Forty-three young women attended this event, including several old school friends like Emily Billings.

In "coming out" in 1921, these young ladies were moving out of the schoolroom during a period of vertiginous change accelerated by the First World War. The late 1910s and early 1920s marked the moment when America finally metamorphosed from a land of farming and small towns into a nation of gleaming urban modernity, mass production, and mass consumption. Spared the ravages of war, America's economy raced ahead of its decimated European competitors after 1918, exploiting American technological advantage in automobiles, airplanes, and architecture. As the American economic engine roared into life, New York roared with it. Partly because there was so little space for heavy manufacturing in Manhattan, New York was a city where consumption, rather than production, predominated. "You might do the work of 'making' outside the city, but you 'made it' in New York, and everyone who was anyone knew it," notes Ann Douglas. A beacon of American economic success, a city defined by consumption, and a great international port, New York was the place where changing American tastes and fashions first revealed themselves.

By the time Diana left Dongan Hall, New York's upper-class young women were embodying some of the sharpest changes in fashion of the period. A new generation of independent, confident females had emerged from the war effort. They were quite unlike anything American and European society had ever seen before. The vote was extended to them in 1920. In an underestimated but

revolutionary change they were suddenly in charge of their own mobility—on foot, on public transportation, and increasingly in their own cars. They took full advantage of this brand-new freedom, emerging from the home to disport and display themselves in the public realm. They were constantly in motion. They smoked, long cigarette holders held "aloof," to keep themselves slim as cigarettes began to be promoted as a slimming aid. Rebellion against the attitudes of the older generation, its mature body shapes, and its Victorian artistic taste (or lack of it) was given an extra piquancy by Prohibition in 1919, which drove the new syncopated jazz music and the new dances into a countercultural underground, reinforcing the clash. A young woman drinking in public was a new development. Drinking and dancing in illegal speakeasies was even more delightful. The older generation was predictably outraged, giving vent to frequent moral panics, which were often about sex—the predilection of the "New Woman" for "petting parties" was a particular source of consternation in 1921.

Fashionable young women, meanwhile, demanded ever greater choice over what they were wearing and how they looked. The slim, androgynous flapper, as popularly conceived, did not emerge fully with her short bob, short hemlines, and antiestablishment attitudes until later in the 1920s, but she was already evolving by the year of Diana's debut, in lighter-weight, corset-free fashions that allowed her to slide in and out of automobiles, jump on a bus, bound along sidewalks, and dance the night away. For the first time in history, young women would soon be wearing backless dresses and skirts above the knee. There was, of course, continuity as well as change in style; the influence of the Ballets Russes in terms of color, line, and silhouette lasted until the end of the decade. As important as any specific fashion, however, was the way in which a fashionable, affluent young woman could suddenly express her individuality like the "types" in Diana's essays: through consumption. The prevailing view was that consumption was uncomplicated, desirable, and even a patriotic duty. Shopping was perceived to be modern, and the driver of American economic success. There was a shift

away from the idea of female fashion as a vehicle for displaying male wealth and power. Though this approach to getting dressed certainly did not disappear, booming American capitalism handed the New Woman the means to create her independent persona through shopping, and a range of services dedicated to adornment and the manner in which she styled herself. It was a phenomenon that fascinated male writers of the period, from Scott Fitzgerald in "Bernice Bobs Her Hair" to Michael Arlen in *The Green Hat.*

Even Emily, who used cosmetics well before they became widely acceptable, was taken aback by the way Diana adopted exaggerated makeup as a way of establishing her separate identity while she was still quite young—which was, of course, the point. "I adore artifice. I always have. I remember when I was thirteen or fourteen buying red lacquer in Chinatown for my fingernails. 'What *is* that?' my mother said. '*Where* did you get it? *Why* did you get it?' 'Because,' I said, 'I want to be a Chinese princess.'" If the corollary of this exciting approach to defining oneself was that advertisers pounced on women as a group and exploited new anxieties about their bodies, nobody seemed to care. "When cosmetics began to be seen as an 'affordable indulgence,' beauty became a multimillion-dollar industry," writes the historian Lucy Moore in *Anything Goes.* "In 1920 there were only 750 beauty salons in New York; that number had risen to 3,000 in 1925. . . . Elizabeth Arden and Helena Rubinstein were launching flourishing business empires capitalizing on the Flapper's obsession with her looks."

EMILY'S LUNCH FOR Diana at the Colony Club was followed by a ball at the Ritz-Carlton for Diana and Anne Kaufman, on December 21, 1921. New York's newspapers, which continued to report on society events in great detail throughout the 1920s, described the ball as "one of the largest coming-out parties of the Winter" and "a very jolly event." Diana's preparations for her coming-out party were meticulous, if isolated: the family home was filling up with the heads of dead beasts, and no one, least of all Emily, took

much interest in what she was doing. Diana had graduated from poring over picture catalogs and the *Woman's Home Companion* to following French fashion closely in the pages of *Vogue*. Her dress for her coming-out ball was copied in white satin from a Poiret design, and she remembered it in detail: "a fringed skirt to give it *un peu de mouvement* and a pearl-and-diamond stomacher to hold the fringe back before it sprang. It looked like the South Sea Islands— like a hula skirt."

At this point in her life, Diana was going through a phase of covering herself with calcimine (otherwise known as distemper and more commonly used for painting on drying plaster), with a view to looking like a lily. "I was always a little extreme. . . . On the night of my coming-out . . . was I calcimined *that* night. My dress was white, naturally. And then the reds were *something*. I had velvet slippers that were *lacquer* red." She carried a bouquet of red camellias to the ball, sent by fast-talking showman J. Ringling North of the Ringling circus family. This time Emily did snap to attention, uncertain whether to be more appalled by the circus or the camellias. " '*Circus people* . . . where did you ever meet *them?*' my mother wanted to know. I told her that for some reason J. Ringling North had taken a fancy to me and sent the red camellias." Emily then delivered some mother-daughter information that suggests that the Dalziel household was not unduly afflicted by Victorian prudery. " 'You should know,' she said, 'that red camellias are what the demimondaines of the nineteenth century carried when they had their periods and thus weren't available for their man. I don't think they're quite . . . suitable.' I carried the camellias anyway. They were so beautiful. I had to assume that no one else at the party knew what my mother knew."

Thanks to the social convulsion of the postwar years, some of the debutantes at the ball were already leading lives very different from their mothers' at the same stage. Anita Damrosch, the daughter of the conductor Walter Damrosch, went to drama school that winter and became a professional actress. Others went on to make

their mark in a more traditional manner, notably the Morgan twins, Thelma and Gloria, who would, respectively, become the mistress of Edward VIII and marry a Vanderbilt, but there was a remarkable degree of latent creativity on the guest list too. Jeanne Reynal, a great friend of Diana's while they were both debutantes, later had a pioneering role in the abstract expressionist movement in New York as a mosaic artist, before marrying Thomas Sills, an African American painter. Maud Cabot, a guest at Diana's debutante lunch, became a distinguished painter, exhibiting alongside Jackson Pollock and Mark Rothko. She hated everything about being a debutante. "Since I was not interested in getting married, the entire structure of this social edifice was for me a hollow shell. I was a dismal failure." Her mother's response was to send her off to shoot a moose, though it may have been emblematic of the changing times that Maud was allowed to go to college when this failed to work.

Maud Cabot's view of the season was emphatically not shared by Diana, who had been longing to find a husband for years so that she could get away from home. Her debutante year was a triumph. She attended Fokine's newly opened studio at 4 Riverside Drive; she was photographed playing tennis at Hot Springs, Virginia, and at the United Hunts Meet with her friend Barbara Brokaw at Belmont Park; she took part in amateur theatricals as a member of the Junior League; and she became an editor of a publication called *The Debutante Calendar*, which announced that she was "keenly interested in amateur journalism." Diana also threw herself into the music, dances, and fashions of 1920s New York and the Harlem Renaissance. She adored the newly fashionable lowlife mistrusted—and unvisited—by the older generation, and sneaked off with her more daring friends to the Cotton Club in Harlem and to watch Josephine Baker perform on Broadway. She loved the idea of being thought "picturesquely depraved" for going to cabarets and nightclubs. One very good reason for frequenting such places was privacy: the purpose of going to nightclubs way downtown was "to avoid running into my mother and father—and doing what I

loved to do best . . . dancing." Like many of her fashionable con-
temporaries, Diana reacted against the sanitized Castle ballroom
dances of the prewar era in favor of something more authentic, in
an atmosphere where, at least temporarily, class distinctions meant
little. "By the time I was seventeen, I knew what a snob was. I also
knew that young snobs didn't *quite* get my number. I was much
better with Mexican and Argentine gigolos (they weren't *really*
gigolos—they were just odd ducks around town who liked to dance
as much as I did). They were people who knew that I loved clothes,
a certain nightlife, and that I *loved* to tango."

In 1922 the press complimented Diana on her looks for the
first time. Photographs show her favoring both the fashionable
straight-line chemise, and the exoticism of Bakst. Diana was "one
of the most attractive of this season's debutantes" and the "lovely
daughter of Mrs. Frederick Dalziel." *Vogue,* which started life as
a New York society magazine and still covered the comings and
goings of the city's fashionable elite in great detail in the early
1920s, described her as a "smart figure" and variously admired her
way with her furs and a chic leather hat, "one of the new notes in
millinery." The only sour note was struck by a gossip columnist
in Southampton who speculated that now that Miss Dalziel had
enjoyed such glittering social success she would probably be de-
serting Southampton and going off to Newport with her elegant
new friends. Three years after Diana first explored the idea in her
diary, sheer determination, much thought about what constituted
high style, and self-aware development of an alluring personality
had brought her to the point where she had indeed become the
Girl—and a young woman whose debut was as successful as her
mother's in 1896. To onlookers who knew both of them, she seemed
very like Emily—theatrical, stylish, articulate, amusing, full of
energy, very made-up, with a host of admirers—but in the idiom
of the modern young woman.

BUT IF DIANA was enjoying success for the first time in her life, it
soon became obvious that Emily was much less happy. The place

Emily chose to make this clear was *Harper's Bazar*, spelt with one 'a' until 1929. This was one of two American magazines aimed at affluent women, though unlike its rival *Vogue*, *Bazar* covered more than fashion and was designed to appeal to an educated female elite. In February 1922, in the middle of Diana's debutante year, Emily published an article in *Bazar* bemoaning her return to New York in terms calibrated to undermine Diana. "She assures us that she would rather discharge a Winchester than a chef; that bringing up a leopard for a good bead is easier than bringing out a debutante daughter. As she has done both within the last twelve months, we assume that she knows," concluded a snide editorial preamble. The gist of the article, titled "Ten Thousand Miles from Fifth Avenue," was that the pleasures of so-called civilization in New York were inferior to "primitive" life in the African forest, where in spite of the dangers one was protected from all cares. On her return to the modernity of New York, Emily wrote, she was swamped by problems with servants and irritated by inane comments about Africa at society parties. The message was unmistakable: Emily would rather be in Africa, the amusements of New York society were trivial, and those who enjoyed them were foolish. By inference this included her debutante daughter.

Just over a year later *Vogue* published a major article about big-game hunting in the Rockies, in which Emily featured prominently. The effect, whether it was intentional or not, was to reposition the Carmencita of New York society as the beautiful and daring goddess of hunting, and to deflect attention from Diana as a social success and young woman of style. Before long, however, Emily's public rejection of the modernity of New York for the "authenticity" of the wild came back to haunt her, for she was far less secure about social acceptance than her article implied. After Diana made her debut, Emily put it to her that she should become a member of the exclusive Colony Club. There was a strong family connection: Mary Weir had been a founder member, Emily had belonged for many years, and Diana's debutante lunch party had taken place

there in December 1921, so membership should have been more or less automatic. Diana was not much interested in what she saw as a middle-aged establishment, but Emily persuaded her that it was somewhere to have her hair done, that it might be useful to her in later life, and that she should at least agree to attend an interview. Emily then received a letter telling her that Diana had not been admitted. It transpired that she had been blackballed because she was "fast"—a fine example of a 1920s intergenerational clash. Diana was a "jazz baby," a young woman who dressed well, wore makeup, smoked, and had boyfriends, and this had apparently been read as a sign of loose morals by the committee ladies.

To Diana's astonishment, Emily was exceedingly upset by this rebuff. It was one of the few times she ever saw her mother in tears. What Emily perhaps suspected was that the committee's rejection of Diana was aimed more at Emily herself, as punishment for her all too public comments in *Bazar*—and for being fast. Diana, on the other hand, was quite untroubled. At a party at the end of her first post-debutante year she met Thomas Reed Vreeland.

"I BELIEVE IN love at first sight because that's what it was. I knew the moment our eyes met that we would marry. I simply *assumed* that—and I was right," said Diana. They met at a Fourth of July party in Saratoga in 1923 and were formally engaged the following January. In falling in love with Reed Vreeland, Diana was following the pattern of her own parents' marriage, where the man married upward. The Vreeland family was not in the "Four Hundred" or *The Social Register*. By the time of their engagement, Reed's father, Herbert H. Vreeland, had been a distinguished and sometimes controversial president of the Metropolitan Street Railway Company, but he had left school at fifteen and worked his way up from the bottom of the streetcar business, starting as a gravel shoveler. Unlike Diana's British father, however, Herbert Vreeland and his family regarded his humble beginnings with pride.

As always, *Town Topics* was on hand to ponder such matters.

Diana was positioned as one of the elite, as the great-granddaughter of the late John Washington Ellis. Choosing to disregard both Herbert Vreeland's career and the fact that Reed was a graduate of Yale, a member of the prestigious Scroll and Key society, not to mention President of the university's famous Glee Club, *and* Popocatepetl (director) of its *a capella* group the Whiffenpoofs, *Town Topics* hinted sadly that Diana was marrying beneath her: "I am sorry I cannot go on record, for unfortunately I have never met the young man who will lead Diana away from the altar," sighed its anonymous correspondent. The fact that *The Social Register* was "strangely silent" on the matter of Diana's fiancé was a cause for concern, though the author took heart at the revelation that his family was resident at 135 Central Park West and had a country house in Brewster, New York. This seemed to suggest, said *Town Topics*, that young Vreeland was "financially O.K."

Oddly, *Town Topics* did touch on an aspect of the relationship between Diana and Reed that would never really change. Almost from the beginning it was Diana who made the life into which Reed stepped, though this already had less to do with her family background than her stylish originality, which was attracting wider attention. Shortly before they met she had been invited by the owner of *Vogue*, Condé Nast, to one of his celebrated New York parties where he famously mixed up guests who intrigued him but who would never otherwise have stood in the same room. Being invited—without one's parents—to a party by Condé Nast was a very great honor. The evening more than lived up to its promise, for the guests included Josephine Baker in a white Vionnet dress cut on the bias with four points and not much more. "Everybody who was invited to a Condé Nast party stood for something," said Diana. "I was so thrilled to be asked. There was no living with me for days."

For her part, it is not surprising that Diana sensed she had found a soul mate in Reed the first time she saw him, for even as a child, Reed, like Diana, possessed an intense aesthetic sense allied to a fascination with presentation. (Years later his brothers

recalled how they teased him about his youthful fondness for fashionable narrow neckties by coming down to supper with their shoelaces tied around their necks.) If Reed knew he was marrying a young woman with the power to open doors to entrancing, beautiful worlds, the most important thing for Diana was Reed's gorgeous appearance. "He was the most beautiful man I've ever seen. He was very quiet, very elegant. . . . I loved all that. I thought it was beautiful to just watch him . . . just be— B.E." Being chosen by such an attractive man transformed Diana's sense of herself. Landing a husband within two years of her debut brought considerable cachet, but it was even better that her fiancé was older by four years with the visage and physique of a film star. Much as Diana had enjoyed the nascent flapper scene in New York in the early 1920s, she never lost sight of her main aim. Years later she described netting Reed as an "achievement," and it was. Her engagement to him justified all the determined and secret work involved in making the very best of herself; and her belief in the power of dreaming and making real the imaginary proved to be reasonable. Her extraordinary success was noted by her contemporaries too. Years later one of them was still saying that she could not understand how the ugliest girl in society had captivated the most handsome man.

But Reed's attractive features introduced another dynamic into the relationship that never really changed. On the one hand, Diana finally relaxed about the way she looked. "I never felt comfortable about my looks until I married Reed Vreeland," she said. On the other, his good looks introduced a new kind of inhibition—and anxiety—into Diana's life. "Isn't it curious that even after more than forty years of marriage, I was always *slightly* shy of him? I can remember him coming home in the evening—the way the door would close and the sound of his step. . . . If I was in the bath or in my bedroom making up, I can remember always pulling myself up, thinking, 'I must be at my very best.' There was never a time when I didn't have that reaction—*ever.*"

The wedding date was set for March 1, 1924, at Saint Thomas

Church Fifth Avenue, and preparations were put in hand. Then Emily's life erupted all over Diana's one more time. As Diana remembered it, she was out lunching with friends when the telephone rang and she was called to it. To her astonishment, the call was from a woman journalist who affected to admire Diana's style and claimed she did not wish to see her hurt. The journalist told Diana that her mother was about to be named in a divorce case and warned her of a blaze of publicity. She was right. The news that Lady Ross was suing Sir Charles for divorce and citing Emily Dalziel as co-respondent was carried on the front page of New York's leading newspapers on Thursday, February 27, 1924, two days before Diana's wedding on Saturday, March 1, vindicating the gossips who were unable to believe that over the years Emily had really exchanged hunting men for hunting animals, since she had clearly been doing both. As soon as the story broke both Emily and Frederick Dalziel stepped forward to deny the allegations strenuously. "Lady Ross has evolved a very interesting fiction in her mind—far from the scenes where she imagines it to have taken place," said Emily. Frederick Dalziel scoffed at the charges and said it would make no difference to the wedding plans. Behind the scenes he was equally adamant, reacting with total denial. " 'All these stories about your mother,' my father said to me later, 'are untrue. You must simply rise above them.' . . . Daddy was British in a very healthy way: he could get over things. 'Worse things happen at sea.' That was his great expression. It summed up any unpleasantness."

Diana's memory was that the scandal did have an impact on the wedding, and that before she went into Saint Thomas her father warned her that attendance would be sparse. "It wasn't sparse—it was practically empty." But here, it would seem, her memory was playing tricks. Diana seems to have forgotten that a big wedding was never planned. The Dalziels were not rich, and only a small number of guests were invited to the tiny chantry of Saint Thomas and to the reception afterward at 15 East Seventy-Seventh Street. It was also the custom to send out cards of invitation to one's wider

acquaintance for the church service. The list that survives indicates that most of these were dispatched to people living miles from New York and were probably sent only as a courtesy. Those invited to both church and reception signed their names in a book; and while it is possible that a few people on the church-only list decided against going after the story broke, there were no mentions, even in the newspapers reporting the scandal, of an embarrassing boycott of Miss Dalziel's wedding. On the contrary, even *Town Topics*, which was watching closely, had to admit that it all went according to plan.

On the morning of the wedding itself, Diana went to see her unofficial godmother, Emily's friend Baby Belle Hunnewell, who was lying in bed drinking gin and "having a marvelous time." Diana noticed that she had a little black bell embroidered on her nightgown. "Oh, everything I own has my baby bell on it," said Mrs. Hunnewell. Escorted to the church by her father, Diana wore a dress that had "a very strict line and a very high neckline— very *moyen âge*. There was lace strapped round my head and face, and the train was all *diamanté* and encrusted with pearls." Alexandra was her maid of honor, in apple green satin and tulle, and her bridesmaids were friends from Diana's debutante circle, wearing orchid satin and carrying bunches of sweet peas. The groom's ushers included Godfrey S. Rockefeller, a friend from Yale. "Everything about the wedding of Diana Dalziel and Thomas Reed Vreeland in St Thomas's last week measured up to the exacting standards of the younger set," reported *Town Topics*. There was a generous supply of champagne and a good sendoff for the newlyweds. The nearest *Town Topics* came to a dig was its note that "although Mrs. Dalziel's face was shaded by a large black hat, she mingled with the guests very gayley [*sic*]."

Years earlier Diana had longed to grow up and get away from home. She had dreamed of men asking her to drive with them in cars. "In other words it means that I am popular," she had written. "I have heard it said that dreams do not come true but I will make

this one come *true!*" On her wedding day, she succeeded in making two dreams come true at once. On March 1, 1924, she managed her escape from a family engulfed in lies, scandal, and denial ("We're all exiles from something," she would later remark). And she drove away with an astonishingly handsome husband, to start, finally, the European upbringing that had so far eluded her.

BECOMING MRS. VREELAND

First there was a short diversion to upstate New York. At the time of the Vreelands' wedding, Reed was assistant to the president of the National Commercial Bank and Trust Company. This meant that the newly married Vreelands were obliged to set up their first home near the bank's headquarters in Albany. Instead of being dismayed by this, Diana threw herself into Albany life, away from Emily and away from scandal, while she concentrated on being hopelessly in love. Life was delightfully provincial. Reed's fine tenor voice was soon in demand. He joined the local Mendelssohn Club, where his star turn was "The Bells of St. Mary's," while Diana did very little except play house. She liked Albany's domestic Dutch style—"this environment of good food, good housekeeping, polished floors, polished brass"—but their house was small and there were servants to attend to it. "I loved our life there," she said. "I was totally happy. I didn't care what any other place was like." It was the beginning of a very long period of leisure: "I had nothing to do—but *nothing*. I never had an *idea*."

Everyone whom they met socially in Albany was older, but Diana had a supporter in a local grandee, Louisa Van Rensselaer, who found her way of doing things amusing. "During this phase when I lived in Albany I'd walk around in a mackintosh and a *béret basque* with *very* extreme, very exaggerated makeup—I've always had a strong Kabuki streak." The Vreelands lived in a mews house at the back of the Van Rensselaers' mansion on State Street. It had a red front door and blue hydrangeas in its window boxes. "Reed and I were like the little children down the garden path, and we'd

be asked to dinner in their great house on the hill on State Street." Far from having no ideas, however, Diana had been dreaming about the decoration of her own house for years. When the moment finally came, her design sense was so ahead of Albany taste that it piqued the attention of the local press. Under the heading "Labor Economy" the *Albany Evening News* reported that Mrs. T. R. Vreeland was following a fashion that had begun in New York and Boston. She had knocked down the wall between the living and dining rooms of her small house, making life easier with fewer servants. The furniture was arranged "artistically," and the predominant color was yellow, offset by a black couch and a lion-skin rug stretched before the fireplace.

Diana soon had other matters to occupy her, since the Vreelands' first child, Thomas, known as Tim or Timmy, was a honeymoon baby. He was born on January 1, 1925, and she was enchanted by him, even if his baby book suggests an unusual degree of maternal focus on his clothes. "He still wears his little wooly [*sic*] nightgowns all the time and has not yet gotten all dressed up in his dressiest petticoats except to come home from the hospital." After the first heady rush of enthusiasm, Diana gave up keeping the baby book— once again she showed very little appetite for a long-haul literary project. The incongruity of Emily as a grandmother and Diana living in Albany was noted with delight by *Town Topics*, which contemplated the possibility that this new state of affairs might finally calm Emily down: "Now that Diana, who married Reed Vreeland last winter, and, like a dutiful wife, went to live with him in Albany, is a mother, will Emily, the Diana of the Hoffman clan, continue to stalk wild animals in Africa?" Ignoring these mutterings about how unsophisticated she had become, Diana completed the migration to American housewife by taking U.S. citizenship in April 1925, an event trumpeted in the local newspaper as "Albany Society Matron Eligible to Citizenship." The Albany matron was twenty-two; and she was only twenty-three when she gave birth to the Vreelands' second son, Frederick, known as Freck or Frecky, on June 24, 1927.

Freck's safe arrival in 1927, which coincided with a move back to New York City when Reed briefly joined the Fidelity Trust Company, turned out to be a bright moment in an otherwise bleak year. Once again it was Emily and the Ross divorce case that caused the misery. It was clear from the outset that the matter would be protracted. Sir Charles was an enthusiastic litigant and was determined to avoid paying a penny more in alimony to his embittered wife than was necessary. Conceding her charges in the Scottish courts also meant conceding that he was British and thus liable to British taxation. He fought a long-drawn-out double battle both against the charges and against being taxed in Britain, opining that his family home, Balnagown in Scotland, was part of America. Frederick Dalziel, meanwhile, fiercely denied any possibility that his wife was guilty of adultery and vigorously defended her against all slights, real and imaginary. In 1925 he even forced apologies from the *New York Herald*, the *New York Post*, and the *Boston Evening American* for printing a story that Emily had started a fad for walking barefoot on the golf course at White Sulphur Springs.

Thanks to Sir Charles Ross's appetite for time-wasting litigation, the Ross divorce case was heard at the Court of Session in Edinburgh only in June 1927, the year of Freck's birth. Sir Charles insisted on defending the charges, which meant that all Lady Ross's allegations finally came out in court, a most unwelcome development for the Dalziels, who were plagued by the gutter press. Since Lady Ross's case revolved entirely around whether Sir Charles and Emily had or had not indulged in "guilty passion" in the African jungle, it naturally attracted a great deal of attention. In the end Lady Ross was refused her divorce partly because the Dalziels compelled Alexandra and Kay Carroll to travel to Edinburgh and swear in the witness box that Emily was always at home in the afternoons and was therefore not available for love affairs. Alexandra knew very well that this was not true and later described the experience as deeply traumatic. Emily was cleared of adultery, but there were many beyond the courtroom who begged to differ, including Lady Ross.

Meanwhile, three years of scandal took a great toll on Emily's health and, by extension, her looks. She had returned unwell from East Africa in 1921, and illness was given as the reason she was unable to attend the Court of Session in person in 1927, though this seems to have been a recurrence of the "nerves" that had long plagued her, rather than a tropical illness. For all her public repudiation of New York society in *Harper's Bazar*, she was brought low by salacious allegations in the newspapers and cold-shouldering from people who should not have mattered. "None of her African experiences . . . affected her more than when Lady Patricia Ross filed suit for a divorce," said society columnist Maury Paul when he looked back on the story some years later. The Dalziels' rich Bohemian friends simply went abroad when disgrace threatened, but Emily was unable to escape very far. After the scandal broke in 1924, she spent time alone on Nantucket, where the Dalziels had a house. In the end Emily proved too fragile to cope with the consequences of her bid for freedom in East Africa. Three months after her name was cleared in the Court of Session in Edinburgh in June 1927, she died of pneumonia on Nantucket at the age of fifty-one. But that was not the end of the story. Ignoring the impact of their behavior on her bereaved husband and daughters, the furious Rosses battled on. In 1928, a year after Emily's death, Lady Ross produced evidence more sensational than anything that had gone before, involving air beds on open decks and side trips into the heartlands of Africa with only porters for company. This time their lordships decided that regardless of the defense argument that the couple were simply hunting mad, "the madness was attributable to something more personal" and that Emily had indeed committed adultery. Frederick Dalziel continued to dispute this. The case was finally settled only in 1930, and the matter of Emily's "guilt" was never formally resolved.

Emily's death in 1927 shut a door on a most unhappy chapter in Diana's life. It would be many years before she talked much about her mother. Of her death she remarked: "She lived only for excitement. When she died . . . I think it was because she could

find nothing to interest her." After Emily died, Nanny Kay became Frederick Dalziel's housekeeper. He never married again and developed such a hatred of popular newspapers that housemaids were threatened with dismissal if they brought them into the house. Both his daughters escaped from New York and, finally, from their mother's overbearing perception of their respective natures. Alexandra left Bryn Mawr to complete her degree at Barnard so that she could be closer to her widowed father, and then married Alexander Kinloch, heir to Sir David Kinloch of Gilmerton in East Lothian, Scotland, in a small wedding in the chantry of Saint Thomas Church on September 11, 1929. She remained British, rejecting the label of "goddess" imposed on her by Emily, finding a way through life that centered on her family and houses in London and East Lothian and taking very little interest in high society, though it was certainly available to her. Diana traveled in a different direction. Eventually she was able to say of her mother: "She was quite young and beautiful and amusing and *mondaine* and splashy, all of which I'm glad I had in my background—*now*. But I've had to live a long time to come to that conclusion." It is not clear that she grieved for Emily at all. Instead of grief (and in common with Proust, Freud, Joyce, and Max Weber), Diana had a different reaction to the death of a damaging parent. A short time after Emily died, her imaginative powers took flight.

DIANA OFTEN DECLARED that her real education took place during the six and a half years she spent with Reed in Europe; and sometimes, when she spoke of her "European upbringing," it was to this period that she referred. "All the things that happened to me there were the foundation of my whole adult life," she said. The year after Emily died, Reed accepted the post of assistant manager of the Guaranty Trust in its London office. The Vreelands moved to London at the beginning of 1929 and left Europe again in the early summer of 1935. The impact on Diana of their stay was partly a matter of timing. In the late 1920s, in spite of the emergence of the Flapper, real elegance still began

after marriage and childbirth. Diana was twenty-five when she arrived in London; she had captured a notably handsome husband; and she was ready to join the ranks of chic married women who were beyond the exigencies of pregnancy and tiny babies and had years of active life ahead of them. She also had some money of her own. In 1929 the Vreelands came to London armed with the proceeds of the sale of the Villa Diana in 1922, on top of Reed's salary from the Guaranty Trust. They were able to employ a nanny, a cook, and a butler and had at least one Bugatti. As they immersed themselves in London life, Reed's good looks and charm were a great asset, but the pace was set by Diana's hungry eye and a growing faith in the power of her dreams.

Diana was the first to acknowledge the extent to which her fantasy life in this period was nourished by fashion magazines. "I lived in that world, not only during my years in the magazine business but for years before, because I was always *of* that world—at least in my imagination," she said. In the late 1920s magazines were the single most important means of circulating new style ideas. Diana had stared at their pages for hours when she was younger, and her one surviving scrapbook shows the extent to which *Harper's Bazaar* and *Vogue* continued to influence her in the 1920s and 1930s, *Vogue* above all. The scrapbook suggests that she was actually more interested in interiors and photographs of society women than fashion at this stage, and in one sense this was no accident. By 1929 Condé Nast was revolutionizing the way *Vogue* made money by transforming it from a New York society magazine to one that appealed to the indefinable yearning of young women like Diana, who wished both to express their individuality through fashion and live the magical life of fashionable people.

Condé Nast reflected this back in *Vogue*'s pages through the images of Edward Steichen, Baron de Meyer, George Hoyningen-Huene, and Cecil Beaton. He then delivered readers like Diana to advertisers, as a "class" that advertisers could not otherwise reach. Nast and his first editor in chief Edna Chase played a successful

double game, ostensibly producing *Vogue* as a house magazine for
the world's most beautiful and privileged women, while knowing
that its real success lay in its appeal to middle-class women with
spending power, who lived at some distance from the life in its
pages but nevertheless aspired to it. But Diana did not see it quite
that way. As far as she was concerned Condé Nast was, quite sim-
ply, a visionary: "Condé Nast was a very, very extraordinary man,
of *such* a standard . . . he had a dream. The fact that people don't
still dream, I don't understand."

Diana, of course, knew Condé Nast slightly already, and on ar-
rival in England at the beginning of 1929, she determined to turn
the fantasy world of *Vogue* into reality for the Vreelands. Her first
step was to create a stylish backdrop for her family on a much
larger canvas than before. The Vreelands moved into 17 Hanover
Terrace, one of several rows of magnificent white stucco houses
on the edge of Regent's Park designed by John Nash in the early
nineteenth century. They took over the lease of 17 Hanover Terrace
from the widow of the writer and critic Sir Edmund Gosse via a
Mr. Leitner, neither of whom had given it any attention for years.
In spite of its dilapidation the Vreelands were enchanted by its
Georgian proportions, and its large elegant rooms that looked out
over Regent's Park. To Diana's delight the house had a proper Brit-
ish larder and a small garden. ("Greenery, you know, is as much a
part of England as a nose is part of a human face.") Her upbring-
ing had always been more European in tone than that of most of
her New York contemporaries, but even she was horrified by the
discrepancy between the quantity of water pouring down from
London's skies and the lack of it inside the house. She immediately
set about putting matters to rights, installing extra bathrooms and
radiators for servants who informed her it was quite unnecessary.

Well before she moved to London, Diana snipped articles from
magazines about the English decorator Syrie (Mrs. Somerset)
Maugham's "White House" in Chelsea and the American decora-
tor Elsie de Wolfe's use of "old pieces in modern ways." She was

interested in those who mixed the old with the avant-garde, such as Princess Guy de Faucigny-Lucinge, whose medieval apartment in Paris had black rubber floors. While Diana took on many of these modern ideas, the decoration of 17 Hanover Terrace was very much her own. The walls were painted dull ocher, a color she located on the face of a Chinese figure on a coromandel screen; the chintzes were the color of Bristol blue glass with bowknots and huge red roses; and every door inside the house was varnished Oriental red. Correspondence that survives from this period shows her great attention to detail and her insistence on the most luxurious and the best: Porthault in Paris for linen, glass from Lalique, advice from *Connoisseur* magazine about where to obtain good-quality prints. Diana's perfectionism showed everywhere in the house, as the writer Phyllis Lee Levin reported: "Friends who visited never forgot the bowls of bulbs blooming white in midwinter, the perfection of the food, the children in gray flannel shorts and red silk shirts, nor the time their mother sent out to the Ritz for some special soup for them."

Despite such evidence of maternal concern, the two boys in gray flannel shorts and red silk shirts saw little of their parents, for the years in Europe resulted in a huge expansion of the Vreelands' friends and acquaintances. Many of the people whom Diana met for the first time in Europe in the early 1930s exerted a great influence on her and became friends for life. A number of them were rich or led lives of a particularly European kind of glamour, and several appeared decades later in *Allure*. It was Diana's relationships—rather than Reed's—that held the key to the Vreelands' rapid entrance into the *ton* in the early 1930s, for Reed's job at the Guaranty Trust appears to have been less than high-powered. One important new English friend was Kitty Brownlow, who, as the sister of Alexandra's husband, Alexander Kinloch, was almost a relation. Her husband, Perry Brownlow, was an aide at Court, and they were a sociable couple. After the Vreelands arrived in London, a warm friendship with the Brownlows developed. Diana accompanied Reed when he went to shoot at Belton House in

Lincolnshire, the Brownlow family home. At Belton they joined house parties for local balls attended by the Duke and Duchess of Rutland and Lord David Cecil. Diana was no more enthusiastic about killing pheasants than she was about bagging wild beasts in Wyoming, but she thoroughly enjoyed reading by the fire, picnics with the shooting party, and observing the way in which staggeringly competent Englishwomen ran their huge country houses.

FRIENDSHIP WITH DIFFERENT parts of the international d'Erlanger family was even more decisive in accelerating Reed and Diana's entry to fashionable circles in both London and Paris. The d'Erlangers were members of a banking family, originally from Germany but with banking establishments in Paris and England and a strong transatlantic connection through marriage with the Slidells and Belmonts. Robin d'Erlanger, the eldest son of Baroness Catherine d'Erlanger and Baron Frédéric, trained in New York with Frederick Dalziel in the foreign department of Post & Flagg. "I first met him there," said Diana. "Then, when Reed and I went to live in London, he was the first person to look us up. Then we met the other d'Erlangers—all of them—and from then on, you might say, we joined the d'Erlanger family." It is noticeable that when the Vreelands appeared at London parties, there was often a member of the d'Erlanger family there too, suggesting that it was probably a d'Erlanger who effected the introduction in the first place.

When it came to educating Diana's taste, it was Robin d'Erlanger's mother, Catherine, and his sister, Baba, who first opened her eyes. Their originality and imaginative panache were quite unlike anything Diana had ever encountered in New York. Baroness Catherine was a scarlet-haired amateur artist whom Beaton described as an "avant-gardiste" of interior decoration. "The family house in Piccadilly (which once belonged to Lord Byron) was full of witch balls, shell flowers, mother-of-pearl furniture, and startling innovations picked up for a song at the Caledonian Market," he wrote. Baroness Catherine's flair for achieving high style with

inexpensive paint colors, shells, and baskets of wool had an imme-
diate influence on Diana. Baba d'Erlanger, meanwhile, was a re-
markable sight even as a child, for she was sent out on walks in St.
James's Park by her mother, accompanied not by a nanny but by a
Mamluk in robes and a turban, with a sword and a dagger, looking
as if he had stepped straight out of the Ballets Russes. Baba, said
Diana, "was an absolutely fascinating, marvelous-looking, totally
extraordinary creature—without question the most exotic-looking
woman, white or *black*, I've ever met." Baba came to represent a
particularly recherché 1930s chic. She wore dresses made from gold
tissue paper and briefly opened a shop in Paris that sold nothing
but Tyrolean beachwear.

By the time the Vreelands arrived in London, high society was
becoming more international and more diverse. From the 1920s
onward, *Vogue* itself increasingly focused on that elusive, amor-
phous group of artists, socialites, aristocrats, and persons of high
style known as "café society," reporting on their frenetic activity
as they moved around Europe and across the Atlantic, capturing
them in the contributions of Cecil Beaton and the society colum-
nist Johnnie McMullin in "As Seen by Him." A mention in *Vogue*
was a mark of acceptance in these circles. In the Vreelands' case
one society friend from the pages of *Vogue* led to another. By 1929
Baba d'Erlanger was married to Prince Jean-Louis de Faucigny-
Lucinge, partygiver and partygoer extraordinaire. They were
probably responsible for introducing Reed and Diana to another
Vogue favorite, the beautiful Mrs. Harrison Williams, who be-
came a lifelong friend. Mona Williams (later Mona Bismarck) was
American. The daughter of the manager of a Kentucky farm, she
married five times, striking gold with utilities millionaire Har-
rison Williams in 1926, who provided her with the largest yacht in
the world and vast establishments including Il Fortino on Capri,
an island she did much to make fashionable. The most pressing
problem of rich Americans like Williams was staving off boredom,
and the film stars, painters, actors, photographers, and other cre-
ative types who made up the new international *gratin* were only

too happy to provide friendship and amusement in return for patronage. Café society was therefore characterized by a web of commercial relationships between the rich, especially the American and South American rich, and the artists who needed their money.

Diana's friendship with Cecil Beaton began in true café-society style with a professional commission. She had never met him, but she telephoned to ask whether he would draw her as a Christmas present for Reed, probably in the autumn of 1929. Beaton came to 17 Hanover Terrace and started work. Ten days later the drawing arrived. Diana was horrified: Beaton had drawn not just her face but her hands, with one hand holding a cigarette, which was reasonable, and the other wearing a wholly imaginary diamond, which was not. The diamond was "the size of an ice-rink" and all the rage at the time. "I was terribly offended by this," said Diana. "I got him on the phone and I said, 'Look here, Mr. Beaton, I don't own a diamond. I don't want a diamond like that. And if you think this is a suggestion for my husband to give *me* for Christmas—who's loony now?'" Beaton replied that he had not meant to be offensive, he simply thought it might be amusing. "I said, 'There is nothing amusing about vulgarity, nothing. And it's the most horrible vulgar fashion, the average hand is hideous—and the average hand is the one who wears those.'" She was, she said later, somewhat stuffy at this stage in her life. Immediately realizing he had misjudged Mrs. Vreeland, Beaton removed the offending diamond, and they became close friends.

It is possible that Diana saw something of her own father in Cecil Beaton's determination to make a life at a distance from his modest middle-class background (Beaton's father was a timber merchant). Beaton, whose photographs were themselves highly composed fantasies, took the lease of Ashcombe in Wiltshire in 1931 and turned it into another setting for decorative flights of the imagination, giving it a veneer in the grand aristocratic manner that was far removed from his origins. It was an impulse Diana understood; and for his part, Beaton held back the curtain to reveal an English social vista that was of much greater consequence

than a few more names in Diana's expanding address book. Beaton led both Vreelands into the company of English artists and writers whose lives were charged by the same kind of imaginative energy as Diana's. In her book *Romantic Moderns*, Alexandra Harris presents a picture of an English renaissance in the 1930s and early 1940s, composed of a network of gifted individuals who, in different ways, were intent on exploring the nature of Englishness and reconciling its present with new readings of its past. It was a movement that played itself out in a myriad of different modes, but fantasy, especially historical fantasy, was enacted in a particularly English way by Beaton and his circle of "Bright Young People" in the late 1920s as they fashioned themselves "both as silver-suited futurists and as eighteenth-century squires."

If the aesthetic explorations of Beaton and his friends fortified Diana's belief in the power of fantasy as a bulwark against the prosaic and unpleasant, the American expatriate Elsie Mendl taught her that dream making and the continuing quest for the Girl required meticulous discipline of an order different from anything Diana had yet imposed on herself. London society in the early 1930s was a small galaxy, and there was much overlap between its star clusters. Diana had been slightly acquainted with the great interior decorator in New York, while she was still Elsie de Wolfe, but it was only after Diana came to Europe that they became friends. Elsie was much older and became a mother substitute for Diana, the kind of mother who recognizes and fosters a child's particular genius. In many ways they were kindred spirits: Elsie had also thought of herself as an ugly child and had vowed to fight her way out of it. Like Beaton, she was determined to leave a colorless upbringing well behind her. She first tried her hand at interior decor at the home she shared in New York with the theatrical agent Bessie Marbury, but after the First World War Elsie turned her back on Bessie and wed Sir Charles Mendl in a *mariage blanc*. ("For all I know the old girl is still a virgin," he said as he continued pursuing young women.) Elsie, meanwhile, had a gallant who kept her company, Johnnie McMullin, the *Vogue* columnist who became

another friend of Diana and Reed's. As with café society's great party organizer Elsa Maxwell (whom Frederick Dalziel knew in New York and could not abide but whom Diana adored), it was said that Elsie Mendl took payment for arranging introductions. Those who did not pay were simply taken under her wing, though they were often invoiced in the end—Elsie was famous for forcing presents on her friends and then charging them.

However, if, like Diana, one was on her list of favorites, most of international high society was only an invitation away. Elsie often asked Diana to stay at the delightful Villa Trianon, where a short walk through an immaculate ornamental kitchen garden led to a door into the park of Versailles. Diana admired Elsie's style and her self-discipline: her health regimen famously included standing on her head every day. But it was Elsie's precision that Diana liked most. "I adored her because she was so . . . methodical," said Diana. "I was only romantic, imaginative and my mind was always far away. . . . Of course Elsie frightened me a lot. I was quite young. And I was always learning from her to be exact. To be definite. To be on the ball. Never to put up with nonsense. Not that she sat and told me these things, but I watched her." In Europe, Diana took in everything about the stylish Europeans and Americans she was meeting. "I started to get a little education," she said later. "Just from listening to the language and seeing the manners and the views of people who were highly educated. . . . *That* was the time that I took to *see* as much as I could. I was avid to learn."

Diana's social success in England was noted by the New York press. "Diana has made an enviable niche for herself in top-lofty social, artistic and musical circles," reported Maury Paul in an article about her in the *New York American* that he thought of calling "Home Town Girl Makes Good in London." Emily, he thought, "would have been intrigued by the manner in which Diana Dalziel Vreeland dresses up her exotic looks," and he commended Diana on continuing to entertain visiting Americans, unlike some of her female compatriots. These visitors included Condé Nast himself, who took to inviting himself for tea at 17 Hanover Terrace when

he was in London. It was a sign of Diana's standing that she was invited by the wife of the American ambassador to join a group of socially prominent Americans in being presented to King George V and Queen Mary at Buckingham Palace in 1933—an afternoon of pageantry she never forgot. It left her with lasting respect for both royals, particularly Queen Mary, whose regal style she much admired.

"There was something about the way she sat and her proportions and the size of her hat which was immediately recognizable and never changed. A very, very, good idea, especially for queens," Diana said later. "I'm mad about her stance—it was up up *up* and so was she." In spite of the fact that Queen Mary was Edward VII's daugher-in-law, Diana thought of her fondly as an Edwardian. "The Edwardian influence in England lasted long after Edward's death and blossomed like a cherry orchard in the best sun. That's my period, if you really want to know. You might think it was my mother's period, but it's mine. One's period is when one is very young." Her respect for King George V and Queen Mary rose further when she noticed that they had extended the hand of friendship to Nubar Gulbenkian. Gulbenkian was an Armenian petroleum magnate and playboy who had formed the habit of greeting Diana extravagantly in fashionable places, to the horror of her more aristocratic friends, who thought he was seedy. On the day of Diana's presentation at Buckingham Palace he was present in a formal capacity, and he cut her dead. "He passed me by like so much white trash," said Diana. It was obvious to her that he had been given his position behind the dais in the throne room because of his money. " 'Listen,' " I said to my English friends afterward, 'you just don't know what your empire has to go through. King George and Queen Mary do. No flies on them!' "

AS THE VREELANDS made their way into international high society, Diana encountered a new incarnation of the Girl: the 1930s woman of fashion. This woman was a fashion dictator, one of an elite group of women who wielded power outside the home as tastemakers,

compelling other women to follow in their footsteps. "It was not an era of gentle friendships or simple living," wrote Bettina Ballard, who came to know several of these women while she worked for *Vogue* in Paris in the 1930s. "The small egocentric group of women about whom fashion revolved accepted or rejected ideas with ruthless capriciousness, maintaining their leadership by making fashionable what they chose for themselves." In many ways this tiny circle of very rich women was as important to fashion as the couturiers in the 1930s. These were the people for whom the designers created their greatest pieces, knowing that such clients could make or break their reputations; and they were known as *"Les Dames de* Vogue*"* in contrast to a less elegant group who were known as *"Les Dames de* Femina*,"* an inferior fashion magazine.

"Les Dames de Vogue*"* included Baba de Faucigny-Lucinge, famous for her hats and headdresses, for starting a fashion for Cartier blackamoors, and for painting the tips of her nails; and the preternaturally poisonous Daisy Fellowes, daughter of the Duc Decazes, and heiress to the Singer sewing-machine fortune. Daisy Fellowes epitomized hard thirties chic. She possessed, said Diana in *Allure*, "the elegance of the damned." Daisy Fellowes made Elsa Schiaparelli's fortune by wearing her most surreal fashions. When she appeared bare legged at the Paris collections, all fashionable women removed their stockings. At her bidding women ordered jewelry in pairs; adopted leopard-print pajamas; and sported cotton dresses in the summer. The American fashion pack included Millicent Rogers and Mona Williams, who rejected Daisy Fellowes's fashionable hard chic in favor of the softer silhouette of Madeleine Vionnet and her paler pastel colors. "Don't forget," said Diana later. "None of these were stupid women, these were all very *privileged* women who very carefully sifted out the luxury, the privilege, the time allotted, the care in the house once [the clothes] were delivered, where and how you would wear them, with what jewels, what gloves, what slippers, what stockings, how your hair would appear. . . . It's a world that's so *remote* from today it's ludicrous."

It did not seem so ludicrous to Diana at the time. Fashionable

clothes and makeup had long been of vital importance in her quest for the perfect version of herself; and soon after the Vreelands settled in London, she embarked on an apprenticeship as a connoisseur of fashion and an "editrice" in the manner of "*Les Dames de* Vogue." She began making regular trips to Paris where she stayed in a cheap hotel and ate lunch in her room so that she had more to spend on dressing. She felt her way with some caution, following "*Les Dames de* Vogue" in her choice of couturier. Looking back, she remembered her clothes of the 1930s with affection: "I can remember a dress I had of Schiaparelli's that had fake ba-zooms—these funny little things that stuck out here. When you sat down, they sort of went . . . all I can say is that it was terribly chic. Don't ask me why, but it was." She admired Schiaparelli's adventurous use of new synthetic fabrics, threads, and fasteners, even when this led to a dry-cleaning disaster. "I had a little string-colored dress—it was like cotton but it was also like something out of a garden. . . . I wore it quite a lot, and well, it was time for it to go to the cleaners because nothing stays immaculate forever. It didn't come back, you see, because there was nothing to send; there was a little, tiny, round piece of . . . glue. . . . This fabric wasn't totally tested."

Diana also patronized Madame Vionnet, and Vionnet interpreted by Mainbocher. An American by birth, Main Rousseau Bocher was born in Chicago and eventually became editor of French *Vogue* by a circuitous route. He set himself up as dressmaker in Paris at 12 avenue George V in 1930 until the outbreak of war forced him to leave. He was unusual for a couturier in several respects. He was an American; he was a fashion editor who became a designer; and he taught himself to cut and sew. Backed by Elsie Mendl, Kitty (Mrs. Gilbert) Miller, and others, he greatly admired the work of Madame Vionnet and deployed her bias-cut technique to great effect, producing exquisite evening dresses and other fashions of deceptive simplicity that were a runaway success with the American *patronnes* he condescended to dress.

Fittings with these Paris couturiers constituted the basis of Diana's fashion education. For the rest of her life she never wavered

in her conviction that Paris was the wellspring of all great couture. Ferocious concentration was required of the client. Women of fashion fussed until every aspect of the garment was perfect. Customers like Diana became connoisseurs of cut, fabric, and technique. Talking to George Plimpton about this later, Diana had difficulty conveying the effort that went into it. Whether a shoe, a hat, or a dress, it was, in essence, a highly focused collaboration: "It's one thing I do care so passionately about—this wonderful, privileged world in which I lived where, literally, actually, it was almost a compliment to a man to drive him absolutely crazy every afternoon with fittings. But of course you were *expected* to give him as many fittings as he needed." Being fitted for couture clothes in Paris was not cheap, but Diana was able to obtain them as a *mannequin du monde*—someone who went to the right parties, was seen at the right places, and wore a designer's creations to advantage.

In Diana's opinion, however, the greatest designer of all was Coco Chanel. Twenty years older than Diana, Coco Chanel was already famous—and expensive—by 1929, so being fitted by her was a rare treat. Diana started by going to her shop at 31 rue Cambon, where Chanel sold scarves, handbags, and a few prototypes of what would later be called ready-to-wear. "She'd come in to see about a skirt; she'd always pat me on the back and say, 'It looks very nice on you, I like you wearing that.'" In the 1930s Chanel was in a romantic phase. "Everyone thinks of *suits* when they think of Chanel. That came later. If you could have seen my clothes from Chanel in the thirties—the *dégagé* gypsy skirts, the divine brocades, the little boleros, the roses in the hair, the pailletted nose *veils*—day and evening!" One of the best presents of Diana's life came from a member of the d'Erlanger family who generously offered her anything from Chanel that she wanted. The result, said Diana, was a "huge skirt . . . of silver lamé, quilted in pearls, which gave it a marvelous weight; then the bolero was lace entirely encrusted with pearls and *diamanté*; then, underneath the bolero was the most beautiful shirt of linen lace. I think it was the most beautiful dress I've ever owned."

A dress of this complexity was made in the couture salon of 31 rue Cambon, which was up several flights of stairs. "First, there was the beautiful rolling staircase up to the salon floor—the famous mirrored staircase—and after that, you were practically on a *stepladder* for five more flights. It used to *kill* me." Once she had landed safely, the fitting with Chanel herself was another strenuous experience. There was not much sense of collaboration, though someone as curious as Diana about the technicalities of couture could learn a very great deal. Chanel was a designer who knew exactly what she wished to achieve, and despised drawings. She cut and pinned the model on her clients and was a driven perfectionist.

Coco was a nut on armholes. She never, ever got an armhole quite, quite perfect, the way she wanted it. She was always snipping and taking out sleeves, driving the tailors absolutely crazy. She'd put pins in me so I'd be contorted, and she'd be talking and talking and giving me all sorts of philosophical observations, such as "Live with rigor and vigor" or "Grow old like a man," and I'd say, "I think most men grow old like women, myself," and she'd say, "No, you're wrong, they've got logic, they've got a reality to them"—with my arm up in the air the whole time! Then if she really wanted to talk, she'd put pins in under both arms so I simply couldn't move, much less get a word in!

Diana was in awe of almost everything about Coco Chanel. Chanel, she wrote later, was the Pied Piper of contemporary fashion: "Chanel saw the need for total simplification. Corsets, high heels, skirts dragging in the dust had to go. She anticipated the women of the twentieth century." She loved the way Chanel responded to the natural, unconstrained female body and designed for women who dashed about; and her "fantastic instinct" for arranging clothes for women who sought luxury at the same time. "Smart women went to her shop for short, wool-jersey dresses, tailored suits, slacks, simple black evening dresses short to the knee, and pullovers much like those worn by English schoolboys," she

wrote. But it was not just Chanel's designs or inspired costume jewelry that Diana admired. "The art of living was to Chanel as natural as her immaculate white shirts and neat little suits." Talking to George Plimpton later, Diana described Chanel's wit, the completeness of her taste, the rooms in her house that glowed with beauty. And there was also, of course, the sense of smell, the perfume, the perfection of Chanel No 5. "Chanel was the first couturier who added scent to the wardrobe of the woman. No designer had ever thought of such a thing."

While Diana thought Coco was entirely fascinating, she did not think she was very nice. She also did not think it mattered. "I'd always been *slightly* shy of her. And of course she was at times *impossible*. She had an utterly malicious tongue. Once, apparently, she'd said that I was the most pretentious woman she'd ever met. But that was Coco—she said a lot of things. So many things are said in this world, and in the end it makes no difference. Coco was never a *kind* woman, she was a *monstre sacré*. But she was the most interesting person *I've* ever met."

Diana and Coco Chanel had much in common beyond fashion: dysfunctional but mythologized childhoods, a love of horses, dance, coromandel screens, Diaghilev and the Ballets Russes, and the same blend of artistic vision and pragmatism. More important perhaps, Coco Chanel informed Diana's thinking about the nature of inspiration itself. Diana admired the way in which Chanel derived ideas from everywhere—from Breton sailors, from the tailoring of her English lovers to the sumptuous jewelry, ropes of pearls above all, of the Russian czars, to which she was introduced by her lover Grand Duke Dmitri Pavlovich, the putative murderer of Rasputin. A Chanel suit that Diana bought in the late 1930s was inspired by a Watteau painting; and years later she was certain that the classic boxy Chanel suit of the 1950s was inspired by Russian ethnic clothes during Chanel's affair with Dmitri. For all that she designed clothes for very rich women, Chanel believed in a democracy of taste, refusing to copyright her designs, and delighting in the idea that she was making duchesses indistinguishable from

stenographers. Like Diana, Chanel reveled in trompe l'oeil, the theatrical perspective. "Faking it" was not a question of making cheap copies, but interpreting the original in one's own inspired way, within the fashion structure of the time.

In the early 1930s it helped Diana greatly that the look of the period played to her strengths. As British *Vogue* put it rather rudely: "Today, an old boot of a face can win all along the line, since our present standards demand beauty of figure and finish, rather than mere prettiness. . . . If there is any animal today that is the *beau idéal* for female charm it is probably an otter emerging wet from the stream or a chestnut horse glittering with grooming." The high fashion of the 1930s required a sleek, slim figure and willingness to devote oneself to the care involved in achieving a gleaming, streamlined surface. Fortunately for Diana it did not call for conventional loveliness. What mattered was one's style, and that—as Diana had noted in her diary as early as 1918—meant every aspect of one's image, including the way one stood and walked.

However, "style" went much further than one's exterior appearance. "Personality" was just as important. When a group of Paris dressmakers drew up a best-dressed list in 1935, they made a point of judging the winners on personality and charm as well as the knack of dressing to best advantage. (One enterprising type went as far as advertising herself throughout the 1930s as a "personality specialist" in the back of *Harper's Bazaar*: for a consideration she could modernize the reader's personality to match the latest fashions.) It was essential to be amusing, and failure to pass the test could lead to a critical reaction. In 1930 Beaton found himself seated next to Baba de Faucigny-Lucinge. He had long admired her from afar but was deeply dismayed by her at close range, dressed in "conventional Chanels" and interested only in gossip. "What a disappointment that woman is," he wrote in his diary afterward. "She might have been so amusing."

AWARE OF THE dangers of becoming a gossipy bore, and with time on her hands, Diana embarked on an energetic campaign of

self-improvement, catching up on the reading she had neglected at school. "I'd spend days and *days* in bed reading and think nothing of it. There were so *many* books. I learned *everything* in England. I learned *English*." This was not reading as understood by an academic student of literature. Diana made long lists of writers including Freud, Spinoza, Nancy Cunard, Isak Dinesen, biographies of Lady Hester Stanhope, and work by Gertrude Stein. Her response was highly visual. She dipped and scanned, and what she took from world literature frequently landed back in the world of fashion: "When I think of Natasha in *War and Peace*, when she's just seen a young lady kiss a young man she was obviously having a walkout with . . . I know *exactly* what she's wearing. It's actually known as the 'Natasha dress.' " Reed and Diana would read books together, out loud, which had a further impact on her feeling for language: "When you've *heard* the word, it means so much more than if you've only seen it." Beaton was the first to capture the manner in which Diana spoke in the 1930s, noting her "poetical quality," her insistence on accentuating the positive, and the way in which she gave color and life to the most quotidian event:

> "What a bad film," one might remark. "Yes, but I always adoare [sic] the noise of rain falling on the screen." To me, beautiful Mrs. Paley in sequins is beautiful Mrs. Paley in sequins, but to Mrs. Vreeland: "My dear, she is the star in the sky." A swarthy brunette may seem ordinary to me, but to Mrs. Vreeland she is "exceptional, my dear, she's wonderful! A wonderful sulky slut.'"

Around this time Diana threw off the name Emily had given her, with all its fraught associations, for something more in keeping with her grown-up, 1930s European self. Friends in international society began to pronounce her name differently from the English "Die-*anna*" to something more frenchified: variously "Dee-*anne*," "Dee-*anna*," and sometimes "Dee-*ahna*." This intensified her air of European sophistication, and had the additional advantage of distinguishing her from Diana Cooper and Diana Mosley, though

her first name continued to shift around forever more, and English friends called her "Die-*anna*" until she died. As well as making adjustments to her name, Diana took steps to capture her new image, commissioning a drawing of her European self by Augustus John; and in 1931 she was painted by the society painter William Acton, who took a series of preparatory photographic studies that capture Diana's European persona almost better than the portrait itself. At one point she slipped one of Acton's photographs into her own fashion scrapbook. For a moment in the 1930s, in her own mind at least, Diana stood comparison with the writer Princess Marthe Bibesco, Marlene Dietrich, and Greta Garbo.

Above all, Diana observed *l'art de vivre* as practiced by the international beau monde, leaping on the smallest details of their savoir-faire with delight and carrying them home. This was a world in which the Vicomte and Vicomtesse de Noailles kept a houseboat with shiny green shutters on the Seine, and took to the rivers when the cares of the world became too much for them; in which Princess Jean-Louis de Faucigny-Lucinge dressed her two little girls in hats with skyrocketing feathers to set off her dead-black dress; and in which Lady Mendl dictated memorandums ordaining that her most successful sandwiches should be photographed for *Vogue*. Diana developed a taste for great luxury, and she was quick to learn the ways of rich friends. "The vision of Diana Vreeland arriving at a friend's quattrocento villa in Fiesole with her own sheets and with so much luggage and so many books on the de Medici that she nearly overflowed the guest room, has, if anything, grown more vivid in her hostess's eyes in the past thirty years," wrote Phyllis Lee Levin. But at the same time, following the inspiration of Chanel, she adopted cheap and cheerful Breton tops, Neapolitan trousers, espadrilles, and the thonged sandals she saw on the feet of locals when staying with Mona Williams in Capri in 1935. The most important lesson of her time in Europe was that in the end, style had little to do with money. What counted was the divine spark.

..

IN 1931 DIANA and Reed were invited to stay with Baron Rodolphe d'Erlanger and his wife at their house Dar Nejma Ezzahra in Tunisia because they were friends of the couple's son Leo and his wife, Edwina. A composer and eminent musicologist who made the study of Arab music his life's work, Baron Rodolphe was the odd one out who never went into the d'Erlanger family bank, "which was as queer as if you decided to walk on your hands rather than on your legs." Dar Nejma Ezzahra was a beguilingly beautiful palace, painted in blue and white, perched on the top of a cliff above the Mediterranean, with terraces of orange, lemon, and oleander all the way up from the sea, where Diana stunned her fellow visitors by swimming in a pink rubber swimsuit. The manservants were dressed in pantaloons with gold and silver brocade and lamé boleros, and little birds flew in and out of marble columns in the hall, where water trickled in a rivulet and gardenias floated. There was a muster of silvery white peacocks. "The top of the palace was flat, and on hot nights we'd go up there after dinner to get the air and look down at the peacocks with their tails spread and their *tiny* heads against the reflection of the moon shining on the sea."

Baron Rodolphe did have one disconcerting habit, however. On the first day of the stay, Diana was placed beside him at lunch. As they made light conversation and he paid her compliments ("you know, the sort of business that men say to women by the sea"), Diana noticed that he held a beautiful linen handkerchief. It was "like an absolutely transparent cobweb" that never left his hand and he sniffed constantly. "You're the night's morning (sniff) . . . you're the sun, the moon and the *stars* (sniff, sniff)." With a growing sense of panic she realized she was sitting next to someone addicted to ether, said to relieve pain and produce intense exhilaration. " 'Reed,' I once said, 'What happens if I really get a *blast* of it?' 'You won't,' he said. 'Just remember—when he breathes *in*, you breathe *out*.' " Their fellow guests included Kitty Brownlow, Elsie Mendl, and Baroness Catherine d'Erlanger. They were photographed in a row with Diana in the middle, looking notably chic in a linen dress and white gloves. The photograph appeared in

British *Vogue* in July 1931, and it marked a turning point. Diana had moved from looking in at *Vogue* to looking out, surrounded by some of international high society's most fashionable people. The Vreelands had arrived.

IN THE EARLY 1930s society was constantly on the move, and Diana often slipped over to Paris, taking advantage of the fact that it was now possible to fly from Croydon in the early morning and arrive by lunchtime. Disentangling what actually happened on these trips is not easy. Diana liked to tell a story about sitting next to Josephine Baker at the cinema in Paris in the early 1930s. She had, of course, encountered Josephine Baker before, in New York in the 1920s, and memorably at Condé Nast's party. But in 1932 Diana met her again when she went to a screening of *L'Atlantide*, starring the German actress Brigitte Helm, in a small cinema in Montmartre. Caught up in the film, Diana barely moved a muscle. "I have no idea if I actually saw the movie I thought I was seeing, but I was absorbed by these three lost Foreign Legion soldiers . . . their woes . . . the fata morgana. That means that . . . if you desire water, you see water—everything you dream, you see. But you never reach it. It's all an illusion." In the film the desperate soldiers crawl into an oasis to find a very wicked Brigitte Helm surrounded by cheetahs. Spellbound, Diana allowed her arm to drop down beside her in her cinema seat while Brigitte Helm and the cheetahs dispatched an unhappy ending to all concerned. "The lights went on, and I felt a slight movement under my hand. I looked down—and it was a *cheetah*! And beside the cheetah was Josephine *Baker*! 'Oh,' I said, 'you've brought your cheetah to see the cheetahs!' 'Yes,' she said, 'that's exactly what I did.' "

On the street outside the cinema there was an enormous white-and-silver Rolls-Royce waiting for Josephine Baker. "The driver opened the door; she let go of the lead; the cheetah *whooped*, took *one* leap into the back of the Rolls, with Josephine right behind; the door closed . . . and they were off!" *L'Atlantide* appeared in

1932 when Josephine Baker had moved to France, and she did indeed go about Paris in the company of a cheetah called Chiquita. It is perfectly possible that Diana came across Baker and Chiquita leaping into a Rolls-Royce together. They may all have been in the cinema at the same time. But the idea that Diana was able to keep her hand on Chiquita throughout *L'Atlantide* collapses when one considers Chiquita's character. In common with several others in Diana's new European world, Chiquita was not quite what she seemed. She was a he, of independent disposition, and prone to terrorizing the musicians during Baker's shows. On the other hand, the possibility that Chiquita was stunned into good behavior by the sight of fellow cheetahs on the silver screen should not be entirely discounted.

Stories told by Diana against herself often revolved around the sense of unreality that pervaded high society in the 1930s. In the face of economic depression and the rise of dictators in Germany, Italy, and Russia, there was more than an element of denial in the *gratin*'s obsession with trivialities, its intense inwardness, its fancy dress parties, and its constant movement from one modish resort to another. Astonishingly, spas in Germany and Austria continued to be fashionable until the end of the decade. Although Diana said later that she could feel everything "weakening, weakening, weakening" in the 1930s, she and Reed were among those who continued to prefer resorts in Germany and Austria to those in the south of France, and they regularly visited a spa near Freiburg in the company of the Brownlows and d'Erlangers. During one of these sojourns Diana had her only encounter with psychoanalysis. Curious about what this might involve, she consulted an eminent German psychotherapist who had a consulting room at the spa where she was staying. He saw her for three or four sessions, at which point they mutually called a halt. Each consultation left Diana flattened with exhaustion. "I simply had . . . to sleep for twelve hours I was so exhausted talking about myself," she said. She resolved never to repeat the experience, a point of view allegedly

shared by the eminent German psychotherapist. "You can't handle it. Because you're not ill," he is supposed to have said. "It's a bore for you and me."

In June 1934, inspired by reading Henry "Chips" Channon's *The Ludwigs of Bavaria*, Reed and Diana embarked on a tour of the castles and important places in the life of King Ludwig II. By her own admission Diana and Reed took very little notice of German politics, though there was a moment when Diana peered at Hitler over the edge of a theater balcony and thought his moustache was just plain wrong (she also sent Freck a postcard saying, "Watch this man"). Otherwise the Vreelands were enchanted by everything they saw. But one evening they arrived at their hotel in Munich to find goose-stepping soldiers on the street outside. Diana pushed her way past them to get into the hotel, and even Reed was annoyed with her. " 'Really,' Reed said to me. 'You've got to behave yourself. You simply cannot push your way past these men saying, "Excuse me, excuse me, I've got to get into my bath!" ' "

It was Diana's maid who realized that something was terribly wrong. The following morning she rushed into Diana's room crying, insisting that they must leave at once because something horrible was happening, though she was unable to explain what it was. Diana told her to pull herself together. "But Julie was getting more and more upset until she couldn't even fasten a hook. She was a very sensible Frenchwoman, nothing simpering about her. She knew she was in very, very bad company." It was only two weeks later that the Vreelands realized that Julie had been upset on the morning after the so-called Night of the Long Knives, which began on June 30, when Hitler moved against both the paramilitary Sturmabteilung (SA) and other critics of his regime. In her memoir Diana asserts that fourteen murders took place in their hotel that night. There is no record of this at all: the murders took place outside Munich at Bad Wiessee. Nonetheless there was a terrifying atmosphere of violence across the city, with hundreds of bludgeonings and arrests. But, like her father before her, turning away from ugliness and unpleasantness had become one of Diana's habits. As

she said: "The curious thing about me is that I only listen to what I want to hear. It's not all deliberate. It's just a sort of training of mine because I try to concentrate totally on what I want to hear."

This trick of positive thinking, of blotting out ugly behavior and ugliness, and dreaming the beautiful, the "duh-vine" into existence had, of course, started years earlier during Diana's childhood. The dream-come-true atmosphere of the early years of the Vreelands' marriage and the delights of their new life in Europe had the effect of reinforcing what Diana described as "a sort of training of mine." But it was not always easy being the children of a mother with this approach to life. Tim and Freck passed time in the nursery with Nanny at the top of 17 Hanover Terrace or in the basement with the butler. Their relationship with their parents was so distant it would now be regarded as neglectful, though such domestic arrangements were typical of the period. Diana's notion of putting up world maps on the walls of their bedrooms so that her sons would know where she and Reed were traveling was not perhaps entirely helpful in this respect, even if it did discourage a provincial point of view. When Reed and Diana were at home there were privileged visits at stated hours, with occasional unscheduled glimpses of Diana in the distance when she had her rumba lessons. Reed often appeared to say goodnight, beautifully attired in evening dress, before he and Diana went out for the evening.

Neither son remembered being allowed into the gorilla cage at London Zoo on Nanny's day off so that they would learn not to fear noble animals, as asserted by Diana later. On the other hand, the boys did have a genuine connection to the London Zoo, for Emily had presented it with two bear cubs after one of her hunting trips in the Rockies; and there were excursions with their parents to less glamorous destinations in Britain including the English seaside and a hotel belonging to a cousin of Diana's in Devon. They also accompanied Reed and Diana to Belton and stayed with their aunt Alexandra at Gilmerton in East Lothian, where Tim Vreeland's abiding memory was of a girl being dangled upside down after she swallowed mothballs. Tim Vreeland was four when he

and his parents arrived in England, so much of his early childhood was spent there. "It was never very comfortable, I will say that. Little boys are very conventional. I often wished she was like other mothers. I wanted the kind my friends had, just an ordinary old mother." Being raised by someone who minded so much about external appearances was "terrible—in both senses of the word." Diana loved English clothes for little boys, putting her own in long dressing gowns and small monogrammed slippers with pompoms. She insisted on dressing her two boys so alike that the visors on their little caps had to be at precisely the same angle.

It was the other side of her positive attitude, her denial of anything negative, that made the boys' lives particularly difficult. Diana admired Baba de Faucigny-Lucinge's approach to child rearing: "Her little girls are enchanted by her. Around them everything moves, everything is gay. They live in a continual fairytale, conceived by Baba, not Grimm," said *Harper's Bazaar.* "I had made a solemn vow to myself never to allow my children to know that anything in the world was frightening, impure or impossible," said Diana. But this approach to life reached a pitch of absurdity in the terrifyingly gruesome Chamber of Horrors at Madame Tussaud's. "That was a bit of all right for them," she opined. "Nothing wrong for them to see. Everybody had to *go!* All I can say is that my sons had a very healthy upbringing." This view was not shared by her sons. Once they went to school, humanity's darker side came as the most terrible shock. "I feel now that I was deprived of fifty percent of human existence," said Freck much later.

IN NOVEMBER 1933 Diana enjoyed a triumph: She became a *"Dame de* Vogue" in her own right. The November 1 issue of American *Vogue* included a drawing by Cecil Beaton of Diana lounging on a garden seat. It was intended, said *Vogue,* to comfort the reader and put her mind at rest. Mrs. Reed Vreeland was one of "the European highlights of chic" but here she was, sitting in a garden. It all went to prove "that even these glamorous women—these focal points—of Parisian fashion—have their off moments. . . . They

loaf, they read, they sleep—even as you and I." Such reassurance was probably necessary, given Johnnie McMullin's description of Diana at Mainbocher's atelier a few pages later:

> *Mrs. Reed Vreeland . . . is considered one of the most chic of the international set living in Europe. In London, where she has a house in Regent's Park, she is much admired for her taste in dress, which, because of her striking, exotic personality, is extremely conservative. She is tall and thin, with a profile of a wife of the Pharoahs, a beautiful figure, and jet black hair, which she arranges like a cap on her head, curling at the nape of the neck. She knows what she wants at a glance—a thing that not all women are supposed to know.*

As McMullin looked on, Diana chose a black wool Mainbocher coat as the basis of her winter wardrobe. "Under the coat she will wear different crepe de Chine dresses, mostly in colors, together with several different hats, all black." Diana then turned her attention to evening dresses. "How delighted I am," she said, "to see black satin again." She favored an evening dress with two ostrich plumes placed like flowers on its bodice. "It is a new idea," she remarked. But then her eye lit on a dark blue double-faced satin dress with a train over an underskirt of pleated blue tulle, with blue curled osprey feathers as a corsage decoration. "It will be my grand party dress, because it makes one think of footmen on the stairs," said Diana, who was sketched wearing Mainbocher's creations in the same issue.

IN SPITE OF her sterling efforts, however, Diana's Arcadia was not to last. Once again beauty proved to be treacherous. She was, she discovered, not the only woman who considered Reed handsome: English society women could be breathtakingly predatory. "I made great friends among the English during the time I lived there but, then, I wasn't there to get their men," she told Christopher Hemphill. "Those English women look after English men like nobody's baby has ever been looked after. On the other hand, they'll go after

anyone's husband themselves. Brother, what I saw *left* and *right*! I certainly had a more attractive husband than most women have. He wasn't that flirtatious, but they were, and, naturally, it was flattering to me . . . up to a point." If an instinct for denial was one price paid by Diana as she fought back from her childhood, Reed's role in giving her self-esteem was another. "Anyone who has been emotionally wounded is prepared to pay a very high price to preserve the stability of a bond that protects him," writes Cyrulnik. Reed was kind as well as handsome and the extent to which he resisted as desperate Englishwomen flung themselves at him is not clear. Diana rarely spoke of this, coming closest with: "At times they liked him a bit too much for comfort but we can . . . forget it."

Money was another disagreeable problem. Diana later maintained that the Vreelands were able to live well but inexpensively in London in the early 1930s, thanks to the relative strength of the dollar against the pound. At some point in 1933, however, their finances suffered a reverse. America was still in the grip of the Great Depression, and although recovery began slowly during 1933, stocks remained volatile and Reed appears to have made some poor investments. Moreover, Reed and Diana, like her parents before them, were mixing in very rich circles, on a relatively modest income, and had spent a great deal of money on 17 Hanover Terrace, believing that they would be there for many years. A favorable rate from the couturiers as *mannequin du monde*—like the generosity of richer friends—went only so far, and it would have been very difficult for them to live as they did in London without eating into their capital.

From the time she was fourteen and wrote to the "pin-money club" of the *Woman's Home Companion,* Diana responded to financial problems by taking small practical steps to relieve the pressure. In London in 1933 she reacted by following the example of other wellborn women, especially Americans, by opening a small exclusive shop for a rich clientele. Diana's shop sold lingerie, a small selection of scarves, and some fine household linens and was based in a mews near Berkeley Square. Lesley Benson, who had

recently divorced Condé Nast and married Rex Benson, helped her to set the business up, but Diana supervised all the work thereafter, causing some amusement among her friends. "I should love to see you among your delicate lines of lingerie," wrote William Acton from Florence. Running a shop made new, interesting demands on Diana. It drew on her sense of style, her love of luxury, and her perfectionism. The search for designs and fabrics took her frequently to Paris, while most of the sewing was done in a convent by the Sisters of Marie Auxiliatrice in Bow Road, in London's East End, and the young women in their care. "I was never *not* on my way to see the mother superior for the afternoon. 'I want it rolled!' I'd say. 'I don't want it *hemmed,* I want it r-r-r-*rolled.'* "

Commissioning lingerie called for precision. Discounts had to be negotiated with suppliers; there were irritated exchanges about canceled orders with the fabric house Simonnot-Godard in Paris; and even the nuns were businesslike. While Diana may have been meticulous when commissioning lingerie, sound arithmetic was not her strong point, unlike her friend Mona Williams, who scrutinized every penny in the way of the very rich. Records for the business at the end of 1933 show that Diana's customers were largely drawn from her friends—Mona Williams bought chemises and sheets, while Edwina d'Erlanger, Syrie Maugham, Kitty Brownlow, Kitty Miller, and Lesley Benson all placed orders, as did Lady Portarlington and Mrs. Fred Astaire. The nightgowns were so beautiful that Edwina d'Erlanger's sister Mary bought one and wore it as a ball gown. "I was very thin. I was about twenty-three and I saw the most beautiful nightgown which I bought and wore backwards because it was low in the front and in [the] back. It was pink, so I wore it and I had great fun at the ball." And according to Diana, it was the nightgowns that brought a new acquaintance into the shop, one Mrs. Ernest Simpson.

Diana only knew Wallis Warfield Simpson slightly, though she had been to lunch at her flat at Bryanston Court, where the food was memorably delicious thanks to Wallis's tutor, Elsie Mendl. Wallis Simpson ordered three luxurious nightgowns and was exact

about the deadline—three weeks. Diana remembered that she had already left Ernest Simpson, that she was feeling poor, and thought she splurged on the nightdresses in anticipation of her first weekend alone with the Prince of Wales at Fort Belvedere, a timetable that has led some to suppose the story must be apocryphal because the dates do not tally. Like many of Diana's stories, however, this one is probably true in essence even if some facts require fine-tuning. It has recently been suggested that the relationship between Mrs. Simpson and the Prince of Wales warmed up much earlier than either of them later suggested, while Wallis was still living with Ernest Simpson, and that their close circle was well aware of it. Mrs. Simpson's union with the Prince of Wales was probably not consummated until later in the year, but she had good reason to think she might need glamorous nightdresses in the spring of 1934, while Diana was running her lingerie shop.

THEN THERE CAME a most unexpected blow. "When Reed and I got to Regent's Park, it was going to be our life. We thought we'd live there for the rest of our lives. You always think you're going to live somewhere forever. It's the only way to live—it's forever!" But it turned out that their life in London was not going to be forever. In what Diana later described as the most ghastly single moment in her life, Reed came home from work one evening and delivered a bombshell: his role had changed, and unless he wished to lose his job with the Guaranty Trust, they were return-ing to live in the United States. "It was a fait accompli. There was nothing to discuss. There was nothing to do but get dressed and go to dinner." For once Diana's brave face deserted her. The Vreelands had been invited to the Savoy by Mona Williams, and Diana was wearing a beautifully pressed pink Vionnet dress with a long banner of pink crepe de chine. By the time they ar-rived at the Savoy, she looked a mess. "You've never seen anyone in such a condition. I was a disgrace. I can still remember Mona's face when she saw me walking in, looking as if I'd fallen out of

bed in this thing. All I'd done was drive from Regent's Park to the Savoy but I'd had what you'd call a *total* chemical change. It was a shock. I was absolutely, literally, totally *crushed*."

Friends commiserated on both sides of the Atlantic. Lesley Benson wrote to say that Diana had been wonderful about the lingerie business, that she had a real genius for it, and that it was a tragedy that she was leaving. "I am pleased about Reed staying with the Guaranty, and I know you must be, that's the bright spot." Another friend wrote: "It is really too dreadful—I know so well how you feel—but you are such a marvelous person I know you will be able to cope with the situation and as long as you have Reid [*sic*] and the children it doesn't matter much where you are." Diana slowly pulled herself together. She wound down the lingerie business. The Vreelands gave notice to Freck's prep school, taking him out at the end of the spring term in 1934, and they terminated the lease on 17 Hanover Terrace so that it came to an end in June 1934. Then there was a reprieve. Reed, who was suffering from a mysterious debilitation that he seemed unable to shake off, was sent to Switzerland to recover. The Vreelands stayed for several months in the opulent Hotel Beau-Rivage at the lakeside resort of Ouchy near Lausanne, a stay that stretched into the early months of 1935. The change of scene did Reed good. By September 1934 a friend, Ben Kittredge, was writing: "It is wonderful to have seen Reed so much better and to know that he is getting well so rapidly and thoroughly, that at last you have found both the cause and the cure," and by the end of the year Elsie Mendl remarked: "I am so glad about Reed and how much better he is."

Diana was fascinated by Lausanne in general and the Hotel Beau-Rivage in particular. "Switzerland before World War II was much more mysterious than it is today. It was full of Greeks and money." The Aga Khan (who would also appear in *Allure*) used to bring his girlfriends to the hotel: "always with a different girl but always with the most beautiful girl you'd ever seen in your life. . . . He was a dreamboat, he'd be announced: His Highness, the Aga

Khan!—and a *personage* really entered the room!" A banker from Lyon kept his second family in the hotel, unknown to his first, who lived elsewhere. Even when he was absent his mistress would dress for dinner, covered in jewels. Tim Vreeland was already at prep school in Switzerland by the time his parents came to Lausanne. Reed read Hans Christian Andersen stories to his sons in a large sitting room in front of a fire, and later he and Diana would go downstairs for dinner.

> *I was so happy in Ouchy, on the water. My bed faced Mont Blanc. . . . Every day was totally and completely different. I can remember thinking how much like my own temperament it was—how much like everyone's temperament. The light on Mont Blanc was a revelation of what we all consist of. I mean, the shadows and the colors and the ups and downs and the wonderment . . . it was like our growing up in the world.*

In May 1935 Diana went ahead to set up a home in New York, with the boys following a month later in time for the long summer vacation. "It's strange, isn't it—the things that happen in life over which one has absolutely no control? I thought my life was over. I couldn't imagine anything other than the totally European life we led." But as it turned out, a different kind of life was just about to begin, thanks to a slight, clear-eyed, and unusually determined woman called Carmel Snow, editor in chief of *Harper's Bazaar.*

ON A SUMMER evening in New York in 1936, in a nightclub on the roof of the St. Regis Hotel, Reed and Diana Vreeland rose from their table and began to dance. As they eased into a slow foxtrot to the sound of Victor Lopez and his orchestra, heads turned and whispers fluttered round the room. Mrs. Snow's eye was drawn to Mrs. Vreeland, who was wearing a white lace Chanel dress with a bolero, and roses in her blue-black hair (the better dancer of the pair, she moved with sinuous grace). Carmel Snow was not acquainted

with the Vreelands, but she soon found out who they were. She was famous for her intuition about talent, and the next day she telephoned and offered Diana a job. "But Mrs. Snow," Diana replied, "I've never been in an office in my life. I'm never dressed until lunch." This reaction was tactically correct. Carmel Snow liked her lady fashion editors well connected as well as stylish and talented. "But you seem to know a lot about clothes," Snow replied. "Why don't you just try it and see how it works?" In spite of her apparent hesitation, Diana had no choice but to accept. In reestablishing her family in New York, she was going through money like "a bottle of scotch, I suppose, if you're an alcoholic."

That was how the story was later told. In reality Carmel Snow, who worked at *Vogue* in the 1920s, had known of Diana as a fashionable New York debutante and had occasionally mentioned her in the magazine. After the Vreelands returned from Europe in 1935, Snow probably did not spot Diana in a white dress by Chanel in summer but in a pink dress by Vionnet in the winter of 1935, at a party where New York society paid for its tickets, a new trend. And Diana had in fact known she would have to earn a living somehow in New York well before she left England. The Vreelands had spent money on 17 Hanover Terrace that would never be recovered. She had been obliged to close her lingerie shop. Reed had been ill. Several months in the sumptuous Beau-Rivage could only have further depleted their funds. At the same time she was unsure of her direction. Before she left Europe, Diana took tentative steps toward becoming an interior decorator by signing an agreement with Syrie Maugham that she would receive a commission on "Syrie" furniture she sold in New York. By the time Snow approached her in New York, Diana had already started work for a small Hearst magazine, *Town & Country*, that would have involved her in society journalism.

But the outcome of the story was the same. Until this point Diana's divine spark had been directed at herself and her household. From now on, with her faith in the power of dreams and dream

making vindicated, and her "European upbringing" complete, it would be transmitted outward to many thousands of readers. Carmel Snow did not yet understand this, but she knew she had spotted a woman of rare taste and originality who deserved a broader canvas. She telephoned the editor of *Town & Country* and ordered him to hand Diana over to *Harper's Bazaar.* He did as he was told—and another legend was born.

PIZZAZZ

I arrived at Harper's Bazaar. I came in on a Monday. . . . I was given a tiny office. I was sitting in my office talking to myself. I kept saying, "I work here! I work here!"—I couldn't believe it.

George Davis, the fiction editor, stuck his head around her door and said: "What this country needs is Bob Hope." Then he disappeared.

I didn't know one thing. I didn't know who Bob Hope was! My God, when I think of what I didn't know, of what I had to learn.

It was all very puzzling.

After a few days had gone by, I made friends with the Managing Editor, a divine woman named Frances McFadden. And I said to her, "I've got to tell you something—I do stay up rather late at night and I just can't do without lunch."
"Well," she said. "Why should you?"
"But there's no time for lunch, is there?" I said to Frances.
"Of course there is. Why don't you just have lunch?"

THE STRANGE NEW world in which Diana found herself in 1936 was all the more interesting because *Harper's Bazaar* was undergoing a transformation. *Bazaar* first emerged as an upstart competitor to *Vogue* when it was bought by William Randolph Hearst in

1913, but it only became a serious threat once Hearst started poaching *Vogue*'s staff. Three years before Diana arrived, Hearst pulled off a great coup by luring her new boss Carmel Snow to *Bazaar.* Snow had been heir apparent to *Vogue*'s formidable editor in chief, Edna Chase. She had begun her career by working in the dress shop of her domineering Irish mother, who made copies of French designs for rich New Yorkers. By the time she was in her early twenties, Snow knew everything there was to know about sewing and tailoring, French couture, and smart customers. But her own stylish flair, her omnivorous interest in much beyond fashion, and her desire to write brought her to the attention of Chase, who set about training her. Snow served a long apprenticeship as Chase presided over some radical changes at *Vogue,* including the shift from line drawings to fashion photography; and by 1929 Chase was so busy supervising international editions of *Vogue* that Snow became editor of American *Vogue,* while Chase herself became editor in chief. Condé Nast and Edna Chase both adored Snow, making their sense of betrayal when she left for *Bazaar* all the greater. In the end, however, her decision to defect was not surprising. Chase was a frustrating boss who became more autocratic with every passing year. Her rigid ideas about chic extended to every aspect of life. And although she kept promising to retire and make way for Snow, she never did.

Released from the oppressive atmosphere of Mrs. Chase, Carmel Snow came into her own. Within two years of arriving at *Bazaar* in late 1932 she had transformed a dull and musty magazine. She sacked the fashion department; appointed herself the temporary art director; and implemented lessons learned at Condé Nast Publications, operating at a peak that lasted until the late 1950s. During the week she left her three children with a nanny on Long Island, and she and her husband led separate lives. A slight woman, with an upturned nose, a face that reminded Beaton of a fox terrier, and hair that was almost blue, Snow never lost the Edna Chase habit of wearing a little hat and pearls to work but that was where the similarity ended. She was warm, funny, full of life, and

open-minded. At the same time, her soft Irish lilt was deceptive, for she was much tougher than she looked or sounded. She was determined, rigorous, discerning, even ruthless in her search for quality. She believed that *Bazaar* had to startle and surprise and at her best, she was very bold. She was keenly aware that *Bazaar* could only succeed by being daring in a way that *Vogue* was not. She had a gift for spotting gifted people; and she was extremely good at creating a stimulating, disciplined atmosphere in which they flourished.

One of Snow's early breakthroughs at *Bazaar* came when she noticed the work of the Hungarian photographer Martin Munkácsi. She had developed a keen understanding of the importance of fashion photography at *Vogue*, where she had worked closely with its innovative, irascible art director, Mehemed F. Agha (always known as "Dr. Agha"), and *Vogue*'s chief photographer, Edward Steichen. At *Vogue* the work of Steichen, Beaton, and others not only brought art to fashion but also had a profound impact on fashion itself, making it possible for readers like Diana to see new designs with far greater clarity. These images captured the independent, confident atmosphere of the New Woman of the 1920s, and extended the public space she inhabited while creating a fantastic, soft focus world of "real" but impossible glamour. On arrival at *Bazaar*, Snow was dismayed by the work of its house photographer, Baron Adolph de Meyer, whose ornate, romantic style had changed little since the early twentieth century. But she could find no satisfactory alternative until she came across Martin Munkácsi, a news photographer with an interest in sports who had never taken a fashion picture in his life.

"I decided that I had to let him re-photograph a bathing-suit feature that had been taken, as usual, in the studio against a painted backdrop," she recalled. Together they came up with the idea of taking the swimsuit model to the beach at Piping Rock Club on Long Island on a cold November day. Here, to general astonishment, Munkácsi directed the model to run toward him as he photographed her with a sports camera, a 35 mm Leica. The

resulting picture of the model running along the beach with her cape billowing out behind her became a defining image of the active American girl. It was also, said Snow, "the first action photograph made *for fashion*." (It made such an impact on Diana at the time that she later put it in *Allure*.) Snow immediately dropped de Meyer and allowed Munkácsi free range, starting a new direction in fashion photography that connected high fashion with action, on location. Munkácsi's photographs were dismissed by Edna Chase as "farm girls jumping over fences," but they made *Bazaar* look modern and exciting at *Vogue*'s expense.

In a move that was even more farsighted, Snow hired Alexey Brodovitch, a designer of outstanding brilliance, in 1934. Russian by birth, Brodovitch had come to the United States by way of every European artistic movement of the early 1920s. Forced into exile during the Russian Civil War, he had made his way to Paris, where he found himself at the center of dadaism, constructivism, Bauhaus design, futurism, surrealism, cubism, and fauvism, working first as a backdrop painter for the Ballets Russes before becoming a highly successful graphic designer. In 1930 he moved to the United States to work at the Pennsylvania Museum School of Industrial Art and subsequently became head of its Advertising Design Department. An outstandingly good teacher, he set about pulling American advertising up to European standards while continuing to produce radically innovative work of his own. Snow spotted some of his work at an exhibition of advertising design run by the Art Directors Club of New York and, with her unfailing instinct, knew she was looking at the work of someone extraordinary, with the potential to become a great magazine art director. Without Hearst's authority she persuaded Brodovitch to sign a contract with *Bazaar* on the spot. She then flew to see Hearst at San Simeon in California and persuaded him, most uncharacteristically, to approve a fait accompli.

As art director, Brodovitch transformed the look and feel of *Bazaar* and, ultimately, most American magazines. He was not the first to introduce Bauhaus-inspired design to the pages of a

magazine, since Dr. Agha was already doing this in a more modest way at *Vogue*. Agha may also have been the first to tilt type, to allow white space on the page, to "bleed" photographs to the edge of the page, and to spread images into fan shapes. But Agha was limited in what he could achieve by Edna Chase, who could see no relationship between form and content. Snow was quite the opposite. She was decisive; she was very much in charge; but she had a gift for collaboration. She and Brodovitch worked together closely so that crisp, snappy titles and editorial content conceived by Snow worked in a unified way with Brodovitch's graphic design and modernist typefaces. Snow encouraged Brodovitch to be daring, to use type to compose arresting graphic shapes on huge white spaces, even permitting him to experiment with cellophane overlays that changed the image of the page beneath. Their most significant innovation was inspired partly by Brodovitch's love of ballet and partly by film montage. They developed a way of working together in which they laid out each issue of *Bazaar* on the floor of Snow's office, with the aim of introducing a sense of cinematic movement through its pages, juxtaposing the close-up with the wide shot and placing tranquil content next to more exhilarating material. *Bazaar* became, to quote Calvin Tomkins, "a monthly run-through of popular and high culture with its own ebb and flow, cadence and rhythm," a magazine that captured the dynamic quality of 1930s modernity.

As Emily Dalziel's article about her safari in Africa attests, *Bazaar* had always covered more than fashion. Once she became editor, Snow took this further, projecting her wide-ranging interests onto every issue in a way that has led her to be described as the first "magazine editor as auteur." She conceived of the magazine precisely as a kind of "bazaar" where exotic items jostled for space, and she famously dubbed it a publication for "the well-dressed woman with the well-dressed mind." She reeled in Jean Cocteau very early; she recruited the illustrator Marcel Vertès whom she found working for Schiaparelli; she published the first fashion drawing by Salvador Dalí; and fashion photographs by Man Ray.

She was a voracious reader. There were none of *Vogue*'s restrictions on publishing fiction at *Bazaar* and, unusually for a Hearst magazine, fiction writers were paid well. With the help of Beatrice Kaufman, the wildly unpredictable George Davis (who put his head around Diana's door on her first morning), and several others, *Bazaar* became a vehicle for some outstanding twentieth-century writing. Snow poached Frances McFadden from *Vogue* to become *Bazaar*'s managing editor, and she took in other refugees from Chase's regime, including one of *Vogue*'s star photographers, George Hoyningen-Huene. The *Bazaar* office was small, housed on two floors of a former hotel at 572 Madison Avenue. It bore little resemblance to the stately premises of Condé Nast Publications, but it hummed with excitement. In the end *Bazaar* never overtook *Vogue* in terms of circulation. But, as Calvin Tomkins has observed, by 1935 *Harper's Bazaar* "seemed years—decades—younger."

CARMEL SNOW INITIALLY hired Diana because she saw her as a stylish representative of the international set; and she introduced her to *Bazaar*'s readers in January 1936 with a Munkácsi action photograph of Diana striding down a New York pavement in a Mainbocher suit and cape, topped off with a Tyrolean cap featuring four sharp feathers (and wearing the characteristic T-strap shoes that were handmade for her odd, seemingly boneless feet until the shoe designer Roger Vivier made a special pump for her years later). Snow had learned at *Vogue* that featuring the lives of chic women from the highest echelons of society was the way to draw in a wider middle-class readership. But many of the most interesting members of American high society had blended with international café society in the 1920s and 1930s, and in her view *Vogue* was failing to capture the special essence of their lives. She was determined to put this right at *Bazaar*. She had already made one attempt at evoking the spirit of the international beau monde by hiring the exceedingly fashionable and exceptionally difficult Daisy Fellowes as Paris editor in 1933, and for a while this arrangement worked surprisingly well. Fellowes's association with *Bazaar*

had the effect of putting the magazine on the Paris fashion map, and she mesmerized American fashion representatives, receiving them lying on a chaise longue in peacock blue pajamas. When she decided to wear cotton, she started a trend that earned the eternal gratitude of cotton manufacturers, whose advertising financed *Bazaar* through the worst of the Depression. But in early 1935, after many tantrums, Daisy became bored and she resigned. Snow continued to draw attention to the ideas of society women who were just a little different, commissioning a piece on clans and tartans written by Diana's friend Mrs. Robin d'Erlanger in September 1935. But she did not find a true replacement for Daisy Fellowes until she met Diana.

Once she had offered Diana a job, however, Snow had to solve the problem of what to do with her. It was clear that Diana—who preferred to be called "Diane" by her new colleagues—was extremely stylishly dressed, that she was fascinated by everything new and interesting, and that she had a way of expressing herself that was all her own. "Diane converses *naturally* (according to her nature), sometimes in poetry, sometimes in startlingly original slang, sometimes in pithy comments that sound like the Sphinx she somewhat resembles," wrote Snow. But in 1936 what interested her most were Diana's exhilarating observations on the art of living as practiced by international high society; and in the earliest days of Diana's association with *Bazaar,* at least one member of the magazine's staff remembered that Snow simply took down exactly what Diana said and edited it. "She used to come in once a week to talk and the whole thing was that she just gave Mrs. Snow a stream of consciousness," said Mildred Morton Gilbert, one of her new colleagues. By the time Diana was given her own office, however, Snow had worked out what Mrs. Vreeland ought to do. As editor of *Bazaar* she was extremely good at coming up with bright ideas for articles that connected the middle-class reader to women of high society in a very direct way. In a feature called "I'd Be Lost Without . . . ," for example, Mrs. William Averell Harriman reported that she'd be lost without her old white raincoat in Bermuda, Mrs.

William Deering Howe thought she'd be lost without her traveling radio in a pigskin case, and Mrs. Harrison Williams was sure she'd be distraught without one enormous Mexican straw hat in Palm Beach. Snow now hit on an idea for a column in a similar vein for Diana: a list of suggestions for fashionable living that drew on Diana's six and half years in Europe and her experience of life as it was lived by the international elite. Called "Why Don't You?" it caused a greater commotion than any list like it, before or since.

"I didn't know then what I was going to do when I got to New York. But I knew how to do what I did when I did it because of what I'd learned in Europe. It was a brief period of luxury that gave me my *whole career*," said Diana. Her first "Why Don't You?" column appeared in *Bazaar* in March 1936. It opened with "Why don't you zip yourself into your evening dresses?" for the zipper had only just been introduced to the couture by Elsa Schiaparelli. In the very next line Diana submitted that the reader of *Bazaar* should "waft a big bouquet about like a fairy wand." After that there was no stopping her. Many of her columns naturally revolved around the presentation of the self. "Why Don't You sweep into the drawing-room on your first big night with an enormous red-fox muff with many skins?" Diana inquired. "Nothing is smarter with your shooting tweeds than linen gaiters," she opined, unless it was donning "Suzanne Talbot's black crepe glove embroidered in gold, like the hand that bore a falcon." She had many suggestions for refreshing a tired old outfit: "Why Don't You have the sleeves of your mink made square and bulky and cut off six inches above the wrist? Then pull on big hand-sewn chamois gloves to keep you warm."

Spearing one's tweeds with a Scotch kilt pin of mauve, green, and pink stones was one possibility. Wearing a blue sapphire thistle in one ear and a ruby thistle in the other was another. "Why Don't You order Schiaparelli's cellophane belt with your name and telephone number on it?" Diana asked, though quite why one should want to do such a thing was never explained. Some of Diana's fashion ideas were borrowed from Hollywood: "Try the

effect of diamond roses and ribbons flat on top of your head, as
Garbo wears them when she says good-bye to Armand in their
country retreat," she advised. But many sartorial suggestions drew
directly on Mrs. Vreeland's grand social life in Europe and all her
new friends there. "Why Don't You wear, like the Duchess of Kent,
three enormous diamond stars arranged in your hair in front?" she
wondered. If that did not appeal, one could copy Elsie de Wolfe.
"Try Lady Mendl's thick black leather bracelets, which she wears
just above the elbow with a huge diamond bracelet at the wrist."

Diana did not, of course, confine herself to clothes. "Why Don't
You have your bed made in China—the most beautiful bed imag-
inable, the head board and spread of yellow satin embroidered in
butterflies?" If China was unrealistic, there were solutions nearer
home. "Why Don't You bring back from Central Europe a huge
white Baroque porcelain stove to stand in your front hall, re-
flected in the parquet?" she proffered. The authorial voice of the
column could at times be rather strict: "Why Don't You reconsider
the hopelessness of a room without a mantel, and put in a fake
fireplace draped in flowered chintz and holding an urn of carna-
tions?" If none of this appealed one could have a room done in ev-
ery shade of green. "This will take months, years, to collect, but it
will be delightful—a mélange of plants, green glass, green porce-
lains, and furniture covered in sad greens, gay greens, clear, faded
and poison greens." There was some shameless name-dropping.
"Study closely the perfection of taste and amazing variety in the
paneled boudoir of the Vicomtesse Charles de Noailles—buttoned
brown satin, straw baskets and fruit, a Cranach, an engraving of
Byron, a straw hat and exquisite objets d'art." It was clear that
Mrs. Vreeland was *au fait* with the ways of artists: "Why Don't
You embroider enormous red lobsters on a pure heavy white silk
tablecloth and mark it with a bright blue monogram? (Sacha Gui-
try has ordered one like this for his summer house)." She was
quite a scholar too: "Put on a long lacquer table in your dressing
room large leather boxes such as Voltaire might have used for pa-
pers—of tan leather etched in gold, lined in pink quilted taffeta

and sachet and locking with a little bronze lock and key to keep your gloves, lingerie and artificial flowers within."

Once the column was up and running, no part of the household was safe from Diana. Given the attention she paid to her own sons' outfits, it was not surprising that making children suitably decorative was a particular interest. "Why Don't You rinse your blond child's hair in dead champagne to keep its gold, as they do in France?" caused a certain amount of adult fuss, though from the point of view of the children, being made to look like little Tyrolean cowherds in high white-knitted Tyrolean socks was probably worse. And if Nanny thought she was going to avoid Mrs. Vreeland's critical gaze, she was wrong. "Why Don't You keep your nurse out of any uniform or veil in the park? The best English nannies wear gray flannel suits, white shirtwaists, black boots and white cotton gloves." There was no escape for the dog either. "Put all your dogs in bright yellow collars and leads like all the dogs in Paris," Diana advised. Indeed "Why Don't You?" addressed the fashionable life from almost every angle. It dealt with the giving of presents: "Why Don't You give to the wife of your favorite band leader an entire jazz band made of tiny bancette diamonds and cabochon emeralds in the form of a bracelet from Marcus?" It considered stylish smoking: "Why Don't You have your cigarettes stamped with a personal insignia, as a well-known explorer did with this penguin?" It touched on gardening: "Why Don't You start a topiary garden of box or yew and clip the bushes into peacocks and poodles?" And it certainly did not ignore Christmas: "Why Don't You ask for a Skye terrier?"

"They were all very tried and true ideas," Diana said later, apropos of an elk-hide trunk for the back of one's car. "We had a trunk like that on the back of our Bugatti." In 1936 she kept a notebook in which she jotted down ideas that then resurfaced in the column. "Millicent's ski coat . . . pink gold cuff links . . . wonderfull [sic] ski-coat like Italian truck drivers" became "For a coat to put on after ski-ing get yourself an Italian driver's coat, of red-orange lined in dark green." A scribbled note on "little

boys purple tweed" emerged as "Remember that little black-eyed boys look divine in bright purple tweed coats and velvet collars," though it was perhaps for the best that a note to herself to "get that bandaged look" never saw the light of day. The notebook suggests that Diana was taking in ideas from everywhere. "Why Don't You?" appeared against the background of a surge of interest in surrealism in New York in late 1936, stimulated by a major surrealist exhibition at the Museum of Art. Diana joined in by putting earrings on the furniture: "Why Don't You give a new note to your sitting-room by introducing a Victorian chair upholstered by Jansen in bright emerald green cotton, buttoned in white with little white chenille earrings on either side?"

In late 1936 and 1937, when the column appeared most frequently, the United States was still recovering from the Wall Street crash and was teetering on the brink of another sharp recession. "Why Don't You?" was not, of course, impervious to the concept of thrift: "Why Don't You use a gigantic shell instead of a bucket to ice your champagne?" it suggested helpfully. Nonetheless, the idea that readers would enjoy being invited to install "a private staircase from your bedroom to the library with a needlework carpet with notes of music worked on each step—the whole spelling out your favorite tune" was counterintuitive. From the outset, however, "Why Don't You?" was a runaway success. Even Hearst was delighted. "I never met the old boy," said Diana. "But once, when I'd just started writing 'Why Don't You?' for *Harper's Bazaar,* he sent me a note in his own hand: 'Dear Miss Vreeland, It is always a pleasure to read your columns. I reread them all the time. I am a particular admirer of yours.' I was so touched. Don't you love the 'Miss'?" The column was brilliantly served by Brodovitch's layouts, and Cecil Beaton had his own explanation for its popularity. "It can be seen that Mrs. Vreeland's column was directed towards an imaginary upper-income bracket in a magazine whose circulation was largely due to the average American woman. The psychology of this, however, was shrewd and appropriate. At the height of a depression, to list such things as fanciful as porcelain stoves brought

back from Europe or beds from China gave the reader a feeling that a sentiment *de luxe* (and hence the perverse, the capricious) was still operating."

Pace Beaton, *Bazaar*'s readers were sufficiently intelligent to realize they were not expected actually to implement Mrs. Vreeland's more grandiose plans. An obvious reason for the column's success was that it made the readers of *Bazaar* laugh. The yawning gap between its flights of fancy and everyday middle-class life was hilarious. Part of its appeal also lay in its chummy tone, as if one were being addressed by a rather grand and eccentric friend who was sure that you knew "Syrie" and "Lady Mendl" as well as she did, that you would be no more troubled by sweeping into Hermès for an elk-hide trunk than would Mrs. Harrison Williams, and that you were so slim, so busy, and so frequently at the dressmaker's that it made sense to "call up John Powers, the model agency, for a professional model" as a stand-in at $7.50 an hour. But the column also had a more subtle appeal. Descriptions of "Why Don't You?" have become so overwhelmed by dead champagne, porcelain stoves, and beds from China that it is easy to overlook the fact that Diana regularly included suggestions that cost next to nothing. Winkling them out was part of the column's charm to its readers. "Use eggplants complete with their green stalks in a bright yellow room. The effect is very Chinese and delicious," was one suggestion in this vein. "Knit a little skullcap," was another. "Why Don't You realize that everyone really hankers for a toothpick after a good meal, so have blatantly on your table quill toothpicks as you would have cigarettes?" was remarkably down-to-earth. So was "Whitewash a pair of old linen-closet steps and use on a porch with finger-bowls and jars full of flowers or as a child's bedside table for lamp, books and pencils."

Less happily the column had one serious collision with politics. "Why Don't You wear bare knees and long white knitted socks as Unity Mitford does when she takes tea with Hitler at the Carlton in Munich?" was held against Diana for decades afterward. It was a shocking lapse of judgment by someone who judged the world too much in terms of style and was as deaf to the dangers of fascism in

1936 as she had been in 1934 on the Night of the Long Knives. How-
ever, nothing appeared in *Bazaar* without Snow's express approval,
and she would have excised this particular "Why Don't You?" if she
had thought it noxious. Snow's liberal record at the time is other-
wise good—she was fêted for publishing a photograph of the con-
tralto Marian Anderson in the teeth of Hearst's racist objections
as early as 1937. But in 1936 she was less sure-footed about fascism.
Like Diana, and in common with many others in society, she was
temporarily blinded by its glamour, permitting *Bazaar* to flirt with
the idea of fascist chic in 1936 in a piece about "politically minded
scarves" on sale in Henri Bendel in New York. The scarves were de-
signed around Mussolini's signature; and in the same article there
was a photograph of the star tenor Nino Martini, lifting "his ad-
mired and passionately Fascist face above a white silk variation of
the same scarf." But Snow seems to have realized that her intense
and unending quest for the new had tripped her up, and that this
was fraught territory: political fashion and Unity Mitford as style
icon disappeared at the end of 1936 and did not appear again.

Even without fascism, "Why Don't You?" was all too much for
The New Yorker. The first parody appeared in February 1937, when
writer Bett Hooper suggested that *Bazaar* combine the column
with a rather startling article on how to look good with one's arm
in a sling in a feature called "Fall Clothes": "Why don't you give
the first maid a black eye every morning before grapefruit? The
time it takes for the bruise to spread is negligible, and the effect is
startling against dull-gold breakfast-room drapes." Just over a year
later Diana was paid the compliment of a brilliant lampoon by the
great New Yorker humorist S. J. Perelman, who fell upon the col-
umn with the air of a starving man at a banquet:

> The first time I noticed this "Why Don't You" department was a
> year ago last August while hungrily devouring news of the midsum-
> mer Paris openings. Without any preamble came the stinging query
> "Why don't you rinse your blond child's hair in dead champagne, as
> they do in France? Or pat her face gently with cream before she goes

to bed, as they do in England?" After a quick look into the nursery,
I decided to let my blond child go to hell in her own way, as they do
in America. . . .

Whenever I got too near a newsstand bearing a current issue of
the Bazaar *and my head started to swim, I would rush home and*
bury myself in dress patterns. And then, one inevitable day, the dam
burst. Lingering in Brentano's basement over L'Illustration *and*
Blanco y Negro, *I felt the delicious, shuddery, half-swooning sensa-*
tion of being drawn into the orbit again. On a table behind me lay a
huge stack of the very latest issue of Harper's Bazaar, *smoking hot*
from the presses. . . . "Why don't you build beside the sea, or in the
center of your garden, a white summer dining-room shaped like a
tent, draped with wooden swags, with walls of screen and Venetian
blinds, so you will be safe from bugs and drafts?" . . . "No, no!" I
screamed. "I won't! I can't! Help!"

According to Diana, Snow reacted with concern to these send-
ups, worrying that they might somehow damage her confidence.
Snow even wrote to S. J. Perelman, telling him that it was upset-
ting for such a young girl to be criticized. "Good heavens!" said Di-
ana, "I was in my thirties at the time and very flattered." By April
1938, however, she was being asked to incorporate suggestions she
disliked, such as, "Why Don't You discover a pair of cream-colored
horses to drive you to the church, as did the Hon. Mrs. Reginald
Fellowes for her daughter when she became the Comtesse de Cas-
téja?" This "Why Don't You?" may have been inspired by one of
the most stylish women in Europe, but it was the sort of costly but
prosaic idea that missed the whole point of the column. The point,
said Diana, was that "one could have fantasy . . . even if one did
not have cash." It was simply a question of being on the *qui vive*,
and cultivating the imagination. " 'Why Don't You?' wasn't *totally*
absurd to me," Diana said later. "Of course, the columns had a
certain absurdity that tickled people—just to think that anyone
would think of writing anything so absurd. But it wasn't even
writing. To me, writing—Edith Wharton, Henry James . . . *Proust,*

for God's sake . . . is a thing of beauty and *sustainment.* 'Why Don't You?' was a thing of fashion and fantasy, on the wing. . . . It wasn't writing, it was just *ideas.* It was me, *insisting* on people using their imaginations, insisting on a certain idea of luxury."

DIANA APPEARED AS fashion editor on the masthead of *Harper's Bazaar* for the first time in January 1939. She even received a small pay raise. "I am so happy to tell you that Dick Berlin [head of the Hearst magazine division] has okayed the increase of your salary to $125 per week, beginning April 15th," wrote Snow. It was all very ladylike. "I think it would be terribly nice if you would write him a little line." In fact Diana had been working on the fashion pages behind the scenes for some time. Soon after she started "Why Don't You?" the language of *Bazaar*'s fashion captions began to change: blue felt hats acquired the sad, soft blue of plasticine in kindergarten boxes, a pink faille gown became an iridescent sea-shell that shone in the firelight, and rubber diving glasses took on a spectral quality. However, the formal title of Fashion Editor marked a new departure for Diana, and a formal division of labor. Snow had always been an expert on the Paris couture, and she had no intention of relinquishing what she most enjoyed. Henceforth she would cover Paris, and Diana would take charge of American fashion.

In practice this meant covering New York fashion. Although she had grown up in New York, its fashion industry was unfamiliar territory. Diana had been brought up in the school of Parisian haute couture, where the couturier was the artist from whom all else flowed. This system had been established by Charles Frederick Worth during the Second Empire, but it drew on an older French tradition of elite artistry going back to Louis XIV. New York's fashion industry had emerged very differently. It had been aligned to rude commerce from the start. Trade in beaver pelts had brought the city into existence. Thereafter it became home to a vast garment industry on New York's Lower East Side that grew up to cater to America's fast-growing populace. In this domain the powerful

figures were the manufacturers who exploited the invention of the sewing machine and the arrival of thousands of immigrants from Europe prepared to work for very low wages. The New York clothing industry met a huge demand for cheap work clothes and garments for play, and at a range of prices. There was a place for designers in this cosmos, but they were hired by manufacturers, did their bidding, and worked anonymously in back rooms.

This picture was complicated by the desire of New York's rich to distinguish themselves from the common herd. In the years following the Civil War, fashion became a vital element of competitive display among the city's elite, whose members liked to define themselves by identification with the sophistication of European culture. When New York's plutocrats traveled to Paris in the late nineteenth century, their womenfolk distinguished themselves from their more lowly female counterparts by purchasing beautifully made clothes in luxurious fabrics from French couturiers, or having them copied by skilled dressmakers back home. In the early twentieth century, department stores on Broadway and Fifth Avenue opened up to cater to the aspirations of many more middle-class women by importing and copying Paris clothes and by making garments to order, often finishing garments with a false French label. It was no coincidence that Diana's dress for her debutante party was a copy of a design by Poiret. She may well have seen the original in *Vogue*, which occupied a pivotal place in this fashion system, reporting on Paris couture for the benefit of privileged American women.

It looked, therefore, as if Snow had decided to keep the glamorous world of Paris couture to herself while delegating the second-rate to Diana, but it was more complicated than that. By the early 1930s the market for French fashion in America had grown to such an extent that a number of dressmakers, store buyers, and manufacturers from New York had begun to travel regularly to Paris to catch new trends. However, Snow grasped that simply reporting on French fashion trends would no longer be enough. To stay ahead *Bazaar* had to be proactive. It had to work with the New York fashion

industry, and encourage the manufacturers whose advertisements
were the lifeblood of the magazine to raise their own standards so
that their clothes were sufficiently attractive to be photographed
for *Bazaar*. This needed someone to whom American manufactur-
ers would listen. It needed someone steeped in Paris style; someone
with daring and creativity prepared to charm, poke, and prod; and
someone—like Daisy Fellowes—whose fashionable persona the
fashion industry would respect. The success of "Why Don't You?"
had the effect of positioning Diana as a worthy successor to Daisy
Fellowes. Her task now as fashion editor, as directed by Carmel
Snow, was not only to report on new trends but to catalyze change
in the American fashion industry and give it some pizzazz. Snow's
conception of the role of the American fashion editor as a creative
force—and a stylish international thorn in the flesh of Seventh
Avenue—set the tone for the rest of Diana's career.

By the time Diana entered the fray in the late 1930s, New York's
garment industry had moved uptown and to the west from the
Lower East Side, into specially designed fireproof buildings with
large lofts around Seventh Avenue, with much of the activity con-
centrated in the eight blocks between Thirty-Fourth and Forty-
Second Streets, spilling over onto Broadway. These new buildings
combined factories with showrooms and concentrated on the man-
ufacture of particular types of clothes, at particular price points.
They were only a stone's throw from the influential buyers in the
great department stores of Fifth Avenue that sold their own made-
to-order models and copies of Paris designs. It all led to a conver-
gence of frenzied fashion activity in one tiny area of midtown New
York that became known as "Seventh Avenue." "Could we take
you on a tour of the district. . . . You'd see small workrooms where
fashion is turned out as if custom-made, and huge factories where
a dress must sell at least two thousand copies to be considered suc-
cessful and power-driven machines cut thirty coats at a slash," re-
ported an article in *Bazaar* that had Diana's fingerprints all over
it. The great characters of the garment district were "merchants
with knowledge in their fingers." Often Jewish or Italian, they had

a language of their own: "A good model is known as a runner, a bad model a dog, and the dress that you are going to get engaged in, and lay away in lavender, is simply called a piece." Diana soon discovered that Seventh Avenue was an acquired taste. Though it was a world away from the couture salons of Paris, she loved it. "I was always going up rusty staircases with old newspapers lying all over the place and the most ghastly-looking characters hanging around . . . but *nothing* was frightening to me. It was *all* part of the great adventure, my métier, the scene. . . . It wasn't a letdown, even after Chanel. After all, it was my world."

Diana's chic helped her to win acceptance. "I never wore clothes from Seventh Avenue, myself, you understand. I always kept a totally European view of things. Maybe that's why I was so appreciated there. I was independent." The more inspired manufacturers learned to listen even if it did mean agreeing to tiresome alterations in order to get a piece photographed in the magazine. "She began suggesting daring and successful ideas to manufacturers," wrote Snow. "When she talked to Seventh Avenue about 'corduroi' they didn't understand at first that she meant *corduroy* (later, she always pronounced a popular synthetic Chelanazee 'because it makes me feel better about it'), but they latched onto her brilliant ideas for its use." Diana had another success when she persuaded the milliners John-Fredericks to adapt the South American *chola*, a big felt hat with a cloth attached that tied around the head. "It was found that the effect was best produced by knitwear, which had been completely out of fashion," wrote Snow. "That hat may have started the 'snood' effect that was so popular then, too." Snow and Diana were women on a mission. As well as American manufacturers, they also had the American woman in their sights. Diana was deeply shocked when she returned from Europe. "I couldn't believe what I saw," she told Christopher Hemphill. "Every woman wore diamond clips on crepe de chine dresses. And they all wore silk stockings—this was before nylons—under these hideous strappy high heels. This is in the summer—you understand—in

the *country.* It was *unbelievable.*" To make matters worse it was combined with an intolerable sloppiness. "There was one other thing I noticed right away about American women. Everyone— but *everyone*—had chipped finger nails."

At *Bazaar,* Diana revealed a capacity for hard work unsuspected by those who did not know her. "You never do anything unless you're asked, and I was asked. And I couldn't get over it. I'm so basically simple, you know. I had a job and I thought it was the best thing that could ever happen to me. I had a job and I wanted to make the most of it because every job is *made.*" She fitted with ease into the *Bazaar* team and loved the camaraderie. She was once again avid to learn. The harshness of her upbringing meant that Diana was far more resilient than many women of her background, and unusually well placed to withstand what Beaton called the "tough elegance" of the fashion world. Some criticism from her boss was inevitable as Snow set about training Diana in the craft and practice of producing a groundbreaking magazine. There was certainly a good deal to digest about the business side. It was not long before Diana's dedication to ideals of silhouette and line clashed with immutable commercial reality. "I knew so little when I started," she said. "I must have terrified them." One of her earliest brain waves was inspired by a Chanel shirt with pockets inside. If Diana could carry around her lipstick, her rouge, and her cigarettes and money in an inside pocket, so, in her view, could everyone else. American women would look much more elegant without handbags. "What do I want with a bloody old handbag that one leaves in taxis and so on? It should all go into pockets. Real pockets, like a man has, for goodness sake." On top of that— and this was a very serious matter to Diana—a heavy handbag affected the way a woman walked. She once put this to an editor who happened to be ambling about outside her office. "Well, the man ran from my office the way you run for the police! He rushed into Carmel's office and said, 'Diana's going crazy! Get hold of her.' So Carmel came down and said, 'Listen, Diana, I think you've lost

your mind. Do you realize that our income from handbag advertising is God knows how many millions a year?' "

AFTER THEY MOVED back to New York in 1935, Reed and Diana still returned to Europe frequently. Diana, of course, continued to buy her clothes in Paris: at least two Chanel suits that she later gave to the Metropolitan Museum date from this period. And they saw their friends. The "Why Don't You?" column had the effect of reinforcing Diana's position in the pantheon of 1930s women of style in international circles too. Lighthearted fashion journalism was perfectly acceptable in high society, though Diana kept quiet about the extent of her professional relationship with Seventh Avenue, which many of her acquaintance regarded as distinctly infra dig. Far from being damaged in any way by Diana's work or by their departure from Europe, the Vreelands' social life flourished. The *Tatler* described them as "one of the most popular American couples in Europe" in 1937, when they were photographed with Gilbert and Kitty Miller at Le Touquet. They were guests, with Mona Harrison Williams and many others, at a magnificent *fête champêtre* given by Cecil Beaton at Ashcombe that summer. But amid the parties and the fun, café society sensed the tension in the air, even if some of its members denied that anything was going to happen until the last possible moment.

WHEN WAR WAS declared in September 1939, Diana was in Paris with Reed. They were on their way back from a holiday with Mona Williams on Capri. Reed promptly boarded a ship back to America with friends, leaving Diana behind to get on with fittings at the couture houses. This caused a certain amount of adverse comment from their friends. " 'You mean you'd leave your *wife*,' they said—you know, that bourgeois spirit—'in a country that's at *war*?' 'Look,' he said, 'there's no point in taking Diana away from Chanel and her shoes. If she hasn't got her shoes and her clothes, there's no point in bringing her home. That's how it's always been and that's how it has to be.' " Bettina Ballard

remembered Diana beside the pool at the home of the photographer and illustrator André Durst, "packing and unpacking an enormous suitcase in her indecision about leaving." Eventually Leo d'Erlanger forced her onto one of the last passenger ships to leave France. "I'll never forget that afternoon, coming down the rue Cambon—my last afternoon in Paris for five years. I'd just had my last fitting at Chanel. I don't think I could have made it to the end of the block, I was so depressed—leaving Chanel, leaving Europe, leaving all the world of . . . of my world." She cheered up on meeting an acquaintance whose aptitude for denial was even greater than her own. In reply to "Isn't it awful about the war?" he said, "What war?" and walked on past her "like a shadow."

IN SEPTEMBER 1939 Snow's first instinct was to continue to support the Paris couture for as long as possible, but it soon became clear that this would be impossible. Life became extremely difficult for Paris designers. Some were called up for military service or, like Chanel, closed their ateliers. Foreigners such as Mainbocher headed home. After the fall of France in June 1940, trade between the United States and France broke down, and the influence of Paris over New York's fashion industry came to a standstill. To the dismay of many, there was no alternative to clothes designed and manufactured in America. But there were others who immediately saw war in Europe as a huge opportunity for American fashion. The charge was led by Dorothy Shaver, the influential vice president of Lord & Taylor since 1931. She had long argued that American design talent was underestimated and that proper attention to a handful of key American designers was overdue. Shaver felt strongly that Paris couture was not necessarily suited to the rapidly changing lives of many of her female customers, particularly after the Wall Street Crash. In a bold move she had started promoting American designers as early as 1932, putting their work—and their names—in the windows of Lord & Taylor. Under her aegis the work of Clare Potter, Vera Maxwell, and Lilly Daché came out of the wholesale back rooms of Seventh Avenue and into shop

windows on Fifth Avenue where it could be seen by the paying cus-
tomer. With the outbreak of war these designers and others found
themselves swept to the forefront of American fashion—partly of
necessity, and partly on a wave of patriotic enthusiasm. The out-
break of war gave them a chance to shine; but it also marked a
turning point for Diana, the editor at *Bazaar* who was in charge of
American fashion.

The first all-American *Harper's Bazaar* appeared on September
1, 1940, followed by another on September 15. "This is the first issue
of *Harper's Bazaar* that has ever appeared without fashions from
Paris," said the editorial on September 1. "We publish this record
of the New York autumn openings with pride in the achievements
of our American designers and with full acknowledgment of our
debt to the French. We have learned from the greatest masters of
fashion in the world: learned, and then added something of our
own. Such clothes have never been made in America before." Diana
worked flat out on both issues. "You managed the impossible—not
only completing September 1st, entirely a fashion issue—but doing
practically all of the September 15th pages," wrote Snow. Diana's
spreads in September 1940 were aristocratic in tone, featuring de-
signs from upmarket made-to-order houses, including Germaine
Monteil, Nettie Rosenstein, and Hattie Carnegie. The captions
were not short on Vreelandesque bicontinental flourishes either:
"Skirt lengths are an atom shorter than last year's. . . . By night
they just touch the Aubusson or just miss the sidewalk."

Once America entered the war in December 1941, however, Di-
ana's tone changed. The didactic cadences of "Why Don't You?"
disappeared (and so, more or less, did the column), to be replaced
by a more empathetic tone. Upper-class American women went
out to work in greater numbers than ever before. Their servants
disappeared. They needed serviceable, adaptable clothes that were
easy to care for. Everyone, including the editorial staff of *Bazaar*,
was in the same boat. Snow and Diana were united in the view
that their task was to keep up morale by helping *Bazaar*'s read-
ers look as attractive as possible in such difficult circumstances,

and they turned to American sportswear designers for help, a move unthinkable before the war. In 1940 "sportswear" meant clothes for sports like tennis and golf, so-called resort wear, and included swimwear, beach clothes, light summer separates and dresses, yachting clothes, traveling clothes, and informal clothes for town and country.

The rise of American sportswear has conventionally been seen in stark terms, as a democratic, egalitarian form of dress emerging in opposition to aristocratic French couture. In many ways this is a false distinction, since Chanel created clothes for dynamic women and both she and Patou designed for the more active parts of their clients' day. Sportswear also had a close cousin in English country tweeds. However, it was undeniably American garment manufacturers who developed sportswear in response to a demand for cheaper clothes, made to simpler designs from fabrics that were easy to look after and suitable for cutting by heavy machinery. The fashion scholar Rebecca Arnold and others have suggested that the sportswear look was a homogenizing force—an important dimension in American fashion—suitable for anyone wishing to sign up for a certain kind of elite American identity; and she also detects in its rise undertones of New England puritan simplicity and thrift. Sportswear certainly met a demand for clothing for an active life. It flattered the uncorseted female body, and because it was so adaptable it was capable of holding together many conflicting ideas about womanhood, quite often in the same woman. In 1942 the American government introduced Limitation Order L-85, restricting the amount of fabric that could be used in civilian clothes. This actually played to the simple, minimalist look of American sportswear; and both *Vogue* and *Bazaar* supported L-85 as a stimulus to sportswear design.

The particular focus of Diana's attention was a brilliant young designer called Claire McCardell. Diana met McCardell while she was working for Hattie Carnegie in 1938. Diana took in some French jersey and asked for it to be made up into a "little two piece Chanel kind of uniform," but got a one-piece McCardell instead. She liked

it so much she asked to meet the designer and became one of her most powerful supporters. Claire McCardell, who would later be considered one of America's greatest designers ever, was only two years younger than Diana, but arrived in fashion by a very different route. She studied fashion design at the Parsons School for Design in the 1920s. As a student she went to Paris where she was greatly influenced by Chanel and Vionnet, pooling resources with student friends to buy secondhand couture clothes to see how they were made. Back in New York, McCardell was taken on as a designer by Townley Frocks in the early 1930s, and for most of the decade she copied Paris designs in its back rooms, though even there her creativity and inventiveness broke through. Her first real hit (still as an unnamed designer) was the "Monastic" dress, a waistless shift cut on the bias, which appeared in the fall of 1938. Widely copied, it had the unfortunate effect of forcing Townley to close because the firm lost so much money fighting copyright suits until it was restarted in 1940 by Adolph Klein. Klein was a very different character from every other manufacturer on Seventh Avenue. He greatly admired McCardell's creativity and gave her her head, allowing her to work as a named designer. This gamble resulted in huge success for Townley, thanks in no small part to Diana.

Diana's sudden metamorphosis from 1930s woman of style to wartime fashion editor reflected rapidly changing social and economic circumstances in the United States even before Pearl Harbor. This sudden, radical change in American daily life opened Diana's eyes in the most powerful way to the symbiotic relationship between fashion and changing everyday reality. It was an insight that would stay with her for the rest of her life, and in 1942 she took action. "Please don't be modest," wrote McCardell's biographer Sally Kirkland to Diana later. "I know that without designing for her you nevertheless inspired her to do lots of things like the popover." The "Popover" was the garment that made McCardell's name, but it was conceived by Diana. Diana thought of it as a dress made in accordance with L-85 that could be worn for housework, though it evolved into an outfit in which

one could step out to the shops, or fling over work clothes at a moment's notice to look respectable. Diana and Snow approached Claire McCardell with this idea in 1942 as part of an attempt to show how L-85 could stimulate American creativity. The first Popover appeared in *Bazaar* in September 1942. Manufactured in workmanlike fabrics like denim, McCardell's version allied the ideas of Madame Vionnet with the simplicity and informality of sportswear design. This was the first time a magazine dedicated to contemporary high fashion proposed a solution to its readers in the form of a sportswear garment, and the impact was instantaneous. The Popover was mass-produced at $6.95, well below the usual price of Claire McCardell's designs. A runaway success, it was a career-defining piece for McCardell and a bestseller for Townley. It also showed what could be achieved when a businessman with vision joined forces with an outstanding designer.

Diana's next attempt to ally the aesthetic values of *Bazaar* with clothes for the wartime woman was less successful in commercial terms but was even more daring and reflected her longstanding fondness for ballet clothes. In late 1942 the designer Mildred Orrick came to see her with ideas for a "leotard"—not a ballet leotard, but a tabard dress worn over a striped sweater with leggings. Realizing that it might be too avant-garde for *Bazaar*'s readers, Diana floated the idea with a drawing in the January 1943 issue, describing it as "an old idea based on every ballet dancer's rehearsal costume." The idea appeared again in the July 1943 issue, considerably developed. By this time Diana had involved Claire McCardell, believing that Mildred Orrick did not have the expertise or the profile to launch such an idea on her own. The leotard then appeared on the cover of *Life* magazine on September 13, 1943, earning itself a send-up in *The New Yorker* along the way. In the end the notion failed because it proved too expensive for college girls, the only people slim enough to wear the leotard to advantage. Meanwhile Diana's ideas spread in other ways. She circumvented leather shortages by putting models in fabric espadrilles; and fashion editor Babs Simpson credits her with putting women in ballet slippers in wartime,

though others maintain this idea came from McCardell and the dance shoe manufacturer Capezio, and was then enthusiastically adopted by Diana in the pages of *Bazaar.*

Such questions of attribution do not seem to have been of great importance in wartime. What is striking, however, is the extent to which war turned the New York clothing industry into an all-female world. Women had played an important role before the war, though they were disproportionately clustered in its lower ranks in both manufacturing and retail. But even in 1936, when Diana first started at *Bazaar,* the New York fashion world was providing a wide range of occupations for educated, middle-class young women, particularly those looking to earn a living before they married— and increasingly before and after they had children. These women worked not only as designers but as copywriters, buyers, entrepreneurs like Cora Scovil, who made window mannequins, retailers like Dorothy Shaver, and photographers like Louise Dahl-Wolfe and Toni Frissell. "Probably about the best paid of all women's jobs are fashion jobs," said *Bazaar* in August 1939; and in 1937 the Tobé-Coburn School for Fashion Careers aimed itself squarely at educated young women with the express aim of finding them the right sort of professional work in the field of fashion.

With so many men away at war, New York fashion became dominated by a small and powerful female group. There was little thaw in relations between Edna Woolman Chase and Snow; but designers like Joset Walker, Clare Potter, and Carolyn Schnurer pooled their ideas to such an extent that even experts have trouble telling their wartime work apart. Diana proved to be a good team player in this wartime all-female world too. Besides her relationship with Snow, she worked closely with one highly progressive fashion buyer, Marjorie Griswold of Lord & Taylor, who was fast gaining a reputation as having an instinct for the best American designers, and was given great leeway by Dorothy Shaver as a result. Griswold's view of the American woman had an influence on Diana's thinking. "I rang her 7 times a day," she said, and later wrote to Griswold that "you were the person I always worked the

closest with and I was the most devoted to and respectful of." Diana was the indirect beneficiary of lectures arranged throughout the war for senior staff like Griswold by Dorothy Shaver of Lord & Taylor on the relationship between fashion and changing socioeconomic conditions; and she often had lunch with Dorothy Shaver to discuss such matters face-to-face.

Diana's greatest creative partnership of the war years, however, was with the first woman in the canon of twentieth-century photographers, Louise Dahl-Wolfe. A former art student, Dahl-Wolfe trained and worked as an interior decorator before she took up photography; and she ended up at *Bazaar* only when she discovered that Dr. Agha of *Vogue* had described her in an internal Condé Nast memo as "making a great effort to learn photography . . . but on account of her advanced age—about forty-eight—perhaps a little too late." In developing her craft, Dahl-Wolfe absorbed lessons from the leading male photographers around her: Munkácsi's images of strong, dynamic women; Huene's love of form; the glamour and imagination of Beaton's portrait photographs; and the surrealism of Huene's successor at *Vogue*, his lover and protégé Horst Paul Albert Bohrmann, known simply as Horst. "We had the best time—we were all such friends," she recalled. Dahl-Wolfe's own contribution to the development of photography was her use of color. She experimented endlessly with the new color film launched by Kodachrome in 1935, achieving the first successful fashion photographs in color in interior natural light, and taking her palette outdoors to create some of the most memorable fashion shoots of the early 1940s.

"Dahl-Wolfe freed color from convention and timidity, wedding the American ideal of natural wholeness to a European standard of elegance," writes the American photographic critic and photographer Vicki Goldberg. Dahl-Wolfe achieved this in part because, unlike Huene, she was able to work with others. As Diana said: "One was never selfish with Louise. There was an extraordinary, immediate communication of her seriousness." For her part Dahl-Wolfe greatly admired Diana. "She was the tops," Dahl-Wolfe

said. "No one knew color or could pull a sitting together like Diana." The color photographs in each issue were expensive, and were allocated to clothes by advertisers and designers whom Snow and Diana agreed were important. Snow and Brodovitch, meanwhile, deliberated on how the images should be placed in the issue. Once Diana had selected the pieces, and Snow approved, Diana and Dahl-Wolfe agreed between them what the mood of the image should be. Diana, with her theatrical streak, often had a hand in dramatizing the scene, suggesting roughly the pose of the model and the wording for the caption that was later polished by a copywriter. Dahl-Wolfe then developed the idea in her own way, actual garment or swatches on hand, designing and building the set or finding locations. She would often take a day over just one photograph, and at this point in her career Diana was on hand to style the model. They frequently worked in sweltering temperatures with no air-conditioning. "There'd be big rows between Dee-Ann and Louise on some point to do with the pictures. They'd end up, both of them, sending flowers to each other," said Babs Simpson. But the rage came from passionate commitment to the task at hand, and the relationship was one of great mutual respect.

One bane of both their lives was the garments that had to be photographed for *Bazaar* because the manufacturers were regular advertisers. Diana was heard to exclaim, "That's perfectly ghastly!" before asking the manufacturer to change a piece slightly and make it more appetizing. Particularly hopeless cases were grouped together in a feature called "Pearls of Little Price" at the back of the magazine. "Sometimes you'd get [these clothes], and just not know what to do," said Louise Dahl-Wolfe. But in these circumstances Diana proved unexpectedly calm and resourceful. "Diane always managed to make it work," she said. At the other end of the scale, some of the most outstanding work from the Dahl-Wolfe and Vreeland team took place out in the open. As the war progressed, deploying the beauty of the American landscape became a powerful way of reinforcing the identity of the clothes and the all-American talent of designers like Claire McCardell, Carolyn

Schnurer, Tina Leser, Bonnie Cashin, and others. Munkácsi had already used New York architecture as a backdrop to American design before the war, but Dahl-Wolfe took this further, using some of America's most dramatic open spaces and developing her color technique as she did so.

One of her most remarkable shoots, at which Diana was present and played a central role, took place in Arizona in 1941. At certain moments in the shoot, Dahl-Wolfe exploited the graphic sculptural qualities of the cacti in the Arizona desert. On another day she took Frank Lloyd Wright's house in Scottsdale, Taliesin West, as a backdrop—a building that itself represented a uniquely American integration of indoors and outdoors. "Dahl-Wolfe's use of colour and light to create form and texture in a photograph could produce a unifying aesthetic that provided a visual and stylistic link between city and nature," writes Rebecca Arnold. This happened at Taliesin West; and when the model Wanda Delafield fell ill, Diana stepped in herself to model "cigar-brown" Jay Thorpe slacks, a black fringed shawl, and goggle-shaped sunglasses with white rims, against the background of the house. She also stepped in as model during a shoot on a disused movie set of an old Western town, in a different kind of all-American blurring of appearance and reality.

Some of their best work together came from photographing the designs of Claire McCardell, who was a close friend of Dahl-Wolfe's. But in spite of her occasional excursions into emergency modeling, Diana was well aware that American designers projected their ideas onto an idealized version of the modern American woman—who did not look like Diana. Instead, the fashion historian Valerie Steele suggests, she was rather similar to Claire McCardell herself—youthful, long-limbed, and glowing with health—a new American body. During the war Diana became aware for the first time that the face and body of the model were just as important as the clothes in projecting the mood of the times. After Pearl Harbor, American designs in American landscapes were not enough. American fashion needed a new kind of

all-American girl to propel it forward; and in 1942 Diana found just the person she was looking for.

IN NOVEMBER 1942 a sixteen-year-old called Betty Bacall was trying to break through as an actress in New York when she met an Englishman, Timothy Brooke, who thought she would make a good photographic model. He introduced her to Baron Nicolas de Gunzburg, who was working with Diana at *Bazaar* and who took Bacall to meet her. Bacall thought Diana looked quite extraordinary, remembering that she was covered in bits of jewelry and scarves, was extremely thin, and was clad from head to toe in black. Her manner was very direct. Before Bacall knew what was happening Diana put her hand under her chin and turned her face left and right. When this terrifying inspection was over, Diana told Betty that she wanted Louise Dahl-Wolfe to see her. "I was scared to death. The efficiency and matter-of-factness of the whole magazine operation and particularly of Mrs. Vreeland were intimidating," said Bacall. The next day Betty presented herself at the photographic studio, where Diana met her and Dahl-Wolfe took a few snaps. After this sitting Diana called back and asked her to come in and pose formally. "Mrs. Wolfe was there—and Mrs. Vreeland. She put a suit on me, told me which make-up to use— but very little. 'Betty, I don't want to change your look.' (Whatever *that* was.) When all was done she put a scarf round my neck— knew just how to tie it, a little off-center—and I was ready for my first sitting for *Harper's Bazaar*." Diana was there throughout the sitting, making constant adjustments to Bacall's hair and clothes.

Shortly afterward Diana asked Bacall to join a two-week shoot of summer clothes with Louise Dahl-Wolfe and her husband in St. Augustine, Florida. The shoot went without a hitch. "I remember going into Diana Vreeland's room one evening as she was sitting in her one-piece undergarment—not a girdle, it was all easy, like thin knitted cotton or wool. . . . We talked of how the work was going. I talked more of my ambitions, my dreams." The problems started when the *Bazaar* team tried to get back to New

York. By this time it was pouring with rain and the town was full
of young servicemen desperate to get home for Christmas. The
staff of a fashion magazine was not a transportation priority. But
Diana had promised Betty's mother she would bring her home
safely, and she was also thoroughly fed up. "We were staying in a
ninth-rate hotel," said Diana. "Every day it poured rain . . . but I
mean it poured *buckets*. And every day I walked to the train sta-
tion in the rain, trying to get us tickets to go home to New York.
You couldn't *move*, you understand—it was *Wartime*. I've never
been on a Pacific Island at war but I've been in St. Augustine
and it was the most ghastly town." In the end Diana lied her
head off, telling everyone that Betty was her pregnant daughter,
that she was liable to miscarry, and so had to return to New York
urgently. "Talk of acting—what a character!" said Bacall. "She
got the tickets. . . . That's why she flourished. Talent—her gift of
creativity—is not enough—determination, perseverance, resolu-
tion, that's what makes the difference." All went well until Betty
insisted on going to hear the comedy performer Martha Raye
entertaining the servicemen in the club car. Filled with trepida-
tion that her lie would be discovered and they would all be put
off the train, Diana went, too, finally persuading the "pregnant"
one that she had to go to bed at two o'clock in the morning.

The first St. Augustine picture appeared in January 1943. In
March, Betty Bacall appeared on the cover of *Bazaar* and Hol-
lywood came calling. Alerted by his wife, the director Howard
Hawks took note, Betty went for her first screen test and followed
advice to change her first name to Lauren. Diana said later: "Bet-
ty's always been what used to be called a 'good kid.' It's rather a
period phrase but it's the way I always think of her. I didn't think
about her—I loved her. She was my special friend. She's always
kept her own thoughts and her own dreams. . . . She literally had
nothing to offer but her *existence*. But I was so *interested* in her."
After the war, when Bacall was married to Humphrey Bogart, Di-
ana went to see her in Hollywood. She approached unobserved as
Bacall gave instructions to a gardener about laying out a flower

garden beside a swimming pool: "This is the little girl from 22nd Street and *Second Avenue*. She was taking dried flowers out of a little envelope and her eyes were filled with stars. I've never seen anyone so happy, so adorable, and so in love. It was a dream come true . . . these things are so touching. You see them so rarely, so *rarely* . . . but they stay with you always."

It has been suggested that the Second World War was the greatest period in Diana's fashion career. "She was in her glory," Babs Simpson said. "Dee-Ann was a *major* force then." It was indisputably a time of great success. Under Snow's watchful but delighted editorial eye, Diana learned her way around Seventh Avenue, fought to raise standards, created fashion as well as reported it, and pushed back the boundaries of fashion photography with Louise Dahl-Wolfe. She learned about typography and layout from Brodovitch. She understood the power of the model for the first time and discovered Lauren Bacall; and she learned a vital lesson about the extent of fashion's power to transform itself in the face of social change.

Within the tight, small world of New York fashion, Diana's reputation spread; and in 1941 she was parodied again, although this time it was onstage rather than in the pages of the *The New Yorker*. Episodes from life at *Bazaar* in general and Diana's bons mots in particular were collected by one of its fiction editors, Beatrice Kaufman, who related them with glee to her husband, the writer and theater director George S. Kaufman, and his frequent collaborator Moss Hart. The upshot was that stories about *Bazaar* made their way into *Lady in the Dark* by Moss Hart, set to music by Kurt Weill, with lyrics by Ira Gershwin.

Lady in the Dark went through many changes after it first opened on Broadway in 1941. Set in the offices of a fashion magazine called *Allure*, the earliest version opens with *Allure*'s editor Liza Elliott (played by Gertrude Lawrence) suffering from panic attacks and finding it hard to make decisions. Against her better judgment she agrees to see a psychoanalyst who addresses her complex love life. He focuses on tension between Liza and Charley, the

advertising manager who wants her job and accuses her of being "married to her desk" and "having magazines instead of babies." Diana was the model for Alison Du Bois, *Allure*'s eccentric fashion columnist. Ideas tumble out of Alison Du Bois. The Easter issue should lay an egg; a Bonwit-Teller dummy, male, should fall in love with a Saks dummy, female, and pursue their love affair in the store windows. "Saks is *so* conservative," declares Alison. "I think they sometimes mix themselves up with St. Patrick's, they've been next door so long." Intriguingly, there are moments when Liza Elliott's unhappiness is explained by a childhood exactly like Diana's. It transpires that Liza Elliott's beautiful mother was cruel to her about her ugliness. "I ran to the nursery and looked in the mirror. I felt ugly and ashamed," says Liza to the psychoanalyst. Liza remarks that she found it impossible to grieve when her mother died. In fact it was liberating because the taunts about the gap between what she was and what she longed to be finally stopped. *Lady in the Dark* closes with Liza agreeing happily to share her job with Charley, an ending that is only marginally less irritating if allowances are made for male anxiety in 1941 about the dominance of women in New York fashion in wartime.

IN 1942 AN article called "No Place Like Home" appeared in the October issue of *Bazaar*. The Vreelands featured in it incognito as a united family enjoying simple pleasures at a difficult time for the country, a picture of family unity that was only a partial version of the truth. By September 1939, both Tim and Freck were boarders at Groton School in Massachusetts, returning home for occasional weekends and school holidays. Reed was hardly at home at all. Soon after the outbreak of war he finally parted company with the Guaranty Trust and took up a new job running part of the d'Erlanger financial empire in Montreal. In the summer of 1940, a new arrival joined the family to compensate, when Diana's niece Emi-Lu Kinloch, the twelve-year-old daughter of her sister, Alexandra, was evacuated from Britain. Diana later claimed that she "adopted" Emi-Lu and "brought her up" during the war years.

But although Emi-Lu called Diana "Mom," she spent the week with her grandfather and Kay Carroll during term time, following her mother, her aunt, and her grandmother to Brearley. On weekends and holidays, she was sent to stay with Aunt Diana. This arrangement had the effect of reigniting the old antipathy between Diana and Kay Carroll, who was wont to say "You're going to your *Aunt Diana* this weekend," in tones of such loathing that it affected Emi-Lu's feelings about her aunt.

Diana's reaction to Emi-Lu's arrival suggests that the traumas of her childhood had by no means played themselves out, even though she was now in her thirties. There is no doubt that Diana minded very much how her substitute daughter looked. She was having lunch with Dorothy Shaver when Reed met Emi-Lu from the boat and telephoned to say she had arrived. By her own account Diana's first question to Reed was "Is she good looking?" Reed was able to reassure Diana that Emi-Lu was very good looking. "Well, she wasn't good looking, she was *divine* looking," said Diana later. "She was the most beautiful thing you ever saw. I'd be so *proud* when I'd walk down the street with her."

With Emi-Lu cared for by Frederick Dalziel and Kay Carroll during the week, Diana continued working at *Bazaar* throughout the war. This could potentially have been the source of some tension with her father, for Frederick Dalziel disapproved of Diana's job, not because he disliked the idea of women working but because he loathed everything to do with Hearst, whose newspapers had caused the Dalziel family so much misery during the Ross scandal. But, as ever, Frederick Dalziel dealt with unhappiness by refusing to mention it. "After I went to work, he never asked me how I was getting along, or how much money I was making, or whether they treated me well . . . the subject was never referred to—*ever*—because of his disapproval," said Diana. Frederick Dalziel was seventy-four when war broke out. He lived quietly on a small income until 1960 and died aged ninety-two, so it was a long silence. In the meantime he continued to do a little work at Post & Flagg and changed lady friends approximately every six months.

(Occasionally Emi-Lu would surprise him and his latest inamorata canoodling on the sofa.)

Regardless of Frederick Dalziel's feelings on the subject, it was essential that Diana keep her job at *Bazaar* throughout the war because the Vreelands were very short of money. In 1941 Reed was obliged to write to the headmaster of Groton requesting scholarships for both his sons, citing the difficulties of getting cash out of Canada, and extra freight from Britain in the form of Emi-Lu. Reed and Diana had also taken on an additional financial commitment. They bought Turk Hill, in Brewster, New York, in June 1940, keeping a visitor's book from June 1941. An enchanting house, where every internal door was painted a different color, it formed the background to several *Bazaar* shoots and led to one last "Why Don't You?" on the joys of country living before the column finally stopped for good. "Everything is this color around here," scrawled one of the Hearsts in red crayon in the visitors' book. Diana was given a helping hand in its decoration by Baroness Catherine d'Erlanger, who had left England at the outbreak of war and created for her a fantastic fireplace with shells. "While it looked nothing more than a remodeled farm on the outside, the interior was painted magenta and the walls, two ceilings high, were lined with 10,000 books," wrote Phyllis Lee Levin. "Buckets stowed with hanks of beautifully colored wools were composed as carefully as though they were flower arrangements and, as with flower arrangements, guests were not supposed to touch them."

Friends and colleagues streamed through the Brewster house in the early part of the war. They were often friends escaping from Europe. The jewelry designer Johnny [Jean] Schlumberger came to recover after Dunkirk. Edwina d'Erlanger was a frequent visitor, as was Kitty Miller. Elsie Mendl appeared with Diana's cousin Pauline Potter, who would later become Pauline de Rothschild. Isabel Kemp, who had been a childhood friend of Diana's and one of her bridesmaids, was another regular guest: she may have reappeared at this point in Diana's life because she had a close relationship with Pauline Potter. Syrie Maugham came to stay. So

did the fashion editor Nicolas de Gunzburg and the journalist Janet Flanner; and Virginia Cowles scribbled in the visitors' book that she had decided to move in for good. Colleagues from *Bazaar*, including George Davis, George Hoyningen-Huene, and Frances McFadden, all signed the visitors' book. Elsa Schiaparelli's sense of humor failed her when Emi-Lu, for reasons best known to her twelve-year-old self, referred to her as "the Great French Cleaner" during a parlor game.

Later Emi-Lu wrote to Diana: "I *did* love it so much there—*everything* about it—the flowers—your wonderful bedroom and the divine living room with Timmy and Frecky playing their records. The gorgeous food I never appreciated." There was, of course, the occasional squall: "Frecky slapping my face for saying you were too swanky—me writing Grandpa—he saying it was dreadful and doing nothing." And she certainly found tiptoeing around her intimidating aunt's sleep schedule at Brewster a little tiresome. "You—who were very nice—but terrifying—you know the *thing* one always had to be quiet in the morning for." Looking back Emi-Lu realized she might not have been so very easy herself: "Gosh I thought I was badly treated and how you spoilt me!! Brewster always was divine. In fact I teenaged through it—which always is—Hell but heaven!"

THE WAR YEARS were often much closer to hell than heaven for Diana. Like thousands of other mothers, she had to see a son off to war when Tim graduated from Groton in 1943. He was utterly astonished when she burst into tears as she waved him good-bye. He was rather excited about taking such a step into the unknown, and was taken aback by her reaction. Feeling like a grown man, he had no idea how young he looked to his mother. Tim did not reach Europe until the fighting was over, and Freck only joined the merchant marine in 1945, but Diana could not foresee that in 1943. "You don't know what it was for a mother to see her sons off," she said. "The only thing that made it possible was that you weren't alone. Every person you'd pass on the street was in the same boat."

But there was another reason why the war years were difficult, in spite of all Diana's professional success. "During the War years, during the soi-disant best years of my life—the soi-disant best years of my life, *not* the best years of my life—I spent them *entirely alone* working," said Diana to Christopher Hemphill. On her own in New York, she sensed a degree of prejudice. "I knew that I wasn't very important. I wasn't really what they were looking for at that important spot at the table." Moreover, the men who were left behind were distinctly second rate. "They had no exaltation," said Diana, "or they wouldn't have been around town."

But the real reason for her misery was Reed. When he first started running the Moorgate Agency for the d'Erlangers in Montreal in 1939, Reed returned to New York every month, but early in 1940 this pattern changed. His return visits became fewer and fewer, though he was in New York to meet Emi-Lu off the ship from England in 1940, and he reappeared each Christmas.

Work was not the reason for these long absences. Reed was having a very serious affair with an unnamed married woman with children of her own. By all accounts Diana never spoke of this to anyone. ("Are some things better left undiscussed? Can a duck swim?") Indeed she rarely discussed his absence at all, other than to say he was in Montreal and working for British interests. If the Vreelands were invited somewhere together, she would refuse on his behalf as if his absence were temporary. But she knew at the time that Reed was in love with someone else, and for much of the war the survival of their marriage was in doubt. Later she was a little more forthcoming about the toll this took on her. "He was there for seven years. We were married for 43 years and this is only seven of them but it was a very vivid period in my life. For seven years, I was by myself, by myself." Even Emi-Lu, who was little more than a child, could sense how much her coiffed and lacquered aunt Diana loved her uncle Reed. Emi-Lu thought it was Diana's saving grace, the one great thing about her. "She really, really knew how to love." Yet even this was unable to hold Reed. It is perhaps not surprising that as the war progressed, the women

dramatized by Diana in collaboration with Louise Dahl-Wolfe metamorphosed from romantic figures staring at themselves in rococo mirrors to industrious women who were always alone, enigmatic, often gazing into the middle distance in some kind of private reverie, probably thinking of an absent man—a mood that captured the feelings of thousands of *Bazaar*'s readers in wartime and contributed to its success.

In the end it was energy and dreaming and making surfaces beautiful that got Diana through:

One morning, I said "Betty, I'll tell you what I do whenever I'm depressed: I clean my shoes and out of that energy comes a gleam of survival."

I cleaned my shoes every morning to keep my mind off....
 Listen, the great thing was to get out *of St. Augustine.*

NEW LOOK

In spite of their encouragement of American designers in wartime, Carmel Snow and Diana continued to regard French couture as the wellspring of all fashion inspiration, and no amount of American inventiveness could persuade them otherwise. As soon as Paris was liberated in August 1944, Snow made her way to France to discover whether the couture had survived. She discovered that it had, but at a price. The dressmakers of Paris had resorted to every kind of behavior from breathtaking courage to frank collaboration in order to pull through. "I've never taken any side in anything that went on in Paris during the war . . . because I was not there. I didn't have hungry children," said Diana. But news that the couture had actually thrived by purveying rounder, fuller shapes to rich women went down badly in Allied countries, where fabric and clothes were severely rationed and volunteers were still sending clothing parcels to the poorer parts of France. In New York, American designers objected fiercely to the possible return of Paris influence, maintaining that American taste and technique had so improved during the war that U.S. manufacturers were producing better-quality garments than the French, and for a fraction of the price. For a time, continued L-85 restrictions, distaste for what was seen as collaborationism on the part of French designers, and a feeling that it was unpatriotic to wear extravagant clothes meant that the return of the Paris couture to its former dominant position hung in the balance.

This cut no ice with Snow. "I was no more willing to concede the permanent fall of Paris than was General de Gaulle," she said.

She was helped by a change of mood that gripped America as soon as the war ended. By late 1945 women were yearning for something different from the straight, boxy, L-85 fashions associated with the trauma of war—and so were their menfolk. "Why brilliant fashion-designers, a notoriously non-analytic breed, sometimes succeed in anticipating the shape of things to come better than professional predictors, is one of the most obscure questions in history," writes the British historian Eric Hobsbawm. In this instance, however, the answer was quite straightforward: "Men want women beautiful, romantic . . . birds of paradise instead of hurrying brown hens," said *Bazaar* in October 1945. As families were reestablished, there was a move toward a celebratory fashion of fecundity, with closer-fitting waists and rounder hips. Rebecca Arnold notes that this response to peace was as prevalent in the United States as it was in Paris. U.S. sportswear designers, led by Claire McCardell, also began to move in the direction of a different, more curvaceous silhouette between 1945 and 1947, developing an idea introduced by Mainbocher just before the outbreak of war.

It was the new French couturier Christian Dior who successfully captured the change of mood. Snow identified Dior as a rising star as early as 1946. A few months later he was backed by the textile magnate Marcel Boussac in a self-consciously patriotic campaign to restore French design to its prewar ascendancy. A nervous Dior was urged to proceed on behalf of France by his friend, the artist-designer Christian Bérard: "There is no other way," said Bérard. "You must be Joan of Arc." Excitement about Dior's first collection in February 1947 built up for weeks, much of it stoked by Bérard. It was made known that the designer would be taking fashion in an extraordinary new direction. Tickets for the opening sold on the black market and a huge crowd assembled outside beforehand. Dior left his most dramatic new idea until the end of a highly theatrical show. This was the "Corolle" line, crystallized in "le Bar": a huge, full, deeply pleated black wool skirt that dropped to midcalf, with a light-colored silk shantung jacket closely fitted to the bust. The jacket was padded below the waist, emphasizing

curvaceous hips and a tiny waist, and the outfit was designed to be accessorized with high heels, a broad-brimmed hat, white gloves, and a small clutch purse. Some of the skirts in the Corolle line measured as much as forty yards in circumference, their hemlines just twelve inches off the ground. The craftsmanship was exquisite, the extravagance astounding. The applause started almost as soon as the show began, and grew louder and louder. Dior burst into tears. Carmel Snow remarked, "It's quite a revolution, dear Christian. Your dresses have such a new look," producing the catchphrase that encapsulated the whole phenomenon.

In the New York office of *Harper's Bazaar,* anticipation mounted. Babs Simpson was a junior fashion editor at *Bazaar* in 1947. "I remember *everybody* being so excited. These telegrams would come in, these cables from Paris . . . the new look . . . changed everything, and she [Carmel Snow] sort of stopped the press kind of thing. It was very exciting." The office waited breathlessly for Snow's return since no one there had yet seen Dior's New Look at close range. She walked in wearing it. As ever, Diana found the words. "Carmel, it's divine!" she cried. "It makes you look—*drowned.*" The New Look started an international fashion craze. Foreign buyers who had returned home before Dior's show, believing it to be an irrelevance, found they had ordered outdated models. Furious manufacturers were left with unwanted stock. And politicians beyond France fulminated in vain at the extravagant new French fashion in a time of postwar austerity. American designers like Claire McCardell, who had already sensed the change of mood, found themselves in demand. Nonetheless the old Paris magic worked against them. With the New Look, Dior successfully reasserted the supremacy of Paris couture. "Dior saved Paris as Paris was saved in the Battle of the Marne," said Carmel Snow.

Diana's reaction to Dior's success was more ambivalent. She was thrilled by the survival of Frenchness and delighted that French craftsmanship, romance, drama, and artistry were making a comeback. But while she admired Dior's talent she did not care for the New Look. "I always call it the guinea hen–look," she said

to Lally Weymouth later. Women of real chic looked marvelous in it, she thought, and the clothes by Dior were extravagant and beautiful. But unlike Chanel, who cut her models on live women, Dior designed his collections on stuffed dummies. However slim Diana was, she had a wide diaphragm, and the nipped-in waist did not suit her. Apart from the occasional strapless evening dress, she never wore the New Look herself, objecting to a fashion that required the wearer to don tight corsets, skirts that were heavy to the point of immobilization, and to totter around on very high heels that she thought damaged female posture. "Oh I couldn't stand [the clothes] for myself—because I think all that wiring and what you call trussing. . . . You wore the cinch—you wore the Merry Widow—do you understand?" However, the mood in its favor was so strong that no mere editor could challenge it.

There were other aspects of the reemerging French couture that concerned Diana. As soon as she returned to Paris in 1946 she could see that the couture was changing in order to stay in existence, but not all the change was welcome. The society that had made the prewar couture possible, in which powerful female tastemakers had a close collaborative relationship with the couturier, had virtually disappeared. There was certainly no more *mannequin du monde*. "The first thing I asked after the war was: 'Does it still exist—as an expression?' I wasn't hinting around. 'Absolutely not!' I was told, 'It's as dead as mud.' " Paris couture was rapidly becoming much more expensive. Designers needed very rich customers who could pay for the privilege, and that meant that most American women could only afford second-rate copies from American manufacturers who paid a license fee to copy the originals. This, in Diana's view, meant inferior clothes. She wrote to Louise Dahl-Wolfe a few years later that it was all "awfully sad":

> *Of course I look at all of these clothes of how* [sic] *they look when reproduced on Seventh Avenue as those are the only versions of these clothes we will ever see, and in the long run the only way they really ever count as so few woman* [sic] *in the world will ever*

*be seen in originals that it is rather heartbreaking. It is a crime
that Paris prices are so high making it impossible therefore for
people to buy from them privately. . . . You may think I am on a
minor note but it is something I feel so keenly and I think that the
"masses" are being given really such vulgar clothes because any
copy of a great thing is bound to look second rate unless it is espe-
cially designed to be watered down.*

The return of the Paris couture also meant the return of Carmel
Snow to fashion's front line. The prewar division of labor at *Ba-
zaar* was firmly reinstated. As editor in chief, Carmel Snow would
continue going to the Paris collections. As fashion editor, Diana
would focus entirely on the American market. At the same time
the emphasis *Bazaar* had placed on the reader's independence of
choice, and her freedom to stride around in low heels, faded away.
The "thrown-together" reader of *Bazaar,* who had forced manu-
facturers to adapt as she borrowed her brother's topcoat, rolled up
her dungarees, and ran around in moccasins and espadrilles, "the
girl who knows what she wants, when she wants it, the dead-set,
dead-right American girl" of *Bazaar* in August 1944, simply disap-
peared. Within three years it was back to command-and-control
fashion again. "You Can't Be A Last-Year Girl" a *Bazaar* edito-
rial announced when the New Look appeared in 1947. "There's not
much in the old picture that survives. Not the hemline, waistline,
nor the shoulderline." The reader was going to love the new Paris
fashion, the high heels and the hips. "Every woman has a waist,
and this year she must find it." If for some unfathomable reason
the reader could not locate her waist, she must find a *corsetière* or
do the exercises to be found in *Bazaar.* It all meant that for the
time being the fashionable women of America—including Mrs.
Vreeland—were back in their box.

FOR ALL THE joyous reunions at the end of the war, there were
those who had a more complex reaction to the Allied victory. An
article in *Bazaar* noted that the whole country was in transition;

that the return to family life was making some women unhappy; that everyone was coming to terms with the terrible new threat of nuclear annihilation; and that the strained mood was making even the most comradely women snap. In Diana's case the cause of nervous tension was Reed. He did not come home from Canada as soon as the war ended, and she had to put up a real fight to get him back. "You can divorce me, Reed," she is reported to have said. "But I'll kill myself." Gossip had it that she took matters into her own hands by going to Montreal, confronting Reed's girlfriend, and forcing her to sit down in front of a mirror. "Look at you, you are young and beautiful, and you have everything ahead of you," she is rumored to have said. "I am getting older and I have only my wonderful husband." The woman in Reed's life was married. Continuing the relationship meant breaking up two families. Perhaps it had already run its course. In the end both Reed and his mistress backed away from their wartime romance. Reed's Montreal job came to an end in 1946, and by 1947 he was making entries in the Brewster garden book again. This outcome required considerable compromise on both sides.

On his return to New York, Reed, who did not fulfill his early promise in banking, turned to a range of financial activities with friends, including stints as president of a cement company and as chairman of the board of the International Trust Company of Liberia. His directorships were so closely related to his father's business interests that it is reasonable to suppose they came through the family connection. Though he was always optimistic and convinced that he would make a fortune, his entrepreneurial projects were often mysterious and not as successful as he hoped. "Reed was always about to make a million dollars," the interior decorator Billy Baldwin recalled. "He had the richest friends, men who made fortunes—Reed just never got around to it." Reed may not have been very well suited to life in business, and it is quite possible that marriage to Diana came at some personal cost. He longed to be a singer, and with his looks, his connections, and his good tenor voice he might have succeeded at a time when Mario Lanza

was having huge popular success. But this was a dream that Diana firmly quashed, perhaps for reasons of snobbishness, perhaps because of financial insecurity, and almost certainly because she was terrified of losing him. She wanted him to continue as a financier. "Showbiz breaks up families," she said, and that was the end of it.

At the same time Reed greatly appreciated the dream world created for them both by Diana, provided that he was not required to engage with the more problematic aspects of the reality underpinning it. Diana once mentioned that she rarely talked about work at home, saying that Reed hated her bringing back office problems and that when she did, he threatened to leave. He does not seem to have been jealous of her success; but, like Diana, he preferred fantasy and a culture of denial, and never discussed his own business problems either. Though there was little that was fashionable about Seventh Avenue itself during the 1940s, there is no doubt that Diana's job at *Bazaar* not only brought in a much-needed vital income but allowed the Vreelands to live like rich people. In fact *Bazaar* gave Diana herself a degree of fashion influence that was no longer possible for even the very rich. Reed liked the way of life and glamour of Diana's job, and after he returned from Montreal he supported it wholeheartedly.

"Diana Vreeland's home," wrote Phyllis Lee Levin, "is more original than any ever to appear on a magazine page, her husband is more polished and her friends are precisely the ones whose pictures are used repeatedly, whose menus, luggage, jewelry, furniture, paintings, sofa pillows, and children are avidly recorded by the fashion magazines, month after month, year in and out." "I always *looked* rich," Diana once said. "That was something Reed and I always had. . . . I've spent so much money in my life that it's almost taken the place of the real thing." It was often remarked that Reed and Diana looked marvelous together. Reed, like his wife, dressed as elegantly in his fifties as he had ever done. Billy Baldwin remembered the Vreelands arriving late for lunch at Adelaide Leonard's in Southampton in the 1950s. The hostess was on the point of proposing that the party should start lunch without

them when they arrived over the dunes, with the sea behind them, "looking as though they had come out of some other world." They were "dressed exactly alike in gray flannel knickers, suede waist-coats, and silk cravats. They were wearing the most incredible shoes and carrying golf bags."

It all looked very decorative, but Diana had her own worries to contend with, for she had very nearly lost Reed to another woman during the war, and as she said herself, "He was never withered. He never struck age—*ever.*" Rumors of his infidelities during the postwar years need to be treated with caution, for Diana's power made her the target of malicious talk; and there is no evidence that he ever philandered with the trail of beautiful young women who worked and fluttered through *Bazaar* and the Vreelands' lives, however much he may have enjoyed looking at them. Gossip that has lingered centers once again on the Vreelands' social circle, especially Cordelia Biddle Robertson, a long-standing friend of both Reed and Diana's. But it is a little puzzling: Cordelia Biddle Robertson was five years older than Diana, and looked rather like her, "but without the makeup," according to one friend. She was certainly not short of personality. Her father was the inspiration for the play *The Happiest Millionaire*, based on the memoir she wrote of him. He taught her to box and threw a huge wedding for her when she dropped out of school at fifteen to marry her first husband, Angier B. Duke. Reed was a much kinder man than most of his tycoon friends, with time for long lunches while his wife was at work; and Cordelia Biddle Robertson may well—at least for a time—have joined the line of women who found Reed attractive and made Diana uneasy. Those who knew the Vreelands well, however, did not doubt that theirs was a real marriage, based on deep mutual affection. Neither of them made the other suffer like some of their multiply married rich friends, and Billy Baldwin, who subsequently became their interior decorator and was in a position to know, observed that the feeling between them ran very deep: "It must be understood that Diana and Reed were a very happy couple, and it was because of her real infatuation for him

and his great appreciation of her that they sailed this wonderful boat so beautifully together. Until the time that he went to the hospital to die they slept together in an enormous double bed."

By the mid-1950s Vreeland family life had moved on as Tim and Freck became adults with lives and families of their own. On their return to New York from Europe in 1935 the Vreelands lived first at 65 East Ninety-Third Street and then at 400 Park Avenue. By 1946 both Timmy and Freck were at Yale and lived more independently thereafter. Though Emi-Lu returned from England for a few months in the late 1940s after leaving a finishing school in Switzerland, she became engaged to Hugh Astor in 1949 and settled in Berkshire. In 1950, Freck married Elizabeth Breslauer (known as "Betty") and joined the CIA, a career move that took the newly married couple first to Washington and then to the first of several foreign postings in Europe in conjunction with the U.S. Foreign Service. After some hesitation about his future career, Tim joined the Yale School of Architecture. He eventually became engaged to Jean Partridge in 1958 before qualifying, taking up posts in New Mexico and in California as an academic and practicing architect.

The role of Diana's daughter-in-law was demanding, even at long distance. Diana was not alone in wanting to see her sons married to perfect women, but the potential for conflict was greater when what she implicitly wanted for them was the Girl. But all sides made an effort, and both her daughters-in-law wrote regularly. Betty, in particular, sent long, affectionate letters. She was a graduate of Vassar who would later become a published poet, and her letters were often delighted evocations of the early years of married life with Freck, written to a mother-in-law she admired and regarded as a kindred spirit. Freck's first European posting was to Geneva in 1951. Diana clearly anticipated that Betty would find the European way of life in the 1950s as thrillingly inspiring as she had in the early years of her marriage in the 1930s. Betty seems to have hoped so too but she was sorely disappointed. "Geneva isn't inspirational," she wrote. "The people look very nice

very conservative & nothing special it is a time for me to experiment but there's no one here to look up to—no one who is really the top. . . . But I shall try to keep standards higher than high."

In 1954 Cecil Beaton published *The Glass of Fashion*. "Any number of contemporary critics have devoted volumes to Picasso or Stravinsky, Le Corbusier or James Joyce, but little has been said about those people who have influenced the art of living in the half century of my own lifetime," he wrote. "This book is a subjective account of them and their achievements, as well as of the current of fashion against which they more often than not swam." Alongside profiles of his aunt Jessie, the fin de siècle socialite Rita Lydig, and Coco Chanel, he included an affectionate portrait of Diana that lit on her "walk like a rope unwinding," her voice with its "almost Rabelaisian roar," her "pimentoed expressions," her all-embracing taste, and surroundings reflecting a "haphazard genius." Her habit of leaving the room for a vitamin B injection was, wrote Beaton, "all part of her scientific way of preserving inspiration, so that when you do see her she is always, like an athlete, at her best, talking as one would write a poem, allying her verbal brilliance with the novelist's true gift of description and a tremendous sledge-hammer emphasis." If she was exaggerated, the excess was natural. "Everything that has cropped up along the line has been absorbed by her, until she is like a fine tea mixture of orange pekoe and pekoe. There is nothing artificial about her."

It was almost too much for Betty Vreeland. "The main point of this letter is that we have just received Cecil Beaton's book and read his absolutely wonderful & perceptive description of you—it is quite remarkable that in such a short space he has found *so* much of you and written *it* so completely. We both really had tears in our eyes when we finished," she wrote. The problem for someone beautiful, intelligent, and well educated like Betty, living in a poorer and duller Europe in the 1950s, was that the female standard was still set by the 1930s and by women like Diana, and it was so difficult to reach. "It is such an inspiration and yet I feel so weighted down by the banalities of my generations & so unable to be for

myself what you have been for yours. This sounds so egotistical to read the Beaton piece & immediately talk of myself—but his book is really besides being a tribute to the elegance & originality of the women he describes—a depressing and altogether accurate picture of the banalities of today's women—it is a lesson to us—but a difficult one. . . . I feel so stupid and *banal*—& clothes & thoughts are all part of it. How I should love to see you, and get another shot of inspiration."

By the mid-1950s, with both their sons grown up, Reed and Diana were no longer obliged to house anyone other than themselves. They bought 550 Park Avenue in 1955 and asked Billy Baldwin to help them transform it, a process he later described as "almost an entire winter of pure satisfaction and pleasure." Because they were all working during the week ("even though Diana and I didn't know what Reed was working at"), they met in a restaurant for Sunday lunch throughout the year, and would often still be sitting there at four o'clock, talking about the apartment. Working with Diana on 550, said Baldwin, was like being at a fantastic party. The lunches were not prolonged by alcohol. "There was plenty of prolongation on the part of Diana, but it had nothing to do with drinks. It had to do with her wonderful imagination, which she translated into reality in such a way that it really was quite hard to tell sometimes what she was doing."

Both Diana and Reed contributed ideas that made the apartment at 550 Park Avenue one of New York's most famous interiors. It was Reed's idea to eliminate the hall, turning the living room and dining room into an L shape. "Diana attacked the whole apartment as though it were a perfectly divine little palace," remembered Baldwin, and it was she who defined the spirit of 550. "I want this place to look like a garden, but a garden in hell," she said. "I want everything that can be to be covered in a lovely cotton material. Cotton! Cotton! Cotton!" Baldwin found a scarlet Colefax and Fowler chintz for her in London. "I raced home with yards and yards of it and we covered the whole room—walls, curtains, furniture, the works." A solid red wall-to-wall carpet covered the

entire floor of the apartment. The bedroom was papered in the same Colefax and Fowler pattern in blue and green. Apart from the enormous bed, loaned to Diana by Syrie Maugham in 1935 but still in her possession in 1989, there was a comfortable chair for Reed when they had supper there; a Chinese screen and some red lacquer furniture; and a closet for Diana's clothes. "In it were the most beautifully made shelves for shoes, many of which she had had for several years and were unworn until they had been polished year after year so that they would have the quality of eighteenth-century leather." In Reed's bedroom ("where he never slept because first of all there wasn't a real bed in it") there was a "mausoleum" for his clothes, "certainly the most beautiful over-coats and topcoats of any man in New York."

The most celebrated space in the apartment, however, was the L-shaped room where the Vreelands entertained. It was not, as the diplomat and writer Valentine Lawford subsequently pointed out, remotely hellish or particularly horticultural but it was certainly red: "red carpets, red lacquered doors, closet lin-ings and picture frames." The apartment was not very large—apart from the living room, dining room, and kitchen, and two bedrooms, each with its own bathroom, the only other room was a small space where Diana's maid took care of her clothes and polished her bags, belts, and shoes, including their soles. Diana's main concern when discussing the arrangement of the furniture with Baldwin was that there should be plenty of flat spaces for her photographs and *things*. These had jostled for space in the Vreelands' old apartment: "Piero della Francesca rubs shoulders with drawings by Christian Bérard, while gold-mesh fish pa-perweights curve their tails on her desk. . . . It is a full room, almost a Victorianly stuffed room, but it does not seem so, for every last shell is polished," wrote Beaton of 400 Park Avenue. The principle was taken even further in the new apartment. "I don't want you to show me one Chippendale chair or one French commode," Diana instructed Baldwin. "I want lots of flat space for photographs of my beloved friends. I want plenty of room for

flowers everywhere, growing plants as well as cut flowers, and I want plenty of space for ashtrays because I smoke. At one end of the room I want banquettes and at the other end will be my sofa . . . when I am in a room I want to sit close to somebody." Baldwin thought that this room was the most definitive personal statement that he had seen in all his years of decorating. Fur and needlepoint pillows covered chairs of all heights and of many epochs. Diana's collection of Scottish silver snuff horns nestled among dozens of photographs. There were drawings by Beaton, Bérard, and Augustus John. In the spirit of "Why Don't You?" there was a flowering tree, as well as flowers in vases on every surface.

This oft-described apartment became the backdrop for much entertaining. The Vreelands' close friends were largely the people they first met in Europe in the 1930s, and those they came to know thereafter: there was little sign of the friends from school and debutante days amid the dozens of lunches and parties scribbled in Diana's engagement diaries. Kitty and Gilbert Miller had a much larger apartment at 550 Park Avenue, and they all moved in similar circles. The Vreelands knew "everyone." The New York of the 1950s was a world of such stylish socialites as Slim Keith, Gloria Guinness, Marella Agnelli, C. Z. Guest, and Babe Paley; of artists and writers including Cecil Beaton, and Truman Capote; and such café society stalwarts as Cole Porter, Johnny Schlumberger, Serge Obolensky, and the Duke and Duchess of Windsor: a world of "Va-Va" and "Mona" and "the Engelhards." It was a private world of dinners and parties on the Upper East Side that spilled over into El Morocco, the Stork Club, the Colony Restaurant, and the Côte Basque. But amid all this, an invitation to dinner chez Vreeland was much coveted. Reed and Diana were good at mixing people. Guests were generally limited to twelve and ate at round tables pushed up against banquettes. One visitor remarked that Diana's parties were the nicest in New York because she had the knack of inviting the most entertaining people in town. And the apartment, said the visitor, was just like Diana: "outrageous, individual, but warm."

......

MEANWHILE THERE WERE changes at *Harper's Bazaar.* New tal-
ent came rushing to *Bazaar*'s door to join Snow, Brodovitch, and
Diana after the war, propelling the magazine into another brilliant
phase that lasted until the early 1960s. The stampede was led by
Richard Avedon, a young photographer who was determined to
work with Brodovitch and headed in his direction as soon as he
left the merchant marine in 1944. By 1944 *Bazaar* and *Vogue* were
almost level in terms of circulation, but *Bazaar* was the lodestar
in terms of graphic design. Avedon had to persevere to secure his
dream job. He maintained later that he tried to see Brodovitch at
least fourteen times before the great art director agreed to meet
him and grudgingly conceded that he might show some promise.
Even then Avedon had to attend Brodovitch's classes at the New
School for six months. It was only after this that Brodovitch was
prepared to introduce him to Carmel Snow. She sensed at once that
Avedon was exceptionally gifted. "I knew that in Richard Avedon
we had a new, contemporary Munkácsi," she wrote. Avedon's arrival
was featured in the October 1944 issue, though initially most of his
work was for a new supplementary publication, *Junior Bazaar.*

Avedon had his own studio a few blocks away from *Bazaar,* and
it took him time to find his feet. Early on, he wandered into Diana's
office unannounced. She was sitting behind her desk, watching
intently while Baron Nicky de Gunzburg tucked and pulled at a
wedding dress on a beautiful fashion model. "Mrs. Vreeland never
looked at me. She cried, 'Baron!' Beside her stood Baron de Gunz-
burg, the only male fashion editor in the world, a pincushion hang-
ing like a Croix de Guerre from a ribbon at his throat. . . . She cried,
'Baron! Baron, the pins!' She took one pin and walked, swinging
her hips, down the narrow office to the end. She stuck the pin, not
only into the dress, but into the girl, who let out a little scream.
Diana returned to her desk, looked up at me for the first time and
said, 'Aberdeen! Aberdeen! Doesn't it make you want to cry?' Well,
it did. I went back to Carmel Snow and said, 'I can't work with that

woman. She calls me *Aberdeen*.' And Carmel Snow said, 'You're *going* to work with her.' "

"Boy was I lucky," said Avedon later. "I didn't realize when [Brodovitch] chose me to work on the magazine that I would have Carmel Snow as my editor and Dee-Anna Vreeland as my fashion editor . . . my new chosen mother, father and crazy aunt—brilliant, crazy aunt." Like others who worked for *Bazaar* in this period, Avedon was struck by the close working relationship between Snow, Diana, and Brodovitch. "It was a three-way vote on everything," he said, though the final word was Snow's and Diana was quite often outvoted by the other two, particularly when it came to matters of photography. In the view of Adrian G. Allen (known as "A. G."), who joined the art department as an assistant to Brodovitch in 1951, Snow believed that in Brodovitch and Vreeland she had the best. "It was a triumvirate and they all worked marvelously together. . . . There was so much creativity just going on every day. And everybody was very excited about what they were doing."

As *Bazaar*'s workforce expanded and working relationships were formalized, Snow and Diana became the grandes dames of the magazine whose arrival each morning had everyone on their toes. Junior serfs arrived promptly at 9 o'clock. Snow and Diana appeared somewhat later. Diana would generally march in first, having dispatched her first round of instructions by telephone from home. "It was always an entrance," A. G. Allen recalls. "Every accessory was perfect. But it was always a relief that they were both there. You knew who was in charge." She was fascinated by the way in which these two women, who made a living out of telling other women how to look, rarely varied their own appearance. "They had each found their look, Mrs. Snow by the time I got there, Balenciaga. . . . Always the same stand-up collar. The pearls, the loosely fitted jacket. . . . Mrs. Vreeland was in Mainbocher, cashmere sweater top, velvet straight skirt. Black, navy blue. And they did it summer, winter." Writing about Diana in this period, Bettina Ballard recalled that somehow this look never dated. "Unmarred by a hat, she has a genius for

looking contemporary without changing the brush of her polished blued-charcoal hair, the style of her ankle-strapped shoes, her own exotic way of wearing a Mainbocher costume that might be of any year, her loping camel's gait with her long neck thrust forward like an inquisitive tortoise's, or her way of holding a cigarette in a holder as if she were about to write with it." One fashion editor, Laura Pyzel Clark, commented that the atmosphere of the office changed when Diana arrived. "Anyone who had any contact with Diana Vreeland caught something special," she said. "In the morning she would sweep off the elevator and the whole floor would change. Diana gave off an electric charge. There was a mood you would catch. It wasn't anything that happened to just one person. It happened to all of us."

The atmosphere throughout *Bazaar* was didactic. Brodovitch and Snow were both natural teachers. If Diana saw a spark in someone, she was an inspiring mentor too. "Mrs. Vreeland and Mrs. Snow were such incredible teachers. You got the most unbelievable training," said the fashion editor Polly Mellen, whom Diana encouraged through a first disastrous sitting when she joined *Bazaar* in 1950. Ali MacGraw agreed: "I learned to 'see' by listening to her. Whether or not her colorful life story was real or partly fantasy made no difference. I was mesmerized by the possibilities of her life, by the people she knew and the style she invented." Some of those who worked for her adored her. "D. D. Ryan worshipped her," said A. G. Allen. "When D. D.'s desk was moved away from just outside D. V.'s office she cried all day. She patterned her look and manner on her." D. D. Ryan said later that four acolytes in the office, including her, all ended up wearing the same black cashmere Braemar sweater in imitation of their mentor. When the manufacturer heard about it, he sent a designer to the magazine offices to cut a special style just for "the girls at *Bazaar*."

Others found Diana intolerable. By the mid-1950s she presided over a team of fashion editors and two secretaries. One secretary attended to serious administrative work, while the other was a special assistant, generally an extremely attractive young woman from a socially prominent family, who either worked for debutante

wages or for nothing at all. Diana's childhood temper resurfaced
in an occasional streak of ferocity; and since personnel in her office
changed frequently she could not be bothered to learn names. "To
Diana Vreeland, I was 'Girl,'" wrote Ali MacGraw. "'Girl, bring
me a pencil.' 'Girl, get me Babe Paley on the phone.' . . . One day,
as I struggled on the carpet to arrange violet snakeskin shoes for
a photo shoot, Mrs. Vreeland swept dramatically by me, throwing
her heavy Mainbocher overcoat at me, and I involuntarily chucked
it right back at her." When Barbara Slifka finally told Carmel Snow
she could stand it no longer, she noticed that Snow understood and
transferred her without comment to another job. Jacqueline Ken-
nedy's sister, Lee Radziwill, on the other hand, enjoyed the variety
of her short stint with Mrs. Vreeland. She telephoned her with gos-
sip, accompanied her to Seventh Avenue, and chose hats for shoots.
She never knew what was going to happen next. "Once Diana was
hooked on a shade of orange that she wanted to put across at an
editorial meeting," writes Radziwill's biographer, "and she asked
Lee to go out and buy some fresh carrots."

Those who worked with Diana always had to adjust to her
manner of getting what she wanted. "She had such interest in
European culture so that she could talk about all sorts of obscure
painters and use them to influence the make up or light of a sit-
ting," said Lillian Bassman who worked for Brodovitch as a junior
photographer at the time. "She was really a wonderful catalyst,"
said Richard Avedon. "She was terrifying, awful, but she had this
thing of speaking in code in her way. And throwing the ball out
and expecting you to run with it, and come back with something
else." People of Avedon's caliber found this extremely stimulating;
and many thought that Diana's greatest gift was indeed as a cata-
lyst of the work of others. She challenged them by obliging them
to guess at what she had in her mind's eye while giving those she
respected all the latitude they needed, with the result that they
then came back with something even better. But one did have to be
on her wavelength. Once, before a shoot in Egypt with the model
Dovima, Diana wrote to Richard Avedon enjoining him to think

about Cleopatra. "Cleopatra was 'the kitten of the nile' [*sic*],'" wrote Diana:

> *I have always seen her as a small boned child with an exquisite tiny boned face. . . . I see the head encased in small scales, like fish scales, shiny and slightly twisted toward the front . . . with the shimmer of a serpent. . . . She hated Egypt—surrounded by death—surrounded by tombs an exquisite child walking through dead streets. but a wild child inside. . . . Of course, anyone that slept with Cleopatra died in the morning, because there couldn't be* any *talk.*

"She just sort of threw your way of thinking because of her erudition," said Avedon, "and because of her imagination. . . . And that's why those pictures hold."

It took new acquaintances time to understand that Diana's poetic manner of speech was not just empty verbiage. Those who came to know her well noted how meticulous she was and how hard she worked. "She was without exception the hardest-working person I've ever known," said Avedon. They also came to understand that even her most peculiar statements were quite precise and often made perfectly good sense. When she said, "Pink *is* the navy blue of India," Diana was noting that middle-class Indian women put on pink saris at certain times of year in the same way that middle-class New York women donned navy blue suits in spring. When she said, "The Bikini is the most important thing since the atom bomb," she was talking fashionese, but she meant that it was the first publicly worn garment to reveal almost the entire line of the body; and this had a major effect on body image and body line in both sexes from the 1950s onward. Taken alone, these epigrammatic quips came to represent Diana's *Lady in the Dark* zaniness, but friends noticed that they often made sense afterward.

"You think, of all the nonsense in the world, that's it," said Billy Baldwin. "To your great surprise and sometimes dismay almost, an hour later or maybe a day later, you realize that she has uttered

pearls of one hundred percent wisdom." None of it was affectation, in Baldwin's view. "In her remarkable lingo she is speaking what she believes to be the truth and it almost invariably is. She believes entirely in those remarkable hurdles, curls, and gymnastics of speech that she indulges in." Lillian Bassman could often hear Diana just down the corridor. "Her office was not so far away and we could hear it just rolling out of her. She could entertain you for hours." She was incapable of talking to order, however. She hated speaking in public or giving speeches. "We tried to persuade her to go on radio or television, but she wasn't very good," said Bassman. "When she had a camera on her she just froze."

As the 1950s wore on, French and American fashion became more, not less, entangled. After the appointment of Marie-Louise Bousquet as Paris editor in 1947, Carmel Snow turned her attention to other centers of European fashion too, introducing readers to Italian designers such as Emilio Pucci, Simonetta, and Irene Galitzine. In spite of coining the phrase "the New Look," Snow did not become a slavish follower of Dior. Though she supported the rapid twists and turns of the Dior collections through the 1950s, her single most significant contribution to American fashion was introducing the work of the Spanish couturier Cristóbal Balenciaga to the United States. Snow saved Balenciaga by supporting his "unfitted" suits during the fall collections of 1950. Snow loved Balenciaga as a man—so much that Paris gossiped about her unrequited crush. But she also loved him for his forgiving, semifitted, fluid couture ("Monsieur Balenciaga *likes* a little tummy," said one of his fitters). Snow celebrated his designs, which included shift dresses, narrow skirts, tunic-line ensembles, and flattering jackets that happened to suit her own short neck; and it was Snow, rather than Diana, who met top American manufacturers during the Paris collections, talking to them about how best to "Americanize" the latest ideas, and took credit for the way in which these conversations played out in New York. "It was a satisfaction to know that during those evenings in Paris with Ben Zuckerman, or David Kidd of Jablow, or other Seventh Avenue friends, I had in

some measure influenced the appearance of millions of American women," she wrote.

Inevitably this led to tensions between Diana and Snow, though they were good at hiding them from the staff. "It was always very interesting to me that Mrs. Vreeland knew Mrs. Snow was the boss," said A. G. Allen. Richard Avedon thought that not being allowed to go to the Paris collections for years on end in a professional capacity did in fact "gnaw" at Diana, and that there must have been moments when Carmel Snow's continued insistence on going alone seemed ridiculous. Diana's knowledge of the Paris couture came as a private client, through her rich friends, and second-hand from Snow. There were moments when Snow acted as if she felt threatened by Diana's talent. She tried, for example, to stop her from meeting Balenciaga when he was visiting New York, regarding him as "hers." "In a curious way, I think she resented my taste," said Diana. The one time she did find herself at the Paris collections as part of Snow's entourage, Diana told Bettina Ballard that she hated the experience. Where Snow thrived on the whirl, and trying to second-guess the market, Diana disliked the frenzy and had little appetite for psychological games with store buyers and rival editors. "How can you work in this confusion night and day?" she asked Ballard in dismay. "How can you understand fashion smothered like this?" (Avedon, on the other hand, adored the frenetic atmosphere of Paris openings, producing some of his most celebrated work, like "Dovima with Elephants," for *Bazaar* on trips to Paris with Snow.)

In spite of their occasional tiffs, Snow and Diana were almost always in agreement about fashion itself. They both welcomed the return of Chanel and the updated Chanel suit with delight after 1953. (When rumors started that Chanel was planning a comeback, Snow immediately wrote offering *Bazaar*'s support; it was American fashion editors who saved Chanel, rather than the French press.) Snow continued to believe in Diana implicitly and gave her all the freedom with American fashion she needed—though she still had to rein her in from time to time, countering

Diana's instinct for exaggeration so that the idea of an entire issue devoted to magenta ended up as one lively magenta spread. Diana's strengths remained the strengths of the grand amateur, the 1930s woman of style who sifted, edited, and selected with great care every garment, shoe, handbag, piece of jewelry that was placed before her. Her task as defined by Carmel Snow was to help readers fascinated by the new to train their taste, by presenting "*the best* in every field."

During the 1950s Diana still regarded this as an uphill battle, particularly in relation to expensive formal clothes and evening wear. She continued to struggle with Seventh Avenue designers who simply regurgitated poor copies of French fashions. Her default view of Seventh Avenue designers was that they were second rate until proved otherwise. She no longer "covered the waterfront" as she once had. Indeed, as part of her drive for quality she took to maintaining a distance. At openings she adopted an enigmatic pose. Bettina Ballard commented that seeing her at a Seventh Avenue show was like seeing the "Wise Men, or Disraeli, or an Ingres odalisque sitting in a hard chair with an inscrutable expression watching clothes go by." When she jotted down a number, others followed suit; and when she did consent to meet an up-and-coming American designer in person, it was memorable. Bill Blass recalled the moment when she came to see him while he was still working in the back room of Anna Miller in the late 1950s. "Diana was not then in the habit of coming to Seventh Avenue. On the day she did arrive (picture her: the raven hair, the pitched-back walk, the flaring cigarette), she brushed past the old boys in the front office, ignoring everyone, and announced: 'I hear you have a young Englishman in your backroom. I must meet him.'" Blass was from Indiana. "Vreeland could always be counted on for getting things slightly wrong, though perhaps for the right reasons," he said.

It would also be wrong to think that every American designer who appeared in *Bazaar* necessarily had Diana's enthusiastic stamp of approval. There had been a trade-off between advertising and editorial since the earliest days of *Bazaar*. As the magazine became

more successful, this became even more complex. Diana had no truck at all with the business and advertising side of *Bazaar.* This was left to Carmel Snow, and it was one of Snow's great strengths that she managed it so well for so long. Nonetheless even Snow was forced to make concessions sometimes, and when she did, Diana had to help her to make the best of it. Both Carmel and Diana re-garded the designs of Adrian, for example, as "tacky." They did the minimum necessary to satisfy the advertising department, though photographs of the heiress Millicent Rogers wearing Adrian might have led the innocent reader to imagine otherwise. At the same time, Diana was known to go back to advertisers and ask them to make adjustments to colors and designs so that the clothes were good enough to merit inclusion in the magazine. "She does not in-dulge in cruelty nor in self-indulgence for pleasure . . ." said Billy Baldwin. "She will not bear to subscribe to an opinion that she doesn't totally believe in. *She is a warrior.*"

At the same time, an endorsement of an American designer by Diana, with Carmel Snow's support, could make all the difference to his or her career. At the very top, custom-made end, Mainbo-cher continued to occupy a privileged place in the fashion pages of *Bazaar.* He never returned to Paris, but he did refuse to allow his clothes to be manufactured by Seventh Avenue and is unlikely to have survived as he did without Diana's help; she patronized him as the only true New York representative of the Paris prewar couture tradition. Named American designers began to emerge on Seventh Avenue to meet a growing demand for high-quality, expensive ready-to-wear clothes, a trend to which the Paris cou-ture was also responding. Diana supported designers and designer-manufacturers of the quality of Norman Norell, James Galanos, and Ben Zuckerman but was extremely demanding. If the clothes were copies of French designs they had to be just as good. French inspiration had to be combined with an original American twist, and the clothes had to be wearable. Her motivating effect was at its most obvious with sportswear designers. B. H. Wragge, for example, was delighted to have her advice, and admiration was

mutual. "My dear," she would say of Wragge, "no one, but no one, can touch his American look—clothes with youth and energy, if you know what I mean. Clothes with breezes running through their seams." Diana supported Claire McCardell's most experimental ideas, including beach shirts over romper suits, which were inspired by children's play clothes, complete with smocking; and she was extremely good at discerning trends long before they became popular—her spreads on biker boots and textured stockings still look contemporary now.

Meanwhile Diana introduced successful ideas directly from Europe herself. ("You must always give ideas away," she liked to say. "Under every idea is a new one waiting to be born.") The Capri sandal was one innovation of which she was particularly proud. She had first bought sandals attached to the foot by leather straps while staying with Mona Williams on Capri in the mid-1930s. Unable to replace her Capri sandals during the war, she arranged for a shoemaker in New Jersey to make copies. Once the New Jersey shoemaker recovered from Diana's description of the sandals in Pompeii's ruder frescoes, he built a very good business out of them as American women opted to go bare legged in summer. Diana claimed to have done even better by Charles Revson, giving him a prewar formula for red nail polish made by a Mr. Perrera in Paris, who "took care of women's hands just for *love*." Revson, who did not take care of women's hands just for love, developed the formula and built a global cosmetics empire. Diana tried to find Perrera after the war to give him his due but he had disappeared. She thought that Charles Revson felt guilty about what he had done ever afterward. "I . . . knew that *he* knew that *I* knew that he had made this incredible fortune off of one small bottle of mine with maybe *this* much left in it. Yes, there was always something in his eye. . . ."

She had an equally keen eye for young talent, like Kenneth Jay Lane, who became one of the world's leading designers of costume jewelry partly thanks to her tutelage. Lane was still designing shoes when Diana first met him in the 1950s. He knew

he had found a true friend during their first conversation, when he asked her how to look after some new leather shoes, and she replied, "You know in the whole city of New York you can't find a rhinoceros horn!" Diana was an early enthusiast for Lane's jewelry, and was one of those who changed the direction of his career by making it fashionable. She was particularly fond of his pairs of enameled black and white bracelets, with jewels mounted on the white cuff, and reversed out on the black. Producing pieces for Diana and her fashion spreads was extremely demanding, but Lane would later say that her precision was a perfect education for a young designer, particularly in matters of color. They once had an argument about a shade of turquoise that went on for days, until Lane eventually wondered—by phone—if she was thinking of the color of Turkish donkey beads. "Yes! *Daunkey*," said Diana, slamming down the receiver.

Indeed, Diana's observations about color became a subset of "Vreelandia": "There's never been a blue like the blue of the Duke of Windsor's eyes. . . . Red is the great clarifier—bright, cleansing, and revealing. It makes all other colors beautiful. . . . Black is the hardest color in the *world* to get *right*—except for gray. . . . Taxicab yellow is *marvelous*. . . . Actually, pale-pink salmon is the *only* color I cannot *abide*—though naturally I adore pink." After Diana and Lane became friends, the young women in her office surreptitiously telephoned him for help with translation. "Once, they called and said she was talking about the color of dried blood and they had no idea what she meant. 'Where was she last night?' one assistant asked. 'Let's see . . . ,' I said. 'Oh, I know. Last night we went to the Russian Tea Room and had beet borscht.'"

As the global fashion industry expanded in the 1950s, the process by which fashion reached the pages of *Bazaar* became more hierarchical. Diana's team scoured Seventh Avenue for pieces that were presented to her at intimidating run-throughs where she would, according to Bettina Ballard, sit with "eyes far off on cloud number twelve . . . while the nervous editors put the clothes of their choice on the mannequins." Junior editors were struck by

her militant self-belief in matters of taste. Once the selection was approved by Snow, the fashion team had showings for the art department to discuss how the clothes should be photographed and appear on the page. These run-throughs were an event. "DVs showings were her own bit of theater," said A. G. Allen. "This was her stage, and she was always dressed to the nines for it." The photographer Gleb Derujinsky remembered that Brodovitch would start the conversation by talking about the overall plan for the issue, so that the photographers understood the rhythm of the pages.

With that settled, it became Diana's show. "A model would be there walking around in the clothes, and DV would see it as her role to talk up the clothes, trying to inspire the photographers and art department," remembered Allen. Exaggeration was one way of doing this, particularly at those moments when she took over from the model, as Derujinsky recalled. "She would stand in front of the mirror and strike the poses that would make the dress work; or she would bend and move and poke the models into taking the right pose, with her team frantically pinning the costumes and Diana accessorizing with scarves, or ribbons, or something for the hair." It was Diana's turn of phrase that often stayed in the memory. "With pure Dianaism, she describes what effect she wants," wrote Ballard. " 'This, my dear,' pointing to a sequin sheath, 'must look drowned, completely drowned,' as if the word tasted of salt water. 'You know what I mean, like a wet, wet mermaid sliding through the water.'" She did not always seem to be quite of this world. "You got the feeling she was above harsh commercial reality," said Derujinsky, who would never forget Diana instructing two models to kneel in a pose on the floor, going out to lunch, and finding the terrified models still in position when she returned an hour later.

MANY PEOPLE CONTRIBUTED to the fashion spreads in *Bazaar* in the 1950s, and assigning credit between photographer, fashion editor, art director, and stylist is difficult, not to say unwise: the point at which influence began and ended shifted with every relationship

and every shoot. However, Diana's intense feeling for all kinds of fashion and her insistence on quality and originality was critical to the continued success of *Bazaar* during those years. The freshness of the fashion pages continued up to 1961, a considerable achievement, when even those who were interested in clothes, like Betty Vreeland, thought that fashion was growing dull: "There is at this moment nothing more to say about fashion nothing new to show because nothing is being invented anywhere." The changes had to be rung through accessories, she noted, and here Diana reigned supreme, with consistently sparkling spreads on shoes, belts, and jewelry. Her style philosophy that first emerged in the "Why Don't You?" column slowly regained the upper hand as well. Diana continued to promote women of taste with style ideas of their own, persuading C. Z. Guest to be photographed wearing panels of Chinese fabric, for example; and by the late 1950s the dictatorial tone of *Bazaar* in the late 1940s was again making way for a more flexible approach based on the individual reader's point of view. "Individualism emerging," ran one fashion article in March 1961. "See expressed—triumphantly—in this issue of *Harper's Bazaar* perfect individualism: the great and worthy goal that fashion has been straining as toward leaf to sun throughout this generation."

Bazaar was certainly not radical. It was aimed at the reader "who thinks of herself as a woman every minute," and counseled her to eschew confusion, aiming for beauty in everything she did. Throughout the 1950s, however, Diana gave *Bazaar* a contemporary and specifically American point of view. The American "girl" in *Bazaar*—whether a model or a society figure, in sportswear or more formal clothes inspired by French couture—was a stylish young woman in her early thirties. Diana's *Bazaar* pages posited American dynamism in contrast to the stasis of European couture. Models of the 1950s like Dovima and Suzy Parker were good at looking aloof. But in *Bazaar* they exuded energy and enjoyed their own physical health. The Girl they stood for was elegant, no longer a debutante, probably a young married woman, but one who was young at heart. She was, in many ways, like Diana in the

1930s. The fashion on *Bazaar*'s pages may have been bought by the middle-class and middle-aged, but on the page it was enjoyable, interesting, and for women who moved. It did not become jaded.

Time and again Diana's love of beautiful clothes was reflected in language captured by *Bazaar*'s copywriters. Flicking through *Bazaar* the reader might encounter a "lean coat of Stafford silk shantung that shines like wine in the candlelight," shoes that were a "spiderweb of black patent leather," "a suit that changes its face, according to accessories," "a little hold-your-breath jacket," or "checks at the peak of their long career." She might be offered "a cobalt blue suede oxford, a spark red suede pump, a meadow green suede pump," a "dress of charm and self-containment for late afternoon" or "the leopard and fox, the ocelot and lynx—coming in together this year in sharp-tailored, sharp-patterned, chopped-off coats that create a lovely diffusion about the face." She might be told to prepare "for a very pink spring. Pink is inescapable, all the way from peony through coral to flamingo." And she might be asked to apply a little imagination too: for the day "not too far off, when the trees will be not quite leafless and there are buckets of purple lilacs on the street corners and you will see someone—maybe yourself, in a suit of white Italian silk with a shirt of Irish lace."

Such language took the fashion on *Bazaar*'s pages to a level much envied at *Vogue*. It also lent itself to yet more parody. This time, however, Carmel Snow decided that her magazine was going to be on the right side of the joke. Stanley Donen's film *Funny Face*, which appeared in 1957, was very loosely based on the story of Richard Avedon's meeting with his first wife. Avedon acted as "visual consultant," with two of his favorite models, Dovima and Suzy Parker, in walk-on roles. *Bazaar*'s staff was roped in to help, and the magazine was credited. The story was set in a fashion magazine called *Quality*. Fred Astaire starred as photographer Dick Avery; Audrey Hepburn played a bookseller turned fashion model; and there was an art director called Dovitch. But the great spoof in this camp romp was Kay Thompson, as *Quality*

magazine's editor, Maggie Prescott. Other than her Balenciaga hat, which was a joke at Snow's expense, Maggie Prescott was entirely Diana, from her arrival in the office in the morning to a chorus of "Good mornings" from dazzled underlings to her exhortation to "every designer on Seventh Avenue" to "Think Pink!" *Funny Face* has none of the depth of *Lady in the Dark*. Nonetheless, as its story line develops, Maggie Prescott is revealed to be a surprisingly practical and wise old bird, with several Vreelandesque lines: "It's *movingly* dismal," she says. There were regular injunctions to give things pizzazz. There were also a few sharp digs. "One doesn't talk to Maggie Prescott," says Dick Avery at one point. "One listens." Diana did not see the funny side. "Mrs. Vreeland marched out saying, 'Never to be discussed,'" Barbara Slifka recalled. "I'm too real for teasing," said Diana years later.

FOR ALL THE magazine's successes, and the reverence with which Carmel Snow was held in the wider world of fashion, senior executives in the Hearst organization began to worry about her in the mid-1950s. She was in her late sixties but declined to contemplate retirement. Richard Deems of the Hearst organization raised the question of her succession for the first time in 1955, but she rebuffed him and would not even acknowledge that the conversation had taken place. "The inevitable was coming, but she refused to face it," writes her biographer Penelope Rowlands. "She seemed to think that by staring it down . . . it would somehow go away." Part of the problem was that as she aged, she drank heavily and ate little. Her physical frailty became obvious to those beyond the staff of *Bazaar*. Geraldine Stutz, then an editor at *Glamour*, watched her at the Paris collections. "She had bones showing all over the place, little bird bones. She was a little unsteady, sometimes after lunch, and sometimes generally. Dick Avedon was the great cavalier of all time. He was ever attending, he'd put his hand under her elbow." Avedon commented that at sixty-eight Snow already seemed like an old woman. "She was pickled in alcohol and that was sort of preserving her," said her niece Kate White.

By 1956 there were new pressures bearing down on Carmel Snow. There were constant battles with the Hearst executives. As she flagged physically she became no less decisive but much more peremptory. The business side of the magazine became more invasive as printing and paper costs rose; and there were constant clashes with the Hearst organization over covers, in a push to drive up sales and increase advertising revenue. Though Snow fought hard to hold back the tide, advertisers were allowed to acquire more power. Penelope Rowlands notes that, surprisingly, the death of William Randolph Hearst deprived Snow of a key ally. Though they sometimes clashed head-on, and he detested most of the artists whose work she published in *Bazaar*, especially Bérard, whom he called "faceless Freddy," he respected her strength of character and her successful touch.

By the mid-1950s Brodovitch, who had a troubled domestic life, was drinking heavily too. He had always had projects of his own beyond *Bazaar*. Frustrated by the increasingly commercial constraints at *Bazaar*, he reserved his most innovative work for elsewhere. The magazine managed to maintain its energy, thanks to good fiction publishing and its fashion pages, but it was beginning to lose its avant-garde cutting edge quality. Eventually the men of the Hearst organization took the matter of Snow's succession into their own hands and told her she had to go. The new editor they appointed was none other than Snow's niece Nancy White, editor of *Good Housekeeping*. Nancy had always adored her aunt Carmel. And Aunt Carmel was very fond of her niece but she did not regard her as nearly tough enough for the *Bazaar* job, and she was incensed at the decision and the way it was taken. The understanding was that Snow would hand things over to Nancy White during a transition period of several months in 1957, and that Snow would be gone by 1958, but it was anything but smooth. "The time that followed was an agony," writes Penelope Rowlands. "Carmel refused to acknowledge her niece's existence, attempting to do her own work as if nothing had changed. And she didn't do so tranquilly."

..

CARMEL SNOW WAS not the only person who was discontented. Diana would never have dreamed of proposing herself as a successor to Snow, regarding such a move as vulgar, but she was most unhappy at the way she was passed over, particularly since the fashion pages had held up so well while Snow and Brodovitch declined. "When Mrs. Snow got the word that she was no longer going to be editor, Diana Vreeland went in and said, 'Was my name mentioned?'" reported Dorothy Wheelock, *Bazaar*'s long-standing—and long-suffering—theater critic. "Mrs. Snow said, 'Your name never came up, Diana,' incensed at the very idea that Diana could take her job." It has also been suggested that, once she was prepared to discuss the idea of her successor, Snow actively blocked any possibility that Diana should succeed her, arguing that she was too narrowly focused on fashion, and lacked both the judgment and the necessary business acumen to be editor. It was an assessment with which many on Seventh Avenue concurred. The disdain with which Diana treated advertisers was felt to be a particular problem. "She was impossible with advertisers. She snubbed all the advertising department—quite rightly. She was much too eccentric and really frankly original. [Hearst management] couldn't take it," said one colleague.

This was not how Diana viewed the matter. She felt that she had been as good as running *Bazaar* during the last two years of Snow's reign, though others disagreed; and she had a low opinion of Nancy White, by all accounts an exceptionally nice woman but who lacked the flair of her aunt. "We needed an artist and they sent us a housepainter," Diana said with uncharacteristic venom, for she generally did her best to keep the lid on such feelings, even with close friends. Early in 1958 White had to tell Brodovitch it was time to go. There was further unhappiness when his replacement, Henry Wolf, looked down Louise Dahl-Wolfe's camera during a shoot, causing her to storm out of *Bazaar* for good. Diana, too, looked around at other avenues of employment and even made contact with a search firm. By the end of 1958, however, she had

begun to reach a modus vivendi with Nancy White. "She's . . . open minded, because she's emptied headed [*sic*]," she remarked to Richard Avedon later. "There's a hole there—so you can put *anything* in it." She was rather more politic in a letter to Cecil Beaton. "I am slowly, I believe, coming out of my shock period and as no one has so far interfered with the clothes which is my business, I should be satisfied," she wrote. "I've made up my mind that the devil you know is better than the devil you do not and that there is bound to be something wrong with every job."

Carmel Snow still went to Paris on behalf of *Bazaar* as part of her severance arrangement, so there was no change to Diana's mandate. Beyond that Nancy White had more sense than to interfere with Diana's fashion pages, even if she did find their consistent lateness exasperating. Indeed Diana now found herself playing a more creative role, arguing fiercely for the integrity of photographers' work and frequently getting her way. "Vreeland had this annoying posture of superiority, but she was fanatically committed to her work, whereas the best Nancy White could say about a picture was 'It's pretty,'" the photographer Melvin Sokolsky said, maintaining that Diana saved him on almost every shoot.

There were other compensations too. Seventh Avenue listened closely to what she had to say. *Bazaar*'s most interesting contributors stayed close to the magazine, including a freelance illustrator whom Diana found rather perplexing, called Andy Warhol. (Hired by Brodovitch in 1954, he invariably appeared with his drawings of shoes wrapped in brown paper and was nicknamed "Andy Paperbag" by *Bazaar*'s staff.) Diana and Richard Avedon took on Hearst's senior executives and published Avedon's photographs of the non-Caucasian China Machado in the face of much bluster and bullying. And there was fresh talent to educate in the Vreeland way. Henry Wolf, *Bazaar*'s new art director, recalled that Diana told him she wanted the green of a billiard table as the background to a shot. Wolf dutifully went off and returned with some billiard-table baize. Diana shook her head in dismay. "I meant the *idea* of the green of a billiard table, Henry," she said.

·· ·· ··

IN AUGUST 1960 Diana received a long letter from Jacqueline Kennedy. Her husband, Senator John F. Kennedy, was running for president against the Republican nominee, Vice President Richard Nixon. It was a very close race in which image played a critical role for the first time in U.S. history, because of television. Kennedy's camp grasped this, appreciating that his young, handsome face stood him in good stead in contrast to Richard Nixon; and by the middle of 1960 there was intense interest in his wife, too, who stood out by virtue of her charm, her educated tastes, and her beauty. "If her husband reaches the White House, Jackie will be the most exquisite First Lady since Frances Cleveland," said *Time* in July 1960. But as soon as Jacqueline Kennedy's good looks and elegance were deployed as a weapon in her husband's campaign, her clothes became politicized. The attack was led by John Fairchild, who took over *Women's Wear Daily (WWD)* in 1960 at the same time as the Kennedy campaign began to pick up pace. Determined to make a splash with what had previously been a dull industry newspaper, he started adding a social angle and tart comment to *WWD*'s editorial bill of fare. The timing of Jacqueline Kennedy's appearance on the campaign trail was a gift.

In July 1960 Fairchild proclaimed on the front page of *WWD* that Mrs. Kennedy, along with her mother-in-law, Rose, was running on the "Paris Couture fashion ticket." They were spending fantastic sums of money on Cardin, Grès, Balenciaga, and Chanel—at least thirty thousand dollars annually by his calculations. Jacqueline Kennedy's protest that she couldn't have spent that much if she had been wearing sable underwear was swept aside in the ensuing storm. Spotting an opportunity, the Republicans wheeled in Pat Nixon to proclaim patriotically that she liked American ready-to-wear clothes and thought they were the best in the world. "I buy most of my clothes off the racks in different stores around Washington," she declared. Meanwhile, both Alex Rose of the milliners' union and David Dubinsky, the

powerful head of the International Ladies' Garment Workers Union, which had contributed nearly three hundred thousand dollars to Kennedy's campaign, lobbied the candidate about his wife's un-American fashion choices.

Jacqueline Kennedy bowed to the pressure and wrote to Diana for help. Diana's taste and knowledge of the American market were regarded as second to none, and there was also a personal connection. Diana had arranged for Richard Avedon to photograph the stunning Jacqueline Bouvier for *Bazaar* in the year of her debut; Jacqueline Kennedy's sister, Lee Radziwill, had worked briefly as Diana's assistant; and she was a friend of Freck and Betty. Betty and Jacqueline Kennedy had been friends when they were students at Vassar, and they met again after Freck and Betty's marriage, when they moved to Washington and Jackie was one of the few people they knew.

In the late summer of 1960, decisions about clothes were complicated by the facts that Jacqueline Kennedy was pregnant (and wearing elegant maternity coats from Givenchy); that she was a committed and knowledgeable Francophile in matters well beyond fashion; and that so many top American designers simply made copies of French clothes anyway. But that was not the point. "I must start to buy American clothes and have it known where I buy them . . . there have been several newspaper stories . . . about me wearing Paris clothes, and Mrs. Nixon running up hers on the sewing machine. . . . Just remember I like terribly simple, covered up clothes," she wrote. "And I hate prints." She needed a look that was in some way "American," that played to her strengths, and that was simultaneously of the moment and conservative.

Diana applied herself happily to the task, keeping in touch throughout her summer vacation. "It sounds as if you know exactly the right things—you are psychic as well as an angel," Jacqueline Kennedy wrote back on September 7, 1960, from Hyannis Port. The first step was to choose five or six pieces for a press release in October, close to the moment when Mrs. Kennedy would be too pregnant to appear in public for very much longer. But there was

also something much more secret to consider—the inauguration ball gown: "About the Big Eve! I feel it is presumptuous & bad luck to even be thinking about it now—But it is such fun to think about—I would be imagining it if my husband were a garbage man—But don't tell anyone as Jack would be furious if he knew what I was up to!" Once again she wanted to be very covered-up. "I hate all those Cabinet Ladies exposing wrinkled poitrines." The gown, she thought, should be very simple: "I also thought no beading—but you can decide that." And the material should be of the most "fantastic" quality. "I suppose its undemocratic to wear a tiara," she wrote, "But something on the head." As to color, Jacqueline Kennedy thought, "White as it is the most ceremonial." She circumnavigated tempting fate by deciding she was going to have the dress whatever happened. "I will just have to get it anyway & wear it to watch TV if things dont work out!"

Diana responded by suggesting clothes from sportswear designers Stella Sloat, Ben Zuckerman, and Norman Norell. In spite of Jacqueline Kennedy's injunction that she should not appear to be unduly influenced by Paris, all three designers suggested by Diana had a strong French bias. Even Stella Sloat had Givenchy copies in her portfolio, while Hamish Bowles points out that the purple Zuckerman coat Jacqueline Kennedy then ordered was a "line for line copy of a Pierre Cardin coat in purple wool." Nonetheless Jacqueline Kennedy was delighted. "You really chose me the very best places," she told Diana. "In your travels up & down 7th Ave you might tell the same designers to send me spring sketches—as I definitely want to stick with them." She asked Diana for more advice about accessories to go with the purple Zuckerman coat, and wrote that Diana's idea of a fur jacket to go over the inauguration ball gown was wonderful, apart from the expense.

Before long, however, Jacqueline Kennedy was mired in a different kind of political complication—other people started piling in with advice about her wardrobe. She suddenly became anxious that Diana might be offended at the unexpected involvement of fashion public relations guru Eleanor Lambert. She had no

intention of taking advice from anyone except Diana, she wrote. "I wont consider any clothes except from Norell, Zuckerman & Sloat—& the 'big Eve' if it ever happens—will be all you & me." Diana and Jacqueline Kennedy continued discussing the inauguration ball gown in secret. Jacqueline Kennedy tore out pictures from magazines, writing that she wanted to modify the bodice of one idea "so it doesnt look like a Dior of this season—something more timeless." There was no question that at this point Jacqueline Kennedy regarded Diana as the person in charge of the dress, which was to be made in the custom dress department of Bergdorf Goodman, headed by Ethel Frankau. "Why dont you work out with Miss Frankau & the designers something you like?" wrote Kennedy. "They could send me another sketch of a velvet dress that you design completely yourself." She also wanted advice on a headdress for the ball: "The smaller the better—as I really do have an enormous head."

There was then another complication. However much Jacqueline Kennedy may have wished to retain Diana as her fashion mentor, others had her in their sights once Kennedy became president. In November 1960, Oleg Cassini, a family friend of the Kennedys, proposed himself as her personal couturier; and Joseph Kennedy, her father-in-law, offered to pay his bills should she accept, taking the view that her wardrobe bills could not then be exploited by Kennedy's political opponents. Jacqueline Kennedy accepted this offer, a move that was greeted with some astonishment by Seventh Avenue, where Cassini was not regarded as a designer of the first rank and something of a vulgarian as well. As it turned out, Cassini was a good choice in the new era of television politics, since he had already worked in Hollywood costume design. This turned out to be a great advantage in creating a style for the president's wife. Indeed, Cassini's understanding of the relationship between the camera and fashion was critical to establishing Jacqueline Kennedy's global image. "Cassini approached each project with a movie costume designer's eye, 'envisioning how she would look in close ups or from a distance,'" writes Hamish Bowles. "He took

Jacqueline Kennedy's references as starting points, simplifying and then exaggerating lines and details."

However, Jacqueline Kennedy worried that Diana would feel slighted by Cassini's involvement. She resolved the matter of the "big Eve" gown by wearing Diana and Bergdorf Goodman's creation to the inaugural ball while asking Cassini to design another for the inaugural gala. "Now I know how poor Jack feels when he has told 3 people they can be Secy. of State," she wrote to Cassini on December 13, 1960. Both Diana and the temperamental Cassini behaved well, working together to give the new first lady the wardrobe she needed, including a pillbox hat by Halston, whom Diana much admired, and whose fortunes were transformed from that day onward. "The most incredible & helpful thing you have done is to stay in touch with Oleg," wrote Jacqueline Kennedy, shortly after the inauguration, which took place on January 20, 1961: "It is very hard for him & me this 1st year—as we don't quite know the ocassions [sic] for clothes—so he makes 200 sketches—when all I want are 2 dresses! . . . He has such incredible admiration for you—it comes out in a burst of Italian English—he is so proud & touchy & quick to be rattled—not exactly the temperament one would pick for ones grand couturier—but he is devoted & can do lovely things." She very much wanted Diana to stay involved. "But I hope you will guide him—one of his prettiest dresses is the shoulder black velvet you had him do—so if you can ever spare the time I would so appreciate your helping him—as anything you say he takes as scripture & would make me a dress of barbed wire if you said it would be pretty." And regardless of Cassini's involvement, the muff that Jacqueline Kennedy wore to the inauguration itself, which was the topic of much charmed comment, was entirely Diana's idea.

Diana, along with others including Lee Radziwill and Nicole Alphand, the wife of the French ambassador to the United States, continued to advise Jacqueline Kennedy on her clothes, bringing her attention to new designers and coordinating a wardrobe by Pucci for a trip to Italy. In the longer term, advising the first lady

on her wardrobe was important to Diana because it marked the beginning of a real friendship with Jacqueline Kennedy. More immediately it meant an invitation to the inauguration for Reed and Diana. Washington was engulfed in a snowstorm that day, and according to Diana she and Reed made it to the ceremony only by hitching a ride on a snowplow. To thank Diana, Jacqueline Kennedy agreed to be photographed with the president-elect and their children for *Bazaar.* The resulting photographs by Richard Avedon appeared in the February 1961 issue, precipitating a grumpy letter from Jessica Daves, the editor in chief of *Vogue*, complaining that Mrs. Kennedy had promised Cecil Beaton a sitting for *Vogue* but had called it off until after the inauguration. The sitting with Avedon produced images that the Kennedys liked very much. It also turned out to be an exclusive for *Bazaar.* Thereafter Jacqueline Kennedy decided that press intrusion into the lives of her children would be kept to a minimum, and there would be no more formal photographs of the first lady or the first family.

DIANA HAD BROUGHT *Bazaar* a considerable coup. When it came to the matter of a long-overdue increase in salary, however, even this was not enough for the men of the Hearst Corporation, and Nancy White lacked the authority and strength of personality to deal with them decisively. She may also have lacked the will. When Diana brought up the question of a raise, she took her time to respond, saying, "I think the chances of an increase at the beginning of '61 are pretty good. In the meantime any outside work that you wish to do seems to be okay if cleared with them first." This was irritating. Worse, when "they" did finally respond, it was with an offer of a paltry one thousand dollars. Diana was furious: "So I said, 'Would you please take that back. It upsets everything.' 'Oh well, it will upset everything if you don't take it.' I said, 'Then give it to the Red Cross, but don't send it to me.' Can you imagine—a thousand dollars! Would you give your cook that after she'd been your cook for 28 years?" Given this reaction, a change was inevitable.

By March 1962 the small fashion world of New York was humming with the news that Diana Vreeland was leaving *Bazaar.* She would be going to its archrival *Vogue,* not to replace Jessica Daves but to work alongside her. On March 28, 1962, the news was splashed all over the *New York Times* in an article by Carrie Donovan. For all her flamboyance, Diana was well known only in fashion and high-society circles, and Donovan's extended piece introduced her to a wider public for the first time. She was the fashion world's most colorful personality, wrote Donovan, as well as the most respected editor in the fashion business. Crediting Diana, along with Carmel Snow, for shaping the image of *Harper's Bazaar,* and the look of thousands of American women, Donovan's article also kick-started myths including those of Diana's Paris upbringing, her parents' life of pleasure, and their total lack of interest in her education.

The Hearst organization dripped with tears, crocodile and genuine. Dick Berlin wrote: "You know we all wanted so much to have you stay. We consider you part of the *Bazaar.*" Richard Deems maintained that "the *Bazaar* without you is just never going to be the same," though he did not say whether he thought this was a good or bad thing. Nancy White's note was nice but awkward: "So much of the magazine is your talent—your imagination your fondness for doing what you do with passionate belief your taste and your vision all these things and many more. . . . I do wish Carmel was here, I feel so inadequate." John Fairchild of *WWD* sent a message from Paris that simply said: "You naughty girl."

"Greatest relief since Mafeking," cabled Cecil Beaton from London, alluding to the ecstatic joy in England that erupted at the end of the siege of a small town in South Africa during the Boer War. But it was not Diana he had in mind when he said this: he was talking about *Vogue.*

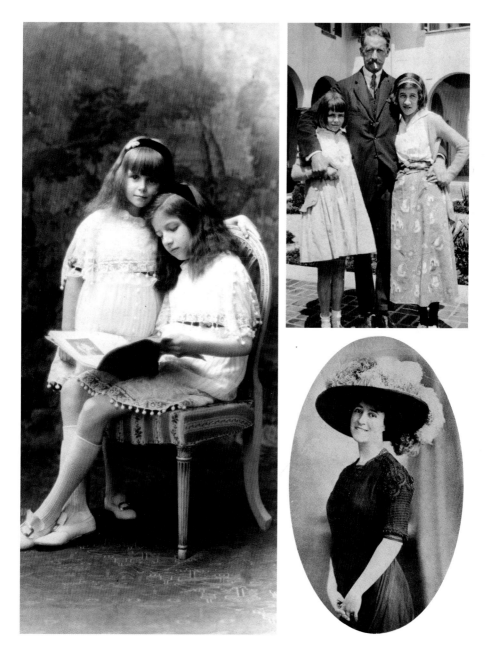

Above, left: Diana aged nine (right), with her sister, Alexandra, c. 1912.

Top, right: Diana aged thirteen (right), with her father, Frederick Dalziel, and Alexandra outside the Villa Diana.

Below, right: Diana's mother, Emily Hoffman Dalziel, photographed by *Town & Country* in 1911. The *Town & Country* caption describes Emily as living with her husband in Paris "until coming to New York a few years ago."

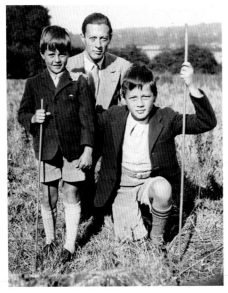

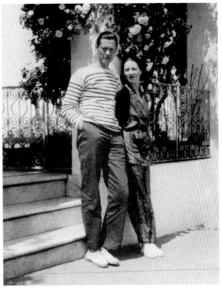

Freck, Reed, and Tim Vreeland, c. 1931.

Diana and Reed in Tunisia in the early 1930s. (Photographer: John McMullin)

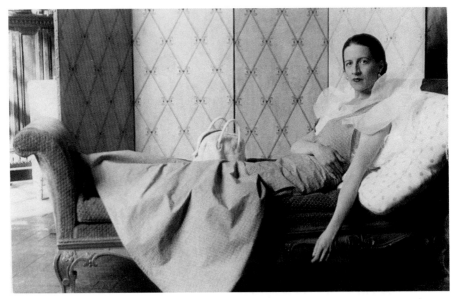

Diana in a preparatory study for a portrait by William Acton, c. 1931.

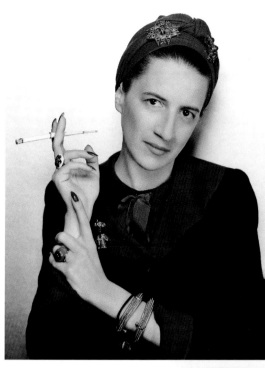

Diana as international woman of style. (Photographer: George Hoyningen-Huene)

Diana presented to readers of *Harper's Bazaar* by Carmel Snow in January 1936. (Photographer: Martin Munkácsi)

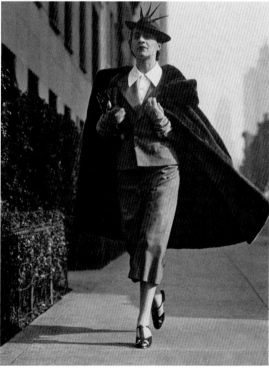

Untitled, n.d. Diana styling a model on a fashion shoot in Arizona in 1941. (Photographer: Louise Dahl-Wolfe)

Diana and Carmel Snow at work in Snow's office at *Harper's Bazaar* in 1952, with a forthcoming issue laid out on the floor. (Photographer: Walter Sanders)

Untitled, n.d.
Freck, Diana,
Tim, and Reed
at Brewster in
the early 1940s.
(Photographer:
Louise Dahl-Wolfe)

Diana and Reed
in Southampton in
the 1950s.

Yearning in wartime: *Harper's Bazaar* cover, September 1943. (Photographer: Louise Dahl-Wolfe)

Anxious in wartime: model in coat by Traina-Norell, outside the Wildenstein Galleries, New York, October 1943. Styled by Diana. (Photographer: Louise Dahl-Wolfe)

Lauren Bacall en route to fame: *Harper's Bazaar* cover, March 1943, styled by Diana. (Photographer: Louise Dahl-Wolfe)

Above: *Harper's Bazaar*, March 1946: "Shipshape in navy . . . wool buttoned bang down the middle with high-sheened gilt," by Nettie Rosenstein; "Shipshape in gray . . . wool jersey buttoned bang up one side with polished sterling silver," by Traina-Norell. (Photographer: Louise Dahl-Wolfe)

Below: *Harper's Bazaar*, October 1956. Jeweled overblouse: "A flowery armature of gold-and-silver paillettes" by Galanos. Jeweled collar: "Clustered with diamonds and worn here like a rajah's ransom above the glint of white mink." Collar: Van Cleef & Arpels. Mink capelet: Maximilian. (Photographer: Louise Dahl-Wolfe)

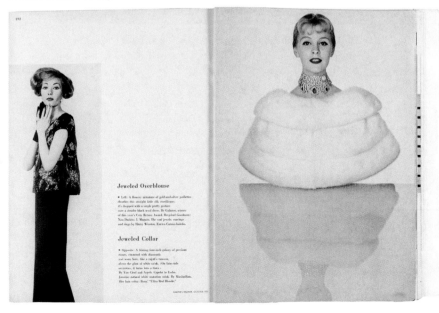

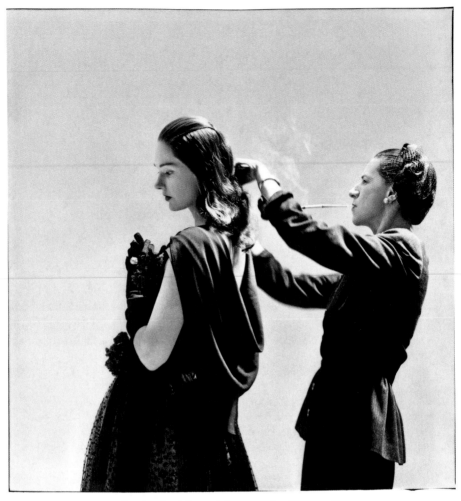

Diana Vreeland with model, on set for *Harpers Bazaar*,
New York, 1946. Photographer: Richard Avedon © 2011
The Richard Avedon Foundation.

YOUTHQUAKE

In 1962 *Vogue* was produced on the nineteenth and twentieth floors of the magnificent art deco Graybar Building on Lexington Avenue at East Forty-Third Street. The magazine had a larger staff than *Bazaar*, and its organization was much more formal. The executives and most senior editors had their offices on the twentieth floor, while the art department and junior hirelings, often from society families who could cope with the low wages, toiled on the floor below. The news that Diana was coming to *Vogue* to work alongside Jessica Daves had an electrifying effect on the fashionable juniors. One of them was Nicholas Haslam, who had recently arrived in New York from London, and was working in the art department. "Suddenly a rumour was buzzing around the corridors of the Graybar Building," he remembered. "'Mrs. Vreeland is coming. Coming *here*, coming to *Vogue*.'" Diana's reputation ran before her. "It was said that her maid ironed her newspapers and her dollar bills, blackened the soles of her shoes to make them look like new, and washed and ironed her bed sheets . . . while she took her bath," recalled Grace Mirabella. "Whether or not all of this was true, we ate it up." There was nervousness about Diana's arrival among those in *Vogue*'s high command who knew her by repute, but for the time being she was protected by Alexander Liberman, the person responsible for luring her away from *Bazaar*.

Liberman's title of Art Editor did not come close to describing his dominance within Condé Nast Publications. A talented sculptor and painter, Russian born and Jewish, he had arrived in the United States during the Second World War and been hired by

Nast himself in 1941. "He had a great gift for jumping into the lap of power," said one *Vogue* editor at the time. Liberman quickly displaced the dyspeptic Dr. Agha as *Vogue*'s art director. He looked like the British film star David Niven, with an attractive manner to match, and he deployed all his charm with Edna Chase to transform the look of *Vogue*. One of his greatest discoveries was a self-effacing man called Irving Penn whose photographs began to appear (in the teeth of considerable opposition from Mrs. Chase) in 1943. Liberman was responsible for transforming and modernizing *Vogue*'s design, and it was thanks to him, as much as to its fashion content, that Nast's flagship magazine maintained its authority from 1941 onward. Liberman also became the éminence grise of Condé Nast because of several characteristics that Diana would have done well to note when she first arrived. His stepdaughter, Francine du Plessix Gray, has described him as a Jekyll and Hyde character: generous, charming, kind, and flirtatious; effective, stimulating, and creative; and manipulative, disloyal, calculating, destructive, and consumed by driving self-interest in equal measure. "He was a strange man," said the British photographer David Bailey. "Always immaculate, never a speck of dandruff, nothing on his desk." When Condé Nast Publications was acquired by newspaper owner Sam Newhouse in the 1950s, Liberman maneuvered himself into place as his unofficial right-hand man and achieved a position of unassailable power within the organization. As an artist, he was ambivalent about the world of fashion. But he was wary of potential rivals, highly controlling, and difficult to read. Though he could reduce junior editors to tears, he rarely confronted Condé Nast's more powerful figures, preferring to set them against one another and stand back until one of them gave way.

Luring Diana to work alongside Jessica Daves, in the hope that Daves would slip away of her own accord, was typical Liberman behavior. Jessica Daves had been editor of *Vogue* since 1946 and had taken over as editor in chief when Edna Chase retired in 1952. Daves had originally joined *Vogue* from the advertising department of Saks Fifth Avenue, and the rigidly conservative

Mrs. Chase came to depend on her, molding her in her own stiff image and pronouncing Daves her anointed successor when she finally stepped down at the age of seventy-five. Daves had certain strengths that the Condé Nast organization later found it missed. She was a good businesswoman. She introduced changes to *Vogue* that made it more useful to readers, especially when it came to finding the clothes that appeared in the photographs. She supported America's sportswear designers and ran a profitable magazine. Married to a writer, she commissioned fiction by artists of the caliber of John Updike and Arthur Miller. But it was not enough. Though Liberman introduced the work of Helmut Newton, William Klein, Bert Stern, and John Rawlings to *Vogue* alongside that of Penn during Daves's tenure, attempts at further innovation consistently foundered on her prim and unwavering insistence, inherited from Mrs. Chase, that *Vogue* was for ladies and must therefore be ladylike. Anything suggestive was taboo. Open mouths were suggestive. Rear views of models in swimsuits were suggestive. So were nightdresses photographed near beds. The photographer Horst once had to retake a whole sitting because he photographed a girl on the floor. When Nicholas Haslam joined the art department in 1962, one of his tasks was retouching fashion photographs to remove all vestiges of the untoward. "We had to touch out navels, such innocent features being then— unbelievable as it now sounds—considered obscene."

By 1962 Jessica Daves's vision of style was widely perceived within the fashion world as uninspiring. It did little for confidence in her judgment that she was mystifyingly badly dressed herself. Round and dumpy—"like a bullfrog," said Bailey—she favored a dowdy uniform of navy blue dress, white gloves, and a small veiled hat that she wore all day even behind the closed door of her office. In spite of occasional concessions to innovators like Rudi Gernreich, American *Vogue* became ever stodgier as Daves advanced through middle age. "NO to a skirt three or four inches above the knee," she declaimed in March 1962; "NO to most of the fashion proposals for the Twist." "She believed in elegance, but her idea

of elegance was that of the bourgeois who wanted it and thought they had achieved it," said Horst. Youth fashion was treated with disdain, unless it came from Dior. In Daves's view, the reader was a well-to-do female who spent her husband's money and was likely to be "the sort of woman who takes a polite, but convinced and beleaguered stand against the current Youth Fixation." She was already in possession of a little mink throw, and prepared to mark time until a really good tweed suit came her way. "You've cased the collections, French and American, made some major clothes-decisions on the basis of them, and your shopping list at this point rather resembles a half-solved crossword puzzle," began one article in October 1961. *Vogue*'s raison d'être was helping the puzzled reader spend her "clothes-dollars" on appropriate clothes for an upper-class lifestyle and nudging her away from expensive mistakes.

Diana arrived at *Vogue* in April 1962 and clashed with Jessica Daves almost immediately, just as Liberman intended. To begin with, her role at *Vogue* was ill-defined—she first appeared on the masthead in June 1962 with the catchall title of Associate Editor. Diana knew she had to proceed with care, and it was extremely frustrating. "We have thought of you so much in the first days of the new job," wrote Betty on April 14, 1962. "It must certainly be wearing to know what one wants to do and yet have to pull oneself back & go slowly." Egged on by Liberman, Diana increasingly took power into her own hands, bypassing Daves on important decisions and going straight to the Condé Nast high command for approval. Contributors found themselves caught in the crossfire. Horst, who had almost given up working for *Vogue* under Daves, was suddenly telephoned and asked to photograph Consuelo Balsan, who had been born a Vanderbilt, and later married and divorced the ninth Duke of Marlborough. He duly photographed Madame Balsan in color, whereupon Jessica Daves phoned him and protested, insisting that society women in *Vogue* were always photographed in black-and-white. Two days later Liberman and Diana both called Horst to tell him to go back and take as many photographs of Madame Balsan in color as he wished.

"I worried that you with your birdlike legerté would find your flights of fancy arrested in mid air and that your wings would have been spattered with heavy oil," wrote Cecil Beaton to Diana. But he need not have worried. Four months after Diana arrived, Jessica Daves ran up the white flag. A disagreement over whether to publish photographs from Bert Stern's last sitting of Marilyn Monroe, taken just before she committed suicide, was probably the last straw, but by then the battle was already over. Although Liberman later pretended that he had never expected her to go, Jessica Daves slipped off, by way of a courtesy title of Editorial Adviser, and by mid-August 1962 negotiations had begun with Diana about her salary and expenses as editor in chief. Diana's appointment was announced publicly in November 1962, to the great relief of her family who had taken nothing for granted. "My goodness we are so proud," wrote Betty. "Freck was so worried that a new Miss White would be a bête noir. . . . But Diana, what an exciting adventure! . . . What fun *to really have* the reins and not be an 'eminence grise' . . . Frecky is just beaming! . . . He had been so worried for you—your news took a huge load off his shoulders."

In January 1963 Diana appeared on the masthead as editor in chief of *Vogue* for the first time. Later she would be accused of wild, publicity-seeking egotism. But at this point it was Condé Nast Publications that exploited her persona to publicize the reenergizing of *Vogue*, circulating an interview with *WWD* that took the form of questions and answers. "What is fashion?" asked *WWD*. "It's a natural delight, stronger than pestilence, war and economic upheaval," replied Diana. "What is the function of a fashion magazine?" asked *WWD*. "To instruct when possible, to delight, to give pleasure, to bring to the reader what interests her," said Diana. "Everybody makes an appearance every day." The imagination was of paramount importance: "Before even the technique, there is the dream. Chanel had it. The dream is everything."

What she did not know, however, was that in the weeks before her appointment was secure, this kind of talk had been causing great concern. Freck had been right to worry that Condé Nast's

owner, Sam Newhouse, and Liberman would lose their nerve at the last moment and appoint a Nancy White "bête-noir" instead. There were those, including *Vogue*'s long-standing features editor, Allene Talmey, who argued that Diana would take the magazine in too frothy a direction, and that Liberman himself should take on the role of editor in chief. Liberman resisted, saying that he knew little about fashion, that *Vogue* had to be edited by a woman and needed strong medication. He nonetheless exploited these anxieties to his advantage. At the same time that Diana became editor in chief of *Vogue* in 1963, Liberman was made editorial director of Condé Nast, with the surreptitious brief of liberating Mrs. Vreeland from *Vogue*'s most conservative forces while simultaneously keeping her under control. But Diana was too excited by her fresh start to scent any danger.

> *My God, when I think of my years on* Vogue . . . *I used to wake up every day of the week and I couldn't wait to get cracking. I mean, I was a nervous wreck until I'd done at least 43 things that morning. I had three, four and five secretaries taking dictation at once—ideas, ideas, ideas . . .*

The new editor in chief took some getting used to. The greige tints favored by Jessica Daves were swept away, replaced by bloodred walls, "*tee*-gray" carpet, a sofa covered in leopard cotton, rattan chairs, Rigaud candles burning in silver saucers, and a black lacquer desk, where Diana kept a stack of lined notepads that were rarely filled beyond the first page. Those adjusting to life with Mrs. Vreeland soon understood that her exploding creativity went hand in hand with fierce attention to detail. She had a large bulletin board on her office wall, covered in swatches of fabric, illustrations, details of a Balenciaga cuff, photographs of Audrey Hepburn's shoes, an Italian Renaissance portrait, and notes with phrases like "luck is infatuated with the efficient." Within a short time, the atmosphere throughout *Vogue*'s offices

began to change. "Diana Vreeland didn't just sweep down the hallway, she loped," Grace Mirabella remembered. "A stream of orders, barks of laughter, and bits of commentary announced her arrival at each doorway she passed. Her voice was low and throaty. It projected, hornlike, into every office. . . . It didn't take long before half the office was moving, and standing and dressing and speaking, like Diana Vreeland."

Admiration for Diana's style was one thing. A universally sympathetic reaction to the flood of "ideas, ideas, ideas" was quite another matter. Susan Train, *Vogue*'s American editor in Paris, found Diana uproariously funny and was immediately on her wavelength. Priscilla Peck, the art director, adored Diana, relishing her imaginative iconoclasm and her preference for the visual image over the written word. Peck had been a painter of note in her youth, and part of the lesbian set that surrounded Joe Carstairs, a tattooed cross-dressing Standard Oil heiress. Several of her *Vogue* colleagues thought she fell in love with Diana, though there was no sign that this was in any way reciprocated or indeed that Diana even noticed. Others came around to Diana's way more slowly. Kate Lloyd was associate features editor at *Vogue* in 1962. She had worked hard on an article about the French ex-model Bettina, who was the mistress of Aly Khan, and had conscientiously covered every aspect of her life: her clothes, her makeup, her house in Paris, her trips down the Nile, and her exercise regime. Feeling rather pleased with herself, she sent the portfolio (the text and pictures) to Diana's office. A short time later Diana rang her and told Lloyd—who had been at *Vogue* for considerably longer—that she didn't quite seem to understand what *Vogue* was all about. "The steam started coming out of my ears at that point. I said, 'Tell me, Mrs. Vreeland, what is *Vogue*?' She said, '*Vogue* is the myth of the next reality.' And I got it. I absolutely got it. Take the words apart and they don't mean a thing, but I saw exactly what she was driving at, and I never had a moment's difficulty with her again."

However, there were those like Rosemary Blackmon, *Vogue*'s

managing editor, who never came to terms with Diana at all. A particular bone of contention was Diana's refusal ever to hold a meeting with more than one person, and her lack of anything that could conceivably be described as a management style. "My mind drifts around a lot," said Diana. "I could take in 17 situations in an hour." Unlike Daves, Diana did not feel the need to explain even one of her seventeen trains of thought. She simply expected everyone to keep up. "Whereas the entire chain of editorial decision—view of fashion, choice of cover, choice of content and presentation—used to flow easily from the editor in chief to the fashion editor to the art department to the merchandising department, no one knew what was going on, from one hour to the next, with Vreeland but Vreeland," wrote Grace Mirabella. "Sometimes she paid attention, sometimes she didn't. I think that's why Rosemary had such a terrible time with her," said Carol Phillips, *Vogue*'s beauty editor. "If you say yes, that's fine. Then two minutes later, she'd say I didn't say it. You had to roll with the punches. I don't think Rosemary could do that. She was quite literal and she was very upset."

Within months of starting, however, Diana had the sense to realize that she needed someone who could interpret her pronouncements and communicate her vision internally if she was to have any chance at all of succeeding. She eventually found the ideal person in Grace Mirabella, but it took some persuasion. Mirabella was working as a fashion editor at *Vogue* when she heard that Diana was coming to Condé Nast. She was so appalled by what she had heard through the grapevine about Mrs. Vreeland's hallucinatory ways that she resolved to get as far away from her as possible. She even went to the lengths of swapping her job as a fashion editor for one in marketing, but she hated it so much that she eventually returned to the fashion side. Mirabella soon learned that working as a fashion editor for Diana was nothing like any job she had ever done before. "At my first run-through with Vreeland, I selected three racks of dresses and presented them, making a case for a story about how the look of dresses that

season was wool jersey." Diana listened without saying a word as Mirabella plowed on.

> *At the end I asked her if there was a problem.*
> *"Well," she said, "I wasn't looking for a market report. I thought you were going to give me a little something."*
> *"Like what?" I asked. I thought I had given a good deal.*
> *"A little something." She said, "A dream."*

The trick, said Diana, was not to give women what they already knew. It was to *"give 'em what they never knew they wanted."*

Diana sent Mirabella back to the sportswear department, where she had been happiest. This was not a compliment. By the time she arrived at *Vogue,* Diana had tired of all but a handful of American sportswear designers, and was preoccupied and excited by the Paris couture whose collections she was finally being allowed to attend in an official capacity for the first time. "Her tastes were as aristocratic and European as mine were democratic and American," Mirabella wrote of Diana later. "Ready-to-wear barely qualified as fashion in her book. She called sportswear 'boiled wool,' said ready-to-wear fabric was 'like the covering of an old tennis ball.'" Even when Mirabella was ensconced back in her sportswear niche, she found Diana's criticisms of her sittings insufferable. The editor in chief demanded endless retakes. She only knew something was "duh-vine" when she saw it. "I'm looking for the *suggestion* of something I've never seen," she kept saying. At the end of one particularly bad day, Mirabella decided to quit and take a well-paid job with Catalina, a swimsuit manufacturer. "It seemed the perfect antidote, like a drying-out period, to the delirium of Vreeland." But a few days later she saw a much more down-to-earth and kindly side of Diana, who had heard about the job offer, knew that Mirabella had once turned down *Bazaar* out of loyalty to *Vogue,* and urged her to stay. A short time later she offered Mirabella the role of an associate who would help her get the magazine out, a producer to Vreeland as

director. After agonizing for a day and a half, Mirabella decided to take the job. "It's going to be a grand adventure," said Diana.

THERE IS A perception, encouraged by Eleanor Dwight and others, that as soon as Diana took charge at *Vogue*, she stormed in, elbowed aside the dull fifties, opened up the magazine to the "swinging sixties," and led the charge in a full-blown fashion insurrection. "From the moment she came to *Vogue*, she created a revolution," wrote Alexander Liberman in 1989. "Diana Vreeland shook up years of tradition that needed to be reexamined. She brought iconoclastic daring. She encouraged the breaking of rules and taboos. . . . She was the most talented editor of her period because she was able to stamp an era in the reader's mind." However, anyone picking up a copy of *Vogue* from 1962 or 1963 hoping for a dazzling display of iconoclasm is destined to be disappointed, for several reasons.

First, the tumult that characterized the decade only began to permeate America from 1964 onward, and though its roots are detectable much earlier, they grew in social and political movements at a metaphysical and geographical distance from *Vogue*'s offices. When it came to fashion, the head-to-toe glamour of the 1950s only disappeared gradually too. Fashion ideas still permeated relatively slowly in the early 1960s, and it would be another three years before the idea of appropriate dressing for different times of day entirely evaporated and the staple of *Vogue*'s pages ceased to be the little suit inspired by Coco Chanel, topped off with a hat and white gloves. Until the mid-1960s Paris couture took pride of place, and issues devoted to the New York collections invariably featured the grandee American designers Norman Norell and James Galanos, who had risen to prominence in the 1950s, and Mainbocher, who flew an ever-more-lonely flag for the spirit of prewar Paris couture from his New York atelier.

Moreover, in moving to *Vogue* from *Bazaar*, Diana moved to a less adventurous magazine. Yet commercially *Vogue* was also more successful. There were twenty issues of American *Vogue* a year (it

only went monthly in 1973) but even allowing for this, *Vogue*'s circulation figures consistently outstripped those of *Bazaar* throughout their joint history. In spite of her grand title, Diana was not in total control of every aspect of the magazine. Like all *Vogue*'s editors in chief before her (and like Carmel Snow at Hearst) she was answerable to the magazine's owner, Sam Newhouse; its publisher, Edwin Russell, followed by Si Newhouse in 1964, and the senior executives of Condé Nast, who controlled advertising, sales, and the business side of the magazine. From their point of view, Diana's task was to provide the content that would deliver readers to advertisers. *Vogue*'s high command regarded both its North American readers and its advertisers as conventional and conservative. *Vogue* had always stood for elite luxury; and the elite to which the magazine addressed itself was not particularly young and anything but radical.

From the time Diana formally became editor in chief, she was also answerable to Alexander Liberman as editorial director of Condé Nast; and while he craved more editorial and visual excitement in the wake of Daves's reign, he was an obstacle to rapid change in the layout of the magazine. Liberman had created *Vogue*'s graphic design, building on the work of Dr. Agha. But for all his skill, and his talent in spotting new photographers, he lacked Brodovitch's brilliance—and David Bailey, for one, thought he knew it. "He could never get over Brodovitch," said Bailey. "He knew he wasn't as good." The effect was a magazine that looked more staid than *Bazaar*, with far more typeface to each page. Though Liberman was open to change, he continued to appear in the art department to cajole and criticize. The result was that even at its most experimental, the layout of Diana's *Vogue* of the 1960s never came close to the remarkable daring of *Bazaar* in the 1930s. It also did not help Diana that *Vogue* was much larger and more factionalized than *Bazaar*, with powerful cliques. "We are talking about a snake pit," said one of her old colleagues. Some senior editors simply dug in their heels. *Vogue*'s features editor, Allene Talmey, had a semifiefdom of her own and

continued to balance the fashion pages with articles about intellectual figures like Georges Auric, and profiles of major contemporary artists by Liberman himself.

Beneath this conservative patina, however, Diana wrought huge changes as she attempted to make *Vogue* her own in the first half of the 1960s. "Editing is four walls of work, walls you have to open to let in the light," Diana informed her staff, as she set about doing precisely that. "You have to ignite women's appetites, titillate them so they want something. But the whole thing has to look spontaneous and you mustn't have too many theories." Diana did not approve of intellectualizing. ("Those were terrible pictures we published. They were taken by an intellectual," she said to Cecil Beaton. "It won't happen again. If we have an intellectual working for *Vogue*, he's running the elevator.") *Vogue*'s role was to present the reader with a palette of ideas that would delight and inspire her and, of course, loosen her purse strings.

> *At* Vogue, *I was what you might call an* enfant terrible. *I remember an absurd scene over a picture when I first started working there. The girl's legs in the picture were superb, but she was quite thick around the middle and her face was ghastly. So I said, "The legs are great but as for the face—forget it! Let's just use the legs and combine them with this torso and that . . ." I thought they'd fall on the* floor. *"But don't you do this all the time?" I said. They thought it was the most immoral thing they'd ever heard of—to take an artist's work and . . . so I said, "Listen, photographers aren't artists, for goodness sake!" There's very little art in the world. What there is is splendid, but let's not confuse it with fashion It's all* trompe l'oeil, *but we're talking fashion now, not art. That was my business.*

On Diana's watch *Vogue* became a composite of different textures, materials, and ideas; a kaleidoscopic montage of fashion and art, high and low culture, imaginative creativity and rampant materialism—and from the start she actively embraced youthful energy, regardless of age.

The change began with the magazine's language. In the summer of 1962, well before Daves's official departure, the reader's attention was drawn to clothes in "clay white, creamy white, chamois white, chalk white, smoky white" and a line that was all "dash and zing." Articles appeared for women with "junior figures,"—not for juniors, but "for women with youthful figures at any age." The issue of August 1, 1962, constituted Diana's first real breakthrough. In direct contrast to Daves's "convinced and beleaguered stand against the current Youth Fixation," the cover trailed "The Pepper in the Fashion News . . . How to Use It in the Young Way." A fresh, vibrant Penn image of a model in a scarf tied around her head and under her chin linked to photographs inside of Mrs. John F. Kennedy, Princess Margaret, and several queens wearing theirs in more or less the same way and the issue brought to life a "free-wheeling school of collectors" who were "the vivacious, the enthusiastic, the enfants terrific; the people who know it's today."

This emphasis on peppery younger fashion and a younger fashionista served notice on the changes that would soon pervade the magazine. "Enfants terrific" were dressed for early 1960s action in white parkas, seal-sleek black stretch ski pants, and scarves tied in a cowl in the manner of international royalty. "Their pitch is black and white this season, runaway, contrary, zoomy, diverse," said *Vogue*, and to underscore the point, black-and-white photographs emerged from more expansive white spaces, the typeface was reversed out in white against a black background, and the article intersected with blocks of zinging mustard yellow. Cropped photographs started another trend that Diana would soon develop—a greater sense of closeness and intimacy with the model, making her something more than a clotheshorse and blurring the distance between the page and the reader. By October 1962 Diana was applying her composite approach to the fashions too, taking liberties with the work of America's leading designers in a manner that was new to *Vogue*. A feature called "What to Wear With Your New Boots," photographed by Bert Stern, teamed a grasshopper green overcoat by Norman Norell with black suede boots by Charles

Jourdan, topped with a black velvet boy's cap. However contemporary this looks now, and however right it may have been at the time, Norman Norell never forgave Diana for such *lèse-majesté* and sent his own dressers along to *Vogue* shoots thereafter.

FROM JANUARY 1963, when Diana formally became editor in chief, she used the editorial column *"Vogue's* Eye View" to explore, describe, and enthuse about new trends and ideas. Priscilla Peck redesigned the layout of the column so that it became bolder and more dramatic, and Diana's remarks were often accompanied by an image that set the mood for the entire issue, and sometimes the fashion season. It is clear from Diana's 1918 diary that she had long taken the idea of the New Year, New Year's resolutions, and a new start seriously; and it is no coincidence that Diana used her very first *"Vogue's* Eye View" of January 1, 1963, to give the world the Girl, the idealized version of the self who first appeared in her diary, that being whose divine spark had propelled her forward so triumphantly since her miserable adolescence. The Girl only ever appeared in *Vogue* obliquely. But, in her first editorial in January 1963, Diana presented her as someone very young, using a photograph by Cecil Beaton of seventeen-year-old Lily Cushing holding a flower to make the point. Lily was a young girl waiting—or listening—in absolute stillness, wrote Diana.

> *In this stillness, it is possible to hear things that are lost in the crowded, clamorous rooms; and to feel and know other things that are unheard. . . . Above all, it's possible to hear the often-disregarded voice of what you yourself think. And if any New Year's resolve is to be made, it might be to listen oftener to this voice—to be true first of all to this person: yourself.*

To be herself, a woman had to allow herself to dream, as Lily was dreaming, of becoming the heroine of her own life.

This was a theme to which Diana would return over and over again throughout her time at *Vogue*; and soon after she took the

reins, she extended the idea of becoming a heroine to women who were not born beautiful and did not conform to contemporary ideas of prettiness. By 1964 Diana was actively challenging conventional American ideas of female beauty, asking *Vogue*'s readers to look instead at women with vital, distinctive, alluring faces. On August 1 that year Diana turned over most of the magazine to two new prototypes, the "Chicerino" and the "Funny Girl." In many ways, the Chicerino read exactly like a projection of Diana herself. She was "full of the zest of doing things." She had "the vividly personal quality" of a girl who liked herself, who expected the best of herself and the best of everything, a girl with "star quality." She was "defiant and unswayable" and thus swayed all, a "mover and maker of fashion—stimulus for the good looks of her era, the measure of chic in her time." As Diana put it:

> *The image she presents is of her own, intensely personal manufacture—a projected vision of herself, nourished by intuition, by ego, and by the single-minded clarity of her thinking. Her presentation is perfect: she comes in a blaze of certainty, engages all interest, sustains it, provokes. Unhesitatingly she chooses what's good for her—the gesture, the look that exactly conveys her mood, her quality, her special dash. No other fashion counts. . . . The Chicerino is every country's phenomenon: she is the girl who owns the world, makes it swing . . . the girl who holds onto her personality with both hands and projects it with style.*

The Chicerino was represented by the actress and model Benedetta Barzini photographed by Penn; the singer Françoise Hardy photographed by David Bailey and wearing designs by Emanuelle Khanh; and the actresses Catherine Spaak and Sarah Miles wearing slip dresses and smocks by young designers.

Alongside the Chicerino, Diana introduced the Funny Girl, initiating an idea of beauty that read like a retort to the unkindness meted out to her in her youth. Women with odd faces, even

ugly women, could be beauties too, Diana suggested. The time
had come for the Funny Girl with the idiosyncratic looks of Bar-
bra Streisand, Tammy Grimes, or Carol Channing: "A funny thing
has happened: there is now, in the best young beauty, a place for
quirkiness. There is a taste for the odd feature, a drive toward
knowing eccentricity. . . . Funny Girls would rather look interest-
ing than safely pretty. The look they avoid, in fact, is prettiness
in the country-club sense." Funny Girls too were strangely like
Diana. "They consider themselves blessed if they have one frankly
crazy feature to work with; they're mad about eyebrows with some
character. One Funny Girl has a large nose—and she makes other
people wish they had large noses."

As editor in chief Diana felt—and was initially allowed to
feel—that she had the freedom to take everything she had ever
learned about becoming the Girl, everything of beauty, every
fantasy that had ever caught her inner eye, and place it all at
the reader's disposal. As the new editor in chief she ranged back-
ward and forward across half a century of experience. The cre-
ative relationship between film actress Audrey Hepburn and the
couturier Hubert de Givenchy blazed with the same inspiration
that flew between the women of style and their couturiers in the
1930s: "What fires his imagination races hers; the message he
cuts into cloth she beams to the world with the special wit and
stylishness of a great star in a rôle that suits her to perfection."
An issue that gave twenty-four pages to jersey and pearls looked
Janus-like back to Chanel in the 1920s while encouraging the
1960s reader to adapt the look in her own way. "Chanel started
it: took jersey, showered it with pearls, and—like *that*—gave the
world its greatest fashion natural. Then, now, forever: the fashion
that . . . causes certain pearls to become luminous for her alone—
delicious new possibilities in her own allure."

"Isn't that life, darling?" said Diana to Lally Weymouth later.
"You pool all the things of your childhood, all your fantasies, all
your imagination—everything together, and then you become a
woman . . . and you've got it all together on your own." But all

the while, she continued, "You're developing every moment. You develop every moment of your life. Don't you think that's how it is?" For all that she brought the past right up to *Vogue*'s present as editor in chief, Diana was just as avid as she had ever been for what was fresh and new. If the reader was to remain open-minded and develop every moment of her life, she had to be able to catch fascinating new moods on an early breeze—and *Vogue* was there to help her do it.

DIANA KNEW VERY well before she left *Bazaar* in 1962 that a new mood was blowing through London and London society. At *Vogue*, she set up a direct line to the tiny handful of people who actually constituted "swinging London" through Nicholas Haslam, who had come from his native England with the photographer David Bailey and the model Jean Shrimpton in 1962, and stayed on. A lesser editor in chief would have left him sitting there, but he charmed Diana and became a friend of both Vreelands and a vital source of firsthand information about who and what was happening in England. Diana quickly came to trust Haslam's instincts. When he made a friend of the fingers-on-pulse New York socialite Jane Holzer, Diana arranged for her to be photographed by Penn and she appeared in the next issue. It was Haslam's father who first drew their attention to the Beatles. He read about them in newspapers and sent his son a clipping. "Being from Lancashire himself, he'd been intrigued by them, though he was the least musical of men. I showed this article on the Beatles to Mrs. Vreeland: 'They're too *adorable*, get them photographed immediately.'" She sent him to England to arrange it. "In those days the fans threw flowers, rather than bottles and knickers, onto the stage. I gathered these up into posies and passed them to the boys. Holding them, these wild young cannibals sat there looking as innocent as Victorian bridesmaids." The resulting portrait, taken after a gig in Northampton in 1964, was the first photograph printed of the Beatles in any American magazine.

Contrary to legend, it was Liberman, not Diana, who gave

David Bailey a contract with Condé Nast a few years before she started at *Vogue*. Indeed, when Bailey heard the news that Diana was coming to *Vogue* from *Bazaar* in 1962, he was sure he would be fired because Diana would entice Avedon, Derujinsky, and other *Bazaar* photographers to follow her. As it turned out, Diana welcomed Bailey and a soaking wet and terrified Jean Shrimpton with great geniality into her *Vogue* office soon after she arrived, roaring, "Stop! The English have arrived!" at a bemused assistant as they came through the door. They immediately became friends and, intermittently, collaborators. Photographs of Jean Shrimpton by Irving Penn and Bailey began to appear in late 1962, and Diana put Shrimpton on the cover of *Vogue* in 1963. "No one knew more about fashion than Diana Vreeland, and she could make or break anyone in the fashion world in the States," said Jean Shrimpton later. "She made us." For her part Diana agitated that her senior staff were failing to pick up the new London atmosphere. "I think we are frightfully missing, and I am sure you agree, in English lore," she wrote to Allene Talmey, urging her to do better. Diana repeated her triumph in anticipating the success of the Beatles by publishing a photograph by Bailey of his friend Mick Jagger while he was still unknown to all but his UK fans. Every other editor to whom Bailey offered the photograph in 1964 spurned it, saying that Jagger was ugly. Diana's reaction was that she would publish it whoever he was. "To women, Jagger looks fascinating, to men, a scare," wrote *Vogue*. "The effect is sex . . . that isn't sex, which is the end of the road." The Rolling Stones were "quite different from the Beatles, and more terrifying."

It was significant that the focus of "English lore" in *Vogue* was initially on London's pop and rock stars, for Diana always maintained that it was 1960s music that opened her eyes to the great social and economic change that was under way. Although she was sixty-one in 1964, she had one great advantage over her younger staff because she had danced, partied, and smoked her way through the early 1920s. "I've known two great decades in my life, the 20s and the 60s, and I'm always comparing them because of the music.

Music is everything and in those two decades you got something so sharp, so new." The parallels between 1920s New York, 1920s London, and 1960s London were startling: rebellion by a younger generation against the attitudes of parents who had either fought in or lived through a world war and the privations that followed; reaction against the idea of patriotic duty; fashion that challenged Victorian mores and mature body shapes and that displayed the youthful body, with bare backs and skirts rising up the leg once again; a much less inhibited sexuality, encouraged by the arrival of the Pill after 1960; underground clubs; moral panics; a tendency on the part of the older generation to equate any part of youth culture, even slightly longer hair, with rejection and full-blown moral degeneracy; and all of it expressed in the sounds of raw, even threatening, popular music and new risqué dances.

Nonetheless Diana had to be careful about how she presented new moods to *Vogue*'s readers. Fresh ideas from London tended to appear first in the "People Are Talking About" column or feature articles about its leading players. Even so, "caution" was the watch-word. Mary Quant, for example, first appeared in *Vogue* in August 1963, in an article titled "The Adventurous Ones." Quant had been designing and selling her highly original clothes in London since 1955; the editor of New York's *Seventeen* magazine had championed the manufacture of her work in the United States; and Quant's designs were already available in Lord & Taylor by the time the article was published. Nonetheless in 1963 *Vogue* positioned her at the cutting edge of fashion experimentation, equating her quite explicitly with Valentina Tereshkova, the first woman in space. Quant and her husband, Alexander Plunket Greene, had gone "against everything expected of them" wrote *Vogue*, discovering "what no one in England knew—there was a whole new 'want' among bright young English girls for new, young, skinny clothes that sometimes have the look of fancy dress. Right for them."

The implication was that while Quant's designs ("at first, more thought-up clothes than designed clothes") were intriguing, they were not necessarily right for the women of the United States.

When it came to innovative youth fashion ideas, Diana was more confident about featuring fashion that came to New York straight from Paris, particularly the work of Emanuelle Khanh, whom she described as the "vanguard and heroine of young French fashion." A former haute couture model, Emanuelle Khanh particularly endeared herself to Diana with her philosophy, inherited from Chanel, that clothes should follow the line, silhouette, and movement of a woman's body; and Diana was also enchanted by the interpretations of youth fashion emerging from the Paris couture salons of the ever-inventive Balenciaga. Indeed Diana later maintained that she always saw the new ideas of the 1960s at Balenciaga first. "I didn't go much for this street-up business . . . because it seemed to me I'd always seen it at Balenciaga. . . . Balenciaga, for instance, did the first vinyl raincoats, like the gendarmes wear, you know, in the winter in Paris. The cape and the boots and the short skirts and the elaborate stockings . . . Balenciaga was incredible."

Once she had decided that the popularity of London's new young designers were more than a passing phase, Diana campaigned to devote an entire issue to them in 1964 but eventually elected to spread the material over several issues. The September 1 cover was shot by David Bailey; the September 15 issue featured British tweeds from Mary Quant and Wallis Shops, accessorized with stockings from Mary Quant and Polly Peck; Alan Brien wrote about the pioneering theater director Joan Littlewood; and the novelist Edna O'Brien offered American readers a glimpse of "Four Eligible Bachelors in London." These issues also included "limber little wool suits" from "the nifty Americans" and a selection from André Courrèges's latest collection from Paris, featuring silver hipster pants that revealed the midriff, pink glitter boots for evening, and skirts that bared the knee accompanied by white kidskin boots.

In the end it was these Courrèges designs that caused an explosion and not the English innovators; and it showed that the conservatism of *Vogue*'s readers was not to be underestimated. *"That* was something," said Diana. ". . . a top, a bare midriff, and a *belly button* showing. The letters came in. 'This is a house

where magazines are put on the coffee table, and now we find it impossible to put *Vogue* there. As the mother of a nineteen-year-old son . . .' 'My God, lady,' I thought. 'Let him go! Send him away! One night in Tangiers! Tunis! *Cairo!*' " Accustomed as she was to the more audacious approach of *Bazaar*, the tizzy of some of *Vogue*'s senior editors also surprised Diana. " 'Why did you run a picture like that?' the staff wanted to know. 'Because I'm a reporter,' I said. 'I know *news* when I see it! What are we talking about, for Christ's sake—pleasing the bourgeoisie of North Dakota? We're talking *fashion*—get with it!' "

VOGUE TOUCHED ONLY lightly on the politics of the early sixties, though in her first *"Vogue*'s Eye View" even Diana, the most apolitical of women, shared a widespread, optimistic delight in the Kennedy presidency and its forward-thinking initiatives: "It's possible to feel on your cheek, like a fresh wind, the hopeful veer of events: the quick forward surges in education, in science, in the courts of law, in the assemblies of nations. To look back with surprise and pleasure on a year in which many good things happened, and many bad things did not (war was avoided; a group of persons over sixty years old joined the Peace Corps; an election was held in which the electorate showed a bizarre, delightful tendency to think for itself.)" It was Nicholas Haslam who broke the news to Diana of Kennedy's assassination on November 22, 1963, having heard it on his illicit radio in the art department. He rushed to find her in Janssen's, the restaurant on the street floor of the Graybar Building where they sometimes met for lunch. "I blurted out, 'Diana-the-president's-been-shot-and-they-don't-think-he's-going-to-live.' She looked aghast, paused for a moment, and then said only, 'My God, Lady Bird in the White House! We can't use *her* in the magazine.' " Later, after they watched the funeral together, she said to Haslam: "He had a golden touch, Jack. . . . The world will get grayer now."

Vogue did "use" both the new president and his wife in 1964, with Mrs. Johnson photographed by Horst. But as if in response to the end of Camelot, *Vogue*'s sparkle dimmed slightly in the early

months of 1964. The fashion pages in the months following Kennedy's assassination seemed to retreat in almost retrograde fashion to the safety of demure, blond, soft 1950s prettiness, a countertrend to the Space Age ideas that started to seep in during the spring. Nonetheless Diana's investment in younger fashion continued, and *Vogue*'s spirits rose again throughout the year. Diana followed up the photograph of the Beatles with a much longer feature article by Betty Rollin in September 1964 that alluded to a new antiestablishment spirit. Rollin brought the "fury" and "sadness" of singer-songwriters like Joan Baez, Bob Dylan, and Tom Paxton to the attention of *Vogue*'s readers, mentioning in passing the Free Speech Movement that was starting to gain momentum at Berkeley. "Aside from new topics, there is something decidedly new about the way topical songs have caught on," she observed. Mary Travers, of Peter, Paul, and Mary, put the popularity of songs written for demonstrations and picket lines down to the spread of television and radio. Another singer, Phil Ochs, commented: "In the fifties young people had a rebellion without a cause. In the sixties we have so many causes we don't know what to sing, write, or just do something about first." Political engagement, observed Rollins, was newly fashionable. "It seems," she wrote, "it is no longer square to care." As political turmoil in the world beyond *Vogue* gained momentum in 1964, however, Diana pulled back from too much overt discussion of the issues that would convulse America for the rest of the decade. She looked instead for trends, particularly those that played themselves out through fashion; and she put her own stamp on the decade as she did so.

"Youthquake" was Diana's celebrated expression for the most significant social and cultural development of the 1960s—the rise of the young, who did not wish to dress like their parents, as an independent style force, a phenomenon she embraced in January 1965. The youth of the sixties no longer waited at home for life to start, she noted:

There is a marvelous moment that starts at thirteen and wastes no time. No longer waits to grow up, but makes its own way, its own look

by the end of the week. Gone is the once-upon-a-daydream world. The dreams, still there, break into action: writing, singing, acting, designing. Youth, warm and gay as a kitten, yet self-sufficient as James Bond, is surprising countries east and west with a sense of assurance serene beyond all years.

It was an international wave that had already hit London and Paris. The new jump-off age was about to be the exhilarating new reality in America too—and she could even back it up with statistics:

The year's in its youth, the youth in its year. Under 24 and over 90,000,000 strong in the U.S. alone. More dreamers. More doers. Here. Now. Youthquake 1965.

Even in the Youthquake issue of January 1965, however, close inspection reveals that Diana was careful about how she introduced youth fashion to *Vogue*'s American readers. She had already formed the habit of breaking down resistance by putting new fashions on the right people. The Courrèges trouser suit was first photographed in March 1964. Once Diana thought it might be pushing aside the two-piece suit, she showed it on a series of society women, and on reigning queens like Sirikit of Thailand. In the Youthquake issue, she initially tackled very short miniskirts by aiming them at *Vogue*'s "daughters." Heidi Murray Vanderbilt, the young Marisa Berenson, Condé Nast publisher Edwin Russell's daughter Consuelo, and Catherine Carlisle Hart, the daughter of Kitty Carlisle and Moss Hart, were profiled next to a model wearing white skirts three to four inches above the knee, patterned tights, and long "bangs." One of Diana's favorite garments, the leotard, was back again too, at her instigation, with three sleek leotards specially designed for *Vogue* by Jacques Tiffeau and made to order by Bonwit-Teller: "Now the body itself is the great fashion-power—the long flow of the body-line, strong, supple, beautiful—the look of youth." In Diana's view 1965 was the Year of the Body. A long, slender body was "the body that *is*

fashion. Strength flows along the long, slender curves; every line is pulled up and held with easy discipline against a spine as pliant as steel-spring." But this did not mean the despotism of youthful figures, *Vogue* was quick to say. There was no need to feel bullied by youth fashion. Clothes might be worn tighter and narrower on the body; skirt lengths might be shorter, but hemlines varied at different times of day, and the choice was an individual one: "It's entirely up to you: 1965 belongs to the woman with active tastes."

As hats disappeared from younger women's heads, what applied to dress also applied to hair. During one of her trips to London to assess new English designers, Grace Mirabella met Vidal Sassoon, who was revolutionizing hairdressing with his updated version of the 1920s bob—geometric cutting, working with the hair's natural strengths, and liberating women from unnatural permanents, weekly trips to the hairdresser, and interminable sessions under the dryer. Mirabella persuaded Sassoon to call on Diana, who was far from convinced. "As I walked into her office, Mrs. Vreeland, with an air of stern authority, said, 'Many of my friends are talking about you but are scared to death of your scissors.'" When Sassoon replied that they had good reason to be because his team was poised to give New York the London look, Diana pointed at a girl sitting in her office and ordered him to cut her hair in one of his looks. Sassoon immediately realized that the assistant's hair was much too fine to hold any of his cuts in place and refused to do as she commanded. "This is the wrong head of hair to demonstrate my work," he said. At this point Diana sat up. "Mrs. Vreeland said, 'Interesting. Sit down.' She turned on a tape recorder and we talked fashion, art, architecture and about the people we admired. She let her hair down in a way that was so unexpected that I was tempted to suggest I cut it."

BY THE END of 1964, *Vogue* was running much longer fashion spreads than ever before; and Diana's chances of imposing her vision on its pages improved greatly when she persuaded Richard Avedon to defect from *Bazaar* in late 1965. She had encouraged

him to come to *Vogue* with her in 1962, as Bailey had suspected she might, but Avedon was bound by contract to the Hearst organization, felt the arrangement to be unbreakable, and thought no more about it. But as he put it later, "The spy system was incredible." Forty-eight hours before he was due to sign a new contract with Hearst, Diana phoned him and said: "I just want to know something. Are you even remotely interested in talking to *Vogue*?" She rang at the right moment. The cheapskate behavior of the Hearst executives during contract negotiations had so angered Avedon that, like Diana before him, he was ready to hear what Alexander Liberman had to offer. Liberman, meanwhile, was more than ready to talk to Avedon. In spite of Diana's own predilection for the new band of English photographers, who included Norman Parkinson and Lord Snowdon as well as David Bailey, Irving Penn's imagery had continued to dominate *Vogue* after Diana arrived. His work had lost none of its quality—indeed it had gained from Jessica Daves's departure—but Diana and Liberman both thought that the beautiful stasis of Penn's work needed to be counterpointed by an equally powerful feeling of vitality elsewhere. New technology was already revolutionizing the distance between photographer and model in the active, aggressive photographs taken with hand-held cameras by British photographers like Bailey, Terence Donovan, and Brian Duffy, but Diana and Liberman believed that *Vogue* needed an injection of dynamism from an American staff photographer in every issue, and that Avedon and Penn would fire each other up. Diana also knew that, unlike many other star photographers including her new friend David Bailey, Avedon had long ago come to terms with the practical limitations of a fashion shoot, including the reader's need to see the clothes. ("If it's art I want, I'll go to an art gallery," Diana once told Bailey.)

Once Avedon had agreed to transfer his allegiance to Condé Nast, Diana set about hiring the fashion editor and stylist Polly Mellen to work with him. Mellen had joined *Bazaar* as a fashion editor in 1950 and had been championed by Diana, but she left after her marriage in 1952. She returned to *Bazaar* in 1960, only

to find that she did not care for the atmosphere of Nancy White's regime. Even though Richard Avedon was still there, the magazine had, in her view, "gone beige." When Diana asked her to go to *Vogue* and work with Avedon, Mellen moved as fast as she possibly could. Her arrival to work with the new celebrity photographer caused some resentment among her new colleagues. "Who needs friends?" said Diana. "Go and do your stuff." Within weeks she dispatched Mellen to work with Avedon in Japan on a shoot that came to define Diana's tenure at *Vogue*.

The model for the shoot was Veruschka, otherwise known as Vera von Lehndorff. As soon as she became editor in chief, Diana started looking for faces and bodies for the new age, and dispensed with great American goddesses of the 1950s like Dovima, Jean Patchett, and Sunny Harnett. The luminously beautiful Jean Shrimpton was the first of Diana's alive 1960s faces, but Veruschka followed close behind, not only redefining beauty but the role of the model in the process. Diana had met Vera von Lehndorff while she was still at *Bazaar*, in 1961. She had been highly complimentary, but in 1961 Lehndorff's looks were ahead of their time. At over six feet, she was regarded as too tall. Her face did not quite fit either. "I had this baby face and was at the same time sophisticated because of my length and height, so it was very difficult. My face belonged in *Elle*, but my body was *Vogue* so nothing worked," she said. But Lehndorff was no ordinary mannequin. She was the daughter of a Prussian count who had been shot for his part in a plot to assassinate Hitler; her family had spent the war in labor camps and been left homeless in 1945; she studied art before she was discovered as a model at the age of twenty; and there was an air of performance art about her modeling career from the outset.

Rejected by New York in 1961, Lehndorff retreated back to Europe and tackled the problem in a manner after Diana's own heart. " 'Vera' was not the person, not the name to successfully embark on the journey to become an internationally acclaimed

fashion model," said Lehndorff. "That person, her behavior and appearance, had to be reinvented to successfully stride into the new era of fashion." She discarded "Vera" and reinvented herself as "Veruschka." "One year on, my second trip, it was Veruschka who arrived in New York with another walk and another talk. Eccentric, feline, charming, and well-spoken, she was the exotic blonde arriving from the borders between Western and Eastern Europe." This time "Veruschka" took control, walking into the studios of many of the leading photographers without a portfolio, demanding to see *their* work. It worked so well that Irving Penn sent her over to *Vogue*.

When she became editor in chief in 1963, Diana realized that Veruschka's tanned, lean body, her long legs, her bone structure, her wide, perfect mouth, and her huge blue eyes, not to mention her remarkable ability to metamorphose, were suddenly of the moment. Veruschka began to appear in *Vogue*, photographed by Penn, from 1963, but her Veruschka persona acquired a new sheen once she met Avedon. "Our sessions together were very intense, both working independently with a great awareness of our own tools but always moving toward a meeting point of creative synchronicity." Whether or not they had a sexual relationship scarcely mattered. "What Antonioni was saying in the photo-shoot scene between David Hemmings and myself in *Blow-Up* was happening with Avedon in a much more subtle way. We were mentally connected from the time I entered the studio to when I left at the end of the day." For his part Avedon thought Veruschka was the most beautiful woman in the world. He loved her extraordinary ability to refashion herself at will in front of the camera. "Veruschka's bones, her body, her extraordinary length have compelled her to invent her own person. . . . Veruschka is the only woman I permit to look at herself in the mirror while I am photographing her. The mirror makes most women aware of their weaknesses. . . . Veruschka knows that it is what's peculiar to her that's beautiful and she works to bring it forward."

The team for Japan included Ara Gallant, hair artist or possibly hair sculptor, since even "hairdresser extraordinaire" does not begin to do justice to the colossal explosions of hair fantasy that became his trademark. (Born in the Bronx as Ira Gallantz, Gallant was another who fled his background for "the land of Style" and changed himself into something more exotic.) Gallant gave models vast tresses that spun, whirled, and soared into the air. "He made hair expressive," writes Holly Brubach. "In Avedon's photos of leaping, skipping models, even their hair [was] energized." Gallant achieved "flying hair" using Dynel, a synthetic fiber that came in many colors. It was much loved by Diana, who described her Dynel period as one of the happiest of her life. The Japan trip was hard going but marked the beginning of an intense working relationship between Gallant, Mellen, and Avedon. "Some of the conditions were very harsh but this is part of what made the magic. We were all in a team constantly working towards the resolve and result," said Mellen.

Before they left Diana briefed Mellen in a manner that was oblique even by Vreeland standards. She instructed Mellen to familiarize herself with *The Tale of Genji*, a great classic of Japanese literature written in the eleventh century, maintaining firmly that it was impossible to understand Japanese culture without reading it. Mellen dutifully read through all 845 pages of the world's first novel. "I said to Mrs. Vreeland, 'Diana, the book is extraordinary. So elegant. The ritual, the poetry, and so erotic! When Genji leaves the Lady of the Bush Clover?' After a pause, Diana said, 'What are you talking about?' I answered, '*The Tales*[sic] *of Genji*. Remember the part where Prince Genji, sated, breaks the Lady of the Bush Clover's heart?' Diana replied, '*The Tales of Genji*? *The Tales of Genji*? You've read it? But doesn't it sound just maaarvelous!'"

ON OCTOBER 15, 1966 a hallucinogenic fashion spread appeared in American *Vogue*. It ran to twenty-six pages, was supposed to have cost $1 million and was titled "The Great Fur Caravan. A Fashion Adventure Starring the Girl in the Fabulous Furs

Photographed for *Vogue* in the Strange Secret Snow Country of
Japan . . ." It opened with cinema credits:

DICK, THE PHOTOGRAPHERRICHARD AVEDON

VERUSHKA [*sic*], THE GIRLCOUNTESS VON LEHNDORFF

POLLY, THE FASHION EDITORMRS. HENRY MELLEN

THE NARRATOR ..MARY EVANS

There was nothing revolutionary about the cinematic format,
which Richard Avedon had used before. But the mysterious mood
of the spread was new and a universe away from the haughty beau-
ties in hats and white gloves who had stared from *Vogue*'s pages
just a few years earlier. The Girl, played by Veruschka, was enig-
matic. Wrapped in luxurious and opulent furs, she traipsed across
snowy, desolate, Narnia-esque landscapes. One moment she was a
Tatar princess on a train, wrapped in pale beige mink, her Japa-
nese *o-bento* box at her side. The next moment she reappeared in a
Noh mask as a ghost in the Valley of Hell (a misty, steamy sulfu-
rous hotbed of springs on Hokkaido, Japan's northernmost island)
metamorphosing into "a Heian beauty too attached to the passions
and enchantments of earthly life to leave it altogether." Later Ver-
uschka turned into a Tatar chief's baby girl in the snow. And then,
for no obvious reason, she became involved in a series of exotic and
mysterious intrigues with a giant, "a young Japanese of mytho-
logical proportions who was a ritual sumo wrestler."

The dreamlike atmosphere of Avedon's photographs was
complemented by the language used to describe the fashions.
A self-conscious authorial voice wove together Veruschka's fic-
tional adventures and the problems encountered by *Vogue*'s fashion
team as it created them. Veruschka—who was referred to as both
the Girl and by her name—was carried across Japan in a first-class
carriage of the Shin Tokaido, then the world's fastest train. Mary
Evans, the narrator of the story, described how cold Veruschka be-
came as she strode through drifts of snow. Veruschka ("For a trav-
elling [*sic*] princess, an enormous shining black ciré headdress over

a wrapped white ermine coif. Adolfo headdress made to order at Saks Fifth Avenue") "could not be without her music, and a portable record player spun in the white landscape, giving out Pergolesi in the pines. Though she never murmured, however white her face became with frost, in between shots we led her back to the hotel, her long legs stiff as stilts with the cold." It was not so cold, however, that Veruschka could not be photographed topless, an image unthinkable a few years earlier. In a mildly erotic finale Veruschka and a priest appeared to prepare for a mock marriage.

"She has the concentration of a child playing some totally private, wordless game alone," Richard Avedon said of Veruschka. "There are times during a sitting when she turns to look at me or at the camera . . . smiles, challenges. It's like the opposite of a Dylan song, 'I'll let you in my dream if you let me in yours.' That seems to be what most people need. But not Veruschka. She'll let you into her dream but she wouldn't fit in yours." But when she played in the strange secret snow country of Japan, Veruschka metamorphosed into the creature of Diana's fantasies, as well as her own. On Hokkaido, in the Valley of Hell, she became Diana's favorite creature, the Girl who spun a world from her dreams. "It's without content. . . . It's without any meaning in it," Avedon said of the spread much later. "It's just this exquisite creature. Diana imagined her walking through the snows of Japan." But the Girl had meaning for Diana. The Girl was a phantasm who would spellbind *Vogue*'s readers with fantasies of perfection, a vision from Diana's vibrant, scintillating imagination, born decades earlier in the circumstances of her childhood. The only time Diana ever rejected Veruschka's pictures was when she played a private game of her own and looked defeated. "You looked like a victim instead of a heroine," wrote Diana to Verushcka, explaining why *Vogue* had not used a spread. "And as you are a 'heroine' we would never publish you looking like a victim . . . do you understand what I mean?" The world had to be kept spinning by the enchantment of possibility. "What sells is hope," said Diana.

..

IT WAS NO accident that Diana chose to send Avedon to Japan on his first major assignment for *Vogue*. "Jets were brand new and brother, did we use them. The jet and penicillin—that's really where our world began. We don't have to think about anything else." The arrival of the jet meant that places and experiences previously only accessible to the very grand, the very rich, and the abnormally intrepid were suddenly within reach of many *Vogue* readers. But as soon as Diana took charge she was insistent that the magazine had to go much further than upscale tourism. She was convinced that fashion itself was enriched by exposure to the new and exotic; and that "the eye has to travel" even when the readers themselves could not. "All over the world, beautiful girls, photographers and kids were flying to Nepal, Afghanistan, Kathmandu. They would see things that other generations only read of as scholars. All of this had an enormous effect on the imagination. Night-blooming jasmine, lotus flowers, sun. Under the equator, the moon is in a different position. Everything was suddenly available."

Some of this was earthbound. Diana opened up American *Vogue* to new international fashion centers, including Madrid. She and Carmel Snow had already put a new breed of Italian designer on the fashion map while she was at *Bazaar*, leading with a ski outfit designed by the aristocratic Emilio Pucci more or less by accident in 1948. Once she arrived at *Vogue*, Diana encouraged his sportswear in multicolored, kaleidoscopic designs, his use of new lightweight fabrics, and his pioneering development of softer, less structured lingerie—Diana is said to have come up with the idea for Pucci's signature psychedelic underwear, but even if she did not, she certainly fostered it. Once again she had a particular fondness for Italian designers who, like Chanel in France, worked with the natural body, but with a European élan. As Valerie Steele has written: "Flaunting bare feet and legs in sandals and no stockings, and wearing dresses without girdles or underwire brassieres, Italians were pioneering easy, comfortable, body-conscious clothing. Simplicity and comfort were central to mass-produced American sportswear, but Italy provided sportswear with greater

sophistication and cultural cachet." As the global fashion industry went through another convulsive expansion in the 1960s, Italy remained, writes Steele, "an oasis of high style." Diana appointed Consuelo Crespi as American *Vogue*'s editor in Rome to keep up with every twist and turn of its couture. She was also attracted to Italian designers as a private customer in her own right, favoring particularly the knitwear of Missoni and the designs of Federico Forquet, Mila Schön, and Rome's new superstar, Valentino Garavani, who had opened his couture house in 1960.

On a more ethereal plane *Vogue* started energizing American fashion by locating it in all kinds of unfamiliar and mysterious worlds as soon as Diana started. Her first issue in January 1963 featured American resort clothes among the camels of Tunisia, photographed by Henry Clarke, whose images of models in floating psychedelic prints against exotic statuary and wild landscapes would come to encapsulate *Vogue* in this period. Helmut Newton photographed American sportswear in the bloodred Australian desert against Ayers Rock, where a new breed of long-limbed, suntanned model in white clothes assumed knowing poses with an undertow of eroticism, the atmosphere lightened by the presence of a kangaroo named Ethel. John Cowan was dispatched to the Arctic Circle to photograph evening wear, accompanied by a fashion editor, an assistant, and two freezing mannequins who were required to model silk taffeta and white silk faille in subzero temperatures in the interest of a new poetics of fashion. Diana's Christmas *Vogue*s were her most personal, the issues for which she held back the ideas, things, and people who particularly enchanted her during the year. The Christmas issue of December 1964 included no fewer than thirty pages of fashion photographed in India by Henry Clarke, featuring models in summer clothes against a background of Hindu gods and goddesses. The text by Rumer Godden and the shoot coincided with the opening up of India to Western visitors in the early 1960s. "India has given a new freedom to her visitors," wrote Godden. "Become accessible, opened 'like a champa flower,' making approachable 'the much vaunted wisdom of the East.'"

"Vreeland made fashion out of her dreams," said Grace Mirabella. If the clothes were not available, she had them made up. Designers and manufacturers naturally listened very carefully to what the editor in chief of *Vogue* had to say, while the New York department store Bonwit Teller was happy to cooperate with Vreeland-inspired suggestions and make them to order for the designers in return for a store credit. According to *New York Times* fashion reporter Marilyn Bender, *Vogue* in the 1960s went as far as instigating twice-yearly seminars to stimulate the imaginations of the Seventh Avenue manufacturers. "The impressionable manufacturers are wooed by *Vogue* editors (they are there to be inspired not only about design, but about advertising in the magazine as well), served culinary triumphs on white china and Georgian silver, and instructed by being shown sketches that represent looks the fashion editors believe in," wrote Bender in 1967. Sometimes it was even more specific. "In the spring of 1966, Diana Vreeland felt in her bones that the suit and the coat with the martingale belt would be right for the fall." Sketches were commissioned for the seminar but failed to ignite the manufacturers. "When Seventh Avenue failed to fall into a martingale mood, an editor was dispatched to Mrs. Vreeland's apartment, where she plucked a Paris couturier's coat with a martingale out of the closet and gave it to a manufacturer, who whipped up such a coat for *Vogue*'s August issue."

From time to time Diana's dreams produced not just experiments by eager-to-please manufacturers and designers but whole new trends. Anticipating a more widespread interest in the East and Eastern mysticism by about three years, Diana demanded that her colleagues keep up as her gaze swiveled in late 1964 around Turkey, Persia, and Arabia and the work of Lesley Blanch, whose book about romantic women travelers in Arabia, *The Wilder Shores of Love,* had been a huge success when it had first appeared in the mid-1950s. It comes as no surprise that Diana loved this book, for Blanch chose subjects who sought escape from the drab industrialization of the nineteenth-century West

and found fulfillment in Oriental exoticism. When it first appeared Elizabeth Bowen found it unsettling that these women were actually reacting against progress and emancipation in favor of romantic fantasies. "The East drew them, the East they sought. . . . In each case, the dominating daydream became reality," she wrote. But in the 1950s this idea resonated with thousands of readers. "*Wilder Shores* opened up far horizons, bestowing on the Middle East and the Islamic world an aura of fascination, and planting in her younger readers a seed of curiosity that often bloomed years later," writes Blanch's biographer.

Diana was one such reader. Boring geographical borders and dull historical facts were not the point when it came to the wilder shores of the East. What Diana wanted on the pages of *Vogue* was the Orient of her inner eye, an Orientalist fantasy that can be traced back as far as 1910, peopled with images of Ida Rubinstein dancing Scheherazade in Diaghilev's production before the First World War, and the paintings of Liotard she had first spotted in Geneva in 1934. Jean-Étienne Liotard was a peripatetic Swiss-French artist who traveled to Constantinople in the mid-eighteenth century, became fascinated by Turkish life, and became known as the "Turkish painter" after he adopted local dress. Diana had first come across Liotard when the Vreelands lived in Ouchy; and she loved his work so much that she instructed Betty Vreeland to look for his paintings when she moved with Freck to Geneva. "At last I have visited your Liotards," wrote Betty in 1956, somewhat puzzled. "They are more Genevois than Eastern." This commendably truthful observation cut no ice with her mother-in-law. Liotard was, wrote Diana, "my complete inspiration to this whole compact of Eastern allure." This crystallized in twelve pages of Scheherazaderie in the April 15, 1965 issue, photographed in Liotard-inspired color by Penn, translated into an American palette of candy pinks and greens, and designed by Diana and her editors "to put over the exotic and erotic" in the hope that this might be "an inspiration for all kinds of clothes."

The spread was intersected with an article titled "The Exotic

and the Erotic" by Lesley Blanch herself, in which she explored the idea that "in the East, they strive to awaken the senses, while we seek to extinguish them"; and she presented a world where "it follows that both the home and the woman acquire a special interdependence, complementing each other, creating together this enclosed, intimate world of beauty and deliberate withdrawal." This was a theme close to Diana's heart, and *Vogue* picked up the idea and ran with it. "You will notice," said Diana in a memo, "that this entire issue is dedicated to our feeling that at this time, this is 1965, the world of the seraglio is coming into the ordinary world of everyday's [*sic*] comfortable, decorative living." The Scheherazaderie feature looked backward as well as eastward to the oriental fantasies of the Ballets Russes and recast them for 1960s America. "It's all here, deliciously translated in the modern idiom of at-home clothes, clothes for *la vie privée*, immediate, contemporary, with all the indolent grace of Turquerie to charm the sheik at home."

In 1964 Freck was posted to Rabat, Morocco, and after the Paris collections Diana flew to see him, Betty, and their two sons, Nicholas and Alexander. She was beguiled by Morocco and by Moroccan caftans. She featured the Moroccan designer Tamy Tazi and her caftans as part of the Scheherazaderie issue in April 1965. A year later she introduced caftans as a trend, persuading those she identified as international "Beautiful People" to wear them. The caftan appeared in a five-page feature in July 1966, photographed by Cecil Beaton, Henry Clarke, Horst, and Vittoriano Rastelli. The Beautiful People wearing them included Lady Antonia Fraser, Antonella Agnelli, Susan Mary Alsop, Mrs. Leo d'Erlanger, Mrs. Alfred Gwynne Vanderbilt, Mrs. Ahmet Ertegun, and Lesley Blanch. *Vogue* sailed breezily past the fact that some of the garments it was appropriating for Western fashion were originally made for men. "Women relaxing into caftans; into caftan-like jibbas, yeleks, djellabas [*sic*] . . . nothing is more completely feminine." In the September 1, 1966 issue there were two further interpretations, "Turquerie at Night" and "New Seraglio Lures at Home." The September 15, 1966 issue featured a Galanos design of a jewel-sleeved djellaba,

another instance of Diana's influence on Seventh Avenue in this period. The caftan epitomized an exotic luxuriousness, and it also signaled a break from structured fabrics, and a much greater fluidity for clothes. As Diana put it: "All float, nothing static—everything moves well, sits well. . . . This is the most feminine hour for a woman's figure—and psyche."

VOGUE WAS THEATER, said Diana. Exaltation must preside. "She was the first editor to say to me: 'You know, this is entertainment,'" said Liberman later. "'In many ways, she acted as a brilliant theatrical producer." Diana was in many ways a creative impresario in the manner of Diaghilev. "You have no idea of the *freedom* I had," she said. "The money! The trips! . . . But *I* never went on any of these trips. Two issues a month is a *hell* of work. . . . I was a terror then— just a *terror.* It wasn't what they'd find, it was what they *had* to find." Diana attributed this philosophy to seeing the vaudeville performer Joe Frisco on a train. He asked the waiter for ice cream and apple sauce at breakfast time. When the waiter said, "But we don't have it," Frisco said, "Okay, *fake it*!" "That made a tremendous impression on me," said Diana.

But faking it did not always go according to plan. In 1965 Norman Parkinson was working for *Vogue* in New York when he was summoned to Diana's office. He had taken some photographs in Tahiti for *Queen* a few years earlier, and Diana recalled him saying that a white horse grazed in every field. She told him that she was sending him back to Tahiti with two hundred pounds of gold and silver Dynel. He was to find a veterinary surgeon on arrival and enlist his help in selecting the finest Arab stallion on Tahiti. The stallion was to be caparisoned in the finest manner, his mane and tail plaited to the ground with the gold and silver Dynel. " 'Use all the Dynel you want, you don't have to bring it back.' 'I understand, Mrs. Vreeland.' 'Secondly, we are sending you to Tahiti with a plastic city.' 'A plastic city?' 'Yes, you hear me aright. You will enter upon people's lands, you will dig holes,

you will run concrete and you will erect this fantastic city of shining screens and tones against the solid dragons' teeth of the mountain ranges.' 'Yes, Mrs. Vreeland, I understand perfectly, but what about the law of trespass?' 'Don't bother me with incidentals,' said Diana. 'Choose the two girls you wish to take. You are leaving on Wednesday week.' "

The plastic city turned out to be too big for the hold of a Boeing 707, but Diana remained extremely enthused about the Arab stallion. She sent one of New York's great hairdressers, Kenneth Battelle, on the shoot. "For inspiration Mrs. Vreeland showed me an 18th century French picture of a horse all festooned and garlanded, with a long, curly white mane and a tail plaited with enormous bows. I packed loads of white and off-white Dupont hair," said Kenneth. He had specific responsibility for the horse's tail, having been told by Diana that its magnificence might well have to be faked. "I was in the middle of my Dynel period then," said Diana. "We had the Dynel plaited with bows and bows and *bows*—these fat, taffeta bows, but *rows* of them . . . no Infantas had ever had it so good! I was *mad* about what we'd done for our glorious tail."

But there was a hitch. Parkinson duly found a veterinary surgeon on arrival, only to be told that the French had eaten every horse on Tahiti some years earlier. Just when all seemed lost, the vet remembered that a plantation owner up the hill had a young, nervous stallion that had somehow escaped the casserole. The owner was rather intrigued by the idea of his animal being made over for *Vogue* and stood patiently for hours holding its head while the crew stitched 150 pounds of Dynel onto its flimsy harness. In Parkinson's version of what happened next, the horse jumped in the air, with a leap "they would have recognised as something special at Cape Canaveral," as soon as the owner handed the bridle to the model, destroying hours of work. In Diana's version of Kenneth's story, Kenneth made the mistake of brandishing the Dynel tail as he approached the stallion's rear end. "Now, apparently, if you go

near a certain part of the anatomy of a stallion . . . well, he took off! He went *all the way*. He was gone for five days." In Kenneth's version of his own story, the stallion "hadn't seen a lady in eight years: he was as horny as hell. As I was dolling him up with fake hair, taffeta bows and real flowers, he saw a donkey around the bend. He took off, flying toward her. All my decorations flew off, too, down the side of a mountain, where no doubt they remain today." In the end Parkinson managed to photograph a model beside a little white pony with its head and mane in two stripey bows, just to show Diana that they had all tried. He noticed that she never held a grudge against anyone who attempted an idea and failed magnificently. "Mrs. Vreeland was always in there punching for the impossible and the unattainable. When her ideas succeeded, and they often did work out well, they were triumphant. She gave the roar to get something not attempted before and there were no post mortems if they did not succeed."

MEANWHILE DIANA WIDENED *Vogue*'s focus so that it featured new talent and Beautiful People across the international social spectrum. The phrase "Beautiful People" was coined by Carol Phillips while she was managing editor of *Vogue* before Diana arrived, and Diana never took credit for it. But it came to be associated with the way she captured a new social order in the pages of *Vogue* in the 1960s, one in which British working-class pop stars and photographers, New York fashion figures, and, increasingly, designers and hairdressers, could be found alongside Moroccan and Italian princesses, and the queen of Thailand. The houses, gardens, and daily lives of fashionable British aristocrats, often identified by Nicholas Haslam but largely unknown in the United States, appeared in a series of articles by Valentine Lawford, photographed by Horst, alongside the homes of Doris Duke, Emilio Pucci, and the Duke and Duchess of Windsor. All the people featured in these articles were, in Diana's view, "creative and warm-hearted human beings, with a sense of the romantic possibilities, as well as the practical demands, of everyday

existence." What interested Diana most, once again, was the philosophy detectable throughout her life: her faith in the divine spark, the complete worlds of imaginative people whose distinctive tastes and determination turned fantasy into reality. Horst and Lawford were enjoined to capture the way their subjects set about this in great detail—an idea that seems banal now but was an innovation in the 1960s. Those featured in *Vogue* often included Diana's friends, many of whom she and Reed had first met in Europe in the 1930s, and they were so frequently related to people who worked at the magazine that *Vogue* in the 1960s often had a family feel about it. The profile of Consuelo Vanderbilt Balsan was easily arranged, for she was a neighbor of Horst's in Oyster Bay, and her grandson-in-law was Edwin Russell, publisher of Condé Nast. Marisa Berenson, who became one of Diana's favorite models, was the granddaughter of Elsa Schiaparelli. Pauline de Rothschild, married to Baron Philippe, and the subject of another Horst and Lawford profile, was a distant cousin of Diana's.

THE JOB OF editor in chief came with a substantial expense account for entertaining, and increasingly the Vreelands' private life became indivisible from Diana's work at *Vogue*. As Diana became ever busier, Reed took charge of the domestic arrangements, a role in which he seemed very happy—much happier, some thought, than in his business life. Secretaries noted that the only time Reed ever became irritated was when things were not done just as Diana liked them, when dollar bills were not folded correctly, for instance, or arranged so that she could tip easily. Their household accounts were managed by Madeleine Wilson, who had been Reed's secretary since 1941. She later said that all the costs of running the apartment were borne by Diana, who transferred money each week to Reed's account so that he could pay out checks. In one sense their role reversal was complete, though this was not quite how it seemed to Diana. "It's always been men with feminine streaks in them that women love—which has nothing to do with homosexuality, you understand.

What I was always aware of was a very feminine thing of *protection*. This, naturally, is what I miss more than anything—I'd never have gotten it from a wholly masculine man."

Yvonne Duval Brown, the Vreelands' French maid, was a particularly important figure in their lives, one who acquired a minor New York reputation of her own for her total dedication to the Vreeland way, particularly in the matter of footwear. "Unshined shoes are the *end* of civilization," Diana was wont to say. Reed, she claimed, had the butler in Hanover Terrace polish his shoes for five years with cream and rhinoceros horn until the leather was "contented." Yvonne used a rhinoceros horn to polish Diana's shoes, too. "A highly emotional French lady, she wouldn't lift a finger to polish the furniture, but she meticulously stained and polished all my shoes after each wearing—including the soles. Why, I wouldn't *dream* of wearing shoes with untreated soles. I mean, you go out to dinner and suddenly you lift your foot and the soles aren't impeccable . . . what could be more ordinary?"

Many of those photographed in *Vogue*—and many who were not—were invited to Sunday lunch or dinner at "the garden in hell" at 550 Park Avenue. By the 1960s the Vreelands were noted hosts, popping up in a book about entertaining by Florence Pritchett Smith. "Woman should be a creature who is inspired by ministering to the male senses," proclaimed Smith, cheerfully ignoring the fact that chez Vreeland it had long been Reed who arranged the menus with their Spanish cook, Sen, noting them down in a book. Diana's rules for entertaining were: pay personal attention to the guests, save yourself for the event, have the room at the right temperature, make sure everything is sparkling clean and smells wonderful, and make the table look attractive. The room should be quiet. "Arrange a quiet room so your guests feel that the only thing happening on God's green earth is happening right there." There should not be too many married couples either. This, apparently, was "suburban." "Have pretty women, attractive men, guests who are *en passant*, the flavor of another language. This is the jet age, so have something new and changing." The most important thing

for the guests, she concluded, was a feeling of freedom. Everything should be kept fluid. "Let guests go home early if they want to. All you should ask of a guest is that he be enthusiastic, rested, interested in meeting new people and talking about the many fascinating things going on in the world. . . . Luncheons are a wonderful time to entertain because people arrive and leave on time and when they leave you can hear them laughing as they walk down the street."

Behind the scenes, however, Reed's health started to deteriorate. He had colon cancer in 1963, the year that Diana became editor in chief of *Vogue*. The following year he had a heart attack. Diana said nothing about this to any of her colleagues. Nor did she say anything when Reed went into the hospital for tests in the summer of 1966, having lost all interest in food and thirty pounds in weight.

Shortly after he went in, a doctor called her at work to say that the results of tests were back. He was about to tell Reed he had terminal cancer.

I said, "What do you take my husband for—an idiot? Don't you think he knows?"

"Have you discussed it with him?"

I said, "Of course not! Why would he and I discuss cancer?"

The doctor said, "Mrs. Vreeland, you're not at all modern. We always tell our patients."

I went to the hospital that evening. Always, Reed had been in the hall to meet me: marvelous foulard, and wonderful this and that. Not this time. He was in bed with his face to the wall. So I said hello.

He didn't answer. So I sat down.

Twenty minutes later he turned, "Well, they've told you and they've told me, so now it's on the table. Nothing to be done about it." I didn't even answer him.

Reed was in the hospital for about six weeks. One person who helped Diana through it was Yvonne Brown, because she

understood the Vreelands so well. "Reed died loving Yvonne more than anything in the world," said Diana.

> *Because she had the tact, the intelligence—the grace—to bring him one flower, never flowers, three times a week when she brought him clean linen. The apartment, you see, was filled with flowers, cards... we had to keep them away from him. They meant that he was dying. But Yvonne would bring him one rose. She'd put the rose in a little cream pitcher by his bed... and he'd be perfectly happy.*

Diana confessed to Christopher Hemphill that Reed's final illness was worse than it should have been because his business affairs were in a muddle. "The terrible thing was that he became ill at a time when he couldn't quite . . . get on top of things. I can remember his looks in his hospital bed. He'd look at me and in his looks I'd read, 'My *God*, I'm going to leave her with nothing.' "

Later Diana said that she refused to think of anything except how wonderful their life together had been. At the time, however, the strain showed. She was rumored to have chased Cordelia Biddle Robertson out of the hospital; and most uncharacteristically, she sent for Emi-Lu, who came dashing across the Atlantic from England to be on hand. Tim Vreeland came to see his father and went back to New Mexico, where he was living. Although Reed's black hair had turned steel gray, it was not apparent that the end was near, and no one mentioned that it might be. Reed died soon after Tim's visit. He discovered later that Diana's first reaction had been not to tell him, and that Emi-Lu had had to insist. Diana was shattered. On the day Reed died, August 3, 1966, she drew a little heart with an arrow straight through it in her engagement diary. But she wore white to his funeral and insisted it should take place privately, and quickly. She was almost sixty-three, and her sons expected that she would now wind down and think about retirement. As they later acknowledged, they could not have been more wrong.

WILDER SHORES

Diana impressed everyone with the way she behaved after Reed died. "She was so brave," recalled Carol Phillips, *Vogue*'s beauty editor, who was astonished at the speed with which Diana replied to letters of condolence, and the trouble she took over them. Reed's business affairs took some disentangling. It transpired that he had not updated his will since 1950; that he was owed money by several of the enterprises in which he had been involved, including Rigaud candles and Emilio Pucci Ltd.; and life insurance policies were swallowed up by his business debts. Diana was just as dependent on her salary from *Vogue* as she had ever been, but it was not in her nature to collapse under the weight of grief or to allow herself to become destabilized by complications with Reed's estate. Far from winding down and starting to think about retirement, she responded to his loss by redoubling the pace.

Within weeks of his death she was busy six nights out of seven, and close friends saw a subtle change. While Reed had been alive, noted Kenneth Jay Lane, Diana had been careful not to reduce him in any way. "She was the wife, the hostess—very much part of a team. She didn't project herself then because she didn't want to overshadow him." This changed; and, if anything, widowhood made her even more insistent on the romantic view. Cecil Beaton noted with amusement how even the most unattractive tycoons benefited from a sprinkling of Vreeland fairy dust. "Some may see Charles Engelhard, the gold, platinum, uranium tycoon, as a tough, obese business genius with fairly unattractive manners and a terrible physical onslaught," he wrote in his diary. "To Diane he

is 'le Roi Soleil.' Put a wig on him, then take the nose, he already has the stick, and watch his walk! With one foot forward! Why, he's from all the pictures!"

New friendships went some way toward filling the gap. One of them was with the designer Oscar de la Renta, which began before Reed's death but blossomed afterward. De la Renta, who had been an apprentice to Balenciaga and an assistant to Lanvin, traveled to New York from Paris in 1962, armed with a letter of introduction from the aristocratic Parisian socialite, fashion phenomenon, and putative designer Comtesse Jacqueline de Ribes. He arrived at 550 Park Avenue to be greeted by the sight of Diana and Reed wafting cigarette holders and wearing caftans; but he also encountered Diana at her most practical. She strongly recommended he take a job he had been offered by Elizabeth Arden, arguing that Arden spent so much on advertising that de la Renta would make his name faster there than anywhere else, particularly since he wished to concentrate on ready-to-wear. It was the right advice and marked the start of a friendship that was important to both of them, one that blossomed when De la Renta married Françoise de Langlade, previously editor in chief of French *Vogue*, the year after Reed died. De la Renta proved to be particularly well attuned to Diana's more exuberantly exotic ideas, re-creating them in a most luxurious way for his uptown New York clientele. Diana's personal style took on more vivid, electric hues after Reed's death. One bejewelled caftan De la Renta made for her in 1966 was described by the Fashion Institute of Technology Museum as evoking "the fantasy of foreign lands," with a color palette recalling a desert sunset: a masterful interpretation of Diana's dictum that "fashion must be the most intoxicating *release* from the banality of the world."

Jerry Zipkin's name also began to appear regularly in Diana's diary from 1967. Heir to a Manhattan real estate fortune, Zipkin made escorting fashionable women with busy husbands a way of life. Indeed, *WWD* coined the word "walker" to describe him. Though he was a man of considerable charm, it greatly amused him to dish out catty remarks to his closest lady friends and watch

them crumple. There is little sign that he made much impact when he tried this on Diana. It was, one observer remarked, a hilarious friendship. Zipkin was neurotically punctual; Diana was invariably late; and they often telephoned their mutual friends to complain bitterly about each other. But lunch at restaurants like La Caravelle or La Grenouille took on new social importance in New York in the 1960s, and one of Zipkin's many advantages was that he brought Diana gossip from the new breed of lunching ladies whom she was too busy to listen to herself.

Bill Blass had known the Vreelands since the 1950s. Like others, he had initially found Reed the more affable: "Astonishingly friendly when you consider that the stigma of being a designer was enough to make you feel like an outcast." After Reed's death Blass drew close to Diana. He was a frequent guest at 550 Park Avenue, and they often went to the movies together. "Those were the evenings I loved most with her," he remembered, though he learned to avoid escorting her to other people's dinner parties. Diana earned a justified reputation for always being late, to the great irritation of her old friend Kitty Miller, who simply started dinner at eight forty-five without waiting for her. "She never had a sense of time, and I don't think it was that ploy of being important when she arrived," said Blass. "Time, like age, simply meant nothing to her." Years later Blass was still laughing at the memory of Kitty Miller threatening, sotto voce, to give Diana a "knuckle sandwich" when she found herself upstaged by Diana's conversational flow at a lunch party. The line was delivered "with startling movie-gangster relish—by a grand dame, about another grand dame."

Blass sensed, like many others, that there was something artificial about Diana, even in her sixties, but he came closer to a sympathetic understanding than many, even if he took her story about being brought up in Paris at face value while dismissing much of what she said as untrue:

She was an amalgam of stories and half-truths and outright lies
that served her ideal, and which sometimes seemed a charade, but

in New York, amid kindred souls, was utterly comprehended. And
for that reason, despite her Paris birth, her love of French clothes,
her polished soles, her frequent evocations of Chanel, Bébé Bérard
and Queen Mary—all those things we have come to associate with
this vague antique world of Vreelandia—I think Diana was deeply
American. She combined Twain's reverence for the reinvented self
with Barnum's love of showmanship, and she spent her life perfect-
ing this blend.

Blass thought her surrealist conception of her self saved Diana
from disappointment many times; and that her skill as an editor
had nothing much to do with some mysterious ability to put her
hand on the pulse of the zeitgeist.

Rather, it had to do with something more powerful, more innate, a
belief held in common with others who had been born outside New
York, and which saved them, too, on many occasions—and that was
her perception of herself. Diana saw the world through her own eyes,
and that was truth enough for her.

DIANA WENT BACK to work very quickly after Reed's death in
1966, and though Alexander Liberman would later attribute her
"wildness" in the years that followed to the absence of Reed's
calm and restraining hand, it was the 1960s that grew wilder
and Diana who caught the mood. In 1965, the year of *Vogue*'s
Youthquake and the very short miniskirt, race riots erupted af-
ter Malcolm X was killed in February, the bombing of North
Vietnam intensified sharply, and ground-troop numbers soared.
Antiwar feeling among college-educated youth intensified in re-
sponse. The year of Reed's death was marked by widespread cam-
pus riots as U.S. troop numbers in Vietnam rose to four hundred
thousand and Timothy Leary encouraged the young to turn on,
tune in, and drop out. Betty Friedan, who had published *The*
Feminine Mystique in 1963, founded the National Organization
for Women (NOW), giving moderate feminists an organizational

voice for the first time. Across America the personal was rapidly becoming the political. The Food and Drug Administration had licensed the Pill for use in 1960, finally making sexual freedom for women possible; but in 1966 the equation of premarital sex with personal liberation still felt radical.

Against this background fashion itself exploded. From the midpoint of the decade, ideas came from wholly unexpected directions; the global market for clothes expanded as never before; and new trends came and went faster than they ever had. To complicate matters further, the structure of the fashion industry also changed rapidly in the second part of the 1960s. Much of this was driven by the Youthquake. By 1970 one-third of the American population was under twenty. This huge demographic shift profoundly affected the way clothes were sold. Even the grandest designers introduced prêt-a-porter lines, stimulating a huge expansion in ready-to-wear. By the mid-6os Mary Quant's shop Bazaar (she hated the term "boutique") had spawned hundreds of imitators, to the extent that designers like Quant and Barbara Hulanicki of Biba in London took over from the couture as the leading experimenters in fashion. The boutique owner-designers produced cutting-edge ideas in brand-new materials and created instant trends. Unencumbered by couture schedules, they reacted instantaneously to fresh ideas from the street and brought new designs to the market in a fraction of the time, which speeded up short-lived fads. The arrival of the jet not only meant more travel for everyone, including the more spiritual young journeying to the East in search of enlightenment. It also meant that boutique design—and thus youth fashion—traveled fast across the Atlantic in both directions, influencing haute couture, ready-to-wear, and the mass market in both the United States and Europe. These changes delighted Diana. She hired Carrie Donovan from the *New York Times* and put her in charge of a boutique column in which fashionable young women like Baby Jane Holzer and Sharon Tate dropped in on small shops in London, Paris, and New York and tried on everything that appealed to them.

The rise of ready-to-wear, boutique, and youth fashion coincided with a further destructuring of clothes themselves that was brilliantly charted by Diana in *Vogue*'s pages from 1966 onward. Her composite approach to editing meant that haute couture and more conventional designers and society figures always had their place; but in *Vogue*'s most prominent spreads the woman in a little mink throw disappeared altogether, to be replaced by Turquerie, caftans, Lurex stockings, hot pants, miniskirts, and white kid boots. Since neither 1960s fashion nor Diana ever moved forward in a straight line, it is courting danger to assert that there was one issue of American *Vogue* in which she achieved a paradigm shift, a moment when the fashion of the long 1950s crossed over to the mode of today. But it was arguably the April 1, 1966 issue, on page 117, where a *"Vogue's Eye View"* editorial titled "Girl in the Chips" presented the magazine's readers with a photograph of the first black supermodel, Donyale Luna, with her hair cut in a Vidal Sassoon bob, wearing a contemporary, pop-arty "fast little shift" made by Paco Rabanne from acetate poker chips. The dress was almost see-through and the effect of Guy Bourdin's photograph was to draw the eye to Luna's lithe body and her implausibly long limbs.

As 1966 gave way to the "be-ins" of Central Park and the Summer of Love in Haight-Ashbury in 1967, *Vogue* too moved toward the overlaying of different lines, volumes, and fabrics, layering design upon design, and mixing new pieces with vintage clothing. The feel of the magazine shifted as fashion, people, and aesthetics subtly altered once again. Though Diana did not have much time for real hippies, regarding them as unkempt and generally disgusting, she engaged enthusiastically with the style of hedonistic countercultures of the late 1960s. From 1967 onward there was hippy inspired fashion from Haight-Ashbury, which manifested itself in psychedelic prints, sandals, headbands, and "ethnic" styles; and romantic fashions inspired by Beau Brummell—velvet skirts, silk waistcoats, knickerbockers, and large floppy hats. Alongside this there was "Nifty American" fashion: inventive sportswear aimed at active women who were constantly on the move, "the

kind of fashion American women live in, look marvellous in . . . the fashion they made famous all over the world." Hemlines fell and rose again; but even when the trend was toward a more covered-up look, *Vogue* led the way in emphasizing the need for a healthy diet, serious exercise, and a toned, dancer's body that could cope with the stripped-back look of Donyale Luna in a Paco Rabanne mini-dress and a leotard as well as a caftan.

In the end it was the fashion eclecticism that emerged during the second part of the 1960s that was arguably more significant than any one style. It was part of a wider process of liberalization that had been going on for two decades but finally reached a point in the mid- to late-1960s where individual autonomy became a defining idea. This profound social change manifested itself in the way both women and men were choosing to dress and style themselves. "On the whole, fashion had become less a matter of designer diktat and more a question of personal choice—in fact it could be asserted that the mini was the last universal fashion," writes the fashion historian Valerie D. Mendes. A wealth of competing fashion ideas handed power back to the consumer, at the expense of the designer, the fashion magazine, and anyone or anything else deeming themselves an authority in matters of style. In certain households this shift led to fine intergenerational battles about clothes and length of hair; but Diana saw it as liberating for readers of *Vogue*. The reader was finally free—within limits—to become her own editor: "It's your show and you run it your way—you pick, you choose, you take what you want and make the most of it."

The "do whatever" zeitgeist of the late 1960s was close to Diana's longstanding and passionate belief in inventiveness. It chimed with her conviction that the American woman of the 1960s could style herself as whoever she wanted to be, given just a little imagination. "Do whatever" in *Vogue* appeared to resonate with the youthful, anti-authoritarian, hallucinogenic feeling of the hour; but it was no different from the aesthetic of the "Why Don't You?" column. Indeed, *Vogue* in the late 1960s often read in much the same way: "You take the most discreet black sweater and you hang

fifteen gold necklaces on it [*sic*]—in fifteen different lengths and fifteen different textures and fifteen different designs; and some are precious and some are bunkum," said *Vogue*. The idea was to put one idea on top of another. Discretion contrasted with surprise; simplicity contrasted with extravagance. "Invent yourself. Improvise—underplay, overplay, create. . . . Modern fashion isn't a setpiece, it changes every day."

Diana's embrace of the free spirit of the 1960s had an electrifying impact on *Vogue*'s fashion spreads. "I was saved by the 60s," Avedon said. "Because the clothes were so extraordinary." The models sent to him by Diana were just as remarkable. Diana reinforced her stamp on *Vogue*'s imagery by unearthing yet more young women whose quirky, kooky beauty, long limbs, and chemistry with the camera projected the spirit of the hour and played to her latest fantasy of the Girl. "The girl herself is the extravaganza that makes the look of the sixties," wrote *Vogue* on March 15, 1968. "Every couturier, consciously or not, knows her as the vital ingredient in his designs." From 1966 onward, as fashion became more eclectic, Diana offered the readers and designers an ever greater range, sending Funny Girls like Barbra Streisand rather than models to Paris to be photographed in clothes from the collections; and conversely, printing the names of favored models and encouraging them to express their individuality.

Unusually, Diana had to impose the model Lauren Hutton on Richard Avedon. The second of Diana's Laurens, Hutton, who was christened Mary, had actually renamed herself after Lauren Bacall, and they both came to epitomize a classic, fresh-faced blond American look. At five feet six, with a slightly asymmetrical face and famously gap toothed, Lauren Hutton was anything but conventional model material at first glance. But when he first met her Avedon rejected her, not because she looked odd but because he thought she was too ordinary, "a broad." In reality Lauren Hutton was not ordinary. She was brought up in Florida, in an atmosphere of subterranean violence, too much alcohol, and a stepfather who wanted her out of the house as much as possible so that he could

have Hutton's mother to himself. By way of outdoor amusement he taught Hutton how to fish and catch a rattlesnake with her bare hands. "There were five things besides my stepfather that lived in our backyard in that swamp that could have killed me: four different kinds of poisonous snakes, 300 pound alligators," said Hutton. When she met Diana, Hutton had borrowed two hundred dollars from her mother to go traveling in Africa. But the plan went awry and she found herself working as a house model for Dior in New York to keep a roof over her head.

Hutton was spotted at Dior by *Vogue* fashion editor Catherine di Montezemolo and invited to come in and model at one of Diana's run-throughs. Hutton decided during this visit that she was in the fashion equivalent of a dank Florida swamp and retreated into a corner, only to find herself at the end of Diana's celebrated index finger. "You. You have quite a presence," said Diana. "So do you, ma'am," said a flustered Hutton. Diana saw in Hutton a quirky, 1960s take on the Lauren Bacall American girl and dispatched her to Avedon who had, by now, dismissed her three times. Not knowing what to do with her, Avedon asked her where she came from. "I said Florida, and he asked, 'What did you do there?' " Hutton replied that she played in the woods. "He asked, 'Woods?' and he looked up from behind his equipment. 'What did you do in the woods?' I said, 'Well, there were lots of snakes and turtles, and I would run and jump over them and leap over the logs.' . . . He got up. He uncurled himself, put a little X on the floor, and said, 'Go over there and run and jump.' " Although they were seen as a radical innovation in 1966, Avedon's pictures of Hutton running and jumping marked the introduction to 1960s *Vogue* of Munkácsi's active, athletic fresh-faced "farm girls jumping over fences" in *Bazaar* a full thirty years earlier. Hutton would turn out to be a model with an extraordinary range, but in 1966 she had the special magic of a tomboy who became an American beauty.

Penelope Tree, by contrast, came to epitomize *Vogue*'s flower-power period and materialized in front of Diana at a party, just a few months after her discovery of Hutton. On November 28, 1966,

she went to dinner with Ronald and Marietta Tree before Truman Capote's Black and White Ball, where she encountered their seventeen-year-old daughter. Penelope Tree was wearing a skimpy, see-through dress by Betsey Johnson that appalled her father but thoroughly impressed Diana and became the talk of the night. Diana telephoned Tree the next morning and sent her straight to Avedon. "She was gawky, a little hunched over, with stringy hair, absolutely not a beauty at all," said Polly Mellen. When Tree came to the studio for a sitting in July 1967, Mellen thought she looked like a gangly little urchin. "I came out and said to Dick, 'I don't know. She doesn't fit the clothes. Look, the arms are much longer than they should be.' He said, 'She's ready. Don't touch her. She's perfect.'" Diana agreed. "I am really fascinated by how beautifully built she is," she wrote to Avedon. "I suggest that we use some highlighting on her cheekbones and that we are of course very careful with the eye makeup that it will not close the eye but will open it. . . . she takes on a definite authority in clothes as she has a real feeling for clothes and not just a selfish feeling for clothes."

Penelope Tree's first major appearance in *Vogue* took place in October 1967, modeling "new fashion raves" and accompanied by an article called "The Penelope Tree," by Polly Devlin. "She projects the spirit of the hour," wrote Devlin, "a walking fantasy, an elongated exaggeratedly-huge-eyed beautiful doodle drawn by a wistful couturier searching for the ideal girl." Tree was photographed by Avedon in a sequence of four poses in a black bell-bottomed pantsuit, straight hair flying; and in a huge close-up with the enormous Briolette of India diamond in one eye. Diana's campaign to confer fashion authority on Tree continued in January 1968 in a feature called "Fantastree"—fourteen pages of fashion that turned on the idea of romance: organdy pantaloons ruffled over moccasined feet, lace at the wrist, and ruffles up to the chin. It took imagination to wear romantic fashion romantically, said *Vogue*, and Penelope Tree was the girl who knew how to do it, who had the special kind of gesture to make lace cuffs blow about, who woke up in the morning and just knew that she should wear

dozens and dozens of tiny Indian silver bells on her fingers. Tree seemed magically to capture the hippy-trippy spirit of the day, but that was the least of it. She was witty and intelligent too. "Penelope Tree is the girl of her dreams," said *Vogue*. "What she is in her imagination she becomes in reality—Greek boy, maja, Indian chief . . . all mystery and seductiveness one moment; in the next, butter wouldn't melt in her mouth."

Diana appears to have divined something of herself and her past in all her favorite models of the 1960s. She loved Veruschka's capacity for reinvention and her instinct for self-fashioning. Lauren Hutton was Diana the huntress, a daredevil beauty whose feeling for the wild and for Africa can only have brought to mind Emily Dalziel at her most dashing. Penelope Tree, meanwhile, came from a smart Anglo-American background that was similar to Diana's own. At one point Diana had three generations of the family photographed for *Vogue*: Penelope's mother, Marietta, her grandmother, Mrs. Malcolm E. Peabody, and her half sister Frances FitzGerald. She also commissioned an article about Ronald Tree at his house in Barbados, presenting the whole family as glamorous, intelligent, and formidable. Curiously, Tree's upbringing was almost as unhappy as Diana's and for much the same reason. Marietta Tree was not a loving mother; and Tree spent most of her childhood in the nursery while her mother had affairs. Marisa Berenson became another of Diana's favorite models from the late 1960s onward. She was a great beauty who felt herself to be profoundly ugly, but she was talked into confidence about her looks by Diana, who refused to allow Berenson to feel undermined by the critical remarks of those closest to her. She earned Berenson's lifelong gratitude and friendship for this, but it almost destroyed the relationship between Diana and Berenson's grandmother, Elsa Schiaparelli, who was furious with Diana for encouraging her granddaughter to model. Ironically, this seems to have been because Schiaparelli was a snob who wanted Berenson to marry a prince, and felt that modeling was vulgar and beneath her.

The model who took the skinny, prepubescent look of the later

1960s further than any other was Twiggy. Diana did not discover English-born Lesley Hornby and never pretended that she had, but she used her constantly throughout 1967, putting *Vogue*'s seal on her celebrity while Twiggy was still seventeen. The love affair began in the February 15, 1967 issue, with Twiggy modeling prêt-a-porter fashion, and photographed by David Bailey. Diana overrode Irving Penn's objections to being asked to work with a "scrap" by commissioning Bert Stern to photograph Twiggy at the Paris collections in a seven-page spread that included a famous image of her gazing wistfully at herself in a mirror. Shortly after this, Twiggy made the cover of *Vogue* for the first time (April 15, 1967), and traveled to New York for a shoot with Avedon at Diana's invitation, to be greeted by a Beatle-worthy frenzy. In the August 1, 1967 issue, Twiggy and Avedon bounced off each other to create strong, vivid new images, including Twiggy in huge "flying hair" created for her by Ara Gallant, and leading a fashion spread called "Daring Young Romantics." This featured eighteenth-century styles from a range of American designers including Geoffrey Beene, Harold Levine, and Anne Fogarty. As far as Diana was concerned, Twiggy was not just a successful young model whose figure was "the master pattern for a million teen-agers all over the world": she was a link between American *Vogue* and the working-class stars of the London pop scene. As far as Twiggy was concerned, Diana's interest and her invitation to New York gave her the all-important break in North America. "The call from Vreeland was the match that lit the blue touch paper," she said.

It was 1968 that marked the end of one fashion era and the high point of another. That summer Balenciaga closed his doors, asserting that there was no one left to dress. With very, very few exceptions—and certainly not enough to sustain his atelier—the great *Dames de* Vogue had disappeared. Diana was staying with one of them, Mona Bismarck, on Capri when the news of Balenciaga's retirement came through. It had a dire effect on her hostess: "Mona didn't come out of her room for three days. I mean, she went into a complete . . . I mean, it was the end of a certain part of

her *Life!*" But it was certainly not the end of Diana's, for the end of the Balenciaga era coincided with some of the most radical images in *Vogue*'s history. During the summer in which Balenciaga retired, Diana dispatched Veruschka, her photographer-boyfriend, Franco Rubartelli, and Giorgio di Sant'Angelo to the Painted Desert in Arizona. Giorgio di Sant'Angelo was Florentine by birth and worked in industrial design before becoming a stylist for *Vogue* and a designer in his own right. Exuberantly original, he liked to ornament the body as well as drape it, and was responsible— among much else—for painting around Twiggy's eyes for the cover of *Vogue* in July 1967 ("Sprig on a Twig," said *Vogue*); making bikinis out of gold chains; using coffin velvet as a fashion fabric; and putting appliquéd flowers on bare legs.

As if to underscore the annihilation of couture, Diana gave Veruschka, Sant'Angelo, and Rubartelli a completely free hand during the Painted Desert shoot. "We took fabrics, cords, tools, pins, scissors, and ribbons and just created everything on the spot," said Veruschka. Described by *Vogue* later as "magnificent windups" of cloth coming from the nomadic workshop of Giorgio di Sant'Angelo's imagination, the designer furled, swaddled, and swathed Veruschka in yard upon yard of fabric. In one famous image he gave her a headdress the size of a small moon made from white jersey lined with fur, and wrapped her in moiré-embossed velvet and golden braids in the manner of a desert sheikh in another. Diana helpfully ran a diagram at the back of *Vogue* for those who wanted to construct such fashions at home. From Veruschka's point of view, being tricked out as a jersey-and-wild-honey Orlon parcel tied up with golden brown polyurethane string in the heat of the Arizona desert was anything but comfortable, but there were consolations: "At some point, I fainted. I just tipped over like a tree onto a slab of solid rock. Of course, it didn't hurt at all because of all the padding."

In the second half of the sixties, as fashion constantly deconstructed and reconstructed, *Vogue*'s reader shifted shape in Diana's mind's eye too. Increasingly, Diana blurred all conventional

demarcation lines. Having positioned Mary Quant in fashion's outer space in 1963, Diana gave pride of place to the publication of her autobiography in August 1966, in which Quant announced: "There was a time when clothes were a sure sign of a woman's social position and income group. Not now. Snobbery has gone out of fashion, and in our shops you will find duchesses jostling with typists to buy the same dresses." At the same time, the clothes Quant and others designed for girls who refused to dress like their mothers were rapidly adopted by stylish women of all ages, as youthful notes in fashion sounded the dominant chord. By 1967 the caution that led Diana to put *Vogue*'s daughters, rather than their mothers, into miniskirts, disappeared, and what emerged was a reader who was somewhere in between. Diana ran photographs by William Klein of Jacqueline de Ribes, who was in her late thirties, wearing a velvet "*mini-jupe*" at least ten inches above the knee, with a crocheted silvered sleeveless turtleneck sweater and silvered stockings. Conversely, she commissioned photographs by Bert Stern of seventeen-year-old Twiggy modeling clothes by Saint Laurent at the Paris collections that might normally have been bought by older women, not teenagers.

Later Diana would be accused of being blinded by an obsession with youth, to *Vogue*'s detriment. In 1967 her excitement about youthful fashion for everyone made sound commercial sense. "For [many] people," writes the historian Alan Petigny, "identifying with youth culture eased the discomfort they felt toward the current state of American society. And because the world of adolescents was so tightly bound to consumption, millions of adults, flush with disposable income, were able to essentially shop for identity." Diana's own view was that when it came to shopping, the most important thing in a woman was an adventurous attitude to her own potential. Every American woman would like to wake up one morning touched with the intoxicating mystery of the European woman, she wrote, but she also had a unique freedom to become her own person. "The fact is that the American woman, plunged

by the accident of history into a unique situation, has—with a good lot of help from men—made herself up as she went along."

DRIVING HER VISION through twenty issues a year and making sure it never flagged was very hard work. Instructions to Diana's secretaries started by telephone from her bathroom at home from 7:30 a.m, though she rarely appeared in the office before late morning. (Down the years she had changed her mind about lunch. By the time she arrived at *Vogue*, Diana's lunch consisted of peanut butter and jelly on whole wheat, coffee that was not too hot, ice cream that was not too cold, and a shot of Scotch. "I think people who lunch don't work," said Diana in later life. "They're just lunchers.") While staying in the bathroom each morning may sound like the last word in affectation, it gave Diana time to let her imagination, memory, and subconscious run free before entering the fray in the afternoons. Ideas dictated to *Vogue*'s secretaries on the phone from early morning onward were circulated as interoffice memos by lunchtime, and were so idiosyncratic that they were frequently shoved into drawers for posterity. Diana's inspiration could come from anywhere. At least once, it came from the bathroom itself: "We really want beautiful bathrooms. We would like to call these bathing rooms."

Sometimes ideas came from deep in Diana's past. Her teenage preoccupation with George Sand resurfaced and so did Isadora Duncan, brought to life—and suitably melodramatic death—in a film starring Vanessa Redgrave. She sent her colleagues back to Chanel's predilection for hair ribbons in the 1930s, and to Greta Garbo as Mata Hari in George Fitzmaurice's eponymous 1931 film. But for the most part Diana's hand was on the contemporary pulse. Cher had to be persuaded to take her makeup off: "There has to be a transparency, a gleam, a lightness and an amused expression or people look dead today and very old." The staff really should read about Barbarella, "a lovely girl who spends a lot of time in space with a variety of types . . . her eye is never hard . . . in every way she

has the upper hand through her imagination and vitality." Close, close attention should be paid to serpents. "The serpent should be on every finger and all wrists . . . we cannot see enough of them." Memos streamed in about colors: "Let's promote gray. For everything." There was even an occasional foray into international politics: "Is there nobody in the village or slightly out of work or a poor old Arab who would make us some passamenterie[*sic*] ornamental belts? . . . Let's give the Arabs a boost, they are very down in the mouth because of the war."

Some of the memos were matter-of-fact and practical. Why had no one been to Oscar de la Renta's last show? Why was no one using Britt Ekland (a Swedish actress then married to Peter Sellers) as a model? Was everyone aware that with health, a good figure, and tanned skin no one need spend much on summer clothes in 1969? Diana was always conscious that *Vogue*'s support for stylish trends could be damaging to the fashion industry's craftspeople and was anxious about it. "I am strong for the shawl, the poncho, the toga what-have-you," she wrote in a memo on November 20, 1969. "BUT. We must not cut in on the coat market. First of all we will lose the workers and there are very few tailors left and they must have the encouragement."

The memos constantly nipped and barked at editors in a battle to keep standards from slipping. Hair was a particularly sore point: "I think it is essential that you all re-think these terrible looking curls next to the face . . . we agreed long ago that they looked dipped in salad oil." Richard Avedon and Polly Mellen received a broadside on this subject too. "I do believe that these pieces of hair dipped in salad oil and then draped up on top of the head is the most horrible thing that has hit hairdressing. . . . It goes completely against the knuckle. . . . It is poverty stricken and horrible." Lack of editorial interest in Givenchy's new leg paint annoyed her intensely: "I think it is curious that none of you have taken up with this colored paint because it is very amusing and projects a mood." Freckles were another source of irritation: "I am extremely disappointed that no one has taken the slightest interest in freckles

on the models. . . . I heartily suggest that we get going as soon as possible on this delicious coquetry." And again on May 12, 1969: "Are we using freckles? Don't forget them." Pamela Colin, who was American *Vogue*'s editor in London, sometimes found herself at the wrong end of memos from Diana, who thought that London was seething with revolutionary new ideas and implied that Colin must simply be missing them: "We must have the moods, this is why we have outer offices."

In 1968 Meriel McCooey, a well-known fashion editor herself, celebrated Diana in London's *Sunday Times*. "There are only a handful of magazines left that create fashion as well as report it," she wrote. "American *Vogue* is one and as its Editor-in-Chief, Diana Vreeland still has the power to alter or transform clothes if she thinks fit, or even invent them if they don't exist." Diana was one of the last great activists, wrote McCooey; she was a woman who was employed for her intuition about fashion and her flair, who stamped her opinions on every page, even if they were sometimes eccentric. " 'I saw her at her desk one day, and I couldn't believe my eyes,' said a girl who worked on *Vogue*. 'She was wearing a pearl and a gold Chanel earring on one ear, and a ruby and diamond on the other. I thought she was getting absent-minded but it was a fashion she'd just thought up.' " Diana had not of course just thought this up—she had proposed it in "Why Don't You?" thirty years earlier, but neither the girl who worked on *Vogue* nor Meriel McCooey was to know. "Her gift, if that's what it is, might be called the reverse of restraint," said McCooey. "Half the clothes she shows are unwearable. . . . But she sticks to the principle present in all her work—which is to lead the way with breathtaking fantasy, so that less emphatic women can adapt it to suit themselves."

MCCOOEY'S ARTICLE APPEARED at a high point of Diana's career at *Vogue*. But 1968, the year in which it was published, was marked by unprecedented turbulence and an increasingly dark mood. The year began with the violence and destruction unleashed by the Tet

Offensive; the assassination of Martin Luther King on April 4 pro-
voked riots across the United States; demonstrations and student
protest brought everyday life to a halt in many places, including
Diana's beloved Paris and, closer to home, at Columbia Univer-
sity. Robert F. Kennedy was assassinated on June 5; antiwar pro-
test surged again as troop numbers in Vietnam reached the half
million mark; at the Chicago Democratic Convention in August,
Mayor Richard Daley's police beat up demonstrators in full view
of the television cameras; and Richard Nixon was elected presi-
dent in November, only four years after Lyndon Johnson's land-
slide victory. The long U.S. economic boom of the sixties ended
with a recession in 1969 that lasted more than a year, caused a rise
in unemployment, and had an immediate impact on consumer
spending that coincided with a hippy-influenced reaction against
materialism. During 1969 the utopian ambience of the so-called
Summer of Love gave way to a much darker atmosphere. The Viet-
nam War, already highly divisive, sunk to a new low with revela-
tions about the massacre at My Lai. For all the peace and harmony
of the Woodstock festival in August 1969, the violent, ugly mood
was crystallized by the killing of a man at a Rolling Stones con-
cert at Altamont, California, in December. The extension of the
Vietnam War to Cambodia in 1970, and the deaths of protesting
students, first at Kent State University in Ohio and then at Jackson
State in Mississippi, sounded the death knell for 1960s optimism as
the idealism of the Summer of Love simply evaporated.

Articles in *Vogue* that addressed the great political issues of
the day were few and far between. Three articles about Vietnam
by Frances FitzGerald that appeared in 1967 were the exception
rather than the rule. Diana was fascinated by Frances FitzGer-
ald's family, the Trees, but this does not account for her decision to
publish FitzGerald's work, since she was ruthless about rejecting
material from celebrities even when they were friends. The expla-
nation lies rather in FitzGerald's approach, and her brilliant char-
acterization (which, though deeply political, did not appear to be)
of the pervasive unreality of the war, which caused soldiers, press,

and Vietnam to startle at phantoms. "The Americans have cre-
ated Viet Nam anew. With language they have fashioned a coun-
try called 'Viet Nam' out of the original chaos, a country which
bears no simple relation to the country that the Vietnamese live
in. Like all such constructions, 'Viet Nam' describes the shape of its
creator's mind," she wrote. It was more usual for politics to appear
in the pages of *Vogue* as a new style key, eviscerating the original
political impulse. As Grace Mirabella put it: "Black nationalism
was wonderful afros and models wearing dashikis. Third World-
ism was girls in djellabas and harem pants, rajah coats and Ne-
hru jackets." Later Diana put it differently. "You read revolution
in clothes," she said. "You read everything in clothes. That's why
clothes are interesting."

At the time, however, her instinct as editor in chief of *Vogue*
was to bat the darker side of the Sixties away from its pages, and to
position its dreamworld as an antidote to controversy and turmoil.
In at least one "People Are Talking About" column, in June 1965,
this was quite explicit. "People Are Talking About . . . Anything
to ease thinking about the two subjects on everyone's mind: Viet-
nam and 'the Negro Revolution.'" Instead, proposed *Vogue*, the
reader should focus attention on the pleasures of "the eruption of
the young in every field—the young, no longer the silent genera-
tion but the generation committed, concerned and loquacious." Ex-
amples included, in this instance, a selection that was random even
by Diana's standards: Peter Beard and his book of African animals;
"a bleak, perspiring British singer" called Tommy Steele; George
Balanchine; and Petula Clark.

In 1969 she responded to the darkening skies outside the Gray-
bar Building by invoking more vigorously than ever the power of
fantasy. One idea that prevailed in *Vogue* in 1969 was the Gypsy
look, which bore no relation to any real Gypsy, dead or alive, but
seemed to imply that the best solution to the world's problems was
to turn one's back on it all and take to the open road looking fabu-
lous. Avedon photographed another of Diana's favorites, Anjelica
Huston, in a Gypsy caravan in Ireland. Jean Shrimpton modeled

Gypsy-inspired garments that included a fringed suede shawl by Joan Kavanagh, worn over brown plush pants. "To roam the earth and know the secrets of the world—to be a Gypsy—to look like a Gypsy, dress like a Gypsy, to move with the splendid freedom and vitality of the Gypsy—is suddenly everybody's dream," said *Vogue*. By mid-1970 *Vogue* was channeling Fleetwood Mac. "You go your own way. And you change your own way . . . one day you paint big orange apples on your cheeks and wrap yourself up in a silk shawl with Chinese embroidery and thick knotted fringe . . . and the next day you're swinging down the street in tweeds and brolly and wrinkly suède boots . . . you've only to give your imagination a little push."

From the end of 1969, however, this sort of fashion was being challenged from several directions at once. There was loud indignation from long-standing readers of *Vogue* who were maddened by not being able to find clothes featured in the magazine in the stores; and a chorus of complaints from those who felt that neither "fantasy" nor "do your own thing" was right for them. Ann Bonfoey Taylor was one of them, and she went to the length of visiting Diana in her office in November 1970 to make her views known. An adventurous and beautiful society woman, Taylor had been a member of the U.S. Women's Ski Team when she was younger. She designed ski clothes that featured in *Bazaar* in the 1940s until her marriage to Vernon Taylor, Jr., and then acquired an exceptional wardrobe of couture clothes by such designers as Balenciaga and Givenchy. The main thrust of Mrs. Vernon Taylor's objections, which were tape-recorded by Rosemary Blackmon, was the lack of fashion direction from *Vogue*. "It's all very confusing to do our own thing . . . ," Taylor complained. "I think it is asking too much. Too much time, too much shopping, too much trouble for the ordinary woman." The styles in *Vogue* were for the young, she objected, but the young looked beautiful in anything, and there were other times in a woman's life when she wanted to look good, in clothes that were suitable for everyday life. "How can life be possible without fantasy?" asked Diana. "The average woman has to

be practical about it, Diana," said Ann Taylor. "It's confusing, now everything is a masquerade, and we can't wear our masquerade clothes to the supermarket."

Diana refused to accept this. The freedom to do one's own thing was wonderful, she asserted. "There's no reason why you shouldn't walk out of the house looking like a nun, if that is what you think is splendid. . . . Doing your own thing is the greatest opportunity that has ever come over the horizon." The best thing about the 1960s, said Diana, was that individual style no longer had anything to do with money. "That's what's so great! Why should we wait six months because one woman in Paris had the privilege of dressing at great expense at a great maison de couture?" But Ann Taylor did not want to look like a nun. She wanted clear advice about hemlines, proportions, and outfits that would last from dawn till dusk with small adjustments. She thought other readers would welcome this advice, and she thought they needed it too. In practice, she said, the problem with "do whatever" was that everyone just looked a complete mess.

MEANWHILE A CHALLENGE to fashion itself was building on another flank. Betty Friedan had published *The Feminine Mystique* in 1963, and although this book did not ignite the contemporary women's movement as sometimes suggested, it hit a nerve. On the one hand, most Americans believed that a normal family consisted of a homemaking mother who looked after the children, and a breadwinning father. On the other, women were going back to work in larger numbers than ever before by the early 1960s; and the young women of the Youthquake were going to college in greater numbers too, frequently becoming involved in protest movements and left-wing debate when they arrived on campus, since it was impossible to ignore. As young, educated women emerged into the job market in the late 1960s, they saw discrimination and sexist attitudes with fresh eyes, and at every turn; and as small groups of women started to raise their own "consciousness" in the late 1960s, they drew the attention of much less extreme women to a panoply

of mechanisms designed to keep them in their place, including the all-powerful media, supported by advertising, especially on television and in women's magazines.

Possibly because they were unsure how to address the success of *The Feminine Mystique*, which was excerpted and much discussed in midmarket women's magazines, Diana and Allene Talmey waited until the March 15 issue of 1966, the year in which Friedan founded the National Organization for Women (NOW), before giving her any kind of platform. They also approached her sideways, by commissioning an article about Friedan's book from Jessica Mitford, who, by dint of being author of *The American Way of Death*, a well-known radical, and the sister of the writer Nancy Mitford, the Nazi sympathizer Unity Mitford, and the Duchess of Devonshire, had a unique point of view that could not possibly be mistaken for *Vogue*'s. "Oh Betty Friedan, what hast thou wrought?" wrote Mitford. "An obsession with being Interesting, a new mass movement, a craze for the individuality of women, that's what. Mrs. Friedan's thesis . . . is that women whose interests are limited to household responsibilities tend to become bored and neurotic. I must quickly say that I agree with the substance of her argument; but as so often happens, it has been seized upon and pulled out of shape by some of her devotees." Jessica Mitford, an Englishwoman by birth, noted that America had a long tradition of highly original, individual women with an "inborn buoyancy of spirit that enables them to withstand the slings and arrows of outraged conformists," and that modern feminists were simply following in their footsteps. Tongue in cheek, she added: "Beware! There are indications of sinister forces at work seeking to undermine your newfound individuality. Somebody up there is watching you, namely the fashion editors. They may force you into a common stereotype yet."

By 1969 this had ceased to be a joke. Many different "feminisms" were now emerging; and while early twentieth-century suffragists—including Mrs. Pankhurst—had embraced fashion and beauty as weapons in the female arsenal, groups more radical than Betty Friedan were loudly taking exception to the idea that

women should be judged by their appearance, and that a woman's life should be dedicated to making herself alluring to men. At sixty-seven, Diana did not deal easily with the idea that a woman should want to do anything else. "I believe women are naturally dependent on men," she told Christopher Hemphill. "The beauty of painting, of literature, of music, of *love* . . . this is what men have given the world, not women. I think all women are muses— *m-u-s-e-s* in one way or another. You're not exactly talking to a feminist mover."

Partly because of Reed, Diana could see that male identity was changing, and she thoroughly approved. "The feminine side of SO *MANY* men has come out that has never come out before. I see this all the time. It's practically every man." She was, however, confounded by changing conceptions of the way women lived their lives. Now that they had the Pill, asked Diana, what else did they want? Her view, in line with Jessica Mitford's article, was that America had a long tradition of doughty female individualists, and once such women had reliable contraception there was nothing to hold them back. "How free can you get? Isadora Duncan was free. How liberated can you get? I remember my grandmother very well. She was an impossible, extraordinary woman. If *anyone* was liberated, she was." Later, Diana liked to recall her riposte to a scruffy radical feminist who challenged *Vogue*'s emphasis on surface decoration and explained that she had no wish to be any man's plaything: "If that's the case, my dear," said Diana, "you haven't got a *worry* in the *world*."

However, *Vogue* was not straightforwardly antifeminist in the late 1960s. One glance at Diana's 1960s fashion pages reveals that she was on the same side as feminists who believed that women should enjoy their bodies and embrace sensuality. She had always loved fashion that worked with the dynamic, active body, and she continued to venerate it throughout her time at the magazine. At *Vogue*, Diana's predilection for body-celebrating fashion showed in spread after spread, from the body-hugging psychedelic catsuit modeled by Mme Jean-Claude Abreu at Giza in 1965, to the

stripped-back fashion of the miniskirt and the midriff-baring top, the minidress that required toned upper arms, and eventually designs that bared bosoms too. "Rosemary, don't forget that transparency has taken a big step in this world. It is very much part of fashion. It is not peekaboo," she wrote in a memo to Rosemary Blackmon, with a copy to Richard Avedon.

> *The body is quite clearly defined whether it is the bust (BIKINI), whether it is the legs, whatever it is. . . . we are dealing with an entire generation who are insane about revealing their bosoms and when I say insane I mean insane with joy and one day soon they hope they will walk down the Champs Elysee* [sic] *with nothing above the waist."*

Here *Vogue* had some catching up to do. While its staff were canceling navels in 1962, Christina Paolozzi appeared naked from the waist up in *Bazaar*, photographed by Richard Avedon. But from 1966 on, images tumbled onto *Vogue*'s pages that no one would have dreamed of suggesting to poor Jessica Daves: a model photographed by Gianni Penati in a Galanos dress, with bare legs and feet, pulling up the skirt of her dress in an erotically suggestive way; Lauren Hutton's breast (but not her face) emerging glistening from an unbuttoned Van Raalte bodysuit, on a beach in 1969, photographed by Richard Avedon; Irving Penn's photo of a naked Marisa Berenson, draped only in chain necklaces, that appeared in a beauty bulletin in April 1970. "Pride of body," proclaimed *Vogue* in September 1967:

> *It shapes the mores, stamps the art, and helps form the special character by which every age is forever identified. . . . In the very best sense, we enjoy our bodies—not in their tape-measured perfection, but in the naturalness with which we've become free to use them. . . . It has taken a century, but at long last we've emerged from our Victorian past.*

Moreover, Diana's pleasure in the glory of the human body was not confined to women. In the early 1960s Richard Avedon

photographed Rudolf Nureyev dancing naked, with every muscle, every sinew stretched in a backward arch that suggested the outer limits of human endeavor striving for perfection. "Nureyev, here in an agony of action, could have been the source and inspiration for many of Michelangelo's sublime realizations of the human form," read the caption. It was an image Diana reserved for the 1967 Christmas issue of Vogue, and later recalled that it had been captured at a memorable shoot. She was a great admirer of Nureyev, and unusually, she made sure she was present when he came to Avedon's studio. Nureyev, who arrived straight from an overnight flight, warmed up by dancing around the studio, in and out of the waiting crowd of assistants. Then he disappeared behind a screen and removed all his clothes. At this point the assistants were dispatched, leaving only Diana and Avedon in the studio as Nureyev emerged from behind the screen. "You know how it is with men in the mornings," said Diana to the writer Andrew Solomon when she was in her eighties, startling him with an extraordinary vertical gesture. "And it was like that! And it stayed that way for *such* a long time! And there was nothing we could do but wait for it to go down! . . . And it was very strange, but it was . . . *impossibly* beautiful!"

Unlike many women of her generation, Diana welcomed the arrival of the Pill and the sexual freedom that came with it, though at the time this was implied in *Vogue*'s fashion spreads rather than made explicit. It was Jessica Daves who first commissioned an article about the Pill a year after it was licensed for use, in 1961. Diana did not run another major feature on the subject until April 15, 1967, when the number of American women using the Pill was thought by *Vogue* to have risen from one hundred thousand in 1961 to more than 5 million. (Passionately interested in the relationship between science, health, and beauty, she gave more space, page for page, to the promise held out by hormone replacement therapy.) Looking back later, however, she saw the Pill as one of the great breakthroughs of the twentieth century. "To me, the Pill was the turning point in the whole younger generation, because it created

a totally different society. . . . The Pill was true freedom. Girls and boys could do anything; they were protected." She particularly welcomed the dent made by the Pill in puritanical American attitudes. "We all know people were as stiff as starch before they met their . . . mmmmm. Sex loosens up."

Vogue's reader, as imagined by Diana, was a sensual, sexy, strong, independent, intelligent, and creative woman. Diana had long believed that women animated clothes rather than the other way around, and had been the first to publish the names of her top models and work with the grain of their individual personalities. Diana's constant emphasis on doing one's own fashion thing, and her conviction that style was accessible to anyone, accelerated the collapse of restrictive ideals of "proper" womanhood that *Vogue* had promoted in the 1950s; and there were moments when the magazine explicitly grappled with the whole issue of changing female identity. A feature in January 1967 mused on the way girls and boys were dressing alike, a phenomenon that fascinated Diana. However, as the stripped-back fashion and the undressed women in *Vogue* became ever more erotic and eroticized through the lens of David Bailey, Richard Avedon, Bert Stern, and Helmut Newton, the magazine came in for sharp criticism, and not just from a shocked older generation.

By 1969 feminists of different political hues were questioning just who was gaining most from the sexual revolution of the 1960s. This reaction was undoubtedly provoked on the left by boorish male radicals who denied women a voice at protest meetings and expected them to do the typing and make coffee. But there was also wider unease at the extent to which the sexual revolution was taking place on male terms. This was a revolution where young women were expected to be constantly "up for it," but characterized as sluts if they exercised sexual freedom. Women who saw sexual liberation differently, as a way of achieving true sexual equality with men, with exciting potential for a new balance and harmony between men and women, often ended up being made to feel ashamed of themselves. It was also clear that men were

enjoying all the advantages of sexual liberation but walking away from intractably old-fashioned problems like pregnancy.

Unsurprisingly, feminist groups started to notice a gap between everyday reality and the rhetoric of sexual liberation with which they felt bombarded by advertisers and the media. By 1970 feminist debate, some of it quite extreme, was concerning itself with images of women's bodies as they appeared in fashion magazines, with voices arguing that fashion itself was mired in false consciousness. Women, went the argument, were being fooled. They were being deluded into thinking they could buy perfection; they were being manipulated into seeing themselves as inadequate; they were even being tricked into thinking that women's magazines were really for them, when in fact, images of seminaked women in fashion spreads were being created by men designing women for the male gaze. From this perspective, Irving Penn's photograph of Marisa Berenson clad in nothing but jewelry represented nothing less than male colonization of the female body, an act of aggression that more radical feminist groups sought to reverse.

As feminist antifashion pronouncements became more doctrinaire, *Vogue*'s position on feminism equivocated and then hardened. In June 1970 *Vogue* ran a profile of several powerful American women titled "People: Liberated, All Liberated," which reflected Diana's view that female liberation was really nothing new. On September 1, 1970, *Vogue* ran an article by Sally Beauman entitled "Who's So Liberated? Why?" which was at best uncertain in tone and at worst positively sneering. It was all very well being liberated in a seminar, said Beauman, but it was quite another matter at a dinner party, in the office, or in bed. The article included a "Feminism v. Femininity" rating, poking uneasy fun at women like Susan Sontag: "A tomboy who suffers from a bad Electra complex, has mysteriously produced a son, and tends to look upon men as intellectual wrestling opponents. Regrettably, no humor." The same issue also ran a beauty feature asserting that "the true impact of an unforgettable woman is a heart-stopping face, each feature an enchantment on its own."

Clearly *Vogue* was never going to appeal to radical feminists. But in dismissing all feminism as so much nonsense, Diana not only ignored the possibility that some feminists might have a point, but overlooked the way in which the insights of more moderate feminism were persuading less extreme women to reconsider their own position, not just at work but at home.

For her part Diana saw womankind heading in a quite different direction. "In my opinion in the year 2001 so many physical problems will have been surmounted that a woman's beauty will be a dream that will be completely obtainable," said Diana to Carol Phillips in 1967. Controlling the figure would no longer be a problem, and all the difficulties caused by "the various feminine rhythms" would have been resolved. So what would a woman do with her time? "It will then amuse and entertain her to paint herself as if she was a heathen idol," said Diana. "Imitating and creating anew each time she wishes to step into the world into her room or wherever it is that she is amusing herself to be." Alongside the body painting, Diana predicted a seriously punishing bathing routine. "She will probably bathe three or four times a day as she will be very conscious of keeping herself in a completely exhilarated invigorated state and very much Diane de Poitiers and will probably take three cold baths a day." Freedom from so many constraints would give women far more time for beauty, as well as time to be busy and productive. The two, thought Diana, went hand in hand. "The future holds a golden world. . . . It will be for beauty it will be for intelligent productiveness."

For the first time in her professional life Diana misread a profound cultural and economic shift. Whether she liked it or not, one powerful consequence of the Youthquake was a new generation of young women, educated as never before, who were aiming for professional careers, not four baths a day. These middle- and upper-class young women in their late twenties and early thirties were no longer spending "clothes-dollars" dished out by men, but earning their own and wanting clothes that were suitable for professional lives. Instead of embracing this new trend, however,

these powerful young women made Diana uneasy. Implicitly at least, she had always made a distinction between women who were "clever" and educated, and readers of *Vogue*. Most of *Vogue*'s readers, she contended to Ann Taylor, did not read a word of it. Fashion was a visual world, and *Vogue*'s readers were inspired by its images, not its text. "I mean [at *Vogue*], we're asked to help, we're asked to direct by people who are fashion conscious." Such people were creative, people with an imaginative spark in contrast to the intellectual genius of, say, a distinguished anthropologist like Margaret Mead. She did not need *Vogue*, Diana maintained to Ann Taylor. "She's got two washed dresses and is the most brilliant woman in the country."

It was the conservatism of the younger generation that Diana disliked more than anything. When educated young women came to work at the magazine she frequently felt that all the pizzazz had been drilled out of them. Her unease about this was reflected in the manner in which *Vogue* presented Frances FitzGerald to readers alongside her article about the people of Vietnam in May 1967. Frances FitzGerald was "disarmingly pretty" and she was certainly educated: "Magna Cum Laude Radcliffe '62," but she was "exacting in her facts and her purposes . . . [and] has caught what the American college woman often only chases after, an independent, creative mind." In contrast with FitzGerald the young college women who came to work at *Vogue* were not only dull but astonishingly ignorant: "They've been to the best schools, and they have never heard of Anna Karenina; they don't know whether you're talking about a brand of toothpaste, or what."

Diana found it difficult to connect with a construction of the female self that was not primarily driven by style, seemed unable to understand that young women earning their own money had to be careful about how they spent it, and was baffled by the idea that they regarded making themselves alluring during the working day as the least of their worries. Rather than understand that unadventurous but versatile clothes were essential for women making inroads into new socioeconomic territory, Diana thought

the modern woman had retreated back to dismal American conformism. "She never wants to be first. . . . Safe from what! Nobody knows. But safe." Could she not help such women by telling them how to look good in a sweater and skirt rather than dressed up as a Gypsy? asked Ann Taylor. But Diana had a different solution. Conservative women should express themselves with an überconservative fashion look like that of the 1950s: "They would probably look perfectly delightful as it would suit them and suit their dispositions."

BY THE AUTUMN of 1970 Diana's failure to sense new moods mattered. The September 1, 1970, issue of *Vogue* misfired badly with a prominent spread created by Giorgio di Sant'Angelo, who styled some of the new season's American designs on models dressed up as Native Americans. Instead of striking an imaginative and witty note this looked ridiculous, passé, and insensitive, since Native American poverty was already a live political issue. As usual Mainbocher and Norell were spared such treatment with more conventional spreads, but the veteran American designer Adele Simpson, who was also an advertiser, is said to have hated the styling of her clothes so much that she refused to allow *Vogue* to photograph them again. There was an air of strain and unease about the issue more generally, and it was forced onto the defensive about furs. But Diana pushed on in her own romantic direction. The silhouette of the Girl of late 1970, she wrote in one memo, "can easily be compared with the moyen age heroines such as Queen Guinevere and Tennyson's Lady of Shallott [*sic*]." In early 1971 Diana saw her in the hippy-chic of the beautiful Talitha Getty as she flitted around the world wearing mirrored dresses, fisherwomen's lace caps, and a wreath of green leaves, before dying of a drug overdose a short time later. Even before this, *Vogue*'s readers were begging to differ in significant numbers. In the face of recession, an antifashion mood underscored by feminist characterization of high style as the enemy, and a feeling that the clothes in *Vogue* were simply irrelevant to their lives, they stopped buying the magazine. As readers

deserted, advertisers took fright. *Vogue* was not alone in suffering falling revenues: *Bazaar* also suffered badly. But *Vogue's* losses became catastrophic. In the first three months of 1971, Condé Nast's flagship publication suffered a 38 percent drop in advertising, and in the rush for cover, the blame was laid firmly at Diana's door.

Her supporters fell away. She had already alienated many on Seventh Avenue. "What is the name of that designer who hates me so?" she once asked. "Legion," Nicky de Gunzburg replied. For every Giorgio di Sant'Angelo, there were many who were up in arms about her approach. Some, like Norman Norrell, had long mistrusted her. Others were alienated by her refusal to attend their openings, and her much-vaunted scorn for Seventh Avenue "cookie cutter" clothes. June Weir, fashion editor of *WWD* at the time, has cautioned about overstating the extent to which the ire of designers was aimed solely at Diana: "They were always complaining, whatever one did." Oscar de la Renta sometimes objected to the way his designs were styled in the late 1960s, yet his friendship with Diana remained intact. But Babs Simpson recalled that by 1971 many designers and manufacturers were genuinely furious, so angry that at least one of them only admitted her to his building by a back elevator because she was from *Vogue*. Carol Phillips thought that, consciously or not, the depth of their anger was caused by Diana's warm embrace of "do whatever" because such radicalism posed a danger to Seventh Avenue by passing decision-making power to the consumer. Diana was blamed for sensing a much wider trend, one that undermined the cosy complicity between the fashion press, designers, and manufacturers who could no longer rely on turning a profit each season by ganging up and telling women what to wear. "In a funny way, it [led] to the destruction of the fashion industry," said Phillips.

Internal support leached away too. Even colleagues who admired Diana began to feel she was losing touch, that "do whatever" was dictatorial in its own way, and that her view of fashion had had its day. Others, like Babs Simpson, had already been ranged against her for longer, believing that Diana had begun brilliantly

but was drunk on self-importance, had gotten much too far ahead of the readers, and was "trashing" the magazine. There were some, of course, who had felt the rough end of Diana's tongue too often and had no urge to defend her. Diana had never been easy to work for even when things were going well. "*Vogue* was high drama, amateur theater. Everyone was trying to be 'adventurous' and 'amusing' and 'Up . . . up . . . up!' to please Vreeland," wrote Grace Mirabella, who adored Diana once she came to know her. But this made for a less than pleasant environment as editors jostled for favor. The atmosphere at run-throughs, as Lauren Hutton had noticed, could be horrible. As the pressure grew, Diana became more ferocious, inconsistent, and arbitrary. She fired one otherwise competent young woman for having a clumping, noisy walk. ("She should have taken more *care*, George," she told Plimpton.) When staff members started to complain about her behavior, Liberman attempted to hold editorial meetings, but they became a shambles. "She wouldn't listen or she'd go off on some subject." She was often fascinating, said Liberman, but that was not the point.

AS THE AMERICAN economy contracted, Seventh Avenue manufacturers began to lose money and the cost of Diana's working habits became another bone of contention. Diana's behavior in Paris during the collections was a particularly sore point. She dismissed the idea of working out of the *Vogue* offices in the place du Palais Bourbon, and set herself up in a hotel as Carmel Snow had always done. But in Diana's case it was a matter of converting her suite in the Hôtel de Crillon into an office, complete with furniture and half a dozen special phone lines, with enough space for Susan Train, her assistant, and Diana's own secretaries. "You never had any peace," said Carrie Donovan. "But imagine the expense. The expense was wild." To make matters worse, Diana increasingly went to see only the collections of Paris couturiers she admired, refusing to do otherwise simply to please the business side of Condé Nast.

Moreover, her inventive fantasies had always been expensive. Motivating the fashion industry did not come cheap. Mirabella

wrote: "Inventing a look like . . . 'Scheherazade' meant drawing up a Concept, finding fabric swatches, commissioning the clothes, working out the accessories and hair with all the different fashion editors, dress rehearsing the look in the office, sometimes with the actual model, and Polaroiding it, so that every detail would be absolutely perfect on the day of the sitting." Shoots became more dangerous as Diana's ideas grew wilder. One involved Babs Simpson, John Cowan, Ara Gallant, and two models, who went by helicopter to photograph evening dresses on top of a mountain peak in the Andes. Cowan was determined to make it look as if the models were floating in the clouds. At five o'clock, when the helicopter pilot told them it was unsafe to stay any longer, Cowan insisted on staying to get what he wanted. The helicopter took off, abandoning the *Vogue* party on the top of the mountain. The team spent the night on the mountain huddled under Maximilian furs. "The next morning they found the Peruvian army waiting, absolutely furious, and pointing to the ground," Mirabella recalled. "It was covered with mountain lion tracks."

There is no doubt that some of Diana's character traits worked against her as the pressure grew. Carrie Donovan was one of Diana's great admirers who felt the turbulence acutely in the fall of 1970. She was so concerned about the way Condé Nast's executives were attempting to build a case against Diana behind her back that she asked to meet her for lunch. But Diana's long-standing habit of not listening to what she did not want to hear meant that she cut Donovan short. Insofar as she did react, she batted away Donovan's concerns by saying that it was all part of the job: " 'Oh, I know how to handle those boys. You just get tougher than they are,' which is what she had been doing for a whole year," said Donovan.

When criticism from Condé Nast's executives became impossible to ignore, there was nothing in Diana's character that enabled her to deal with it strategically. Instead she reverted to the ways she had evolved in childhood. She exiled herself from the problem, shut her office door, and sat with a trusted colleague like Grace Mirabella, soothing herself with a tale of something beautiful,

and moving to her secret inner world, the kind of world she was constantly entreating *Vogue*'s readers to make for themselves. *"Her world,"* she observed of a girl in a Sargent painting:

> *She has created it for herself, it is real for herself—and therefore real to us . . . as we believe in the world of Alain-Fournier's* Le Grand Meaulnes—*a world which we know, in fact, to be no larger than a tiny French village—but a world so fully imagined by its author and so deeply realized that it becomes seductively real, vast and borderless: the world of the romantic. . . . It is for you to discover for yourself, within yourself—within the silent, green-cool groves of an inner world where, alone and free, you may dream the possible dream: that the wondrous is real, because that is how you feel it to be, that is how you wish it to be . . . and how you wish it into being.*

Mirabella, who describes herself as loving Diana with a school-girl crush, became increasingly alarmed by Diana's tendency to retreat into her own "silent, green-cool groves" as the real world grew more hostile. "I used to beg her to go before Alex and Si Newhouse and speak her piece. Because I knew that there was an inner logic to Vreeland's apparent chaos. I knew that she had clear visions and solid plans. I also knew that Alex Liberman, for all his new talk about money, knew absolutely nothing about the business of running *Vogue*," she said. But Diana refused to do it.

However, the die was only finally cast once Liberman decided that it was no longer in his best interests to protect Diana and that it was time to move against her. Diana had made Liberman uneasy from the outset. Though he hired her from *Bazaar,* he had never really succumbed to her charm. He later described her as a "disciplined savage" and appreciated her meticulous side, but he never understood her way of motivating *Vogue*'s readers and her conviction that the best way to persuade women to spend money on clothes was to interest and inspire them. He disliked the "whole sort of court of admirers" who surrounded her. A man of little humor, he thought the atmosphere in her office was downright weird:

"Games were played. I remember Cecil Beaton and Capote trying on different hats in Vreeland's office." Diana's close relationship with *Vogue*'s photographers particularly dismayed him, for she carried on liaising with them closely, just as she had done at *Bazaar.* "I was not involved in planning. Vreeland would plan sittings in her office. And would tell whatever she would tell to inspire the photographer or say what she really hoped to get. And I think I never participated." This was not how Liberman had worked with Edna Chase or Jessica Daves; and it made Diana his rival and altered the balance of power.

The arrival of Avedon, for which Liberman had also campaigned, made matters worse. Used to his own way at *Bazaar,* Avedon took a tough line at Condé Nast after Liberman prevented him from taking a black model to Japan because he was concerned about *Vogue*'s advertisers in the south. After this, Avedon tended to deal directly with Diana. But this worried Liberman intensely. "Frankly, they're both very strong personalities, Avedon and Vreeland. And they sort of became in cahoots." Carol Philips thought that if Diana and Avedon did appear to be "in cahoots" it was unconscious: "I think it struck her as an efficiency. . . . I don't think power was on her mind ever. . . . I think she thought about getting through the day. I think she thought about doing something exciting. I think she thought about being turned on." But Liberman did not see it this way. "She was given too much power; she took too much power," he said. She was out of control "like a wild horse." He often found the images in Diana's *Vogue* troubling, particularly the work of Avedon. The pages "were stronger than they should be," with an undercurrent of violence. "I think there were two aggressiveness [*sic*] at work—Vreeland's and Avedon's. . . . It was too daring for its time." While *Vogue* was riding high, Liberman kept his reservations to himself, and he was in any case occupied with problems on other Condé Nast magazines. But increasingly Liberman became concerned that Diana was just too avant-garde for *Vogue*'s readers: "The extremes of her taste that were beginning to be beyond the limits. You know, high fashion,

high style, extremes in sophistication as opposed to practicality, availability. All of that was ignored. I kept saying, Diana, this is going too far."

As revenues dropped and *Vogue* sailed into more trouble, Liberman moved to ensure that none of the blame was directed at him. He attempted to exert the control he felt he should have exercised from the beginning. But it was too late: Diana refused to listen. Mistakes that might previously have seemed nugatory now loomed larger. One of the worst, about which Diana was deeply embarrassed, involved Lord Snowdon and an assignment for the 1970 Christmas issue. She arranged for Snowdon to photograph the racehorse Nijinsky, one of the great racehorses of all time and the property of Diana's old friend Charles Engelhard. But somehow the head of another racehorse, Minsky, was substituted for Nijinsky's in the final article. Diana was devastated, even though Charles Engelhard wrote a kind letter telling her not to worry. Soon afterward a very expensive shoot in Newfoundland was ruined by Diana's decision to ask the highly unconventional Italian fashion editor Anna Piaggi to style it. Piaggi covered models wearing American sportswear classics with feather boas. Liberman thought she had made the fashion look ridiculous, the shoot was written off, and the expense of yet another costly failure played right into his hands. In building a case against Diana he also insinuated that she was drunk in the afternoons. He managed to convince Si Newhouse, but this view was not shared by anyone else, even those who had mixed feelings about her. As Carol Phillips remarked: "I tell you the truth, a woman like that, you can't tell whether she's drunk or not. How are you going to tell? . . . She didn't smell of it. . . . She believed in water . . . she believed in health."

INTENT ON THE romantic view, Diana failed to understand that she was in serious trouble until the day she was fired. When the moment came, in the spring of 1971, it was Condé Nast's president, Perry Ruston, who did the deed while Liberman lurked in his office. Diana reacted by asking to hear the news from Si Newhouse

himself. By now Newhouse, too, believed that Diana's philosophy of fashion, however exciting, was relevant to only a small handful of people. He went to her office and sat down. "And we sat there for what I remember as being almost ten minutes," he recalled. "She was waiting for me to talk and I was waiting for her to say something." He eventually repeated what Perry Ruston had said. Diana stayed very cool. "She just kind of watched, just kind of watched me deal with her. Perhaps in amusement, perhaps in shock. I don't know." There was no argument of any kind. That night, Newhouse had a terrible nightmare about their meeting.

Once the news sank in, Diana was furiously angry with Liberman, both for firing her and for his cowardice in not giving her the bad news in person. "I've met a Red Russian, a White Russian but I've never met a Yellow Russian," was one of her more polite remarks ("a yellow rat" was how she described him to Leo Lerman some years later). According to David Bailey, she added: "Alex, I've been staring at your profile for ten years. Look me in the eye for once." For his part Liberman continued to insist that he had warned Diana but that she refused to hear what he had to say. In appointing Grace Mirabella as her successor, Liberman clearly thought he would be working with someone more amenable to his point of view. But because Diana was deaf to his pleas it is also unclear what else he could have done, for in the end there was no arguing with the sales figures.

Under the leadership of Grace Mirabella, who represented precisely the younger professional woman whom Diana ignored, *Vogue* took off again in the 1970s. Mirabella championed elegant, functional clothes for busy, dynamic women, the "real" women whom Diana had disregarded. The clothes Mirabella favored were often in new fabrics from American sportswear designers. Ironically, they were descended directly from the clothes Diana herself had championed during her "glory days" in the Second World War but later found wanting in imagination. While the business decision to go from twenty issues a year to twelve in 1973 contributed hugely to *Vogue*'s return to profitability, Mirabella's formula

worked outstandingly well for a decade until she too found herself out of step, this time with the ostentatious spirit of the early 1980s.

SO WHY DID Diana's "myth of the next reality" stall as it did? She had no sympathy for doctrinaire feminists. Like many powerful women who had succeeded before female success was commonplace, she had difficulty understanding what the problem was, particularly since, in a perfect world, she would have enjoyed a life of leisure. She thought that professional young women of the 1970s were conformist and conservative. But she had lived through duller style periods before in the 1950s and produced brilliant pages. Liberman thought that with the benefit of hindsight, Diana should have been made fashion director, leaving analysis of the market to others. But this was not a view with which his boss, Si Newhouse, concurred: "My recollection of Dianne [*sic*] is that she . . . was quite prepared to deal with the realities of magazine publishing. And I don't remember her in any way as being a kind of arrogantly destructive force who said, the only thing we're going to put in the magazine is Giorgio Sant Angelo [*sic*] . . . she was quite realistic about the fact that the magazine lived in a commercial world." Other colleagues thought that in the end, the problem was her age. As well as believing that Diana became carried away by her own importance, Babs Simpson thought that at sixty-eight, she was, like Carmel Snow, simply too old for the job. A fashion editor should be "much, much younger," she argued. Grace Mirabella concurred. "She herself was becoming older—approaching seventy—and the fantasy of youth and exuberance seemed to blind her." Mirabella's view was that ultimately it was Diana's compulsive need to maintain the mystery of the "Vreeland legend" that undermined her: "She could not allow the world to see her intelligence, the method behind her madness. She preferred to remain true to her image, to sink with it, than to compromise it by defending her vision."

Perhaps, however, it was not the "Vreeland legend" that Diana was determined to defend, but something else to which she could not possibly give Newhouse or Liberman access. In the end she

refused to articulate, let alone abandon, her vision of the world of the Girl, that alluring being who had allowed her to survive her mother, who had carried her through life with such success, who had brought her a handsome and adored husband, and who had been the basis of her extraordinary career. Liberman said that Diana was an amateur from a previous generation whom *Vogue* could no longer afford. Diana would have agreed. She always preferred to think of herself as a woman of leisure who wandered into the world of work by mistake, propelled by a vision that allowed her to frame a playful, imaginative view of fashion where transformation and reinvention was possible for any creative woman prepared to dream, and which reached its apotheosis in the 1960s. But in the end the Girl who brought her such triumphant success undermined her too. As feminism took hold, and *Vogue*'s readers began to think differently about identity, Diana's attachment to her romantic ideal of female power made her inflexible. In 1971 it suddenly felt old-fashioned, the thinking of an elderly woman, a hangover from a previous generation. A view of fashion as a means of self-expression, as ludic, creative, and empowering, would, of course, eventually resurface strongly alongside other late twentieth-century ideas about female identity, but that time was some way off. For the time being, Diana and the Girl were in *Vogue*'s way; and a short time later they were both gone.

THE YEAR THAT followed was very hard. Though Diana kept up a dignified front, she was devastated, humiliated, and hurt. She insisted privately that it was all a duplicitous power grab by Liberman and talked about him venomously to confidantes, lacing vituperation with an ample seasoning of anti-Semitism. She was devastated, believing that colleagues she had befriended, mentored, and inspired, like Polly Mellen, had failed to support her in any way that counted. She never forgave Mellen, and refused to sign a copy of *Allure* for her years later. Freck flew to New York to assist with negotiations over severance terms, which were generous. Condé Nast Publications took account of the fact

that Diana was a few months short of pensionable service. She was given the title of Consulting Editor. She remained on full salary for the rest of 1971. For that year her expense account, clothing and entertainment allowances, and a portion of the rent on her apartment remained intact. She was offered half her salary—and half her allowances—for two years thereafter. Diana was free to take on additional consulting work provided it did not compete with *Vogue*; and had an office and a secretary for as long as she remained consulting editor. She was not kicked out. But she was most definitely kicked upstairs and the moment it happened all creative authority drained away from her, and into the hands of Grace Mirabella.

Faced with no alternative, Diana moved to a smaller office, had it painted blood-red like her old one, and then stayed away as much as she could. Liberman, meanwhile, swept into her old office and ordered all signs of blood-redness, "*tee*-gray," and Rigaud candles to be expunged. In public, Diana put on her customary brave face. She made sure she did not behave like Carmel Snow, who had continued to pull rank in similar circumstances and made life as difficult as possible for her successor. She arranged to be out of the country on a four-month tour of Europe when the news broke publicly in May 1971. On the day, she sent a cheerful cable from Paris to the office, saying she missed them all and wished they were sharing the Paris spring day, "which is my marvelous and good luck." But friends knew that she was very unhappy. She went from Paris to stay with Kitty Miller in Majorca. Her old friend Edwina d'Erlanger infuriated her by remarking that at sixty-seven, Diana had to understand that her future was behind her. While it was wise to be away from New York and the chatter of the fashion press, Diana discovered that she hated traveling alone, and she was delighted when her old friend Kenneth Jay Lane, who was coming to Europe anyway, agreed to join her at the Ritz in Madrid. It was an old-fashioned establishment where female guests were still forbidden to wear trousers and Lane found Diana amusing herself by getting in and out of the grand entrance in slacks without being

caught. But there was one evening when he was invited elsewhere. Before he went out, he sat with her in the dining room while she ate an early supper like a little old lady. The band struck up "Fascination," and she started to cry—not just a little sniffle but great heaving, noisy sobs. Once she started she was unable to stop. She was utterly miserable: no Reed; no job; no one to travel with; worried about money all over again.

When Diana arrived in Paris in August, there was another brutal shock. Margaret Case, who was in her eighties and had been *Vogue*'s society editor for forty-five years, had committed suicide. She was Diana's neighbor at 550 Park Avenue, a friend as well as a colleague. Case had been asked to vacate her office and work from home by the new regime a few weeks earlier, and had taken it extremely badly. She fell ill and became depressed. Rumors flew: Case had been asked to leave her office so as to make way for Diana; she had looked immaculate when she jumped from her bedroom window; the nurse who was caring for her had just left the room to make a cup of tea. For Diana, who flew home as soon as she heard the news, it was a blow upon a bruise.

It soon became clear that fulfilling her obligations as consulting editor would be anything but easy. Her relationship with Grace Mirabella suffered in a way that was all the more painful because they had once been so close. Mirabella was genuinely astonished to be offered the job of editor in chief by Liberman. But after she accepted, neither she nor Diana said anything about what happened, something Mirabella later regretted. Mirabella sent Diana pages that she had worked on and then cowered, "ashamed and afraid that I might one day run into her in the hallway and have to look her in the eye and *say something*." Diana, meanwhile, never referred to her demotion. "Her sense of etiquette, her pride, and her inbred feel for the right way of doing things would tell her that it was my place to make the first stab at communication. She was right. But I simply couldn't do it."

Diana had one great success in this unhappy period, though it was not obvious at the time. A young and unknown designer

called Manolo Blahnik came to see her in her new office to show
her his portfolio of drawings. His sketches were mainly of theater
sets and costumes, and Diana saw him alone. "I was so frightened
I could hardly speak," said Blahnik. "She must have thought I
was mad. I could barely walk because I was wearing tiny Victo-
rian shoes, far too small, which were killing me. And there was
the woman I'd idolized." Diana turned the pages of the portfo-
lio making polite noises until she came to Blahnik's drawings
of shoes. "'How amazing,' she said. Then, energized, she looked
up and said, 'Young man, do things. Do accessories. Do shoes.'"
Other than set one legendary shoe designer on the path to great-
ness, she continued to write memos: "Don't you think the beauty
of Mia Farrow is fantastic. . . . I think she is definitely a personal-
ity," and "The underlying ways of beauty: walking, talking, smil-
ing . . . the careful enunciation of the language you are speaking."
The memos grew more and more halfhearted: "Sleeveless knit
low oval front and back looks marvelously—I can show you the
kind of top if you are interested." But no one *was* interested, or
listening, and she soon stopped appearing at the office altogether.
"I am not proud of that particular chapter in my history," wrote
Grace Mirabella in her memoir. "But in my defense, I have to say
that, professionally, I had no choice but to make Vreeland disap-
pear. Her legend was so great, and the resistance to me as her
successor so widespread and so insidious, that I had to push on,
at whatever personal cost, to establish myself, because there were
just too many people gunning to bring me down."

Diana continued to fret about money and looked for consult-
ing work compatible with the terms of her agreement with Condé
Nast. Friends came to the rescue, and she swallowed her pride. In
September 1971 she took on the role of personal shopper for Katha-
rine "Kay" Graham, the publisher of the *Washington Post*, and was
rewarded with discreet checks. She became an adviser to the cos-
tume jewelers Coro-Vendome, advising them on trends and new
designs; and in January 1972 she even proposed herself as a con-
sultant to Marks & Spencer in London, recommending that they

extend their line of "little knitted undershirts," advice the store would have done well to heed, given how fashionable these subsequently became. There was talk about a book for the publisher George Weidenfeld. But it was very difficult to adjust to the lack of structure. "This has been a very curious autumn and winter so far," she wrote to Pauline de Rothschild on January 28, 1972. "Not because anything serious has happened but because after 34 years of total routine, I have had to create each day by itself, most of which has been in various parts of town which is complicated and difficult to get to. Nothing has been overstrenuous, it has been, I can only say, 'different.'" She was lining up jobs, she wrote, and had behaved "like a dream." But there was much to think about: "It is just a question of my sorting out what I really am capable of accomplishing."

Then there was a setback. In March 1972 Diana developed a vertebral infection that required treatment with intravenous antibiotics, and obliged her to stay in the hospital for several weeks until the end of April. It was an "ingenious, clever little bug," she wrote to a friend. "Don't ever get anything in your spine." But illness turned out to be a blessing in disguise. Too many acquaintances had slithered away when she was fired from *Vogue*; but in the spring of 1972, this fresh bout of misfortune triggered a wave of sympathy and support from dozens of people whose lives she had touched, improved, or changed, and who were unhappy at seeing her laid low. However forceful and demanding Diana may have been, she rarely said anything unpleasant about friends and colleagues behind their backs. On the contrary, her enthusiasm and encouragement had transformed lives. "To hear someone say that Diana Vreeland is a positive thinker, an evangelist of enthusiasm, is like seeing water poured over Niagara Falls," wrote Jonathan Lieberson. "She has inspired and encouraged more people per cubic inch than Norman Vincent Peale." This brought its own rewards now.

Her nurses gazed in amazement at the stream of glamorous visitors. "It seems to be a long Valentino parade," Diana wrote to

Valentino on April 24. Jackie, Audrey, and Babe had all worn Valentino when they came to see her, and they all looked marvelous. Even her hairdresser had worn Valentino at her bedside. The actor Terence Stamp paid her a visit. Friends formed the habit of dropping in on their way out to dinner. Caviar, delicious food, and luxurious bedsheets arrived daily. Seventh Avenue rallied: Norman Norell, Anna Potok of Maximilian furs, Marjorie Griswold from Lord & Taylor, and many others sent lavish flowers. In the thank-you letters she dictated to her secretary, Diana made being in the hospital sound like one enormous treat: "I happen to have a very beautiful room, overlooking the bridges and the whole of the city and at night when one starts to dream and think of other things, it looks like a modern Piranesi as the whole thing is so dreamlike and exalted." But as she lay in her hospital bed looking out at the lights of Manhattan, not even Diana could have dreamed of the extraordinary last act that was about to begin.

OLD CLOTHES

Not far from the hospital where Diana lay, the Metropolitan Museum of Art was going through its own upheaval. It had acquired a charismatic young director called Thomas Hoving five years earlier and was still reeling from his arrival. Hoving was thirty-five when he was appointed. He had presided over a celebrated series of "happenings" in New York parks before taking the job, and he was determined to shake up the museum in the same way, informing its trustees that he regarded the place (and by implication, them) as "moribund," "gray," and "dying." Hoving set about enlarging the building and the museum's collections in a manner that might politely be described as piratical, but he revolutionized its attitudes, insisted that a populist approach was compatible with scholarship, introduced blockbuster exhibitions, and withstood much criticism for being a huckster as well as a visionary. He caused a stir early in his tenure by declaring that running the Metropolitan Museum of Art was no different from running General Motors, and that it had to be melded into an efficient business enterprise. He quickly lit on its Costume Institute as a potential money-spinner and crowd puller, but it turned out to be a headache.

The Costume Institute had started life independently in 1937, as the Museum of Costume Art, founded by Irene and Alice Lewisohn. Their aim was to raise awareness of dress in human history and to make the case for fashion as one of the decorative arts. The sisters built up a collection of about seven thousand pieces before Irene Lewisohn's death in 1944. Dorothy Shaver of Lord & Taylor then stepped in with a campaign to bring the collection to the

Metropolitan Museum, insisting that it would inspire American designers and act as a spur to independence from Paris in the post-war years. Shaver deployed this argument so successfully that she raised $350,000 from Seventh Avenue to finance the transfer. The Costume Institute enjoyed semiautonomous status from 1947 before it was formally absorbed into the museum in 1960; but activity was low-key and patchy, a state of affairs Hoving was determined to change when he arrived in 1967. His first move was an exhibition called *The Art of Fashion*. To keep Seventh Avenue happy and involve living designers, he hired the leading fashion publicist Eleanor Lambert to work on the exhibition alongside its curator, making her the first outsider to work on a major show in the history of the Metropolitan. He soon discovered that this was not a good idea when he dropped in late one night to discover Lambert pushing mannequins attired in the clothes of her clients to the front of each display case.

Public relations as a curatorial concept was a step too far, even for Hoving. He closed the doors of the Costume Institute for much-needed building work between 1968 and 1971 and thought about what to do next. Small galleries in the north end of the museum basement were bulldozed to open up larger exhibition spaces; state-of-the-art storage for the ever-expanding collection was installed. After his brush with Lambert, Hoving went to the other extreme and appointed the scholarly Adolph Cavallo to oversee the renovations, but Cavallo's first exhibition fell flat. The trustees of the Costume Institute's new Visiting Committee, drawn from the city's social elite and from Seventh Avenue, decided he lacked the common touch. For his part Cavallo was confronted by a committee who thought that Patricia Nixon's wedding dress was just the thing to draw the crowds. These tensions resulted in the waning of Cavallo's star and a vacuum that Hoving found difficult to fill. The Costume Institute had an outstanding curatorial staff led by Stella Blum, but it needed someone to give it the right sort of pizzazz.

In the first instance, however, neither Hoving nor Diana was very keen on the idea that it should be her. The idea of approaching

Diana came not from Hoving, but from his curator in chief, Theo-dore Rousseau, and the museum's secretary, Ashton Hawkins, both friends of the Vreelands and occasional guests at 550 Park Avenue. Diana's lawyer, Peter Tufo, also claimed to have had a hand in the matter. After his experience with Eleanor Lambert, Hoving remained extremely nervous about installing anyone from a com-mercial background. Diana, meanwhile, was not at all sure she was the right person for the task. She had no interest in an aca-demic approach to clothes; her professional instinct was to look for what was fresh and new; and even though she drew on decades of looking at beautiful things as *Vogue*'s editor in chief, she loathed nostalgia. Her initial reaction to Ted Rousseau's proposition was unenthusiastic. However, he refused to give up. "He came to see me four or five times . . . and he sat right where you are now and argued with me. I'd say, 'Ted, I've never been in a museum except as a tourist.' He said, 'Well, why don't you change around a bit?' "

By the time Diana fell ill in March 1972 she knew that no one at Condé Nast was interested in her point of view, and for all the bravado with which she wrote to Pauline de Rothschild, it is not clear that she enjoyed chasing around after consulting work with its attendant financial uncertainty. The proposition from Ted Rousseau was attractive. It came with an office, a secretary, and an annual salary. There was wisdom in going where she was wanted rather than where she was not; and some of her glamor-ous hospital visitors almost certainly persuaded her to think again, emphasizing that she was not being approached as a conventional curator but precisely because of other, creative talents. The sight of Diana so reduced had a galvanizing effect on her circle, and behind her back they sprang into action. Hoving overcame his re-luctance when a group of Diana's most powerful friends, includ-ing Marella Agnelli, Jacqueline Onassis, Babe Paley, and Mona Bismarck (now Mrs. Umberto de Martini) offered to contribute almost half her salary for the first year. It has been suggested that those who agreed to contribute subsequently did not do so; it has also been said that there were some who were asked to contribute

but declined. However, with the exception of Mrs. Paul Mellon, who pledged one thousand dollars and had still not produced it at the end of 1972, a file note from the museum makes it clear that all Diana's friends who agreed to support her paid up.

Diana signed a one-year agreement with the Metropolitan Museum in July 1972 (though she wrote at least one letter that suggests she had decided to take the job by the end of May). It was renewable annually by mutual consent. Her title was Special Consultant, and she was responsible for generating ideas for exhibitions, organizing them, and seeing them through; suggesting sources for additions to the collection and financial gifts; and acting as a link between the Costume Institute, the fashion industry worldwide, and the fashion press. She would report directly to Hoving. For all this she would receive $25,000 for the year, up to $10,000 in expenses (a closely guarded secret), a full-time secretary, and an office, which she proceeded to have painted blood-red all over again. She had work to finish for *Vogue* in Paris in September, but she would start at the museum on September 5. The apartment at 550 Park Avenue was to be completely spring-cleaned in her absence. Her battered old desk chair would be sent from Condé Nast. "I have been rebuilding my life for the last two months," Diana wrote to Mainbocher in August. She was full of excitement, tinged with apprehension. "I am ecstatically happy," she told Ted Rousseau on August 11, 1972, "and I only hope that I don't let you down or the museum." In her engagement diary she wrote: "Life is a fine performance. There are entr'actes." Elsewhere in the diary she scribbled: "Believe in the total authority of the imagination."

Her first assignment for the Costume Institute was delicate. The Duke of Windsor had died on May 18, 1972, a few weeks before Diana signed her contract. A short time later the duchess agreed to give some of his clothes to the museum. The point of contact had been Ashton Hawkins, who had a connection with the Duchess of Windsor's private secretary in Paris, John Utter. At some point the idea emerged that there should be an exhibition alongside the gift, though it is not clear whose notion this was. On July 10, 1972, Diana

wrote to Hawkins, enclosing a list of the duke's clothes as she remembered them and saying she thought the men's cosmetic industry and wholesale tailors could be asked to put up money for the show. In August, Hawkins reported from Paris that Utter was giving the project his full support and he thought they might be able to announce the exhibition and Diana's appointment simultaneously. He emphasized that the duchess was "changeable" but was sure Diana would sort everything out splendidly. Diana arrived in Paris in early September determined to rise to the challenge. She spent part of every day during her first week in Paris with the duchess and Sydney Johnson, the duke's devoted Bahamian valet, picking out items of civilian clothing of particular interest.

Then something went wrong. Much later Diana wrote to Hawkins that "the news came from the Palace that we were to stop the proceedings." As she recollected the affair, she telephoned the duchess's solicitor in London, who said it would be impossible to do the show. The idea that Buckingham Palace blocked the exhibition then became the accepted version of events. The evidence that survives, however, suggests that it was the "changeable" duchess who had second thoughts, and that Buckingham Palace was greatly relieved. The duchess seems to have decided quite suddenly that it was too soon after the duke's death for an exhibition. While she had been enthusiastic about the idea while sorting through the duke's clothes with Diana and Sydney, she appears to have changed her mind within a few days and decided that the museum was behaving dishonorably in proposing the idea. The biographer Hugo Vickers paints a picture of enormous strains in the household in the months after the duke died. As the duchess's health deteriorated, she became increasingly unpredictable, turning against Utter, who supported the idea of an exhibition, and sacking the loyal Sydney Johnson when he asked for more time off to look after his children after his wife died. "It was like a small court, with little for anyone to do and all kinds of machinations going on in the background," writes Vickers.

Given their long-standing friendship, however, it was easier for

both the duchess and Diana to blame the palace while keeping up the pretense that everything was going beautifully. When Diana heard that the president of the Metropolitan Museum, Douglas Dillon, was in Paris, she enlisted his help in sustaining this illusion because by now the duchess was having second thoughts about the gift itself, let alone an exhibition. "Please forgive me tracking you down in Paris as you probably are here on a flying trip," Diana wrote in some panic. "It is my suggestion that you call and see the Duchess of Windsor if you can possibly manage it. I have struck some rather sticky wickets and I think you could clear the air *so* easily by just *assuming* all was going beautifully." In an attempt to restore harmony, Diana and Douglas Dillon both wrote to the duchess assuring her of the museum's honorable intentions and saying that they would wait until the time was right, reassurances that suggest that it was the Duchess of Windsor, rather than Buckingham Palace, who blocked the show.

HOWEVER, THE COLLAPSE of the Windsor exhibition put Diana under real pressure. She was in Paris on her own, and had little idea how to do the job for which she was now being paid. The Metropolitan Museum of Art was an unfamiliar institution with its own ways; and she was working, at long distance, with colleagues to whom she had barely been introduced. The role of special consultant was an experiment in itself. Expectations were running high. While not explicitly hostile to her appointment, the curatorial team at the Costume Institute was watching to see what she could add. It was already starting to look as if she had failed her very first test, and she had to change tack fast. But there was no one on hand to advise her and she had to feel her way.

The Spanish couturier Balenciaga had died on March 23, and Diana's correspondence suggests that she began tentatively to explore the idea of an exhibition of his oeuvre as early as May 1972. To her great relief her first formal meeting on the subject was productive. The Museum Bellerive in Zurich had mounted its own Balenciaga exhibition two years earlier. Diana flew from Paris to

see its curators, whereupon they offered to lend her anything she wanted, including Balenciagas from the Bellerive's own collection. Their exhibition had been imaginatively mounted and made Diana think afresh about backdrops, mannequins, and lighting. She returned to Paris, hired a temporary secretary, and set about some detective work from her room in the Hôtel de Crillon. She met Madame Felicia, the dressmaker in Balenciaga's atelier who finished his last work. Her secretary tracked down Balenciaga's right-hand man, Ramon Esparza, who agreed to lend documentary film of the master at work; Diana unearthed unpublished photographs by Tom Kublin; and Susan Train at *Vogue*'s Paris office rode to the rescue with much practical help.

What proved unexpectedly hard, however, was the task that should have been easiest: persuading friends in Europe who owned Balenciagas to loan them to the Metropolitan Museum. This was partly because the friends who responded quickly and efficiently had quite as efficiently given away their unwanted Balenciagas years earlier. Pauline de Rothschild, on the other hand, still had her Balenciagas but was not as cooperative as she might have been. "Please Pauline do not be bored," begged Diana in one letter from the Hôtel de Crillon. "As I told you it is agreed that you had the most interesting clothes from Balenciaga and it is important that you be well represented in order to make the exhibition complete." Even when they were cooperative, Balenciaga owners did not seem to appreciate the urgency of the situation—an understandable reaction when it was urgent for Diana only. "Everyone loves and adores Balenciaga but are very lazy about finding the one or two dresses that would make such a difference. . . . Do say a little prayer for me as I need the support at the moment very badly," Diana wrote to Cecil Beaton. Beaton had mounted a costume exhibition at the V&A the year before, and agreed to look in its collection on her behalf. But it was all a great change from *Vogue*, where Diana had only to pick up the phone to get what she wanted. Sitting alone in the Hôtel de Crillon with one temporary secretary, Diana felt her initial exhilaration give way to anxiety and frustration as she

began to understand the scale and complexity of the task ahead. "I am now beginning to wonder how you *ever* put your show together," Diana sighed to Beaton on October 6.

Confronted by such unexpected difficulties, she postponed her return to New York twice. Shopping for Kay Graham was canceled unceremoniously by telegram: "Things moving very slowly in Europe . . . feel terrible letting you down . . . know you will get along famously . . . any trend that looks well on oneself is fashion please forgive me." But slowly the tide began to turn. Mrs. Gardner Bellanger agreed to take over administrative arrangements in Paris. Countess Aline Romanones, who had been Madrid editor of *Vogue*, undertook to approach a group of aristocratic Spanish women on Diana's behalf. Romanones was successful in unearthing Balenciagas in Spain that had never been seen before, including a child's communion dress, and in helping to secure the loan of the wedding dress of Queen Fabiola of Belgium. Diana soon realized that she would have to round up more designs than she could actually use, and from every period of Balenciaga's career. In New York, Mrs. Paul Mellon, Mrs. Joseph Kennedy, Doris Duke, and art collector Mrs. Charles Wrightsman all agreed to lend significant garments. After her grumpy first reaction Pauline de Rothschild produced no fewer than eighteen pieces, including some that were very rare. The Musée de la Mode et du Costume de la Ville de Paris loaned a dress belonging to Daisy Fellowes from 1949; and Diana herself contributed a "baby doll" dress from 1957, a black lace overdress with ruffles at the hem, worn over a closely fitted sheath dress.

However, it soon turned out that locating the right sort of Balenciagas from the important moments in his career was only half the battle. Hoving agreed that a show could take place in March 1973, barely six months after Diana started. This left her very little time to work on the way the exhibition was presented, and there was a huge amount to do to make it look arresting. Diana hated the Costume Institute's mannequins, maintaining that they were too lifelike, gave her the creeps, and made the museum's costume exhibitions look like a display in Saks. She battled to use mannequins

made by the Swiss manufacturer Schlappi, which were taller than the average person, were produced in different finishes, and had an abstract quality about them that Diana greatly preferred. Furthermore she insisted they be as close to the visitors as possible, and not behind glass, and should be grouped together above head height for maximum drama.

The main problem, however, was that surrounded by inert mannequins, Diana badly missed the Girl. Where was the woman who actually animated Balenciaga's designs, with her thoughts, her dreams, her inner world? Deeply frustrated by her absence, Diana drew on years of experience in fashion to re-create the impact and drama of Balenciaga at his most spectacular. She demanded subtle lighting effects on the dresses, insisting that background was as important as foreground and that color was critical to creating atmosphere. The connection between Balenciaga's designs and Spanish culture was highlighted in paintings from the Met's collection by Goya, Velázquez, and Picasso; and Diana prevailed upon the museum to loan a magnificent suit of Spanish armor as a centerpiece for the show. Ramon Esparza's documentary films were cleaned up, dubbed with new music, and looped, a process paid for by Halston. Working in three dimensions for the first time, Diana was able to appeal to other senses. The exhibition was accompanied by flamenco music, and Balenciaga perfume was sprayed through the galleries two or three times a day. When it came to dressing the mannequins, it was Mrs. Vreeland the fashion editor who prevailed, not the scholars. Diana was interested in conveying the tactile qualities of Balenciaga's universe. In the process, she had no compunction about stepping on curatorial toes, and her instinct for what would have impact *now* led to some wild anachronisms. Curatorial staff looked on appalled as Diana improvised a sleeveless Balenciaga sack designed in 1956 as a minidress on a tall Schlappi mannequin.

As she went through the process for the first time, Diana discovered that putting on a costume exhibition involved an enormous amount of unexpected and invisible work, not to mention an aptitude for hustling. She had to talk many people into providing

everything for nothing. She and her secretary handled a multitude of details, from clearing permissions, checking the spelling of names, keeping in touch with every donor to the exhibition in the United States and Europe, acknowledging the clothes as they arrived, and finding the right accessories for every outfit, not to mention editing, mounting, and grouping the displays. A habit of hard work and thirty-seven years in the world of fashion stood Diana in good stead as the opening drew closer. She pulled in all the outside help she could, most of it given out of friendship. Kenneth Jay Lane provided jewelry; Priscilla Peck designed the catalog; Richard Avedon, David Bailey, and Bert Stern contributed photographs. Ara Gallant helped with wigs. Pauline de Rothschild and Gloria Guinness wrote articles for the accompanying program. Oscar de la Renta, fashion illustrator Kenneth Block, and Eleanor Lambert all lent their assistance. This set up tensions that lasted for a very long time. "She'd never say what it needed," said one long-term member of the Costume Institute staff. "Then, just before the opening, she'd call in every famous person she knows . . . to save the show."

Though modest compared with what followed, the preview party for Diana's first exhibition included New York's plutocrats and Diana's friends as well as Balenciaga donors and many Seventh Avenue designers. Kitty Miller lent a Goya as well as a dress, though she complained loudly that she was taking it home because no one could see it in the wretched subtle lighting. Press reaction was favorable, and the exhibition stimulated a debate about the importance and relevance of the clothes in 1973. Halston, for one, found it inspiring though Calvin Klein thought that most of the clothes looked out of date. Standing beside a raincoat of 1962 that was shown with boots and patterned stockings, Diana remarked once again that she often saw what people thought of as street fashion for the first time at Balenciaga. Bernadine Morris, senior fashion writer of the *New York Times,* observed how fast the world had changed since the late 1960s. "Balenciaga closed his house in 1968, when fashion, like other institutions, was splintering," she wrote. "It's a shock to realize it was only five years ago."

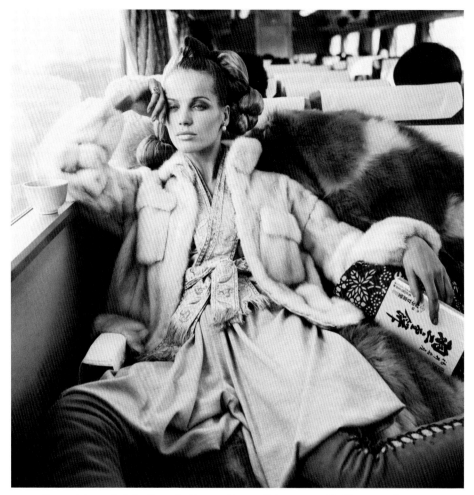

Veruschka, mink by Emeric Partos, Japan, February 1966. Photographer: Richard Avedon © The Richard Avedon Foundation.

Veruschka as a Tartary princess in "The Great Fur Caravan: A Fashion Adventure Starring the Girl in the Fabulous Furs, Photographed for *Vogue* in The Strange Secret Snow Country of Japan." *Vogue*, October 15, 1966.

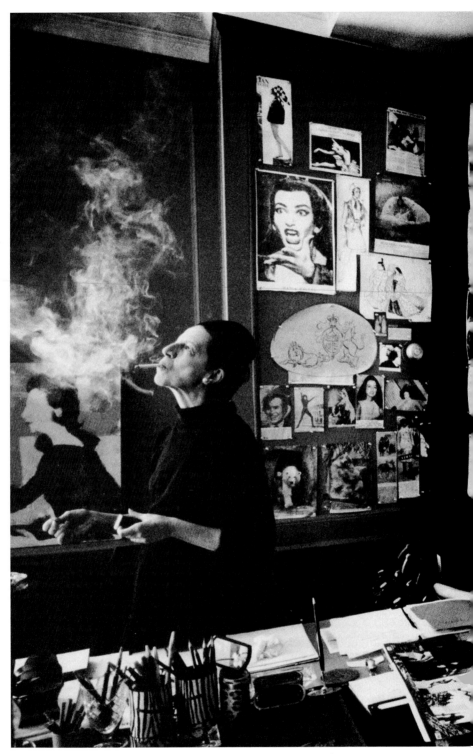

Diana in her office at *Vogue*. (Photographer: James Karales)

Vogue shoot in Palmyra, Syria, 1965.
(Photographer: Henry Clarke)

Veruschka in fur hood by Giorgio di
Sant'Angelo, *Vogue*, July 1968.
(Photographer: Franco Rubartelli)

Veruschka in a
"magnifcent windup" by
Giorgio di Sant'Angelo,
Vogue, July 1968.
(Photographer: Franco
Rubartelli)

Jean Shrimpton
photographed by Bert
Stern, September 1, 1963.
(Stern/*Vogue*/Condé Nast
Archive © Condé Nast)

Four years later:
Vanessa Redgrave,
photographed by
Bert Stern in a 1960s
reworking of one
of Diana's lifelong
favorites, the leotard,
under a rhinestone-
studded vinyl coat.
Both by Oscar de
la Renta. *Vogue*,
February 15, 1967.

Diana at home at 550 Park Avenue. (Photographer: Cecil Beaton)

Installation view, "American Women of Style" (December 13 1975–August 31, 1976), The Metropolitan Museum of Art, The Costume Institute Galleries, photographed in 1975.

Installation view, "Yves Saint Laurent: 25 Years of Design" (December 14, 1983–September 2, 1984), The Metropolitan Musem of Art, The Costume Institute Galleries, photographed in 1983.

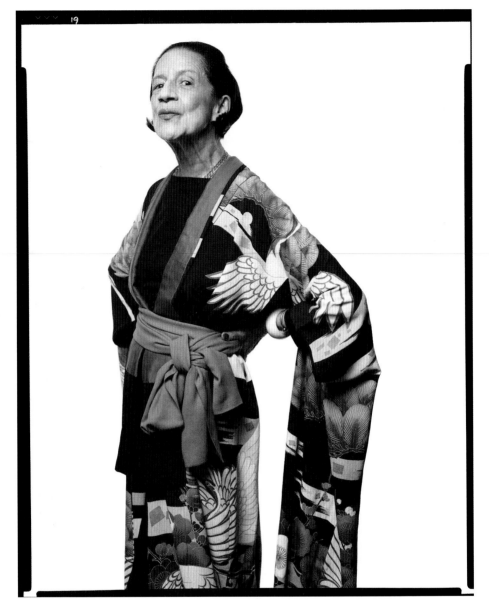

Diana Vreeland, fashion editor, New York, June 21, 1977.
Photographer: Richard Avedon © 2008 The Richard Avedon Foundation.

Diana photographed for "A Question of Style," by Lally Weymouth, *Rolling Stone*, August 11, 1977 (a variant image was published).

..

THE BALENCIAGA EXHIBITION attracted more than 150,000 visi-
tors, making it—as far as the museum was concerned—a success.
But Diana was slightly disappointed by the low-key press reaction
and became anxious about the renewal of her contract. Under the
terms of her severance agreement with *Vogue*, her full Condé Nast
pension was payable only from 1975, and she had given up the sal-
ary and expenses otherwise due to her as consulting editor. She
needed to keep going at the museum for at least one more year to
bridge the gap. According to writer Michael Gross, the turning
point came at a lunch party in 1973 at the Connecticut home of
Oscar de la Renta, when Diana's friends rode to the rescue once
again. Kenneth Jay Lane and Bill Blass were among the guests and
conversation turned to Diana, who was not present. They knew
she was worried about the lack of press coverage and about the re-
newal of her contract. The Balenciaga exhibition showed just how
capable she was; and she had also made a case that benefited them
all, for the couturier as artist. They knew she had exciting ideas for
other exhibitions. As it happened, Oscar de la Renta had just been
made president of the dressmakers' lobby, the Council of Fashion
Designers of America (CFDA), founded a decade earlier. At lunch
that day, the guests decided to support Diana by making the CFDA
a benefactor of the Costume Institute.

This was helpful, but it was even more helpful when Oscar de
la Renta, president of the CFDA and thus cobenefactor of the insti-
tute, turned his attention to the Party of the Year. The Party of the
Year had originally been conceived by Dorothy Shaver and Eleanor
Lambert as a way of adding to the Costume Institute's endowment
in 1948, but in its early years it was essentially an industry event.
"It was basically Seventh Avenue, a lot of Jewish people," recalled
an institute staffer. "A rabbi's wife who knew everyone did the
seating." From the moment Oscar de la Renta became involved,
the Party of the Year changed. Its focus swiveled toward circles
where fashion and high society intersected. All guests, regard-
less of fame or fortune, were obliged to buy high-priced tickets.

To make it attractive to New York's finest, it had to be exclusive. To make it exclusive, its committee had to be drawn from New York's elite, which in turn bound them into supporting the Costume Institute. As far as Thomas Hoving and the Metropolitan Museum were concerned, this was a most welcome development, not just because the Party of the Year brought glamour and social distinction but because the strategy was such a success that revenue from party tickets helped to finance the Costume Institute exhibitions thereafter. For example, expenditure on one exhibition in 1974 was estimated at around $100,000; but costs were covered before it opened by sponsorship of $35,000 and Party of the Year ticket receipts of $78,200.

One effect of the CFDA's support for the Costume Institute and its close involvement in the Party of the Year was to boost the influence of fashion industry figures at the Met more widely, to the dismay of some who regarded the emergence of this new circle of influence and power as sinister. This was not, as alleged later, an aristocratizing plot orchestrated by Diana from her basement office on behalf of her fashionable friends. Apart from being insufficiently strategic, she was far too busy to undertake such a project. In attracting new sources of money to the Met, she was doing what she had been asked by Thomas Hoving; and in any case support from the fashion industry had been central to the development of the Costume Institute since 1944. She had little direct involvement in the Party of the Year, which was run by the museum's development office. She gave away as few tickets as possible and regarded making her friends pay as a way of raising some money for the Costume Institute. "Mrs. Vreeland was actually quite discreet about her involvement in the development of the actual guest list," her assistant from that period remarked. "She did not talk about who she considered 'in' or 'out.' "

By the time of Diana's second exhibition in 1973, Bernadine Morris of the *New York Times* noticed that the party's character had subtly changed. Each of 450 people paid $150 to dine in the Great Hall, surrounded by the Chinese porcelains on permanent

display, upon tablecloths of an Oriental pattern chosen by Oscar de la Renta himself. As president of the CFDA he had sent the fabric around to some of his members' workrooms to be stitched into tablecloth shape. He was also credited by Bernadine Morris with the design of at least three of the most eminent guests' dresses: the mauve satin-back crepe worn by Mrs. Douglas Dillon, the flowing aqua chiffon dress of Mrs. de la Renta, and a red chiffon worn by Mrs. Jacob Javits, though Morris noted with some alarm that both the chiffon dresses sported small burn holes by the end of the evening, which suggested that they constituted a major fire hazard. At least some of the guests, according to Morris, managed to tear their eyes away from each other and look at the exhibits.

The exhibition was called *The Tens, the Twenties, the Thirties: Inventive Clothes 1909–1939*. The real stars of the show were the clothes themselves, chosen by Diana not just for their beauty but for the extent to which they exemplified new ideas: the new freedoms heralded by Poiret; the simple relaxed suits of Chanel, and her embrace of male fashion for the lives of modern women; the craftsmanship and inventiveness of Vionnet, the first to cut fabric on the bias so that it moved with the female body; the wit, artistry, and surrealism of Schiaparelli; the romantic fantasies in lace of the Callot Soeurs; and the Orientalism and the colors of the Fauves and Ballets Russes. Each design represented experiments in length and line that would play themselves out over and over again throughout the twentieth century. There were pieces in the exhibition that Diana remembered well from Europe in the 1930s, lent by other collections at the urging of donors such as Mona Bismarck and Millicent Rogers. Once again Diana called for assistance from every direction, and battled to ensure that each exhibit was beautifully staged and lit. Exhibition visitors wandered through the galleries to the strains of Gershwin, Erik Satie, Stravinsky, and Duke Ellington. Chanel perfume was sprayed in the galleries twice a day. Contemporary paintings, by Guy Pène du Bois and Kees van Dongen among others, helped to set the scene.

This time, the reaction was unequivocal. The press called it a "dazzler," and the designers were enthralled. Apart from remarking that it was the best costume exhibition he had ever seen, Bill Blass was convinced it would have "the most shattering effect on fashion." Valentino, who was closer to French couture than most of those present, was stunned by the Vionnet dresses at close range. The show had such an impact on Issey Miyake that he arranged for it to go to Japan, believing that it would open the eyes of Japanese designers. Harold Koda and Richard Martin later wrote: "The foremost accomplishments of Halston in the mid- and late-1970s seem so clearly predicated on his interpretative engagement with this show." The exhibition was credited with introducing a new generation of New York's designers to the possibilities of the bias cut; and it revealed Diana as a connoisseur as well as a catalyst of fashion. It also inspired Irving Penn to shoot a photographic essay: he greatly preferred photographing clothes on uncomplaining Schlappi mannequins to working with temperamental models. The exhibition and its staging caught the imagination of the public too. The Balenciaga show had been a commercial success, with more than 150,000 visitors. This one broke records. Almost 400,000 people went through the galleries, vindicating Diana's perspective, her showmanship, and her taste, and ensuring that there was no further question about her position at the Met.

Thus far Diana's exhibitions had focused on the couture. The show that followed took her back even further to years of adolescent dreaming as she gazed at the goddesses of the silver screen. Hoving maintained later that most of her best ideas came from him, but that this one was an exception. "She uttered one word, 'Hollywood.' It was my turn to shout, 'Consider it done.'" Diana recollected—probably more accurately—that when she first mooted the idea, Hoving's response was "Why are you dragging Hollywood into the Met?" Once Hoving came around to the idea, Diana went to Los Angeles and embarked on a major search, assisted by costume designer Robert La Vine. This time, the chief difficulty she encountered was Hollywood's lack of respect for its own past. Costumes

were cut up and reused, and many studios did not keep or catalog them. The people who preserved Hollywood costumes were all too often obsessive private collectors who refused to let Diana over the doorstep, let alone borrow the clothes.

She eventually broke through. Paramount and Warner Brothers had kept their more significant items. The family of David O. Selznick had preserved the costumes of *Gone With the Wind*. Mary Pickford had somehow managed to hold on to the costumes from all her films and allowed Diana to explore the attic of her house, Pickfair (faithfully accompanied by Tim Vreeland, who was banned from going to see Jack Nicholson and Warren Beatty with his mother in the evenings on the grounds that he was too middle-aged). Mary Pickford had not been quite so successful in hanging on to her curls, which Diana found in the Los Angeles County Museum of Natural History, along with Mae Murray's costume from *The Merry Widow*. She was stunned by the quality of the workmanship. Carmel Snow and Diana had given the designer Adrian very little support when he moved from Hollywood to Seventh Avenue, but Diana raved about him as a costume designer, along with Travis Banton, Walter Plunkett, and a host of less-known names. "The basis was perfect designing and incredible workmanship—the cut of décolletage, the embroidery, the mounting of a skirt, and miles and miles of bugle beads," she wrote. In Diana's view the best Hollywood costumes were as good as anything produced by the couture.

On her travels around Hollywood Diana met a fanatical collector of movie stills. He allowed her to search through thousands of images until she found costumes she remembered from her youth that had disappeared from view. This resulted in one of the most controversial aspects of the exhibition—Diana's audacity in commissioning replicas when she was unable to find the original, or where the piece in question was too damaged to have any impact. Furs were often "fur interpretations" by Max Koch, from pelts supplied by Diana's old friends in the fur district; jewelry was made especially by Kenneth Jay Lane; and most of the accessories were

new. Designers who helped with replicas of Hollywood costumes for the exhibition included Oscar de la Renta, Bill Blass, Arnold Scaasi, Giorgio di Sant'Angelo, and Stan Herman. They were fully acknowledged, and every copy was faithfully spelled out in the accompanying catalog. But there was a feeling in the curatorial world that it was not done to mix up replicas with originals in this way; that when it came to the point the difference was not made sufficiently clear; and that it was somehow misleading for uninformed visitors who might not bother to read the small print.

The uninformed visitors did not seem to mind one bit, as they lost themselves in a shimmering world of tinsel and marquee lights. They found Marilyn Monroe on an elephant loaned by Andy Warhol. They saw her skirt catching the breeze in *The Seven Year Itch*. They encountered Grace Kelly, Cary Grant, and Greta Garbo. They gazed at Audrey Hepburn in *My Fair Lady* with its fabulous black-and-white designs by Cecil Beaton. They wandered through galleries scented with "Femme" by Parfums Rochas to soundtracks from *Top Hat* to *Dr. Zhivago*. Judy Garland sang "Get Happy." "That's the best advice anyone can have," said Diana on the audio guide. "Movies were the big trip of the twentieth century and put magic in our lives." They took people to worlds of which they could only dream. "It is about the dreams, the grandeur of Hollywood. It's Travis Banton taking you across the Sahara in flowing chiffon. It's Queen Christina dressed historically, romantically, the way you'd prefer history to be. That's the *idea* of Hollywood. Do it Big. Do it Right. Give it Class."

BACKSTAGE, DIANA'S WORKING routine remained the same. After Ferle Bramson became her secretary in 1974, she telephoned with a raft of instructions from home first thing in the morning and then left her undisturbed until after midday, whereupon she would sweep in and leave Bramson with no further time to herself. There was an enormous amount to do, and Diana was meticulous in the way she set about it. Once Diana had an exhibition in view, it naturally became the focus of much of her work. But

she had to think ahead too, and just as she had worked on several issues of *Vogue* simultaneously, there were always two or three other ideas in the pipeline. It took time to establish what was available and to work out whether the clothes that existed really added up to a major exhibition. Research for *Fashions of the Hapsburg Empire* in 1979–80, for example, began three years earlier in 1976. "It was," said Bramson, "a great editing process, a sifting." Bramson had the greatest respect for Diana's creativity. "The ideas poured out of her," she remembered. Though the museum's personnel department warned her that Diana was difficult, her boss's whims became too much for her only once: Bramson had diligently arranged a large number of photos for the Hollywood exhibition when Diana came in and mixed them all up again because she was in a bad mood. Bramson was so upset that she broke a pencil in half and said, "I quit" before running off in tears. Diana, who rarely thanked staff members for anything, never apologized either; but this time she realized she had gone too far. Her way of making it up was to soothe her secretary with an interesting story about a beautiful person: "I say, Miss, did I ever tell you the story about Cher?"

"It could be terrible even if she liked you," said Bramson, but it was naturally even worse if she did not. Stella Blum and Diana had a very strained relationship in the years that they worked together. As associate curator, Stella Blum's responsibility was to ensure the historical accuracy of each exhibition. When Diana rode roughshod over the facts, Stella Blum's professional reputation suffered, something Diana willfully failed to understand, implying that Blum was a dreary little mouse and that her constant emphasis on scholarship was dull. "You had to do things Mrs. Vreeland's way. And be prepared for the way to change from day to day," Bramson recalled. "Mrs. Vreeland's way" was somewhat fluid. Nothing was ever decided until the moment an exhibition opened. Even the night before the preview, Diana was capable of moving everything around and starting again, just as she had insisted on reshoots until the last minute at *Vogue*. However, Diana was frequently rescued

from crass mistakes by the curatorial team, who went around the
exhibits making alterations in her wake, doing their best to en-
sure, where they could, that the costumes were presented with ac-
curate information. There were those who felt that Diana would
not have survived her first year without this. On the other hand,
there were others who believed that Stella Blum could have tried
harder to understand Diana's point of view. "They kept it pleasant
on the surface," said Bramson. "But they really butted heads."

From the time of the setup for *Romantic and Glamorous Hol-
lywood Design* onward, Diana was also assisted by large teams
of volunteers, many of whom went on to have notable careers in
fashion. In 1974 her helpers included Tonne Goodman and An-
dré Leon Talley of *Vogue*. Once she trusted an intern, she trusted
him or her implicitly, though, as always, that intern had to be ca-
pable of running off with Mrs. Vreeland's more gnomic remarks
and bringing something back. Some volunteers were terrified by
her fierce growl and imperious, shouty manner when she was dis-
pleased. For others working as a volunteer was a life-changing
experience. Diana had complete confidence in Tonne Goodman,
and André Leon Talley earned her trust quickly too. On his first
morning Stella Blum handed him a box full of purplish metal
disks and informed him that it was the chain mail dress worn by
Lana Turner in *The Prodigal* and that his task for the day was
to put it back together. After struggling with it for a while, he
worked out what to do and assembled the dress on a mannequin.
At lunchtime Diana glided in. He watched her from behind a pil-
lar. Diana's *Vogue* had inspired his own dreamworlds as a very tall
African-American teenager with an eccentric interest in fashion
in North Carolina. He had admired her passionately from a long
distance for years, but it was the first time he had ever seen her at
close range. "She was a solo pageant," he recalled. Diana stared
at the Lana Turner dress for a long time. Then she sent for him
and, in a dream-come-true for Talley, kept him by her side for six
weeks. Once she was sure he was committed to a life in New York
fashion, she exerted herself mightily to find him a job. "He knows

about every couture dress of the last fifty years and he's worn 'em all," she said by way of recommendation to Oscar de la Renta's right-hand man Boaz Mazor.

George Trow of *The New Yorker* caught up with them all just before the Hollywood exhibition opened in November 1974. Diana was still fulminating about the mannequins but had been taking corrective action:

Well, first *of all we knock off all the bosoms. All the ba-zooms go. We had a little Japanese carpenter with a tiny little saw—exquisite instrument—and he goes rat-a-tat . . . boom! Rat-a-tat . . . boom! I mean, he was doing fifteen ba-zooms a minute. Ba-zooms were falling. The guards were going absolutely dotty.*

Diana walked Trow through the exhibition. "This is from *Madame Satan*," she said, pointing to a remarkable red cape embroidered with silver and gold. "She seduces her own husband at a party on a dirigible." This came as Trow was recovering from Diana's exegesis of Greta Garbo. "Garbo. Garbo! . . . she has the *en plus* of *amoureuse, and* she has a little gray monkey with a scarlet hat and coat. *Oh! How* I have *worked* on that monkey's little *hat.*" Stuart Silver of the museum's display department trailed around miserably behind them. The exhibition was due to open in two hours, all the bases had to be painted, and each time Diana moved a mannequin, it had to be relit. "Stuart works upstairs, in the more *refined* part of the museum," said Diana, patting him on the back. "But don't forget, boys, this is where the money is!" The exhibition was not perfect, thought Trow. The odd mannequin joint was exposed and the program was sketchy. But Mrs. Vreeland had something in common with the great Hollywood producers: she knew how to make people like what they saw. "The message of her shows at the Metropolitan . . . [was] 'It's Good! It's Better! It's Best! It's a million miles away! But it's all yours! Come and get it!'"

Numbers had helped to drive Diana out of *Vogue.* Less than four years later, numbers put her into the Metropolitan Museum

of Art's record books. After the *The Tens, the Twenties, the Thirties* broke one set of records, *Romantic and Glamorous Hollywood Design* broke them all over again. Nearly 800 thousand people visited the exhibition between November 21, 1974 and August 31, 1975, four times more than the most successful exhibitions anywhere else in the museum. "No curator in the history of the Met ever had a more successful run than Diana Vreeland," said Hoving. She was back in *The New Yorker*, back in business, and back in fashion.

BEYOND THE METROPOLITAN Museum of Art and its exhibitions, New York was changing fast. Many who lived in the city through the 1970s thought its decline terminal. Its manufacturing industries dwindled away, causing rising unemployment and spiraling social problems. The city teetered on bankruptcy, and was overwhelmed by a crime wave and a murder rate that made it notorious worldwide. As mugging and robbery spread uptown from the city's poorer enclaves, many of New York's well-to-do elderly were driven indoors by fear. Diana felt the fear too, quite acutely. "When people ask me what the greatest change in my life is, I always say it's being afraid. . . . I used to be afraid of nothing." However, she addressed the matter by taking taxis, and advantage of her friends' chauffeurs. Indeed, she could be a bracing sort of chum to timorous types of her own age. Kenneth Jay Lane recalls that one of her acquaintance went blind, and then regained her sight after five years. Anxious to catch up on what she had missed, she asked Diana, as her most switched-on friend, to take her to a movie. They set off to the cinema and settled back in their seats. After about ten minutes the friend began to hyperventilate with horror. The film was *Deep Throat*. " 'Why did you take me to *that*, Diana?' she said, clutching the wall of the foyer outside. 'Well,' said Diana. 'If you haven't seen anything for five years, wouldn't you want to see something you've never seen before?' " (At a lunch party where this story was reported, the butler is said to have dropped his tray.)

Far from lurking fearfully in her apartment, Diana became a dominant social force in New York in the 1970s. This was partly

because of her job at the museum. "This is a working man's town," she once observed. "Nobody can sit here and do nothing." She was perceived to have great social and professional power because of her role as special consultant to the Met, but she was also sought after because she was stimulating and amusing company, with a vigorously open mind and an equally open eye. David Bailey noticed that she had a habit of changing the subject when a conversation strayed into an area she knew nothing about, but others were less astute. "In the space of twenty minutes she becomes ecstatic over subjects that include surfing, country rock, meditation, the food at Ballato's, *Equus*, water ('It's God's tranquilizer, I enjoy just watching it flow.'), young designers (Calvin Klein, Stephen Burrows), sky, a new health food, her masseur, the Mediterranean life, brandy snifters, Floris scent, a persimmon, waterskiing, Rigaud candles, new potatoes ('tight-skinned,' like Chinese ivories), fresh air, the cooking course at the YWCA, and the look of post–World War II girls," wrote one astonished observer. "Her capacity for enthusiasm is astonishing. 'My God,' she declares, 'What have we got in life? Love, friendship, work, guts, and all these delicious tiny fragments that can be the most attractive things in the world.'" Diana was delighted when her grandson Nicky came to live with her for a time in 1973 while he was at NYU. "There was real intimacy, partly because she didn't settle for any idea of age," he said. "She had lots of 'old' friends. But ultimately, 'vitality' was what interested her, regardless of age."

In the 1970s New York's energy flowed through new channels. The Colony restaurant was eclipsed by the rustic floors and tables of Mortimer's. El Morocco made way for Régine's nightclub down the block from Diana at 502 Park Avenue. Often dressed in black, arms extravagantly covered in bangles, lips and cheekbones redder than ever, Diana was difficult to miss. She was seen at Régine's in the company of Warren Beatty, Iman, Jack Nicholson, and Anjelica Huston. Her social life expanded to take in whole new party sectors. "I was *never* an embassy girl," she said to George Trow. "And now! The French! The Persians! The Italians!

. . . I am constantly at the consulates." At the same time she went to parties that would have made most people in their seventies dive for cover. Andy Warhol watched her arrive with Lucie Arnaz at a party given by Halston's friend Victor Hugo: "He had lots of liquor and beautiful boys I'd never seen before . . . and there was a drag queen there, a former Cockette named I think Jumpin' Jack and he had about 18 pounds of tit." George Trow spotted Diana at a dinner given by the founder of Atlantic Records, Ahmet Ertegun, and his wife, Mica. The guests included Mr. and Mrs. William [Chessy] Rayner, Kenneth Jay Lane, Mr. and Mrs. Frederick Eberstadt, Andy Warhol, Maxime McKendry, Bill Wyman of the Rolling Stones, and Baby Jane Holzer.

The same people, and many others, appeared for dinner at 550 Park Avenue. "What she did was mix people up," said Bob Colacello of *Interview*. "It was partly connected with the museum but not entirely. . . . She had the *curiosity* of a truly great hostess." Diana was at Studio 54 with Halston for Bianca Jagger's birthday party when she rode in on a white horse, and a year later Bob Colacello found her there again, shimmying away at Elizabeth Taylor's birthday party. "It really becomes more like pagan Rome every day," said Colacello. "I should hope so, Bob!" replied Diana. Leo Lerman, who was there too, was less convinced it was all for the good. "Supplicating figures on the pavement kneeling, begging to come in," he wrote in his diary on the same night. "The Studio 54 rings of Hell. Beardsley out of Moreau. . . . Diana Vreeland on the floor gyrating and swaying and shaking. A red, green, gold, glittering blackness."

Diana's friends and acquaintances flowed through the Costume Institute, and often joined her for a sandwich lunch. It was "a world of wonders" for Ferle Bramson, who found herself being kissed by Mick Jagger one minute, and rescued by the boys from Warhol's Factory the next. ("Mick is the most attractive man in New York when he's had one or two days' *rest*," said Diana.) Annie Hopkins Miller, who had worked with Diana as an accessories editor at *Bazaar* and was now a volunteer at the museum, worried protectively

that Mrs. Vreeland's courtiers saw her as a camp joke. There may have been those who did, but neither Nicholas Haslam nor Bob Colacello agreed. "She was too strong a personality to be camp," said Haslam, who called her frequently, long after life took him away from New York. Colacello agreed: "I really felt very close to her—she was like a grandmother and though at least one of my grandmothers was also rather original, it was difficult to find anyone as sophisticated and original as Mrs. Vreeland."

Diana could become so wrapped up in her friends' lives that she became positively bossy. One friend thought she had missed her calling as a doctor, given the frequency with which she recommended pills, laid out health regimens, and cracked her friends' backs. She gave most people she liked a nickname. The photographer Priscilla Rattazzi was known as "Wopola." She was not politically correct. "This was before the days of political correctness but it was refreshing even then," said Bob Colacello. "You're so lucky you're a *wop*," she was fond of saying to him. "Because, when a wop walks into a room, it lights *up*." (Richard Avedon, on the other hand, found Diana's anti-Semitic tone extremely distasteful.) She became involved in friends' problems. "If you told her about a difficulty over dinner she would follow up a day or two later," said Haslam. "She certainly didn't forget." "She was very good at pep talks," said Colacello, who noted that she could be disapproving, too. "She was not an intellectual. Most of the conversation when you went to dinner consisted of her telling stories about the past or about people we both knew. It was, really, gossip." Amid all this, one friendship in the 1970s stood out—with Andy Warhol's business partner Fred Hughes.

Against a 1970s background of huge deficits and spiraling crime, the avant-garde acquired a new edge and intensity. Its ringmaster, Andy Warhol, moved his Factory from East Forty-Seventh Street downtown to 33 Union Square West in 1968. Diana had known Warhol for years, since the days when he came into *Bazaar* with his drawings of shoes, but the relationship was always uneasy. Diana found Warhol a puzzle; and as he became an international star,

Warhol preferred not to be reminded of the days when he was just "Andy Paperbag." Though Diana was pleased by Warhol's success, she did not warm to the Factory scene until she met Fred Hughes, whose name first appeared in her engagement diary in the summer of 1973, when he came for dinner with the interior designer Sister Parish. Though Diana was in her seventies and Fred Hughes in his early thirties, the bond became very close—so close that friends thought Diana was infatuated—or even in love—with him. Hughes reminded many people of Reed, and she adored the way he looked. "Fred was *unbelievably* elegant," said Colacello. "He modeled himself on the Duke of Windsor—or Fred Astaire—and it suited him! He invented a kind of Factory uniform—pressed jeans, suit jacket, expensive shoes, which meant you could sit on a loft floor one minute and be uptown for dinner the next. Everyone copied him, including Andy."

Hughes was mysterious about his origins, but he later turned out to be the son of a furniture salesman, to have been born in Texas, and raised in Dallas and Houston. He was not related to Howard Hughes, though this did not stop him sporting black armbands when "Uncle Howard" died. But he was also an impressive autodidact who was capable of absorbing large amounts of information in a very short time, and he was a delightful and stimulating companion. He studied History of Art at the University of St. Thomas in Houston, a department almost entirely financed by the philanthropists Jean and Dominique de Menil, who were art collectors and beneficiaries of the Schlumberger oil-equipment fortune. The de Menils were charmed by Hughes and helped him into a job with the Iolas Gallery in Paris. In return, Hughes helped out the de Menils with their art collection in Manhattan when he was back in the States. During one of these visits he was introduced to Warhol. They struck up an instant friendship (there is no suggestion of anything more), and he started working at the Factory shortly afterward.

Hughes was just the sort of business partner Warhol needed. He was a catalyst for new ideas and a point of equilibrium in the

Factory's unbalanced world. His polished manner, politesse, and intellectual curiosity did much to counteract the creepy impression made by Warhol. One of his first acts was to persuade the de Menils to sit for portraits by Warhol, along with their friend the architect Philip Johnson. During the 1970s, Warhol's portraits generated a great proportion of the Factory's income, while *Interview* magazine became the vehicle for drawing the young, the famous, the rich, and the interesting into Warhol's orbit. Hughes was responsible for ensuring that money flowed into the magazine and for seeking out portrait commissions. Colacello, *Interview*'s editor, has said that it was Hughes who set Warhol on the road to riches, and that without him Warhol would not have turned into the global superstar artist he subsequently became. "Fred engineered the rise of Andy Warhol from the demimonde to the beau monde," he observed. Hughes was very attached to Diana—he "loved the idea of her," said one friend—but she also gave him a great deal of business help because she so adored him. She critiqued issues of *Interview* and issued advice to which Hughes and Colacello listened. Just as important, Diana went to great lengths to help Hughes find patrons for Warhol's portraits, bridging the gap between the downtown avant-garde and uptown riches in a way that set her apart from anyone else of her generation. "Despite the underlying ambivalence and mistrust between the Empress of Fashion and the Pope of Pop," wrote Colacello, "it was her stamp of approval that put him in the middle of Park Avenue society in the middle of the seventies. It was Mrs. Vreeland, more than anyone else, who *pushed* Andy, and Fred and me, by introducing us to her swell friends at her small dinners and by bringing us to the small dinners of her swell friends."

IN TIME DIANA'S passion for Hughes would lead to serious tension with Warhol; but when she asked Hughes to accompany her to Japan in 1975, Warhol was enthusiastic, saying it would be good for business. Diana was invited to Japan by the Museum of Costume in Kyoto, which was showing *The Tens, the Twenties, the Thirties* at the suggestion of Issey Miyake. Diana was asked as guest of honor

and encouraged to bring a friend. She asked her grandson Nicky to accompany her, but when it became clear he wanted to bring his girlfriend, Priscilla Rattazzi, Diana asked Hughes as well. They all stayed in a sumptuous hotel in Kyoto and were treated like visiting royalty. Diana looked at Japan in "wonderment," said Nicky. There was nothing jaded about her reaction. She breathed it all in. She particularly liked the sight of men in kimonos. There was only one moment when she was thrown off balance. At a reception in her honor a huge box was carried in and flung open to reveal two Sumo wrestlers who tumbled out onto the floor. She collected her wits and proclaimed: "The pink babies!" Privately concerned that they might be feeling humiliated, she subjected the Sumo wrestlers to an in-depth interview about their training, their diet, and how they kept their skin so soft. On another evening they all had dinner in a geisha house. Diana was fascinated by the geishas' clothes and hair and thrilled to discover that their makeup was all from Revlon. She thought her Japanese hosts' use of color in the exhibition was bewitching.

Each morning of their stay Diana remained in her bedroom till lunchtime. Hughes went off walking on his own, while Nicky and Priscilla, both aspiring photographers, spent every morning in Kyoto taking pictures. This led to one disagreement between Diana and Nicky. She had no interest in the way twentieth-century Japan jostled with traditional Japanese life and was horrified when Nicky pointed his camera at ugly objects. When he argued that the ugliness of Japan was part of its unique quality, as much as its beauty, Diana replied that it was a moral responsibility to focus only on what was beautiful. "Her life insulated her from much that was difficult and ugly," said Nicky. But when it was unavoidable, "she looked away."

AFTER THE HOLLYWOOD exhibition Diana returned to another subject close to her heart. *American Women of Style*, which coincided with the Bicentennial celebrations of 1976, was an exhibition of the great stylists who had animated and created fashion

before the Second World War. André Leon Talley thought that it was her masterwork, "a true expression of her own personal history and tastes." He particularly liked the fact that she included Josephine Baker in the show. "This was an important moment; no African-American woman had ever, until then, been placed in the same stylistic league as, say, Isadora Duncan." As well as Duncan and Baker, the women in the exhibition included Rita Lydig, Elsie de Wolfe, Consuelo, Duchess of Marlborough, and Millicent Rogers. They all "created themselves," said Diana. In one way or another, all the women included had inspired her. They met, said Stella Blum, "on the common ground of excellence," and all of them "had an inordinate aesthetic sensitivity—a strong creative drive that looked for a perfect expression for their highly charged motivations." *American Women of Style* was another box-office success, attracting numbers comparable to *The Tens, the Twenties, the Thirties.*

The Glory of Russian Costume, which would break all box-office records, took place against the background of détente with the Soviet Union. It was one of a series of cultural exchanges arranged by Hoving and an "exuberantly corrupt" undersecretary in the Ministry of Culture on the Russian side. The exhibition could never have happened, wrote Hoving, without the involvement of Diana and the recently widowed Jacqueline Onassis, who had taken an editorial job at Viking Press. Diana, Fred Hughes, and Hoving went to Russia to discuss the show early in 1975. Diana told George Plimpton that her reaction to her new surroundings was love at first sight: "When I'd been in Russia for only forty-eight hours, I thought to myself: of all the countries I've known, if it were my country not to be able to come back to *this* one would be the most terrible." Her enthusiastic reaction paid dividends. A meeting was arranged with Russian officials far too early for Diana, at nine o'clock in the morning the day after they arrived. She told Hoving to talk to them about "museumy" details like shipping and promised to appear at eleven o'clock. Tension mounted as Hoving managed to extend the "museumy" conversation to a full two hours.

But Diana did not let him down. "A minute before eleven the door to the conference room opened and in she swept, radiant in crimson and shiny black, her hair pulled back so tightly it looked like a painted surface, neck arched." Hoving knew she could see very little without her glasses, but realized she had taken them off for her grand entrance. "The Russians blinked first. 'Ah, Mrs. Vreeland, what do you think of the Soviet Union?' It was a kind of Last Judgment moment. Diana breathed deeply. 'Ah *marvelous! God! marvelous!*' she said. 'I have been up walking since dawn, ab-so-lute-ly *revelling* in the vast beauty of this city. God, the women are so beautiful. I mean these *complexions*! The land is so *vast*. So . . . *awe-in-spir-ing*! So grand. The women are so *gorgeous*!' "

While Hoving choked quietly in the corner at the idea of Diana on an early-morning walk, the Russians fell for her completely. After her peroration Diana was given everything she asked for. She was determined to find a peasant costume that she believed had been the inspiration for the Chanel suit during Chanel's affair with Grand Duke Dmitri. "The item was triumphantly displayed for her. Diana had been right. There was the garment Chanel had clearly adapted for 'her' classic design," said Hoving. By this time the Russians were hanging on Diana's every word. She spent hours patiently sifting through hundreds of drawers, and thousands of costumes immaculately folded away in acid-free paper, impressing Hoving once again with her powers of concentration and her capacity for sheer hard work. "She would praise lavishly—and, in time, would criticize, very gently but with needle-like effect. By the time Diana Vreeland left the Soviet Union, she had become legend there, too." Hoving returned to Russia again with Jacqueline Onassis, who was editing a book titled *In the Russian Style* to accompany the exhibition. The joint efforts of the two American czarinas persuaded the Russians to lend the winter sleigh of Princess Elizabeth, Catherine the Great's wedding dress, and Peter the Great's three-foot-high boots.

The spirit of détente was rather less in evidence when the costumes finally arrived in New York, however, accompanied by

several KGB agents and three Russian curators: Tamara Korshu-
nova, costume curator at the Hermitage, in Leningrad; Luiza Efi-
mova, costume curator at the State Historical Museum in Moscow,
and Nina Yarmolovich, a costume restorer at the Kremlin Muse-
ums. If Diana "butted heads" with Stella Blum, she locked horns
with her Russian counterparts. There was no getting around Rus-
sian insistence that the clothes must be behind glass; there was
great concern about Diana's idea that the dummies should be
painted red; and complete bafflement at her wish to braid them
with green and blue Dynel hair. At this point George Trow caught
up with Diana again. " 'We have to—ummm—*consult*. The whole
issue of the Dynel braids is being *analyzed* now.' Mrs. Vreeland
is not entirely used to the processes of consultation and analysis."
There was even greater consternation at Diana's scorn for chronol-
ogy. In the event the bemused Russian curators gave way, though
not without great misgivings, shared by Stella Blum. "Stella took
me around the exhibition the night before it opened and talked
me through the way it 'should' have been done," said Harold Koda.

Diana was not greatly interested in the vernacular peasant
clothes provided by the Russians. She solved the problem by group-
ing them together, where they made a brilliant display in two sepa-
rate rooms, one for poorer peasant clothes and the other for clothes
belonging to richer peasants, who used brocade and fur in place
of coarse cotton. Ironically it was the embroidery, the ribbons, the
vivid reds, the pearl detail, and the layering of these clothes that
had the greatest impact on American designers, influencing the
New York collections a short time later. For this exhibition Diana
persuaded the house of Chanel to revive an old perfume, Cuir de
Russie (Russian Leather), and went to work on a tape of Musso-
rgsky, Borodin, Rimsky-Korsakov, and Tchaikovsky. What the
Russians made of Diana's decision to throw furs around to give
the idea of savagery is not recorded. But once again the exhibition
was a blockbuster success, exceeding even the Hollywood show in
terms of numbers. And a truce was finally achieved with the Rus-
sian curators once the exhibition opened. Diana took them out for

a lunch where formidable quantities of alcohol were consumed and then invited them back to 550 Park Avenue for tea with Serge Obolensky, who had been a pageboy at the court of Czar Nicholas. This potentially disastrous encounter ended with all the Russians in one another's arms.

The committee for the Party of the Year that accompanied the Russian exhibition was led by Pat (Mrs. William) Buckley and included a shifting cast of social luminaries such as Leonore Annenberg, Lee Radziwill, and Gianni Agnelli. Once Jacqueline Onassis agreed to become president of the committee, the party swelled again in size and social importance: "the biggest one of these things the museum has ever had," according to Warhol, who went with Halston's party in a fleet of limousines. The 650 guests paid $150 each for a reception and dinner at the museum, and about 1,000 more arrived after dinner to see the exhibition, paying $40 for the privilege. Outside, photographers and journalists lined up to report on the guests. Inside, Jacqueline Onassis received them with Oscar de la Renta, Douglas Dillon, and the chargé d'affaires from the Soviet embassy. Meanwhile, Marella Agnelli and Jacqueline de Ribes circulated in dresses on a Russian peasant theme, while C. Z. Guest, Lee Radziwill, Mica Ertegun, and Françoise de la Renta chose to sport ruffled taffeta dresses from de la Renta in the same vein. Diana spent part of the evening hawking *In the Russian Style* at top volume: "Buy a book! Buy a luvverly book!" The evening was regarded by almost everyone as her show. "The trick of having a regal New York social life is not to go to distinguished parties but to go to distinguished parties publicly," said George Trow. "And in New York at the moment only Mrs. Vreeland has the skill to provide a public event with enough authority to withstand the dissolution implicit in publicity. For one night, she takes over the machinery abandoned by Caroline Astor and the machinery abandoned by Flo Ziegfeld and, combining them into one machine, she *makes it go.*"

ENDGAME

This thing about being recognized in the street is truly fantastic. It amazes me every time.

I mean, I've been recognized by cab drivers. *These things are killer-dillers! I just can't get over it. I've given this a lot of thought and I think that fashion must be even stronger than the lure of the stage.*

I really have come to that conclusion. I think fashion must be the most intoxicating release *from the banality of the world—in the world.*

AFTER THE SUCCESS of *The Glory of Russian Costume,* the acting director of the Metropolitan Museum of Art, Philippe de Montebello, made a suggestion. Diana's flair and taste were generating huge interest. The next exhibition should be nothing less than her personal edit of the thirty thousand pieces in the Costume Institute's closets. Diana called this exhibition *Vanity Fair.* Its title was derived from the town of Vanity in John Bunyan's *Pilgrim's Progress,* where pilgrims stopped on their way to Rome to indulge in "pleasures, lusts and delights." To Diana, following Thackeray as well as Bunyan, Vanity Fair also meant "society, with its foibles, its weaknesses, its *splendeur."* It was no coincidence, as Harold Koda and Richard Martin have pointed out, that Diana appropriated the title of a then-defunct Condé Nast magazine. The theme of the exhibition "was what she believed a magazine should be, and it exemplified the profile of her magazines." Montebello warned in the

accompanying publication that anyone looking for analysis or conventional costume history would be disappointed. "Why? Because we are not presenting an anthology of the collection but a personal choice, Diana Vreeland's choice." Though capricious, her selection was anything but random: "This is not so much an exhibition of clothes as of what Diana Vreeland can show us about clothes."

Jacqueline Kennedy Onassis gave Diana all the help she could. She agreed to chair the Party of the Year committee for a second year, and she wrote an appreciation of Diana for the catalog. She also paid the "high priestess" a visit in her "temple" while she was assembling the exhibition. On the morning of this visit Diana had already collected together "follies and fripperies" from all over the world: tiny shoes for bound Chinese feet, bustles, parasols with intricately wrought handles, kimonos, men's waistcoats of rich brocade, towering hair combs fashionable in Buenos Aires for just one decade between 1830 and 1840, exquisitely tailored sporting jackets belonging to the Duke of Windsor, parachute-silk jumpsuits by Norma Kamali, and lingerie that would later become the talking point of the show. These objects had not been chosen for their historic interest but to show what the human mind could conjure up in the interest of allure. "These incredibly beautiful things," said Diana. "You know, you have to demand them. You must wish for the most ravishing thing of beauty and quality because it's there to be had, even now. Keep the demand high. If there is no one who demands, then what the craftsmen know will disappear." Koda and Martin saw *Vanity Fair* as "the truest reflection of Vreeland's commitment to the opulent expression of concepts; in it she allowed herself the freedom and flamboyance to select the best and most fantastic, as in fact she had always done." But in *Vanity Fair* Diana went even further.

Mrs. Onassis observed that the objects Diana had selected were, for the most part, "from a rarefied world of court and capital, whose inhabitants had had the leisure and the money to indulge their fantasies and their vanities." But Diana countered this.

"Do not be too hard on vanity," Mrs. Vreeland cautioned. "Vanity has given a discipline. 'Is that all you care about, clothes?' people ask me—as if I'd never had children, never had a husband." She smiled. "I happen to think vanity is a very important sort of thing."

She recalled Jean-Paul Sartre's play No Exit.

"Do you remember, at the end, those three characters are standing in a room? There is glaring light, no shadow, no place to ever be away." She turned her head and placed her hand to shade her face.

"This is forever, this is hell. And there is no mirror and you lose your face, you lose your self-image. When that is gone, that is hell. Some may think it vain to look into a mirror, but I consider it an identification of self."

MORE THAN HALF a million people went to *Vanity Fair*, which ran from 1977 to 1978. Diana's fame grew; and she was beside herself with delight when media magnate Jocelyn Stevens asked if he could name a racehorse after her. There were other honors, but the one that pleased her most was the Légion d'Honneur, awarded after *The Tens, the Twenties, the Thirties: Inventive Clothes 1909–1939.* "We all have our dreams. We all want *one* thing. That little red ribbon . . . but to me, it was France, where I was born and brought up. . . . The night I got it, it was enfin, enfin, *enfin*—that night could have been the end of my life because it was *all* I ever wanted." Nonetheless she disliked public speaking as much as she ever had, and when it came to accepting awards her acceptance speeches were short to the point of nonexistent. "I take my cue from the Gettysburg address," she said. She never overcame the self-consciousness that gripped her when she was required to perform to order. When she made television appearances, they tended—with one notable exception—to fall flat.

The most successful attempts at capturing Diana's singular quality were inspired by Warhol and the Factory. It was Fred Hughes who finally worked out what to do. Andy Warhol had been entranced by the tape recorder since the 1960s and was in

the process of composing his autobiography by tape-recording his entire life. Hughes thought that recording Diana in conversation as she moved through her day could be the way forward; and he began by asking Christopher Hemphill to listen to her voice. Hemphill reacted by saying that the tape recorder could have been invented especially for Diana. The listener could almost see her italics; her poetic choice of words was even more arresting than their delivery; and she gave the impression of inventing her own syntax as she went along. At Hughes's behest, Diana came down to the Factory to meet Hemphill. "My first impression of Mrs. Vreeland was distinctly startling . . . ," he wrote. "Wearing a black sweater, black pants, a purple scarf knotted around her waist, and round sunglasses, gliding on the balls of her feet like a ballerina, she advanced several paces into the room before coming to a complete stop several yards from where I was sitting. I rose from my seat. Raising her sunglasses to her forehead . . . she fixed me with a gaze both critical and sympathetic. I waited for her to speak. She extended her hand. '*Hello* there,' she said archly."

Hemphill recorded Diana everywhere: "In restaurants, in taxicabs, and at what she called our 'séances,' sitting around a table on a banquette." The method suited Diana perfectly. Paralyzing self-consciousness, which had plagued her since Mr. Chalif's end-of-term shows at Carnegie Hall, fell away. In fact the presence of the tape recorder had the opposite effect. "Once, during a rare conversational lapse, the machine turned itself off loudly at the end of a tape. 'Poor little thing,' Mrs. Vreeland said sympathetically, 'it has a mind of its own—it gets *bored*. We mustn't let the splash drop! We must be amusing *all the time*.'" *Allure*, the book that emerged from this process, was commissioned by Jacqueline Kennedy Onassis, now working for Doubleday. It was a book of images, accompanied by text edited from the recordings. Diana, the editor in chief, was in charge of the layouts, and Onassis very much wanted to understand how she set about it. Onassis, Hemphill, and Ray Roberts from Doubleday spent many Sunday afternoons at 550 Park Avenue while Diana assembled and reassembled

the book. She credited Brodovitch with teaching her all she knew, and insisted they were working as a team. "Never say 'I,'" she instructed Hemphill. "Always say '*we*.'"

As the images took precedence, Christopher Hemphill's text became shorter and more aphoristic. Diana was reluctant to let *Allure* become a chronological account of her own life, and eschewed pattern making of any kind. "Does anyone read a picture book from the beginning? I don't," she proclaimed at the beginning, opposite a *Vogue* photograph of an Issey Miyake mannequin. *Allure* nonetheless reflected much that had inspired or interested her since childhood. It was the commonplace book of a visual rather than a literary mind. Many old favorites found their way in: the coronation of George V, Josephine Baker, Rita Lydig, Gertie Lawrence, Daisy Fellowes photographed by Cecil Beaton, de Gaulle, Pauline de Rothschild, Bébé Bérard, the Vicomtesse de Noailles, Elsie Mendl, and a photograph of Marilyn Monroe by Bert Stern that Jessica Daves had excluded from *Vogue* in 1962 because it was "too triste." Diana included Irving Penn's close-ups of the face of a geisha; Penelope Tree with a diamond in her eye; the great Munkácsi photograph of Lucile Brokaw running on the beach; and she put an image of the Dolly Sisters appearing as the Little Gods in Diaghilev's *Le Train Bleu* next to "darling Alphonse"—a 1900 picture postcard of Alfonso XIII of Spain when he was fourteen. ("This has got to be our most *peculiar* spread," said Diana.)

Allure captured Diana's views on photography. "A good photograph was never what I was looking for. I like to have a point. I had to have a point or I didn't have a picture." On paparazzi photographs: "They catch something unintended, on the wing . . . they get that *thing*. It's the revelation of personality." It lassoed her opinion of noses. "A nose without strength is a *pretty* poor performance. It's the one thing you hold against someone today. If you're born with too small a nose, the one thing you want to do is build it *up*." In Diana's view the line and silhouette of the twentieth century started with the Ballets Russes, "the only avant-garde *I've* ever known. It all had to do with *line*. Everybody had the line."

It was the line that made blue jeans possible: "Blue jeans are the only things that have kept fashion *alive* because they're made of a marvelous fabric and they have fit and dash and *line* . . . the only important ingredient in fashion." But the question that pulsed through the book was the mysterious quality of allure itself. On Garbo ("but don't let me go grand on you"): "I can't say what it is she does. If I could *say* it, I could do it *myself*." Allure had nothing to do with conventional beauty, but was deeply entwined with personality. "The two greatest mannequins of the century were Gertrude Stein and Edith Sitwell—*unquestionably*." Elegance had the quality of gazelles and Audrey Hepburn. "Elegance is refusal." She loved Deborah Turbeville's photographs of "worn out" girls in *Vogue*. "The girls keep looking in the mirror, which is all right by *me*. I loathe narcissism, but I *approve* of vanity." And finally, allure could never be captured anyway. "Really, we should forget all this nonsense and just stay home and read Proust."

A well-honed version of Diana's life story appeared alongside *Allure*, in interviews that had the effect of complementing the museum's public relations' machine, even when they were not necessarily part of it. Lally Weymouth was the first to bring together successfully the constituent parts of the Vreeland legend. She interviewed Diana for a long article for *Rolling Stone* in 1977 and rounded up the Paris upbringing, Diaghilev, the ugly duckling, the coronation of George V, Buffalo Bill, the return to New York in 1914, the lack of education, marriage at eighteen, a remarkable assertion that she trained with the English dance troupe The Tiller Girls, and being spotted on the rooftop of the St. Regis by Carmel Snow. If Diana was pleased to find herself in *Rolling Stone* in her seventies, she was even more delighted by Jonathan Lieberson's brilliant profile in *Interview* and by becoming its cover girl in December 1980 at the age of seventy-seven. "Diana Vreeland called and said how much she loved her cover story in *Interview*," said Andy Warhol in his diary. "The cover makes her look about twenty, and she said, 'The only problem is I'm beginning to think I look like that woman on the cover.' "

Diana was much less pleased with Jesse Kornbluth's article for *New York* in November 1982, and was reluctant to cooperate with photographers and profile writers thereafter. She allowed Priscilla Rattazzi's images of her seventy-nine-year-old style to endure: black lacquered hair, scarlet lips, rouged cheeks, Vaselined eyelids, scarlet nails, matching ivory cuffs, an ivory tusk on a gold chain, and Roger Vivier scarlet snakeskin boots. But she was furious and upset that Kornbluth distorted a private joke. Years earlier, for the benefit of her grandson Nicky's new film camera, she claimed to have been born to the sound of Berber ululations in the Atlas Mountains. Kornbluth somehow got hold of this story and presented it as an instance of her propensity for self-invention. She complained about this bitterly to George Plimpton who was at 550 Park Avenue to record more conversation for the memoir that became *D.V.* The idea of such a memoir had long been discussed. Diana and Truman Capote had even talked of working on it together after she left *Vogue*; and Capote arranged for Robert MacBride, a married man with whom he was obsessed, to do some preliminary research. MacBride was ill suited to the task and eventually extracted himself from the arrangement, saying that Diana did not quite come through to him and he was therefore not the right person.

The idea of a memoir resurfaced again after *Allure* was published. Hemphill had recorded far more for *Allure* than he needed and had edited some of it into a short "autobiography." George Plimpton was commissioned by Knopf to add some material and knit together Hemphill's manuscript with his own. *D.V.* became the version of Diana's life that persisted unchecked until Eleanor Dwight's 2002 biography, though Diana kept reminding Plimpton that she was "terrible on facts" and that someone needed to check all dates and times. A benighted copyeditor started the process but appeared to give up in despair after one chapter, so that even the date of Diana and Reed's wedding was wrong. When Freck responded to the manuscript with a large number of queries and asked George Plimpton what sort of book he was trying to write, Plimpton replied "A bestseller." Plimpton later said that he really

did not care whether any of it was true: the interesting thing was the way Mrs. Vreeland told it. And when it came the way Mrs. Vreeland told it, boring facts were not the point. "Did I tell you that Lindbergh flew over Brewster? It could have been someone else, but who cares—*Fake it!*" she said. ". . . There's only one thing in life, and that's the continual renewal of inspiration."

D.V. was reviewed favorably and sold very well. The effect was to make Diana even better known and the object of some teasing by her relations. When one of her grandsons found a note telling her secretary that Mrs. Vreeland had now signed a copy of *D.V.* for Elizabeth Taylor, he added in his own hand: "Also a book for Queen Elizabeth and one for Pope John Paul. Did the books for Rosalind Carter and Madame Gandhi get sent? As for Fidel Castro, it shouldn't be too difficult to send him his book. He wants two copies, as he wants to send one to Chernenko, so do make sure Mrs. V. dedicates it appropriately."

DIANA'S FAMILY CAME and went in the 1970s and 1980s. Tim and Jean Vreeland had two daughters, Daisy and Phoebe. After his marriage to Jean ended, Tim married Nancy Stolkin in 1982 and continued to live in Los Angeles. Freck and his second wife, Vanessa Somers, divided their time between Rome and Morocco. Freck's younger son, Alexander, lived in Australia for much of the 1970s where he helped to run the Inner Peace Movement. Nicky continued to live in New York, but departed on a different kind of journey around 1980, toward life as a Buddhist monk. Diana found it hard to come to terms with his growing interest in Buddhism. She battled to keep her feelings under control though the only time he ever saw her cry was when he shaved his head. She made no secret of the fact that she felt Buddhism was keeping him from participating in the life he ought to be leading. She went to the lengths of asking a neighbor and friend, the Reverend John Andrew, who was rector of Saint Thomas Church, to talk to him. Even when John Andrew reported that Nicky was very serious and

that his decision to pursue his monastic studies in India was not just a phase, Diana made one last attempt to turn him back.

Near the time he was due to leave for India, she asked him to dinner with some people she wanted him to meet. Nicky had given up dinner parties by this stage, but he agreed to attend. When he arrived at 550 Park Avenue he was greeted by a butler with the news that Diana was ill and had taken to her bed, but that the dinner party would be going ahead without her. The "dinner party" turned out to be a table set for two, for Nicky and a young woman who was not only ravishingly beautiful but was studying Chinese and Tibetan at Columbia and liked art movies, just as he did. It was a grandmotherly fix-up. Afterward an unrepentant Diana wanted to know all about the dinner—*and what the girl looked like.* Though it took time, Diana did eventually accept Nicky's decision. He knew that Diana had come around to it—more or less—when she said in an interview some time later that she liked people with a twinkle, and that the Dalai Lama had a twinkle.

Fred Hughes, on the other hand, caused Diana much sadness. The first intimation of trouble came in Andy Warhol's diary at the end of September 1977. He reported that Diana had called him and said someone "should talk to Fred about his drinking problem, to tell him he's so attractive but that when he's drunk he's so unattractive." A few weeks later there was a nasty scene. "All the way down in the cab Diana and Fred had been fighting like they were a screaming old married couple," wrote Warhol. There were reports from other sources of a very public row between Diana and Fred in Paris, in which Yves Saint Laurent had tried to intervene. Warhol thought that Diana was jealous of Hughes's friendships with younger, more beautiful women. "She thinks Fred's making it with Lacey [Neuhaus] and I think she wants him to make it with *her.* Can you believe it? It's so crazy." Bob Colacello fielded many long, worried telephone calls from Diana that suggested she was simply concerned that Fred was going off the rails and nothing was being done to stop him. "She and I had had several talks about

his behavior; in fact, it was hard to get her off the subject when we were alone," he wrote. "One night, she went on about the beard that Fred had just shaved off. She hated his beard. It was 'slovenly' she said. But she was disappointed after it came off, 'because Fred *still* doesn't have that look I loved him for: well-proportioned, simple, good clothes, worn perfectly, everything just so. No accessory other than *neatness*. You know exactly what I mean, Bob. Well, I'm afraid he's lost it.'" It would later turn out that Hughes was in the early stages of multiple sclerosis. At the time his behavior was attributed to heavy drinking and a great deal of cocaine. "Style was more than surface for Diana; it expressed the very essence of a person. And Fred's style had changed," wrote Colacello. Hughes, who had once been on the Best Dressed List, took to going around with shredded linings in his suits. "Diana saw the decline in Fred's appearance as a sign of an inner collapse. 'His *spirit* is broken, Bob.'"

In his own way Fred Hughes adored Diana. "I do, I do, I do love you. Happy birthday, Fritzie Pie," he scribbled in one note. But one of the ways it showed was that he ventriloquized Diana when he was drunk, apparently without realizing, but to such an extent that Warhol called him Dr. Hyde and Mrs. Vreeland. Diana attributed Hughes's decline to Warhol's exploitativeness and manipulativeness, and, as he reported it, she was not above telling him what she thought. "She started screaming and belting me, and she really *hurts*!" he wrote of one particularly dire evening. "She said that she just couldn't stand to be around old people, including herself." Andy Warhol hated being touched, and an irate Diana may only have poked him once or twice hard with her famous index finger but Warhol was angry that Diana encouraged Hughes to assert himself. There was also something about Diana's defiance of old age and weakening that made him uneasy. She fought against it by "running and jumping and dancing and humming and pushing forward with her tight body and her beautiful clothes."

It is undeniable that Diana also took on some of the qualities of her terrifying, matriarchal, dark-haired grandmother in her seventies, the only example of old age in her family that she knew

and loved. She had a rough manner with her staff at times; and when she was angry it showed. At the same time she knew how to proffer grandmotherly concern and kindness. Diana was appalled that Warhol stood back and took no action as Hughes appeared to self-destruct, for she sensed that his decline was caused by something no one could identify. By late 1980, however, the problems caused by Hughes's antisocial attitude had gone well beyond either of them. Hughes offended Jacqueline Onassis very publicly; he turned up drunk at Cecil Beaton's memorial in New York, too late to be an usher; and was so obnoxious at the prewedding dinner for Courtney Kennedy that he was thrown out by her mother, Ethel. Diana had Colacello on the phone for two hours after that incident. "I never thought that Fred would end up as a bum," she said.

Unlike many of Fred Hughes's so-called friends, Diana continued to provide moral support as he fell from grace, and did not give up on him after his illness was diagnosed. Although the intensity of their relationship slackened, she continued to have him to supper alone at 550 Park Avenue about twice a month for as long as it was feasible. There was no shortage of other company. There were constant dinners, lunches, movies, and outings, including concerts by Stevie Wonder and Bob Dylan. From 1970 onward, Diana spent a few days each Christmas with Oscar and Françoise de la Renta in Santo Domingo, in the company of John Richardson, Boaz Mazor, and others. She caused a sensation when she visited the local pharmacy, her favorite place in the resort, maintaining that it sold pills and potions she could only get by prescription in the United States. She made a point of going there every afternoon around five o'clock, wearing a caftan. After a day or two, a crowd assembled to watch her arrival. Once she realized that she was the event for which they were waiting, she took to dressing up in ever more outré outfits to please her public, and eventually had to go home when she ran out of clothes.

FRIENDSHIP AND DECADES of experience in fashion continued to overlap. Carolina Herrera first met Diana as a friend in the early

1970s and was enchanted by her wit, extravagance, and style. In 1980 it was Diana who inspired and prodded Herrera into becoming a designer, giving her much encouragement in private, supporting her collections in public, and setting yet another great New York fashion designer on the path to success. There were new friends too. Bruce Chatwin had dinner with Diana in 1982 and watched her inner eye scanning away, with no sign of slackening, at the age of seventy-nine:

> *Her glass of neat vodka sat on the white damask tablecloth. Beyond the smear of lipstick, a twist of lemon floated among the ice-cubes. We were sitting side by side, on a banquette.*
>
> *"What are you writing about, Bruce?"*
>
> *"Wales, Diana."*
>
> *The lower lip shot forward. Her painted cheeks swivelled through an angle of ninety degrees.*
>
> *"Whales!" she said. "Blue whales!... Sperrrrm whales!... THE WHITE WHALE!"*
>
> *"No ... no Diana! Wales! Welsh Wales! The country to the west of England."*
>
> *"Oh! Wales. I do know Wales. Little grey houses ... covered in roses ... in the rain."*

AS SHE BECAME more famous, criticism of Diana's exhibitions became more vocal. As Koda and Martin wrote later, Diana's version of history was history of "the grandest memory, a sweep through the elegances of the court of Versailles, a promenade through the grand silhouettes and extravagant textures of the Belle Époque, and the colorful Russia of the Czars." She liked to express the mood of an era through oblique, impressionistic details: a bouquet of violets on a winter sleigh stood for czarist indulgence (a Russian grand duke once paved an avenue in St. Petersburg with violets to welcome his Italian mistress); Alice in Wonderland, holding a flamingo, implied the topsy-turvy world of the Belle Époque. This approach to the past was extremely popular with the public;

and Diana's early exhibitions were so innovative, and their atmospheric lighting, music, perfumes, and backdrops so dazzling, that objections were muted. Three of Diana's first five exhibitions—*The World of Balenciaga*; *The Tens, the Twenties, the Thirties*; and *Vanity Fair*—all played directly to her connoisseurship. But after *Vanity Fair* the chorus of complaints grew louder.

Criticism by Nesta Macdonald in *Dance* magazine of the *Diaghilev* exhibition that followed was typical of much to come. "Diaghilev created theatrical magic—illusion. *Vogue* created fashion magic—delusion. At the Metropolitan, the exhibits come from one side and the presentation from the other . . . the galleries at the Metropolitan Museum seemed to me to resemble a battlefield." Macdonald believed that mixing up the costumes from different ballets and failing to offer any kind of chronology or context made Diaghilev's impact difficult to understand; and she was infuriated by errors in an accompanying brochure that was too sketchy. Diana Vreeland, she wrote, revolutionized fashion magazines with an instinctive and exhausting perfectionism: "The sad thing is that she seems to have thought that the showy nature of Diaghilev costumes could stand up to window-dressing technique." Some critics found *Fashions of the Hapsburg Empire*, which followed, just as obscure. This was perhaps not surprising, since Diana explained to George Trow that what she liked best about the Hapsburgs was the gleaming brass turnout of their horses, a point of view only comprehensible to those who knew her very well indeed. "What Mrs. Vreeland likes is a source of simple energy so powerful that something rather excessive can be elaborated from what rises to the surface," wrote Trow, manfully doing his best. " 'It's important to *get* the point,' she said. 'The point is the *gleam*. It's what the nineteenth century knew. The gleam, the positiveness, the *turnout*.' "

There was criticism from overseas too. When the V&A reopened its dress collection to the public in 1983, its director, Roy Strong, wrote in *The Times*: "The thing that unites the textile department is a deep loathing of what is being done at the Metropolitan Museum in New York. . . . We are all totally opposed

to Diana Vreeland's degradation of fashion. Instead of exulting in technique, she debases it." This was a trifle unfair since Diana's veneration of Vionnet's bias cut in *The Tens, the Twenties, the Thirties* inspired New York's designers to experiment. Nevertheless she certainly thought that costume exhibitions predicated on dressmaking technique were excruciatingly dull. However, there were further objections: "The Metropolitan's Costume Institute has turned its exhibitions into social events and crowd pullers under the guidance of the autocratic and eccentric Mrs. Vreeland. . . . Her style is to create the mood of a period with dash and verve, even if it means cutting two inches off an eighteenth century petticoat or adding unauthentic gloves. The international museum world criticizes her for lack of scholarship."

In 1986 this line of criticism reached a fresh pitch in a book by Debora Silverman called *Selling Culture: Bloomingdale's, Diana Vreeland and the New Aristocracy of Taste in Reagan's America.* In her book Silverman made the arresting assertion that Diana's exhibitions from *The Manchu Dragon* onward consciously and deliberately propagated the values of the Reagan era. In Silverman's view, Diana's shows reflected Reaganite love of conspicuous consumption, rejection of so-called dependency culture, and a devil-take-the-hindmost attitude. The exhibitions particularly exalted the sort of avidity displayed by Mrs. Reagan, whom Diana knew, and who was well known for her love of luxury and couture clothes. In New York, argued Silverman, politics, commerce, and culture had converged on the Metropolitan Museum so that it was dominated by a clique of designer-tycoons, retail millionaires, and grandees. The museum had allowed itself to be colonized by their values for its own ends and had become grossly commercial. Silverman objected to the manner in which Bloomingdale's was allowed to cash in on *The Manchu Dragon* by producing replicas of Chinese art; she lashed out at both *La Belle Époque* and *The Eighteenth-Century Woman* for reducing France to a parade of luxury goods without looking at the wider social context; and she excoriated a view of history that reduced it to a collection of sponsored merchandise

in the museum shop. Silverman regarded the sale of *D.V.* in the museum as a particular travesty: not content with commodifying art by selling tacky replicas, the Metropolitan Museum of Art was now apparently commodifying its curators too.

Debora Silverman greatly overstated Diana's influence. As the gossip columnist Liz Smith put it in the *New York Daily News*, "her vision of Diana Vreeland as a kind of evil capitalist *deus ex machina* presiding over some imaginary link between New York society and the White House occupants [was] absurd." Jean Druesedow, associate curator at the Costume Institute from 1984, commented that Silverman underestimated the degree of spontaneity and improvisation. Had she consulted anyone at the Costume Institute, she would have discovered that *The Manchu Dragon* was semi-imported and put together at very short notice when another exhibition collapsed, one reason why its presentation and its relationship with Bloomingdale's was not as rigorous as it might have been. Silverman complained—with justification—about Diana's ahistorical approach, but was somewhat ahistorical herself. There may have been a parallel between Diana's views about the value of society, snobbism, and luxury and those of Nancy Reagan, but Diana's concept of their worth went back to the 1930s and did not emerge as if by magic in 1981. It was also the case that while Diana knew the Reagans, and had a close mutual friend in Jerry Zipkin, she was much closer to Jacqueline Kennedy Onassis than to Nancy Reagan. Silverman exonerated Onassis of all faults, even though she castigated *Allure*—on which Onassis had worked closely—because it "nourished fantasies not only of opulent nobilities of the past but of cruelty and decadence in the present."

Moreover, Silverman made no attempt to look at Diana's exhibitions in the context of the history of the Costume Institute. She thought it was suspicious that the shows influenced designers, failing to understand that this had always been part of its mandate. Had Silverman spoken to Thomas Hoving, she might have understood that he had hired Diana to deliver crowd-pleasing blockbusters, and she might have realized that many of the "vices" for which

she was castigating Diana were more appropriately attributable to him. In spite of its weaknesses, however, Silverman's book did light on some of the problems with Diana's approach to exhibiting costume. Her exhibitions were best when their themes allowed her to convey a sense of the Girl—and even the Boy—behind the clothes, and the dreams behind the designs. She was much less secure when dealing with other important issues that also affected the wearing of clothes, such as caste, military rank, religious symbolism, and the display of power, a weakness that showed in *The Manchu Dragon*.

Silverman's book also highlighted concern about the evident convergence of art, fashion, and powerful financial interests at the Met. She was not alone: Diana's 1983 exhibition, *Yves Saint Laurent: 25 Years of Design* raised other eyebrows. This was the first time a living designer had been honored by the museum, and many people felt that this was nothing more than an elaborate public relations stunt that gave Saint Laurent an unfair competitive advantage, a feeling underscored by Diana's rejection of chronology and anything close to a conventional retrospective. What she wanted to show in the exhibition was the inspired work of "the leader in all fashion today," who had followed Chanel in understanding the new century and its changing way of life, and showed it how to dress. "This is an important point," she wrote. "Both Chanel and Saint Laurent are equalizers. You and I could wear the same clothes; what we have on, *anyone* could wear." But unease persisted, and a year later it deepened with the prominence given to Ralph Lauren's sponsorship of the exhibition *Man and Horse*.

In many ways Diana's exhibitions at the Costume Institute were ahead of their time. Exhibitions of living designers are no longer unusual; and exhibition-inspired merchandise in museum shops is now so routine as to provoke indignation if it is not forthcoming. Meanwhile, criticism of Diana's later exhibitions had little effect on the public response. Both *The Eighteenth-Century Woman* (1981–82) and *La Belle Époque* (1982–83) brought in well over 500,000 people, and no fewer than 631,422 visitors went through

the galleries to look at the work of Yves Saint Laurent (1983–84).
Diana was always reluctant to accede to the idea that fashion was
art: "I've never understood that—about art forms," she once said.
"People say a little Schiaparelli design is an *art form*. Why can't it
just be a very good dress?" She never pretended to be an academic
curator. Yet she made a strong case for fashion as culturally signifi-
cant while creating a whole new audience for costume. Her exhibi-
tions at the Met induced many people to visit the museum for the
first time, just as Hoving had intended. And her success persuaded
museums much farther afield, including the V&A and the Louvre,
to open up their own collections too.

BY THE TIME *Selling Culture* appeared in 1986, Diana was eighty-
three and in no position to defend herself against its wilder accusa-
tions. She had long had problems with her eyesight—a photograph
she took of Marina Schiano reveals how little she could see even
in 1976. In conversation with George Plimpton in 1983, she com-
plained that there were days when she had trouble making out
anything at all. She was diagnosed with macular degeneration,
which by its nature slowly became worse. It eventually left her
with so little peripheral vision that she effectively became blind,
though her abilty to see continued to fluctuate unpredictably until
the end of her life. She went to great lengths to disguise this condi-
tion. When she mentioned her deteriorating eyesight to Christo-
pher Hemphill during their recording sessions, she even presented
it as something positive: she no longer had to cope with the gaze
of strangers or, indeed, with seeing too much. "The curious thing
is that now I can approach anyone myself. This started about ten
years ago. As soon as I started going blind, I lost all my shyness.
I was never shy in business, but I always had a terror of meeting
people. Now, instead of *suffering* this terrible thing of seeing ev-
eryone and everything much too clearly . . . it's very easy for me to
speak to anyone."

By 1985 emphysema had set in. Her grandson Alexander came
to live in New York after his marriage to Sandra Isham in the fall

of 1985. He took up a position as head of communications for Ralph Lauren, and they became very close. She continued to entertain. Andy Warhol had dinner with her in July 1985 and wrote in his diary that she had started to have people looking after her at night, including a young woman who sat with her while she slept. In spite of being ill, he observed, she drank four vodkas and smoked about fifteen cigarettes. In 1985 André Leon Talley began coming to the apartment to read to her. In the years that followed Jacqueline Kennedy Onassis was another who often called twice a week to read. The nurses who stayed overnight with Diana kept records that suggest she was not the easiest of patients. She was told firmly by her secretary at 550, Dolores Celi, that she was not to mix Ritalin with vodka, after an "episode" in May 1985. Diana paid not the slightest bit of attention. "On my arrival Mrs. V was sitting up drinking vodka," wrote one nurse in the record book. Guests came for dinner and stayed late; Diana entertained them as she had always done, but there were long and difficult nights after they left. She kept up a cheerful front; but friends thought she was lonely at times, and behind the facade the nurses recorded that from time to time she was "very depressed" and "very upset about everything."

From 1985 Diana worked more from home and did everything more slowly. As time passed, she went in to the museum less and arrived later, though she telephoned her aide-de-camp Stephen Jamail and her research assistant Katell le Bourhis several times a day. She relied on them heavily, along with Jean Druesedow of the curatorial staff, for *The Costumes of Royal India*, which ran from December 1985 to August 1986. She continued to act as the public front of the exhibitions for the press, made contacts and opened doors, but Jamail, Le Bourhis, and Druesedow coordinated much of the installation while Diana animated and directed in the background. In a conversation with Le Bourhis and Jamail on February 13, 1985, the ideas she floated for the *The Costumes of Royal India* included using Andy Warhol's elephant; talking to the British designer Zandra Rhodes, who had just come back from India; designing one of the backdrops as a page from an Indian miniature; and

installing a water garden at the entrance: "Water, flowers, moonlight, to reflect moonlight would be wonderful . . . and good for the costumes."

The exhibition was part of a yearlong Festival of India and curated in association with Prince Martand "Mapu" Singh of Kapurthala, whose connections had unlocked many princely cupboards in India to reveal late nineteenth- and early twentieth-century garments that had never been seen beyond palace walls. Designers found it inspirational. In New York, Liz Claiborne featured scarab-print tunics, jodhpurs, and Nehru jackets the following season, and it had such an effect on Diana's old friend Hubert de Givenchy that he dedicated his January 1986 collection to her. The Party of the Year that opened the exhibition in 1985 was outstandingly glamorous, even by its own standards: guests included Rajmata Gayatri Devi of Jaipur and an assortment of maharajas and maharanis alongside Cher, Henry Kissinger, Donald Trump, and many more.

But although Diana had commissioned a spectacular pink tunic and skirt to wear for the occasion, she never appeared. Her place at one of the dining tables stayed empty. As far as André Leon Talley was concerned, her absence cast a pall over the whole affair. He telephoned to find out what had happened the next morning, and she asked him to dinner. For the first time ever, she received him in bed; and then she dropped a bombshell. "André, I've had such a wonderful life and now I've decided to take it easy. Look, I've done so much for so many people. Look at all the boys I helped down on Seventh Avenue. I have done so much for friends like Oscar, Bill, and Halston. Now I am going to sit back and relax. It's time now to just lie here and enjoy life, from this room. Quite simply, I've had it!" In fact Diana was just able to preside over one more exhibition, almost entirely from home. It was called *Dance*, and its theme was party clothes from the eighteenth century through to the sixties, the Twist, and the Peppermint Lounge.

In spite of her emphysema, Diana managed to record the introduction to the audio guide for *Dance*. Margaret van Buskirk,

her secretary at the museum, went to the apartment with the recording crew to discover that Diana was having one of her less blind days. The crew had gone to 550 Park Avenue at short notice. Margaret had no time to smarten up, and was wearing a baggy sweater and a dirndl skirt. "Oh Margaret," said Diana in dismay, "[a] young girl should be all arms and legs." She managed a few more short press interviews, including one with André Leon Talley for British *Vogue* in December 1986: "Great dance dresses have a spirit of their own," she told him. "They project allure into the wearer and into the evening. To dance is to experience a vitality and a lust for life that exists in each of us." Her visits while the exhibition was being assembled were few and far between. "She came in one day to look at the installation in progress and was wheeled from gallery to gallery, saying what was wrong, asking that lights be moved and shoes changed and mannequins repositioned, that some be given hats and others . . . hats removed," Andrew Solomon recalled. "She seemed an impossible old lady who couldn't let go of her control and who was making everyone's lives miserable for no good reason. And then they did everything she'd said, and it was transformed. Her nearly sightless eyes could pick out things my youthful vision could not; enfeebled, she was still supreme at the discipline of chic." The exhibition was in part a final journey through the twentieth century with Diana. It included clothes adapted for social dancing by Irene Castle, and the Duke of Windsor's midnight blue evening tails. For the first and last time Diana included a picture of her mother in one of her exhibitions: Miss Emily Key Hoffman at her happiest, dressed as an Assyrian dancer, photographed at the Carbonite Studio by James Lawrence Breese. "We live out our parents' lives," Diana once said to Nicholas Haslam; and perhaps Emily Dalziel would indeed have been happier had she led the life of her less-loved daughter.

THE MET REALIZED that Mrs. Vreeland was fading and that without the Costume Institute's great "auteur" its exhibition strategy would have to change. It was decided that the Party of the

Year would be uncoupled from the exhibitions. In future it would be a separate benefit in aid of the operating costs of the Costume Institute. Instead of Diana's blockbusters there would be one or two smaller exhibitions each year in smaller spaces, lasting for a shorter time. There would be greater emphasis on seminars and lectures, and a more scholarly approach. The first restyled Party of the Year was to be a tribute to Diana herself, announced the chairman of the party committee, Pat Buckley. "A Dinner with D.V." took place on December 7, 1987. A huge banner emblazoned with her signature "D.V." hung outside over the Met's entrance; the guests arrived to a barrage of photographers and roving klieg lights; indoors, rooms were done up in Diana's colors of Chinese red and turquoise, the pillars were mirrored, and the guests danced to Peter Duchin's orchestra. "I need a great deal of fanfare, no doubt about it," Diana once remarked to Jesse Kornbluth; but when the great fanfare came, she was already in retreat and too ill to attend.

She was in evidence, nonetheless. At eighty-four, and with a household staff that included day and night nurses, as well as Dolores Celi, she became worried about money yet again and decided to sell her "junk" jewelry. Kenneth Jay Lane estimated that her huge collection of pairs of cuffs, long necklaces, and earrings was worth about fifty thousand dollars, a great deal more than its true value because it was hers. On the day of the sale at Sotheby's, friends and admirers crowded into the saleroom and raised more than $167,000. "Is that all?" said Diana when Lane telephoned to give her the news.

THEN DIANA WITHDREW. It was a conscious decision. She finally called a halt to the grand performance, an end to being seen by others. The turning point came when she could no longer dye her hair. Once it became clear that it was difficult for Diana to leave her apartment, Alexander tried to arrange for her colorist to come to the house. But it turned out that the chemicals in the hair dye were so strong that they could not be used in a private home. So she finally allowed her hair to go gray. Alexander thought she looked

magnificent, but from the time she stopped dyeing her hair, she would allow herself to be seen only by her staff and by members of her family. But she found some answers to this problem. Dolores Celi, who had long replaced Reed's secretary, Mrs. Wilson, ran the apartment—and occasionally Diana herself—with a firm hand, and she observed many of Diana's solutions at first hand. On February 8, 1987, Diana telephoned Leo Lerman and said: "I think we'll have a telephone relationship. I have three or four of those, and I find them most satisfactory." She liked her museum secretary, Margaret, to read her *Eloise* on the telephone. Other friends, like Kenneth Jay Lane, were allowed to visit the apartment but had to converse with her through the bedroom door. For a time a select few were invited to eat supper in the dining room while she talked to them from the bedroom telephone. André Leon Talley was allowed into her bedroom for longer than most, though even he, in the end, had to read to her from the other side of a screen, strategically placed by Dolores Celi to protect her privacy.

She remained neat and groomed to the end. Tim made tapes of books she enjoyed and mailed them to her regularly. When he came to stay he read to her at length for hours, reviving and continuing a family tradition from his childhood. Freck, accompanied by his wife, Vanessa, came back and forth from Europe. Diana was delighted when Alexander and his wife, Sandra, called their son Reed, and she adored her two small blond great-grandchildren. "She seems more relaxed with the family around," reported the nurses. Her family, who had been rather excluded from her busy, famous life, were pleased to have a chance to reclaim her. And although her nurses occasionally reported that she had been "disagreeable," she was never difficult with anyone else. Alexander observed that she showed no sign of self-pity or rage. No one was very sure what her religious outlook was, but she did not seem to be afraid of death.

As the emphysema progressed, it led to bouts of pneumonia. Each time it happened, Diana had to go to the hospital for several days and she became—to his delight—touchingly dependent on

Alexander, at one point refusing to leave the hospital until he was back from a business trip. "We got into a rhythm," said Alexander, though getting Diana from Park Avenue to Lenox Hill Hospital was always a great performance involving Diana's Vuitton bag and much anxiety for Dolores Celi as well as Alexander and at least one nurse. There was invariably a long wait for a room with Diana on a hospital gurney in the emergency room corridor, surrounded by people handcuffed to their stretchers and blood on the floor. "It's like the back streets of Naples," Diana said on one occasion. "Anything could happen." Once she decided she wanted a drink at eleven o'clock at night. Alexander rushed from the hospital to Mortimer's on Lexington Avenue where proprietor Glenn Birnbaum poured her a last drink—a large slug of vodka disguised in a seltzer bottle that Alexander smuggled back in. Old habits died hard. She was so thrilled by the beauty of the hospital bedcovers that she asked Dolores to discover where they came from. She continued to take the optimistic view. She sent Dolores to renew her passport, insisting that it be returned that very day and flying into a rage when Dolores told her it was in the mail. "You have to learn to *demand* what you want," roared Diana, before laughing at herself when Dolores stood her ground and said that even a telephone call to Henry Kissinger would not have made any difference.

A few weeks before Diana died, Margaret van Buskirk telephoned her on a Sunday afternoon. Diana often had ideas on the weekend, and she liked Margaret to note them down on a Sunday in case she forgot about them by Monday morning. She also liked Margaret to tell her what she had been doing and to describe the world beyond. It was not always easy to do this to Diana's exacting standards, and some of the assignments were demanding. Margaret was once required to report back on a drag show featuring Diana. However, in order not to be "dull from dullsville," Margaret made sure she had interesting things to talk about. On one occasion she told Diana that she had come across a stray kitten and decided to adopt it. "Call it Thaïs," ordered Diana. "If you don't know why, you can look it up."

Margaret did as she was told. But she never discovered why her flea-ridden kitten had to be named after a seductive courtesan who repulses a confused monk. By midsummer, Diana had lost all interest in the world. Slowly the world withdrew, though Jacqueline Kennedy Onassis, Oscar de la Renta, André Leon Talley, and C. Z. Guest phoned Dolores frequently to find out how she was. On August 2 she went down with another bout of pneumonia. Dolores realized that matters were deteriorating rapidly when Diana sent for her, thanked her—uncharacteristically—for everything she had done, and started to cry. In her final hours, she often seemed to those around her to be hallucinating about her youth, to be back in a dreamtime before marriage and children and fashion and fame. "I'll call my father, I'll call my father," she kept saying. "Don't stop the music. Don't stop the music. Keep dancing. Keep dancing. Keep dancing." She was admitted to Lenox Hill. This time her body could take the strain no longer and later that day, on August 2, 1989, she had a heart attack and died.

"THE LAST DETAILS of any story are never satisfactory," Diana once said. There was a private family funeral followed by a memorial at the Metropolitan Museum of Art on November 6, 1989. Stephen Paley, who had compiled the tapes for so many of her exhibitions, selected music that included a Scottish lament, the second movement of Schubert's Quintet in C, Mahler, Josephine Baker, Mick Jagger singing "You Can't Always Get What You Want," and *Metamorphosen* by Richard Strauss. Speakers included Oscar de la Renta, C. Z. Guest, Richard Avedon, and George Plimpton. They told their favorite anecdotes, while Philippe de Montebello paid tribute to her work for the museum. Richard Avedon came closest to summing up her achievements as a fashion editor when he said that she had invented the job: "Before her it was society ladies who put hats on other society ladies."

Obituarists brought Diana back to life with varying degrees of success, presenting her first and foremost as one of the great personalities of twentieth-century fashion. *Newsweek* noted that

the headline writers were "stumped over how to sum her up" and called her "the seismograph of chic . . . [whose] most famous creation turned out to be herself." Several preferred to leave it at that. Such memorialists recalled her red mouth, her black turtleneck sweaters, the cranelike walk, the scarlet python-skin Roger Vivier boots, the Kabuki rouge, the red lips, the red nails, the black lacquered hair, and the snood. The more celebrated "Why Don't You"s were given another airing. The aphorisms, witticisms, and pronouncements were recycled, and the legend's legend was polished to a high gloss. Those with knowledge of fashion history credited her with popularizing, among other things, caftans, Gypsy skirts, leopard-print headscarves, psychedelic underwear, and the need for keeping fit long before it was fashionable.

The obituarists' memories tended to be short: Diana's great wartime fashion success, notably the Popover and her support of Claire McCardell, received barely a mention. Neither did her predilection for low heels, flat footwear, bare legs, and her introduction of Capri sandals. Dazzled by her persona, by a view of her as the great 1960s editor of psychedelia and flower power, those summing up her achievements in fashion overlooked her ceaseless, and sometimes unpopular, efforts to bring pizzazz to American fashion from the 1930s onward; her support for the craftsmen and -women of the fashion industry; and her conviction that "the eye must travel." They also overlooked her steady championing of clothes that reflected the new silhouette, the new line of the twentieth century: clothes that liberated the natural female body, whether they came from Chanel, Yves Saint Laurent, Claire McCardell, the Ballets Russes, the dance studio, or the office messenger.

More subtle commentators rightly saw Diana as an extraordinary catalyst, as the Diaghilev of fashion. It was noted that she had inspired great photographers, including Louise Dahl-Wolfe and Richard Avedon, to some of their most imaginative work; made the careers of models like Lauren Hutton, Marisa Berenson, and Penelope Tree; and that she had put a fair breeze in the sails of many famous designers including Halston, Oscar de la Renta, and

Giorgio di Sant'Angelo, inspiring them not just as a fashion editor or as an editor in chief, but with her costume exhibitions as well. At her memorial Philippe de Montebello focused on Diana's contributions to the curation of fashion. "Thanks to her individual achievements, there is now broad public awareness of costume," he said. "How many people are there who can actually be credited with having transformed a whole field?" In 1993 Harold Koda and Richard Martin of the Costume Institute returned to this theme with an exhibition called *Diana Vreeland: Immoderate Style*. The exhibition noted how Diana's imaginative powers went hand in hand with a meticulous perfectionism, and it approached her sensibility thematically. It looked at her from the point of view of memory, exoticism, nature, artifice, opposition, and improbable affinities, and celebrated her as a gifted observer, an "entomologist of style," as someone who understood the 1960s but who nevertheless "gravitated repeatedly to forms and styles saved from entropy or dervish by discipline."

More recently Diana's exhibitions, and the controversies that came to surround them, have been reevaluated. As John Ross of the Metropolitan Museum of Art remarked when she died, "Mrs. Vreeland was a genius for understanding . . . that society expressed itself visually, whether it was through fashion, whether it was through photography, whether it was through the way that people lived." By introducing the idea that society expressed itself visually in a way that cut across dichotomies like young/old, working-class/aristocrat, feminist/nonfeminist, and by placing this insight at the heart of costume display, Diana mounted a series of exhibitions that were undoubtedly radical. They were driven by her instincts, by her inner eye, and by what she knew; but she firmly believed that costume exhibitions were not primarily about historical facts or technique, or even *au fond* about the clothes themselves. Her exhibitions always attempted to reflect the woman, the man, the style of life, the dreams behind the clothes. Even though Diana herself might have been uneasy about it, the exhibitions thus staked a claim for fashion as art: the art of the dressed body.

"Whatever their shortcomings, these exhibitions made a claim for fashion as an art, as a serious aesthetic movement worthy of display in the museum, and for contemporary as well as historical dress as worthy of critical attention," writes the fashion scholar Elizabeth Wilson.

The exhibitions coincided with, and made a contribution to, the emergence in the early 1980s of the idea that the dressed body was a cultural phenomenon in its own right, to be studied by academics and argued over by cultural theorists, a result that would have astonished—and quite possibly appalled—Diana. The work of this new generation of fashion historians and fashion theorists allows us to see Diana in a different way: as a fascinating exemplar of a small group of women who wielded great power in the fashion industry as designers, photographers, journalists, and businesswomen from before the First World War onward. They were breadwinners, wives, and mothers, too, but they derived their social and economic power from a prefeminist view of female identity. In the early 1970s feminists understandably objected to a view of female empowerment that focused too much on the body itself, pointing out the difficulties and anxieties attendant on a woman's body becoming her only site of control; and there has been strident and justified criticism of the industry since then for setting impossible and even unhealthy standards of female beauty, for the con tricks of the beauty industry, and for appalling working practices. At the same time feminist academics have looked with fresh eyes at an industry that gave many women long professional careers, and swept many of them into powerful positions as the industry became globalized. The language of fashion has been part of this reevaluation, and here Diana certainly deserves at least her own footnote; for during her tenure at *Bazaar* and *Vogue*, the language of the magazines was often as arresting as any photograph—and had a lasting influence. Contemporary theorists are also reexamining the idea that inspired Diana and so many of her contemporaries: of beauty and allure as empowering in themselves. They point out that it is an extremely powerful idea; that it is rooted in

sexual attraction; that it has never gone away; and that it contin-
ues to jostle for space with more contemporary views of female
identity. Moreover, it often jostles along with competing ideas of
female identity in the same woman.

DIANA WOULD HAVE been wary of all attempts at posthumous
apotheosis. "Should we spend this much time on ourselves?" she
asked Jonathan Lieberson as he attempted to interview her. "Don't
you think we should rather be *going on* with our lives?" It must be
said that she did not inspire everyone she met; and those who were
inhibited by her forcefulness or discouraged by the sense of failure
she could induce have tended to remain silent. Reaction to Diana at
a personal level depended to some extent on distance. By the end of
her life it was hard to experience the exhilaration that came with
exposure to her many points of view, her pizzazz, her divine spark,
unless one was at fairly close range. Moreover, those who were al-
lowed close had generally earned the right to be there, because of
some pizzazz, some divine spark of their own. In old age Diana
looked very different to those who knew her less well: to strangers
watching—or possibly hiding—at a distance of twenty feet who
saw her behaving like a terror in the manner of her grandmother,
roaring at volunteers and secretaries, and looking, in the words of
one observer, like a strange Kabuki clown. Her ability to sense the
zeitgeist was remarkable, though not, as it turned out, infallible.
"I'm an idearist," Diana once said. "I have these spasms of ideas."
But because she *was* an "idearist," and always worked with other
people, questions of attribution do arise. It was Carmel Snow, not
Diana, who first introduced Italian couture to the United States.
It was the fashion editor of *Seventeen* who made Mary Quant and
her miniskirts possible in America. The work that emerged from
Diana's trip with Louise Dahl-Wolfe to the Arizona desert was
extraordinary, but it was Carmel Snow who sent them there and
Louise Dahl-Wolfe who took the photographs. "The day you give a
dinner in my honor," Diana once said to Jonathan Lieberson, "tell
everybody, including me, it's for someone else."

This does not do Diana sufficient credit. Nor is it enough to say, with some of her obituarists, that her greatest achievement was herself; or that her greatest achievement was to transform the curation of costume exhibitions; or even to assert that she was a great catalyst and impresario in the manner of Diaghilev and inspired great beauty and wealth, though this was also true. Impressive though this may be, none of it explains why Truman Capote and others thought she was a genius. Capote, of course, parachuted out of an explanation by asserting that one had to be a genius to understand what he meant. But other commentators, including Harold Koda and Richard Martin, have also had difficulty articulating exactly what it was that Diana Vreeland *did* that was so special. She undoubtedly fell into the "ill-defined, disturbing category" of tastemaker, they wrote, but she—and by implication, her achievement—was peculiarly difficult to identify. It was impossible to show her solo, they suggested: "We can only see her in the vivid gathering of her obsessions, her friends, and all who are still enthralled by her captivating style, instinct, and passions."

One reason for this, perhaps, is that Diana's greatest achievement is barely visible to the naked eye. It lies out of sight, in memory and dreams. "I don't like to work," she once said. "I only like to dream and achieve . . . quite a different matter." From the time she started work at *Harper's Bazaar*, Diana asserted a privileged role in fashion for the unconscious mind, and its child, the imagination. The rational mind was, she thought, too often prosaic, too often circumscribed by hesitation and fear. Yet the inward journey of psychoanalysis was a cul-de-sac. "If you really want to know," Diana told Christopher Hemphill, "I can't stand a dream that's stronger than my own day." To Diana, from childhood, it was the transmission of dreams, desire, and memory outward, into the waking day, that brought intoxicating release from the banality of the world. Her old friend and rival, John Fairchild of *WWD*, came close when he said that Diana's greatest feat was bringing imagination and fantasy to fashion. But there were imagination and fantasy in fashion before Diana. What she did, indefatigably,

and from a position of great influence at *Vogue,* was to assert the *authority* of the imagination—and the idea of possibility that galloped along beside it.

To Diana the imagination liberated the possible: with a little imagination something ever more "wonderfull" was just around the corner and ever present in the here and now. It was implicit in "Why Don't You?" and the "haikus" with which she sent creative people off to Japan, the Pyramids, and the Painted Desert, willing them to return with something better than her first idea. It was explicit in her cries of "Give 'em what they never knew they wanted," and "The most boring thing on *earth* is to be *of* the world of what you do." After Diana, her hallucinatory spreads in *Vogue,* and her exhibitions, the imagination and the possible were never out of fashion bounds again. "I call it a 'dream' because so many things exist within it. Of course, it's both physical and mental . . . and spirituelle. I know of no other word for it. . . . It brings out all the different sides that make up the *whole.*" Diana's visionary quest had roots deep in her own past: but it stamped itself indelibly as another way of motivating and judging clothes, pushing back the boundaries of fashion and extending its vocabulary, literally and metaphorically. "I'm looking for something else," she said. "I'm looking for the *suggestion* . . . of something I've never seen." Diana might not invariably have welcomed twenty-first-century probing of the darker realms of the fashion imagination, but it is impossible to imagine the work of designers like Alexander McQueen, Vivienne Westwood, or Marc Jacobs without her.

TO DO DIANA justice, finally, it may be necessary to move away from the pages of *Bazaar* and *Vogue,* away from the Costume Institute's galleries, and even away from Diana herself, for we may be looking in the wrong place. Instead, our gaze might usefully swivel toward someone who has been both invisible and ubiquitous throughout this story—the woman flicking through *Vogue*'s pages with whom Diana was, at heart, aligned. Diana always insisted throughout her working life that she was an amateur who had

wandered into the world of fashion because she needed the money. It was, she once said, the only way she knew. Far from aligning herself with the producers of fashion and the fashion industry, her real interest was in the woman who wanted to close a gap: the gap between the way she was and the way she wanted to be. The question that interested Diana was: how do you do it?

The answer, according to Diana, did not lie in transforming or reinventing one's persona in a forced and unnatural way. Rather, it was about becoming the "best" version of oneself; and to do that, one had to become one's own editor, one's own curator. As Carol Phillips noted: "Vreeland understood that, encouraged it, predicted its sweep, believed in it." During the 1960s at *Vogue*, the extent to which Diana developed the philosophy of "Why Don't You?" was radical. What she promoted for the individual was groundbreaking: a shift from a set, appropriate way of dressing and styling oneself to a belief in the reader as a creative force in a world of possibilities. Diana encouraged the reader to explore the art of living through *Vogue*, in a collaborative act of self-expression. During the 1960s the speed at which new fashions and trends emerged and disappeared accelerated, and fashion splintered. But the way in which Diana kept pace with this mattered less than the way she handed over power to the woman reading the magazine. And for all her love of the opulent and luxurious, she always believed that this kind of independence was accessible to anyone with imagination, anyone with pizzazz.

If this created new sets of pressures and expectations, Diana did not see it. She took a romantic view of curating one's own existence. "Editing is *not* just in magazines. I consider that editing should be in everything—thoughts, friendship, life. Everything in life is editing." Her perspective, as Stephen Jamail once pointed out, was "the bright prospect and the long view." There was a belief at the time of her death, and in *Diana Vreeland: Immoderate Style*, that this view of the world made her a glorious relic, a thing of the past. She thought that vanity did not equal narcissism; that ambition did not equal greed; that nothing could happen without

self-discipline; that optimism, not misery, drove creativity; that victimhood was not inevitable; that dreams came true; and that trusting to imagination and fantasy brought a world of wonders to reality. "I think I've been a realist. I think fantasists are the only realists in the world. The *world* is a fantasy. Nothing's remarkably real," she said.

This view is not, in fact, so very far from contemporary cognitive-behavioral thinking. Except for dire tragedy or grinding poverty, Diana was known to say, life had its up-and-down trips. "You must choose one," she said. "The down trip makes for a bad liver, bad digestion and fewer friends. The up trip is naturally delicious and never ceasing. I believe in people who are on the up trip."

Fashion theorists have finally caught up with Diana too. When innovative academic work on fashion first emerged in the 1980s, the ground was broken by Elizabeth Wilson in a book called *Adorned in Dreams*. Although Wilson was a committed feminist, she challenged those who rejected fashion as trivial or symptomatic of false consciousness. Fashion, she suggested, has the power to mark out identity in a way that we should embrace rather than distrust. It even has the power to subvert. "Socially determined we may be, yet we consistently search for the crevices in culture that open to us moments of freedom," she wrote. Fashion, she continued, acts as a vehicle for fantasy. "There will . . . never be a human world without fantasy, which expresses the unconscious unfulfillable. All art draws on unconscious fantasy; the performance that is fashion is one road from the inner to the outer world." Immense psychological and material work goes into the production of the social self, and clothes are an indispensable part of that production. This is what makes it so compelling but causes us to react to fashion with ambivalence as well.

The debate rages on. Diana understood that fashion means far more than just clothes: that it tells the world what we are, and that its power lies in the intimate way it bridges the gap between our fantasies and the outer world. The transformation wrought by fashion can change the way we see ourselves and the world sees

us. "I shall be *that girl*," wrote Diana in 1918. The Girl rescued her from surrender to the downward trip. The Girl propelled her upward. Even in 1918 Diana was years ahead of her time. At the age of fourteen she was thoroughly postmodern; and bang up-to-date.

Still, you have to begin somewhere. It's like when I was thrown by the taxi last year—I didn't tell you about that? I told no one. First of all, it would have become an histoire. *And I knew that if I ever gave in . . .*

It was three weeks before the "Vanity Fair" show opened at the Museum. I had one foot in the door of a cab, the cab started to go and I was thrown back on my head and dragged along the ground. The whole time—this is while I'm being dragged—I kept thinking, "You've got three weeks to go—you've got to be all right." And then the driver saw me, stopped the cab and looked at me on the ground.

"Oh my God," he said, "What have I done?"

"You started to move," I said, "and I wasn't in the car. Why did you move?"

"I have no idea!"

"Now listen, there is a mirror—but never mind. No bones are broken. No one's hurt. Let's get on with it."

So I got in the cab and the driver said to me, "Lady, I've got to tell you something—this is my first night out in the cab and you're the first person I've driven."

"You've got to begin somewhere," I said. "Never look back, boy! Never look back . . . but still, you've got to look in the mirror to see if the person's in the car!"

ACKNOWLEDGMENTS

I have many people to thank for their help with this book. It would not have been possible without the generosity of members of the Vreeland family in giving a stranger total freedom to proceed and their kind insistence that the book should reflect my point of view, not theirs, thereafter. I am most grateful to Tim Vreeland, Freck Vreeland, and Alexander Vreeland for talking to me about Diana; to Nicholas Vreeland for his time and insight; and to Phoebe Vreeland and Daisy Vreeland for their assistance. Lisa Immordino Vreeland was particularly helpful in forwarding elusive information gleaned from her own research, and in arranging a private screening of her documentary about Diana, *The Eye Has to Travel*. I would also like to thank Diana's niece, Emi-Lu Astor, for giving me access to family albums assembled by her mother and grandmother, and for her observations about her aunt.

I was greatly assisted by three biographers: Hugo Vickers, biographer and literary executor of Cecil Beaton, and a friend of Diana Vreeland in the 1980s; Penelope Rowlands, author of *A Dash of Daring: Carmel Snow and Her Life in Fashion, Art, and Letters*; and Dodie Kazanjian, cobiographer, with Calvin Tomkins, of *Alex: The Life of Alexander Liberman*. Penelope provided several introductions to people who worked with Diana at *Harper's Bazaar* from the 1930s onward, and has been exceptionally generous with advice and information at every stage. In the course of writing *Alex: The Life of Alexander Liberman* with Calvin Tomkins in the 1990s, Dodie Kazanjian interviewed many people who knew Diana well but who have since died. I am most grateful to her for making her immaculate records available through the Archives of American

Art, for her kindness in allowing me to quote extensively from her work, and for introducing me to Anna Wintour. I am also indebted to Grace Mirabella for talking to me at length and for lending me her connoisseur's collection of Vreeland memos.

Many of Diana's colleagues and friends shared their memories of her and her world with me, including A. G. Allen, David Bailey, Lillian Bassman, Gigi Benson, Harry Benson, Marisa Berenson, Ferle Bramson, Dolores Celi, Felicity Clark, Bob Colacello, Gleb Derujinsky, Simon Doonan, Jean Druesedow, the late Eleanor Dwight, the late Dorothy Wheelock Edson, Jeanne Eddy, Jason Epstein, the late John Esten, Mary Fullerton Faulconer, Gwen Franklin, Carmel Fromson, Tonne Goodman, Nicholas Haslam, Carolina Herrera, Margaret van Buskirk Heun, Harold Koda, Kenneth Jay Lane, Boaz Mazor, Martha McDermott, Polly Mellen, Annie Hopkins Miller, Beatrix Miller, Betsy Newell, Audrey Oswald, Priscilla Rattazzi, John Richardson, Lynn Riker, Gloria Schiff, Babs Simpson, Valerie Steele, Susan Train, June Weir, and others who prefer to remain anonymous.

The Diana Vreeland Papers are in the Manuscripts and Archives Division in the Stephen A. Schwarzman Building of the New York Public Library. Assistant curator Thomas Lannon and his staff were unfailingingly efficient throughout my many visits. I am especially indebted to Valerie Steele, director and chief curator of the museum at the Fashion Institute of Technology, for her advice and expertise; to Jennifer Farley, assistant curator, with Ann Coppinger and Molly Sorkin, for making it possible for me to view the museum's holdings of Diana's clothes; and to Melissa Marra for her help with the chromes of Louise Dahl-Wolfe. I am equally obliged to Harold Koda, Nancy Chilton, Julie Lê, and the staff of the Costume Institute at the Metropolitan Museum of Art for their help, together with Gwen Roginsky in the Editorial Department and Julie Zeftel and Dina Selfridge in the Image Library. Shawn Waldron, archive director at Condé Nast, and Lisa Luna at the Hearst Corporation gave me every possible assistance; and so did James Martin and the staff of the Richard Avedon Foundation

in New York, especially Michelle Franco. I am also indebted to Jordan Auslander for his genealogical research and to Serena Balfour, Charlie Burns, Julia Fryett, Jean Halford-Thompson, Andrew Harvey, Jennifer Rhodes, Phylis Rifield, Judith Searle, Sue Ryder-Richardson, and Jenna Tinson of Front Row for their efforts on my behalf.

Many libraries and other organizations assisted with research. I would particularly like to thank Mark Bartlett, head librarian, and Carolyn Waters, writer services librarian, and the staff of the New York Society Library, whose assistance in locating and allowing me to photograph back issues of *Harper's Bazaar* and *Vogue* I greatly appreciated; Carol Elliott and Leslie Calmes of the Center for Creative Photography at the University of Arizona, Tucson; Etheleen Staley and Takouhy Wise of the Staley-Wise Gallery; Mark Ekman and the staff of the Paley Center for Media; Karen Canell, head of special collections & FIT archives at Fashion Institute of Technology; Sharon Stearns at the development office of the Brearley School; Michael Jones at the development office of the Staten Island Academy; Calvin Tomkins and the staff of the museum archives at the Museum of Modern Art, New York; Jim Holmburg and Sarah-Jane M. Poindexter of the Filson Historical Society; James Moske, managing archivist museum archives at the Metropolitan Museum of Art; Abi Gold of the Michael Hoppen Gallery; Monica Karales; the staff of the Irma and Paul Milstein Division of United States History at the New York Public Library; the staff of the New York Public Library for the Performing Arts; the staff of the New-York Historical Society Library; George Turns of Durham Research Online; Elizabeth Boardman of Brasenose College, Oxford; Andrew Brown of the Crown Estate; Timothy Livesy, archivist of Highgate School; the staff of St. John's College Library, University of Cambridge; Philippe Chapelin; the staff of the British Postal Museum & Archive; the staff of the Bodleian Library, Oxford, particularly the Vere Harmsworth Library; the staff of the London Library; and in the UK, above all, the staff of the National Art Library at the V&A.

I am most grateful to my agent, Clare Alexander of Aitken Alexander, for steering me in the direction of writing about Diana in the first place, and for her help throughout; and to Terry Karten, editor extraodinaire at HarperCollins Publishers in New York, for all her support, ably assisted by Sarah Odell. I owe many thanks to Susan Llewellyn for her sharp-eyed copyediting and the charming way she grappled with my Scottish English, and to Lydia Weaver and her production team. My gratitude goes to Dr. Heather Tilley for her help with the *Vogue* chapters; and to Alana Adye, Pippa McCarthy, Saskia Stainer-Hutchins, and Schuyler Weiss for research assistance at other times. This often involved them in exasperating tasks for which they were greatly overqualified, but they attacked everything they were asked to do with diligence, intelligence, and great good humor. The mistakes that remain are all mine.

I am greatly indebted to friends on both sides of the Atlantic, especially Peter and Virginia Carry in New York, whose hospitality must by now have earned them a place in the record books; and to Beverly del Castro, Maurice and Elizabeth Pinto, Jane Deuser, William Lamarque, and Max Silver for making my frequent trips to New York so enjoyable. I would particularly like to thank Frances Campbell and Judith Mackrell for their advice, and Candia McWilliam and Martine Stewart for reading the manuscript in draft. I am extremely grateful to Carol Walford for her calm and steady presence throughout, and all her help. To Marianna Hay, Daisy Hay, Michael Hay, and Freddy and Matthew Santer, I can only say this: Diana Vreeland once described fashion as an intoxicating release from the banality of the world. In my case it's not fashion, it's you.

A NOTE ON SOURCES

In her lifetime Diana Vreeland published two autobiographical books, *Allure* and *D.V. Allure* (1980) was the first. It emerged from conversations between Diana and the writer and archivist of Andy Warhol's tapes, Christopher Hemphill. Hemphill recorded Diana over a number of months in 1978, and then produced an edited manuscript, the "Allure Manuscript," referred to in the notes below. This was largely set aside when *Allure* developed in a different direction as a photo-autobiography.

The Allure Manuscript did, however, form the basis of Diana's second autobiographical book, *D.V.* (1984). George Plimpton recorded further conversations with Diana (Diana Vreeland Tapes below) and edited them together with the Allure Manuscript to create *D.V.* While writing this book I have drawn on both the Allure Manuscript and *D.V.* Sometimes the differences are slight but interesting. I have also used material from the Allure Manuscript that George Plimpton subsequently omitted.

Diana rarely "wrote" as commonly understood. She simply talked, or dictated from scribbled notes to secretaries, editors, and copywriters.

When remarks are not attributed in the notes, it should be assumed that they have been made directly to me.

Abbreviations Used in the Notes

DV: Diana Vreeland.
DVP: Diana Vreeland Papers, The New York Public Library, Manuscripts and Archives Division.

DK: Dodie Kazanjian.

DKP: Dodie Kazanjian Papers, Archives of American Art, Smithsonian Institution.

HDFA: Hoffman and Dalziel Family Albums.

Tomkins, II.A.108: Calvin Tomkins Papers, Series II, The Museum of Modern Art Archives, New York.

PCB: Papers of Sir Cecil Beaton, St. John's College Library.

RAF: The Richard Avedon Foundation.

NOTES

INTRODUCTION

1 *"My maid here at the Crillon"*: Allure Manuscript, DVP, Box 35, Folder 2, p. 170. This section of the manuscript is marked "Paris, Spring 1978."

1 "you lose your face": *Vanity Fair*, publication accompanying *Vanity Fair: A Treasure Trove of the Costume Institute* (New York: Metropolitan Museum of Art, 1977), Section 2, DV to Jacqueline Kennedy Onassis (n.p.).

1 "the High Druidess of fashion": quoted in Jonathan Lieberson, "Empress of Fashion: Diana Vreeland," *Interview*, December 1980, p. 25.

2 "She is indeed such a powerful personality": Cecil Beaton, *The Glass of Fashion* (London: Weidenfeld & Nicolson, 1954), p. 311.

2 "She didn't merely enter a room": Nicholas Haslam, *Redeeming Features: A Memoir* (London: Jonathan Cape, 2009), pp. 171 and 172.

2 "Mrs. Vreeland's head": Beaton, *Glass of Fashion*, p. 312.

3 a walk she said she copied from the showgirls of the *Ziegfeld Follies*: see Diana Vreeland, *Allure* (Boston: Bulfinch Press, 2002), p. 42.

3 "Like everyone else": Lieberson, "Empress of Fashion," p. 25.

3 "An authoritative crane": Beaton, *Glass of Fashion*, p. 311.

3 "Some extraordinary parrot": Truman Capote quoted in Lally Weymouth, "A Question of Style," *Rolling Stone*, August 11, 1977, p. 54.

3 "An Aztec bird woman": quoted in Eleanor Dwight, *Diana Vreeland*, (New York: William Morrow, 2002), p. 146.

3 "As you know, that's not the *most* popular": Allure Manuscript, DVP, Box 35, Folder 1, p. 16.

3 "There's a word not much used nowadays": quoted in Dwight, *Diana Vreeland*, p. 146.

3 "When she laughed": Jonathan Lieberson, "Embarras de Richessse: The Life of Diana Vreeland," *New York Review of Books*, June 28, 1984.

4 *"I have astigmatism"*: Diana Vreeland, *Allure*, p. 45.

5 "slanting knowing eyes": quoted in Dwight, *Diana Vreeland*, p. 146.

5 "At the time": Lieberson, "Empress of Fashion," p. 25.

5 "I have not one eccentricity": Allure Manuscript, DVP, Box 35, Folder 3. There are no page numbers in Folder 3 of the Allure Manuscript.

5 "lay a much-heralded mind": Haslam, *Redeeming Features*, p. 172.

5 At Diana's memorial service: by Simon Doonan, who had worked with her at the Costume Institute.

6 one highly critical book: Debora Silverman, *Selling Culture: Blooming-dale's, Diana Vreeland and the New Aristocracy of Taste in Reagan's America* (New York: Pantheon Books, 1986).

7 "the ephemeral, the fugitive, the contingent": quoted in Christopher Breward and Caroline Evans, eds., *Fashion and Modernity* (Oxford/New York: Berg, 2005), p.1.

7 "*Swifty Lazar took me with him*": Allure Manuscript, DVP, Box 35, Folder 3.

7 "nothing I've ever done is extraordinary": Lieberson, "Empress of Fashion," p. 22.

7 "Alas, I am afraid": DV to Marjorie Griswold, May 2, 1972, DVP, Box 3, Folder 6.

7 "She's a genius": quoted in Weymouth, *A Question of Style*, p. 38, and obituaries.

8 a "leitmotif, a continuity": this observation by make-up artist Pablo Manzoni can be found in the publication accompanying the 1993 exhibition *Diana Vreeland: Immoderate Style*, by Richard Martin and Harold Koda (New York: Metropolitan Museum of Art, 1993). After the introduction by Martin and Koda there are no page numbers. Contributions are looseleaf so that they can be read at random, a compliment to Diana's dislike of the linear.

8 "Keep your secret": to Stephen Jamail, quoted in Martin and Koda, ibid., looseleaf.

8 "*I want to tell you that a few years ago*": Allure Manuscript, DVP, Box 35, Folder 3.

CHAPTER ONE: PARIS OPENING

11 She once ejected a friend . . . for suggesting that . . . England had been invaded by the Normans: it was, in 1066.

11 "I said, 'The first image' ": Veruschka in Richard Martin and Harold Koda, *Diana Vreeland: Immoderate Style* (New York: Metropolitan Museum of Art, 1993), looseleaf. More recently, Veruschka has styled herself Vera Lehndorff, dropping the "von" when co-authoring books.

11 She was coy about her age, and genuinely perplexed: Diana's confusion was the result of a misreading. The genealogist Philippe Chapelin of gefrance.com has clarified that there was no discrepancy and that Diana was born on September 29, 1903. The misunderstanding came from the abbreviation "7bre" in her *bulletin de naissance*, which Diana took to mean "July" but is actually shorthand for "September." "7 does not

mean July but seven, that is French 'Sept.'" (Similar abbreviations are used for all the other months of autumn.)

12 People born in Paris: Lally Weymouth, "A Question of Style," *Rolling Stone*, August 11, 1977, p. 40.

12 "People used to say to me": Diana Vreeland Tapes, tape 2A.

12 He was not very Scots: Frederick Dalziel's line can be traced to 1750, when one of his forebears moved over the border from Scotland to Northumberland in the north of England. Successive generations then moved southward toward London. They were mainly agricultural workers, apart from one London branch of the family that produced a startling streak of visual brilliance in the Brothers Dalziel, engravers and illustrators who worked with artists such as John Everett Millais and John Tenniel, and made the blocks for Tenniel's illustrations for *Alice's Adventures in Wonderland* and *Through the Looking-Glass*. Years later Diana was wildly excited when the original Dalziel Brothers' blocks for *Alice's Adventures in Wonderland* were discovered in a bank vault, hoping she might inherit them. There was little chance of this, for Frederick Young Dalziel was only a distant cousin.

12 he left just a year later: Brasenose College Archives, University of Oxford. There is no mention of illness or failing exams in his record, two other possibilities.

12 "He was so wonderful looking": Weymouth, "A Question of Style," p. 40.

13 "There's only one very good life": in documentary film *Bailey on Beaton*, directed by David Bailey, 1971. "Hunting pink" was, of course, scarlet red.

13 Born in 1877: the 1880 New York census gives her age as three, which tallies with the age on her marriage certificate: twenty-four in 1901. Her family thought she was born in 1878, but in the late nineteenth century it was not unusual for women to "lose" a year or more.

14 claims that this side of Diana's family was Jewish: in 1972 Truman Capote persuaded Diana that Robert McBride, a freelance writer with whom he was infatuated, should write her "autobiography." After some so-called research, McBride put it about that Diana was Jewish on both sides. See Leo Lerman, *The Grand Surprise: the Journals of Leo Lerman* (New York: Alfred A. Knopf, 2007), p. 379.

14 Diana's Hoffman forebears: George Hoffman's father, a doctor and gentleman farmer, moved his family to New York before the Civil War because he was opposed to slavery.

14 The "Key" was George Hoffman's mother, Emily Key: Diana's relationship to Francis Scott Key connected her to Pauline de Rothschild and, more remotely, to Scott FitzGerald.

14 where he ran a private investment bank: the bank was Winslow Lanier & Co. It specialized in handling large bond issues for railroads, help-

ing to make New York City the center of American railroad financ-
ing in the 1870s. Its directors sat on railroad boards, enriching them-
selves in the process: John Washington Ellis was one of a group of
financiers who helped to revive the Northern Pacific Railroad in 1873.

15 The Ellises became closely identified with Newport's growing exclu-
sivity: John Washington Ellis's son, Ralph, also became master of the
Meadow Brook Hunt Club on Long Island in 1895.

15 they were listed in the first edition of the social bible, *The Social Regis-
ter*: *The Social Register* was first published in 1886, but was dated 1887.

15 "the most beautiful young lady on the floor": undated cutting from
HDFA. Although Emily was not formally "out" in 1895, her family
was preeminent in Newport circles and she attended the ball with her
mother. Alva Vanderbilt, who was a powerful figure and had no time for
inconvenient social rules, would have regarded youthful Emily's beauty
as an asset.

16 What really set Emily apart: all press quotations here come from an
album kept by Emily, now in a family collection (HDFA). She tended
to arrange her clippings by year, without specific dates. The *News of
Newport* was a column in the *New York Times*. In the late nineteenth-
and early twentieth-centuries, keeping such scrapbooks was a common
hobby among young women from Emily's background.

17 Stanford White's murder by Harry Kendall Thaw in 1906, in the roof
theater of Madison Square Garden, became known as "The Trial of the
Century." Thaw, a man of volatile and possessive temperament, was
jealous of White's earlier relationship with Thaw's wife, Evelyn Nesbit
(which involved the red velvet swing), and her continuing affection for
him. Thaw was judged insane at the time of the murder trial, which
was all the more sensational for what it revealed about the erotic tastes
of Stanford White and his circle. Thaw's diagnosis of insanity was later
reversed. The story was retold in the 1955 film *The Girl in the Red Velvet
Swing*, with Joan Collins as Evelyn Nesbit and Evelyn Nesbit herself as
an adviser.

17 "a budget of fun": undated clipping, DVP, Box 10, Folder 14.

17 One New York newspaper: "Eugene Higgins: Host to Society," *New York
Times*, May 1948.

18 chaperoned by married friends: young American women from Emily's
background were not as closely chaperoned as their European counter-
parts at this period. Indeed there was a certain patriotic pride in Ameri-
can plutocratic circles at the independence extended to well-born daugh-
ters. A mother like Alva Vanderbilt, who controlled every hour of her
daughter's day, consciously adopted the European model and was the
exception rather than the rule.

18 "Miss Hoffman did not approve": *Town Topics*, September 21, 1901.

18 an intolerable fusspot: *Town Topics*, September 7, 1899.

19 Frederick Dalziel rented a room: the bride's residence was given as in the parish of Saint George's Hanover Square, which meant that she and her family were staying somewhere in Mayfair. Frederick Dalziel's address was given as 50 Ebury Street, a lodging house for gentlemen. The register was signed by Emily's brother, John Ellis Hoffman, and his wife, Sybil, and by Frederick Dalziel's half brother, Edelsten.

19 5 avenue du Bois de Boulogne: now the Avenue Foch, and known as one of the most expensive residential streets in Paris.

20 "Mr. Dalziel has plenty of money": *Town Topics*, September 21, 1901, HDFA.

20 "racy, pleasure-loving, gala, good-looking Parisians": Diana Vreeland, *D.V.*, p. 11.

20 "homesick on both continents": quoted in Kathleen Adler, Erica Hirschler, and Barbara H. Weinberg, *Americans in Paris 1860–1900* (London: National Gallery Company, 2006–7), p. 70.

21 his four month-old-son Ian, eventually the 11th duke: Douglas Walter Campbell, heir presumptive to the 10th duke, died before he could inherit, in 1926. His son Ian became 11th duke in 1949. The latter would later be remembered chiefly for his scandalous divorce from his third wife, Margaret Whigham, in 1963 (cf. Thomas Adès's opera *Powder Her Face*).

22 "he had nothing to say": Vreeland, *D.V.*, (New York: Knopf, 1984), p. 12.

22 "Their *shoes* were so beautiful": ibid., p. 14.

22 The Dalziels proceeded to occupy a number of houses: including 22 West Fiftieth Street, in 1904; and 103 East Seventy-Ninth Street in 1906.

22 There are several photographs of Diana: DVP, Box 63, Folder 1.

23 "Sisters remember things differently": Jesse Kornbluth, "The Empress of Clothes," *New York Magazine*, November 29, 1982, p. 32.

23 "a tremendous snob about my mother's relations": private interview, 1991.

24 The Dalziels' friends included: Mrs. Henry Clews, Jr., the former Louise Gebhard, was credited with launching the career of society jester Harry Lehr by splashing about in a fountain with him in Baltimore. She was also felt to have married Clews rather too quickly after her divorce from Mr. Gebhard. Robert Winthrop Chanler was an eccentric muralist who married the singer Lina Cavalieri after a whirlwind romance. The marriage lasted just long enough for Chanler to settle a large sum of money on her, whereupon she deserted him. Chanler's brother, who had been consigned to a lunatic asylum, sent him a telegram saying "Who's loony now?", a story that enchanted Diana. "I am a child of this last, eccentric, independent age," Diana said to George Plimpton (Diana Vreeland Tapes, Tape 2A).

24 "He never had any money": Vreeland, *D.V.*, p. 22.

24 "Whispers would go around": ibid., p. 29.

24 "I remember this": ibid., p. 30.

25 "I think she was someone who was possessed by a great fear": ibid.

25 "My father was rather amused": ibid., p. 30.

25 "She had a great many men": private interview, 1991.

26 "So many of the things": Allure Manuscript, DVP, Box 35, Folder 2, p. 140.

26 "She was all in black": Vreeland, *D.V.*, p. 17.

27 "red red, *violent* violet": ibid., p. 14.

27 "That's where everything happened": ibid., p. 17.

28 "Sister" was a sensation even when taken out in her pram: Diana said that this happened in 1914, the year she claims the family moved back to New York. But Alexandra would have been seven, rather too old for a pram.

28 *"I can remember she was The Most Beautiful Child in Central Park"*: Vreeland, *D.V.*, pp. 10–11.

28 "wretched health . . . nothing definite": *New York Telegram and Evening Mail*, Tuesday, February 10, 1925.

29 "You ask 'do I love you' ": n.d. but probably written between 1925–27 when Alexandra Dalziel was at Bryn Mawr, HDFA.

29 "All I knew then was that my mother wasn't proud of me": Vreeland, *D.V.*, p. 30.

29 Though there was a nurse of that name: Diana appears to have plucked this name for her hated nanny from her childhood album.

30 "She didn't like Diana": private interview, 1991. Years later Alexandra's daughter still felt the full force of Kay Carroll's antipathy toward Diana and found herself affected by it; see chapter 4.

30 "My nurse was appalling": Allure Manuscript, DVP, Box 35, Folder 1, p. 2.

30 "It was a wall of water": Allure Manuscript, DVP, Box 35, Folder 2, p. 178. Diana told Christopher Hemphill that the nightmare only disappeared in her seventies, when she found herself looking at a wave on a lacquered Japanese screen at the Metropolitan Museum and suddenly remembered a wave on a similar Japanese screen at her grandmother's house in Southampton. "I turned to the person I was with and said, 'My God, this is the *beginning* and the *end* of my nightmare.' " (DVP, Box 35, Folder 2, p. 178).

31 "Actually, when I was brought to America": Vreeland, *D.V.*, p. 20.

31 "It's one time in my life": ibid., p. 21.

31 "I lasted three weeks at the Brearley School": "The Empress and the Commissioner," a 1980 documentary for the Manhattan Cable series *Andy Warhol's Fashion*, directed by Don Monroe, featuring Henry Geldzahler in conversation with Diana.

32 a level of expertise and degree of focus that was uniquely exhilarating:

The writer Isak Dinesen described the chase as if it were a euphoria-inducing drug. "There is nothing in the world to equal it," she wrote. Quoted in Fiona Claire Capstick, *The Diana Files: The Huntress-Traveller Through History* (Johannesburg: Rowland Ward Publications, 2004), p. 203.

32 the hunt "took possession of her": *New York Telegram and Evening Mail*, February 10, 1925.

33 An epidemic of infantile paralysis swept through New York: On Saturday, June 17, 1916, the existence of a polio epidemic was officially announced in Brooklyn, New York. The names and addresses of confirmed cases were published daily in the press, and the affected families were quarantined. The epidemic caused widespread panic, and thousands fled the city.

33 "The last time I saw him": Vreeland, *D.V.*, p. 24.

33 "We were there in the wilds with the moose and the bears": Diana Vreeland Tapes, Tape 1A.

34 "If I thought of myself, I wanted to kill myself": Weymouth, "A Question of Style," p. 42.

34 "But I think when you're young": Vreeland, *D.V.*, p. 25.

CHAPTER TWO: THE GIRL

35 Fokine did not open his New York studio until 1921: at 4 Riverside Drive. Diana often muddled or forgot names when she was older and frequently confused Fokine with Chalif.

35 "I am simply crazy over dancing": Diary, DVP, Box 60, Folder 2, January 22, 1918.

35 "Music can do something to me": Diary, DVP, Box 60, Folder 2, June 14, 1918.

36 "I still don't think mother thinks I dance well": Diary, DVP, Box 60, Folder 2, June 14, 1918.

36 "Ama and Daddy Weir went to saw me [*sic*]": Diary, DVP, Box 60, Folder 2, January 22, 1918.

36 "I suffered, as only the very young can suffer": Vreeland, *D.V.*, p. 23.

37 "I realize now I saw the whole beginning of our century": Vreeland, *D.V.*, p. 13.

37 "I like dancing with lots of noise": Diary, DVP, Box 60, Folder 2, January 5, 1918.

38 the invigorated, well-stretched body and long, long limbs: See, as just two examples, photographs by Richard Avedon and Edward Steichen in Diana Vreeland, *Allure*, pp. 125 and 179.

38 "When I discovered dancing, . . . I learned to dream": Vreeland, *D.V.*, p. 25.

38 "Mother and I agree on practically nothing": Diary, DVP, Box 60, Folder 2, January 19, 1918.

39 "Freud thought that a happy man": Boris Cyrulnik, *Resilience: How Your Inner Strength Can Set You Free from the Past* (London: Penguin Books, 2009), pp. 276 and 277. I am most grateful to Frances Campbell for introducing me to the work of Boris Cyrulnik on resilience in childhood.

39 "I have always had a wonderful imagination": Diary, DVP, Box 60, Folder 2, June 14, 1918.

39 "I keep constructing tableaux in my mind": Allure Manuscript, DVP, Box 35, Folder 2, p. 140.

39 "There is something so wonderfull [*sic*] about a girl": Diary, DVP, Box 60, Folder 2, June 23, 1918.

40 "I was much stronger": Vreeland, *D.V.*, p. 30.

40 "Some children have people they want to be": Allure Manuscript, DVP, Box 35, Folder 1, p. 2.

40 "I want sometimes an artist": Diary, DVP, Box 60, Folder 2, June 23, 1918.

41 "I am making a divine collection of pictures": Diary, DVP, Box 60, Folder 2, June 23, 1918.

41 "Mrs. McKeever has lots of taste": Diary, DVP, Box 60, Folder 2, January 15, 1918.

41 "The house is terrible": Diary, DVP, Box 60, Folder 2, January 3, 1918.

41 "I would love a bedroom in French gray": Diary, DVP, Box 60, Folder 2, January 20, 1918.

41 "She was perpetually scanning": Lieberson, "Empress of Fashion," p. 25.

42 "Some times I feel as if I did not want anything": Diary, DVP, Box 60, Folder 2, June 14, 1918.

42 "*I shall be that girl*": Diary, DVP, Box 60, Folder 2, January 12, 1918.

42 "Never to be rude to mother sister or anybody": ibid.

42 "I have descoved [*sic*] I don't look pleasant": Diary, DVP, Box 60, January 23, 1918.

42 "I have decided that my vocabulary is very small": Diary, DVP, Box 60, January 11, 1918.

42 "I shall please everyone in my appearance": Diary, DVP, Box 60, Folder 2, June 5, 1918.

43 "Have smoked a cigarette & adored them": Diary, DVP, Box 60, Folder 2, June 23, 1918.

43 "I am going to be able to sing at liberty": Diary, DVP, Box 60, Folder 2, January 14, 1918.

43 "I dreamt of many men coming to me": Diary, DVP, Box 60, Folder 2, January 14, 1918.

43 Triumph over youthful adversity: See Cyrulnik, *Resilience*, pp. 19–20.

44 "Sister's music teacher told me": Diary, DVP, Box 60, Folder 2, January 8, 1918.

44 "Emily said I talked very well": Diary, DVP, Box 60, Folder 2, June 6, 1918.

44 "You know I'm vastly popular": Diary, DVP, Box 60, Folder 2, January 21, 1918.

44 "Lots of things have happened": Diary, DVP, Box 60, Folder 2, June 5, 1918.

44 "E Billings and I are going to get up a ballet": Diary, DVP, Box 60, Folder 2, June 7, 1918.

44 "he lost them all & we had a wonderful time using slang": Diary, DVP, Box 60, Folder 2, January 2, 1918.

45 "I fought for a long time": Lieberson, "Empress of Fashion," p. 22.

45 "I want art, pure art": Diary, DVP, Box 60, Folder 2, June 14, 1918.

45 "Diana was a goddess": ibid.

46 "It was the most tragic & harrowing thing": Diary, DVP, Box 60, Folder 2, January 7, 1918.

46 The cultural historian Ann Douglas suggests: see Ann Douglas, *Terrible Honesty: Mongrel Manhattan in the 1920s* (London: Picador, 1996), pp. 32–33. I am indebted to Ann Douglas for her analysis of New York at this period, and to Judith Mackrell for introducing me to this remarkable book.

47 "It's not just nightmares I can't stand": Allure Manuscript, DVP, Box 35, Folder 2, p. 179.

47 "Changing herself covered up a deep wound": Dwight, *Diana Vreeland*, p. 15.

47 "In later life . . . Diana's models": ibid.

48 "If I can change the way you see me": Cyrulnik, *Resilience*, p. 11.

48 "I simply must be more perfect": Diary, DVP, Box 60, Folder 2, June 23, 1918.

49 "It's very touching": Allure Manuscript, Box 35, Folder 2, p. 165.

49 "Yesterday I painted my brackets": Diary, DVP, Box 60, Folder 2, January 10, 1918.

49 "He had that *thing* about him": Vreeland, *D.V.*, p. 22.

49 "My father was so much easier": ibid., p. 21.

49 "a tidy little group": ibid., p. 29.

49 "My grandmother could be appalling": Allure Manuscript, DVP, Box 35, Folder 2, p. 177.

50 "He thought it was a riot": ibid.

50 "My grandmother had a huge farm horse": Vreeland, *D.V.*, p. 20.

51 when the Villa Diana was sold two years later: on October 22, 1922, the *New York Times* reported that it had been sold for $125,000, approximately $1.6 million in today's money.

51 He was known as a "stinker": see Fritz von der Schutenberg, *Balnagown, Ancestral Home of the Clan Ross: A Castle Through Five Centuries* (London, Brompton Press, 1997), pp. 83–89.

53 "a natural preliminary to the guilty use of opportunities": *The Scotsman*, December 10, 1928.

53 Emily talked of watching, entranced: *New York Times*, July 27, 1921.

54 a handful of compositions: Diana's compositions, which appear to have been written mainly in the fall of 1920, are in DVP, Box 60, Folder 1.

54 spawned a host of imitators: "Unabashedly flamboyant in sequins, lamé, feathers and transparent veils, the sultry charmers writhed and clawed and enraptured their victims, only to lose them, inevitably, to the ingénues with fluttering eyelashes and sugar-water curls." Jane Trahey, *Harper's Bazaar: 100 Years of the American Female* (New York: Random House, 1967), p. 34.

55 Diana's Type still bore traces of Theda Bara: Bara's real name was Theodosia Burr Goodman, and she came from Cincinnati, Ohio.

56 "debutantes' first bow in town": *New York Times*, October 15, 1921.

56 "You might do the work of 'making' outside the city": Douglas, *Terrible Honesty*, p. 15.

57 cigarettes began to be promoted as a slimming aid: see Lucy Moore, *Anything Goes: A Biography of the Roaring Twenties* (London: Atlantic Books, 2009), p. 66.

58 "I adore artifice. I always have": Vreeland, *D.V.*, p. 27.

58 "When cosmetics began to be seen as an 'affordable indulgence'": Moore, *Anything Goes*, pp. 69–70.

58 New York's newspapers: clippings in private collection, n.d.

59 Her dress for her coming-out: Vreeland, *D.V.*, p. 28.

59 "I was always a little extreme": Allure Manuscript, DVP, Box 35, Folder 1, p. 27. This coincides with *Vogue*'s report at the time: "Miss Diana Dalziel, at her coming-out ball, wore an all-white dress with a skirt of fringe, made of tiny ribbons. But she added a modern accent by wearing brilliant red slippers." Her friends Ellin Mackay and Jeanne Reynal were even more extreme. Ellin Mackay's dress was blue and silver, while Jeanne Reynal wore rose taffeta (*Vogue*, February 15, 1922, pp. 34–35).

59 "'Circus people—where did you ever meet them?'": Vreeland, *D.V.*, p. 28.

60 "Since I was not interested in getting married": Maud Morgan, *Maud's Journey: A Life from Art* (Berkeley, CA: New Earth Publications, 1995), p. 45.

60 Her debutante year was a triumph: clippings in private collection, 1921, n.d.

60 She adored the newly fashionable lowlife: "picturesquely depraved" was a phrase used by Diana's friend Ellin Mackay in an article she wrote about her generation's preference for nightclubs and cabarets over debutante balls, which appeared in *The New Yorker* in November 1925. The article caused a sensation and made Mackay's father furious, though he was even more furious when she married the songwriter Irving Berlin, an Orthodox Jew, a few months later.

60 "to avoid running into my mother and father": Vreeland, *D.V.*, p. 29.

61 "By the time I was seventeen, I knew what a snob was": ibid., p. 28.

61 "one of the most attractive of this season's debutantes": *Town Topics*, clipping from private collection, 1921, n.d.

61 a "smart figure" and "one of the new notes in millinery": *Vogue*, June 1, 1922, p. 45, and July 1, 1923, p. 58.

62 titled "Ten Thousand Miles from Fifth Avenue": The article appeared in *Harper's Bazar*, February 22, 1922, p. 31. *Bazar* presented it as a lead feature, and later ran a caricature by Ralph Barton of Emily in a sola topee in a montage of its outstanding contributors of the period. This was subsequently reproduced in Trahey, *100 Years*, p. 84.

62 *Vogue* published a major article about big-game hunting in the Rockies: "When You Hear the Far West Calling: How to Slip the Leash of Civilization and Still Avoid Tenderfoot Troubles," *Vogue*, June 15, 1923. p. 55.

63 "I believe in love at first sight": Vreeland, *D.V.*, pp. 30-31.

63 Unlike Diana's British father: by the time Diana met her future father-in-law, he was managing the tobacco, insurance, and diamond mining business interests of the magnate Thomas Fortune Ryan.

64 "I am sorry I cannot go on record": *Town Topics*, January n.d., 1924, private collection.

64 "Everybody who was invited to a Condé Nast party": Vreeland, *D.V.*, p. 48.

65 "He was the most beautiful man I've ever seen": Allure Manuscript, DVP, Box 35, Folder 1, p. 31.

65 an "achievement": Vreeland, *D.V.*, p. 33.

65 "I never felt comfortable about my looks": *D.V.*, p. 30.

65 "Isn't it curious that even after more than forty years of marriage": *D.V.*, p. 33

66 The news that Lady Ross was suing Sir Charles for divorce: the New York press had been unusually slow off the mark. The divorce papers had in fact been served in early January, an event reported in Britain in *The Scotsman* on January 4, 1924.

66 "Lady Ross has evolved a very interesting fiction": *New York Evening Journal*, February 28, 1924, p. 5.

66 "All these stories about your mother": Vreeland, *D.V.*, pp. 31–32.

66 "It wasn't sparse—it was practically empty": ibid., p. 33.

67 "Oh, everything I own has my baby bell": ibid., p. 32.

67 "a very strict line and a very high neckline": ibid., pp. 32–33.

67 "Everything about the wedding": *Town Topics*, March 6, 1924, p. 4.

67 "In other words it means that I am popular": Diary, DVP, Box 60, Folder 2, January 14, 1918.

68 "We're all exiles from something": Vreeland, *D.V.*, p. 184.

69 At the time of the Vreelands' wedding: see Lester W. Herzog, Jr., *150 Years of Service and Leadership: The Story of National Commercial Bank and Trust Company* (New York: Newcomen Society in North America, 1975).

69 "this environment of good food, good housekeeping": Vreeland, *D.V.*, p. 35.

69 "During this phase when I lived in Albany": ibid.

69 "Reed and I were like the little children": ibid., p. 34.

70 Under the heading "Labor Economy": *Albany Evening News*, April 26, 1926.

70 "He still wears his little wooly [*sic*] nightgowns": DVP, Box 67, Folder 1.

70 "Now that Diana, who married Reed Vreeland last winter": *Town Topics*, January n.d., 1925, private collection.

70 Diana completed the migration to American housewife: *Albany Evening News*, April 7, 1925.

71 Balnagown in Scotland, was part of America: the British government responded vigorously to this assertion, since allowing citizens unilaterally to declare their homes to be part of other countries would—among other things—have had dire consequences for tax collection. The official response to Sir Charles's maneuver was to have him declared a legal "outlaw"(the last in the UK). This had the effect of preventing him from returning to Scotland legally and further delayed divorce proceedings.

71 In 1925 he even forced apologies: Frederick Dalziel could have responded in this way because he was tired of seeing lies about his wife in the gutter press, but he may also have construed "barefoot" as a subtle slur, linking Emily in the minds of those in the know with the scandalous behaviour of the Happy Valley set in Kenya, where the much-married Idina Sackville went barefoot and appeared naked at parties that turned into orgies at her behest. Clippings from HDFA, April 11–15, 1925.

71 "guilty passion" in the African jungle: see *The Scotsman*, June 6, 1927.

71 Alexandra knew very well: private interview, 1991.

72 "None of her African experiences": Maury Paul was a syndicated gossip columnist for the *New York American*, who wrote as Cholly Knickerbocker; undated clipping ca. 1930, HDFA.

72 "the madness was attributable to something more personal": *The Scotsman*, December 10, 1928.

72 The case was finally settled only in 1930: *The Scotsman* reported every twist and turn of the case in great detail from 1924 to 1931. Lady Ross eventually obtained her divorce in 1930, though she was still pursuing Sir Charles through the courts for payment of alimony in 1931.

72 "She lived only for excitement": Vreeland, *D.V.*, p. 30.

73 "She was quite young and beautiful": ibid.

73 reaction to the death of a damaging parent: see Cyrulnik, *Resilience*, p. 77.

73 "All the things that happened to me there": Allure Manuscript, DVP, Box 35, Folder 1, p. 48. Diana often misremembered or miscounted the number of years the Vreelands spent in Europe. She told Christopher Hemphill they were in England for twelve years, but they spent five and a half years in England, and a further year based in Switzerland.

73 partly a matter of timing: see Bettina Ballard, *In My Fashion* (London: Secker & Warburg, 1960), p. 78. Bettina Ballard was American *Vogue*'s Paris editor before the Second World War. "A woman was not considered important in Paris until she was well in her thirties and had her children behind her so she could concentrate on the fashionable life," she wrote of this period.

74 "I lived in that world": Vreeland, *D.V.*, p. 47.

74 The scrapbook suggests: Diana's fashion scrapbook is in DVP, Box 62.

75 "Condé Nast was a very, very extraordinary man": Allure Manuscript, DVP, Box 35, Folder 1, p. 60.

75 They took over the lease of 17 Hanover Terrace: I am grateful to Andrew Thomas of the Crown Estate for providing details of the Vreelands' lease.

75 "Greenery, you know": Vreeland, *D.V.*, p. 8.

75 Diana snipped articles: in the scrapbook, DVP, Box 62.

76 "Friends who visited": Phyllis Lee Levin, *The Wheels of Fashion* (New York: Doubleday & Company, Inc., 1965), p. 102.

76 Reed's job at the Guaranty Trust: according to Hugo Vickers, biographer of Gladys, Duchess of Marlborough, it was Reed's job to hand over the check when she called to collect her allowance from the London branch of the Guaranty Trust.

77 "I first met him there": Allure Manuscript, DVP, Box 35, Folder 1, p. 63.

77 "The family house in Piccadilly": Cecil Beaton, *The Glass of Fashion* (London: Weidenfeld & Nicolson, 1954), p. 141.

78 "an absolutely fascinating, marvelous-looking": Allure Manuscript, DVP, Box 35, Folder 1, p. 62.

78 Tyrolean beachwear: the last word in whimsy, since the Austrian Tyrol has no beaches. Carolyn Hall, *The Thirties in Vogue* (London: Octopus Books, 1984), p. 35.

79 Café society was therefore characterized: see Thierry Coudert, *Café Society: Socialites, Patrons and Artists, 1920 to 1960* (Paris: Flammarion, 2010), pp. 7–71 passim.

79 Diana's friendship with Cecil Beaton: Diana Vreeland Tapes, Tape 2A.

80 In her book *Romantic Moderns*: Alexandra Harris, *Romantic Moderns: English Writers, Artists and the Imagination from Virginia Woolf to John Piper* (London: Thames & Hudson, 2010), p. 75.

80 "For all I know the old girl is still a virgin": Nina Campbell and Caroline Seebohm, *Elsie de Wolfe: A Decorative Life* (London: Aurum, 1993), p. i.

81 "I adored her because she was so . . . methodical": Diana Vreeland Tapes, 6A.

81 "I started to get a little education": Weymouth, "A Question of Style," p. 42.

81 "Diana has made an enviable niche": Maury Paul (Cholly Knickerbocker), *New York American*, undated clipping, HDFA.

82 "I'm mad about her stance": Allure Manuscript, DVP, Box 35, Folder 1, p. 19.

82 "He passed me by like so much white trash": Vreeland, *D.V.*, p. 64. The tradition of presenting aristocratic women at Court in the early summer went back to the reign of George III (and ended only in 1958). Most of the young ladies presented were marriageable debutantes, but socially distinguished married women were eligible too. "Ladies of foreign nationality . . . and British women married to foreign nationals could be presented only through the diplomatic representative of the country concerned." Anne de Courcy, *1939: The Last Season* (London: Phoenix, 1989), p. 25.

83 "The small egocentric group of women": Ballard, *In My Fashion*, pp. 78–79.

83 "*Les Dames de* Vogue": see Bettina Ballard, ibid., p. 83.

83 "the elegance of the damned": Vreeland, *Allure*, p. 93.

83 "None of these were stupid women": Diana Vreeland Tapes, Tape 15.

84 "I can remember a dress": Vreeland, *D.V.*, p. 95.

84 "I had a little string-colored dress": Weymouth, "A Question of Style," p. 43.

84 Backed by Elsie Mendl: an invoice shows that Diana bought a cape, a belt, and a dress of "crepe de main quadrille" in June 1933, three years after Mainbocher opened his Paris atelier; DVP, Box 1, Folder 1.

85 "It's one thing I do care so passionately about": Diana Vreeland Tapes, Tape 15.

85 "She'd come in to see about a skirt": Weymouth, "A Question of Style," pp. 42–43.

85 "Everyone thinks of *suits* when they think of Chanel": Vreeland, *D.V.*, pp. 95–96.

85 "the most beautiful dress I ever owned": ibid., p. 96.

86 "First, there was the beautiful rolling staircase": ibid., p. 127.

86 "*Coco was a nut on armholes*": ibid.

86 "Chanel saw the need": Diana's entry on Chanel, *The 1972 World Book Year Book: the Annual Supplement to the World Book Encyclopedia*, p. 350.

86 "Smart women went to her shop": ibid.

87 "The art of living was to Chanel": ibid.

87 "Chanel was the first couturier": from Diana's draft of her entry on Chanel for *The 1972 World Book Year Book*, DVP, Box 41, Folder 1.

87 "I'd always been *slightly* shy of her": Vreeland, *D.V.*, p. 131.

87 A Chanel suit that Diana bought in the late 1930s: see Metropolitan Museum of Art catalog for *Chanel* exhibition, May 5–August 7, 2005.

88 "Today, an old boot of a face": quoted in Hall, *The Thirties in Vogue,* pp. 15–17.

88 When a group of Paris dressmakers drew up a best-dressed list: widely reported but see, for instance, *New York Times,* November 26, 1935.

88 "What a disappointment that woman is": PCB, Diary, January 15, 1930, Volume 61, p. 146.

89 "I'd spend days and *days* in bed reading": Vreeland, *D.V.,* p. 83.

89 Diana made long lists of writers: see, for example, notebook in DVP, Box 60, Folder 3.

89 "When I think of Natasha in *War and Peace*": Vreeland, *D.V.,* p. 82.

89 "When you've *heard* the word": ibid., p. 81.

89 Beaton was the first to capture the manner: Cecil Beaton, *Cecil Beaton's New York* (London: B.T. Batsford Ltd, 1938), p. 244.

90 she slipped one of Acton's photographs into her own fashion scrapbook: see DVP, Box 62.

90 "The vision of Diana Vreeland arriving": Levin, *The Wheels of Fashion,* p. 102.

91 the odd one out: Vreeland, *D.V.,* p. 43.

91 "The top of the palace was flat": ibid., p. 46.

91 "you know, the sort of business": Allure Manuscript, DVP, Folder 1, p. 65.

91 " 'Reed,' I once said, 'What happens . . .'": Vreeland, *D.V.,* pp. 44–45.

92 "I have no idea if I actually saw the movie": ibid., pp. 49–50.

93 Astonishingly, spas in Germany: see Hall, *Thirties in Vogue,* p. 18. Hall points out that as late as August 1939, British *Vogue* ran an advertisement for "Germany, that land of hospitality."

93 "weakening, weakening, weakening": Weymouth, "A Question of Style," p. 43.

93 "I simply had to . . . sleep": Diana Vreeland Tapes, Tape 6A.

94 " 'Really,' Reed said to me": Vreeland, *D.V.,* p. 77.

94 "But Julie was getting more and more upset": ibid., p. 79.

95 "The curious thing about me": Allure Manuscript, DVP, Box 35, Folder 1, pp. 16–17.

95 Neither son remembered: see Vreeland, *D.V.,* p. 84.

96 "Her little girls are enchanted by her": *Harper's Bazaar,* December 1937.

96 "I had made a solemn vow to myself": Vreeland, *D.V.,* p. 84.

96 "Nothing wrong for them to see": ibid., p. 84.

96 Mrs. Reed Vreeland was one of "the European highlights of chic": *Vogue,* November 1, 1933, p. 27.

97 "How delighted I am": ibid. ("Paris Fashions: As They Wear It—Seen by 'Him,' " p. 100; illustration, p. 36).

97 "I made great friends among the English": Allure Manuscript, DVP, Box 35, Folder 1, p. 37.

98 "Anyone who has been emotionally wounded": Cyrulnik, *Resilience*, p. 133.

98 "At times they liked him a bit too much": Allure Manuscript, DVP, Box 35, Folder 1, p. 37. Diana may have had Edwina Mountbatten in mind here. She pasted a photograph of Edwina Mountbatten into her fashion scrapbook and advised her on the decoration of her house in 1936, which was not only a compliment to Diana's taste but a major social coup. Yet Diana rarely mentioned Mountbatten thereafter. Gossip has connected Reed to Edwina Mountbatten, though it should be said that gossip linked her to many men, and Reed does not emerge from biographies as one of her lovers.

98 Diana's shop: the address of the shop was 15 Hay's Mews, London W1. DVP, Box 1, Folders 1–2.

99 "I should love to see you among your delicate lines of lingerie": undated letter from William Acton, private collection.

99 "I was never *not* on my way to see the mother superior": Vreeland, *D.V.*, pp. 68–69.

99 Mona Williams, who scrutinized every penny: "Dear Madam," wrote Mona Williams's secretary in January 1934. "We are enclosing herewith a cheque for £44/5. The total of your bill as presented was £53/13, but Mrs. Williams directed us to deduct £8/8 for four chemises which were not received, and we found upon checking the bill that it had not been added correctly, as there was a difference of ten shillings in the total which we have deducted." DVP, Box 1, Folder 2.

99 "I was very thin": quoted in Dwight, *Diana Vreeland*, p. 34.

100 led some to suppose that the story must be apocryphal: Diana ran her lingerie shop from September 1933 to the late spring of 1934. It is known that Wallis Simpson became a favorite of the Prince of Wales in early 1934 while his reigning mistress, Thelma Furness, was away. Charles Higham suggests that although the prince's relationship with Wallis Simpson was probably not consummated till later in the year it was not platonic in early 1934 either, and that this was well known to close friends like Syrie Maugham and Sibyl Colefax. On this basis Wallis Simpson would have had good reason to order glamorous nightdresses from Diana while she was still running her shop in the spring of 1934. See Charles Higham, *Mrs. Simpson: Secret Lives of the Duchess of Windsor* (London: Pan, 2005), p. 90. Diana damned Ernest Simpson with somewhat faint praise: "He was nice enough but rather ordinary in the way that one didn't take notice of him when there were other people in the world." Allure Manuscript, DVP, Box 35, Folder 1, p. 85.

100 "When Reed and I got to Regent's Park": Allure Manuscript, DVP, Box 35, Folder 1, pp. 48–49.

100 "It was a fait accompli": Allure Manuscript, Box 35, Folder 1, p. 88.

100 "You've never seen anyone in such a condition": Allure Manuscript, DVP, Box 35, Folder 1, pp. 88–89.

100 "I am pleased about Reed staying with the Guaranty": Lesley Benson to DV, DVP, Box 15, Folder 1.

101 "It is really too dreadful": DVP, Box 17, Folder 15.

101 By September 1934: letter from Ben Kittredge, DVP, Box 17, Folder 9. The letter from Elsie Mendl dated December 3, 1934, is in a private collection. "I am longing to come up for two or three days in that wonderful air, and Charles says he thinks he could arrange to come," she wrote. "Wouldn't that be wonderful if we could get into the Rolls and spin along to Geneva and then come on to Lausanne?"

101 "Switzerland before World War II": Allure Manuscript, DVP, Box 35, Folder 1, p. 7.

102 "*I was so happy in Ouchy*": Vreeland, *D.V.,* pp. 83–84.

102 "It's strange, isn't it": Allure Manuscript, DVP, Box 35, Folder 1, p. 89.

103 "But Mrs. Snow": Vreeland, *D.V.,* pp. 88–89, passim.

103 in a pink dress by Vionnet in the winter of 1935: Carmel Snow reported her return from Europe thus in *Harper's Bazaar,* December 1935.

103 she would receive a commission on any "Syrie" furniture she sold: For Diana's contract with Syrie see DVP, Box 1, Folder 2. Diana told George Plimpton she had already started working for *Town & Country* by the time Carmel Snow approached her (Diana Vreeland Tapes, Tape 5).

CHAPTER FOUR: PIZZAZZ

105 "*I arrived at Harper's Bazaar*": this account of Diana's start at *Harper's Bazaar* is excerpted from Allure Manuscript, DVP. Box 35, Folder 2, pp. 95–97.

107 "I decided that I had to let him re-photograph": Carmel Snow and Mary Louise Aswell, *The World of Carmel Snow* (New York: McGraw-Hill, 1962), p. 88.

108 "the first action photograph made *for fashion*": ibid., p. 89.

108 before becoming a highly successful graphic designer: the breakthrough in Brodovitch's career came when he won a poster competition for an artists' soirée, "Le Bal Banal," in 1924, with a design in which he played with the idea of masks and identity. This lead to work with Athélia, the design studio of a leading Paris department store. He set up his own studio too, producing posters for Cunard and illustrated books for La Pléiade, a French publishing company, before emigrating to the United States in 1930.

109 "a monthly run-through of popular and high culture": Calvin Tomkins, "The World of Carmel Snow," *The New Yorker*, November 7, 1994, p. 153.

109 first "magazine editor as auteur": ibid.

110 *Harper's Bazaar* "seemed years—decades—younger": ibid.

110 she introduced her to *Bazaar*'s readers in January 1936: Munkácsi's photograph appeared in the January 1936 issue of *Harper's Bazaar*, p. 78.

111 "Diane converses *naturally*": Snow and Aswell, *The World of Carmel Snow*, p. 103.

111 "She used to come in once a week to talk": quoted in Penelope Rowlands, *A Dash of Daring: Carmel Snow and Her Life in Fashion, Art, and Letters* (New York: Atria Books, 2005), p. 195.

111 In a feature called "I'd be Lost Without . . .": *Harper's Bazaar*, January 1936, p. 41.

112 "I didn't know then what I was going to do": Allure Manuscript, DVP, Box 35, Folder 1, p. 93.

112 Her first "Why Don't You?" column: The "Why Don't Yous?" mentioned in this chapter appeared in the following issues of *Harper's Bazaar*: March 1936, July 1936, August 1936, September 1936, November 1936, December 1936, February 1937, March 1937, July 1937, August 1937, November 1937, February 1938, April 1938, and May 1941. The February 1937 column was dedicated to the inspiration of Schiaparelli: "Why Don't You realize that this wonderfully creative woman is expressing our life and times in her little suits and dresses and in her unique materials . . . and realize that it is up to you to match her genius by adding perfect details to make them part of you?"

112 After that there was no stopping her: the "Why Don't You?" column appeared in different designs and layouts, but the usual format was that the title "Why Don't You?" appeared at the top of the page or double page spread, with illustrated ideas below. The question was usually not repeated. I have therefore inserted "Why Don't You" with capital letters at the beginning of each of Diana's suggestions for ease of reference.

114 "They were all very tried and true ideas": Vreeland, *D.V.*, p. 92.

114 In 1936 she kept a notebook: DVP, Box 1, Folder 10.

115 "I never met the old boy": Vreeland, *D.V.*, p. 92.

115 "It can be seen": quoted in Rowlands, *A Dash of Daring*, pp. 204–5. Cecil Beaton made this remark in the American edition of *The Glass of Fashion* (Garden City, NY: Doubleday, 1954), p. 363.

117 less sure-footed about fascism: the article about politically minded scarves appeared in *Harper's Bazaar*, November 1936, p. 61.

117 " 'Fall' Clothes": Bett Hooper, *The New Yorker*, February 20, 1937, p. 64.

117 "*The first time I noticed*": S. J. Perelman, "Frou-Frou, or the Future of Vertigo," *The New Yorker*, April 16, 1938, p. 17.

118 "Good heavens!": Vreeland, *D.V.*, p. 93.

118 The point, said Diana: Allure Manuscript, DVP, Box 35, Folder 3.

119 "I am so happy to tell you": DVP, Box 1, Folder 6. The Hearst organization was notoriously ungenerous. "Even then it was despicable," said fashion editor Babs Simpson. Diana's salary did rise over the years: she remarked later that they paid her eighteen thousand dollars a year for twenty-eight years, which, even allowing for Diana's way with facts, was very little. Penelope Rowlands notes that in the 1950s, Carmel Snow does not appear to have been paid much more—around twenty thousand dollars. "Brodovitch, no doubt, did better: almost all men at Hearst, as at so many other organizations, did." Rowlands, *A Dash of Daring*, p. 255.

121 give it some pizzazz: "pizzazz" was one of Diana's favorite words, though she did not invent it, as Cecil Beaton and others thought. It is listed in *The Oxford Dictionary of Slang* as being of American origin and first appearing in 1937. Carmel Snow thought it was coined by the "boys" of the Harvard *Lampoon*. (Snow and Aswell, *The World of Carmel Snow*, p. 124.)

121 New York's garment industry had moved uptown: a move spurred in part by the deadly Triangle Shirtwaist Factory Fire in Greenwich Village on March 25, 1911, in which 146 garment workers lost their lives. See David von Drehle, *Triangle: The Fire That Changed America* (New York: Atlantic Monthly Press, 2003).

121 It all led to a convergence: the garment district covered approximately a square mile, between Thirty-Fourth and Forty-Second Streets and Fifth and Ninth Avenues. The fur district was located a little farther south, between Twenty-Seventh and Twenty-Ninth Streets and Seventh and Eighth Avenues.

121 "Could we take you on a tour": *Harper's Bazaar*, September 1, 1940, p. 43.

121 "merchants with knowledge in their fingers": ibid.

122 "I was always going up rusty staircases": Vreeland, *D.V.*, p. 109.

122 "I never wore clothes from Seventh Avenue myself": ibid.

122 "She began suggesting daring and successful ideas": Snow and Aswell, *The World of Carmel Snow*, pp. 124–25.

122 "I couldn't believe what I saw": Allure Manuscript, DVP, Box 35, Folder 2, p. 110.

123 "You never do anything unless you're asked": Allure Manuscript, DVP, Folder 2, pp. 96–97.

123 "I knew so little when I started": Vreeland, *D.V.*, p. 89.

123 "What do I want with a bloody old handbag": ibid.

124 'You mean you'd leave your *wife*': Vreeland, *D.V.*, p. 96.

125 Bettina Ballard remembered: Ballard, *In My Fashion*, p. 145.

125 "I'll never forget that afternoon": Vreeland, *D.V.*, p. 97.

125 In a bold move: see http://americanhistory.si.edu/archives/WIB-tour/dorothy_shaver.pdfBiB.

126 "This is the first issue of *Harper's Bazaar*," September 1, 1940, p. 40.

126 "You managed the impossible": Carmel Snow to DV August 8, 1940, DVP, Box 1, Folder 6.

126 "Skirt lengths are an atom shorter": *Harper's Bazaar*, September 1, 1940, p. 41.

127 The rise of American sportswear: Rebecca Arnold, *The American Look: Fashion, Sportswear, and the Image of Women in the 1930s and 1940s* (New York, I. B. Tauris, 2009), pp. 3–92 passim. I am indebted to June Weir for introducing me to this outstanding book.

127 It flattered the uncorseted female body: ibid., p. 17.

127 Diana took in some French jersey: Sally Kirkland on Claire McCardell in *American Fashion: The Life and Times of Adrian, Mainbocher, McCardell, Norell, Trigère*, ed. Sarah Tomerlin Lee (New York: Quadrangle/ The New York Times Book Co., 1975), p. 232.

128 her creativity and inventiveness broke through: McCardell returned to the United States with noncouture ideas as well, such as the dirndl skirt, big buckles, and leather straps copied from European 1930s skiwear, which she adapted for American coats and jackets, developing a philosophy of "fashion is where you find it" very similar to Diana's own. She felt passionately that "I belong to a mass-production country where any of us, all of us, deserve the right to good fashion and where fashion should be made available to us all." Quoted in Kohle Yohannan and Nancy Nolf, *Claire McCardell: Redefining Modernism* (New York: Harry N. Abrams, 1998), p. 98.

128 "Please don't be modest": Sally Kirkland to DV, DVP, Box 4, Folder 1. Sally Kirkland's work on Clare McCardell eventually appeared as a chapter in *American Fashion: The Life and Times of Adrian, Mainbocher, McCardell, Norell, Trigère*, ed. Sarah Tomerlin Lee. (New York: Quadrangle/The New York Times Book Co., 1975), pp. 209–314.

130 an all-female world: much of the workforce in New York's fashion industry was already female by the 1930s but concentrated at its humbler end. In the late nineteenth century, in common with other industries that were rapidly mechanizing, skilled men were replaced by semiskilled women capable of learning particular functions and prepared to work for less, increasing the profits of male manufacturers. This pattern was replicated on the retail side, with shopgirls clustered in the lower ranks and men owning the stores.

130 "Probably about the best paid of all women's jobs": *Harper's Bazaar*, "How to Get Into The Fashion Business," August 1939, p. 51.

131 "you were the person I always worked the closest with": DV to Marjorie Griswold, May 2, 1972, DVP, Box 3, Folder 6.

131 "making a great effort to learn photography": quoted in Rowlands, *A Dash of Daring*, p. 207.

131 his lover and protégé Horst Paul Albert Bohrmann: Horst became a naturalized American in 1943, when he abandoned his surname and chose to be sworn in as Horst P. Horst.

131 "We had the best time": quoted in Vicki Goldberg and Nan Richardson, *Louise Dahl-Wolfe* (New York: Harry N. Abrams, 2000), p. 28.

131 "Dahl-Wolfe freed color": ibid., p. 4.

132 "One was never selfish": ibid., p. 7.

132 "She was the tops": ibid., p. 30.

132 "There'd be big rows": Babs Simpson to Calvin Tomkins, Tomkins II.A.108, MoMA Archives, N.Y., p. 15.

132 asking the manufacturer to change a piece: Rowlands, *A Dash of Daring*, p. 210.

132 "Sometimes you'd get [these clothes]": Goldberg and Richardson, *Louise Dahl-Wolfe*, p. 30.

133 "Dahl-Wolfe's use of color": Arnold, *The American Look*, p. 160.

133 Jay Thorpe slacks: Jay Thorpe was an exclusive fashion store on West 57th Street with its own custom-made department and a team of in-house designers.

133 a new American body: see introduction by Valerie Steele, *Claire McCardell*, p. 12.

134 "I was scared to death": Lauren Bacall, *By Myself and Then Some* (New York: HarperEntertainment, 2005), p. 72.

134 "Mrs. Wolfe was there—and Mrs. Vreeland": ibid., p. 73.

134 "I remember going into Diana Vreeland's room": ibid., p. 75.

135 "We were staying in a ninth-rate hotel": Allure Manuscript, DVP, Box 35, Folder 2, p. 120.

135 "Talk of acting": Bacall, *By Myself and Then Some*, pp. 75–76.

135 "Betty's always been": Allure Manuscript, DVP, Box 35, Folder 2, pp. 118–19.

136 "This is the little girl": Allure Manuscript, DVP, Box 35, Folder 2, p. 128.

136 "She was in her glory": Babs Simpson to Calvin Tomkins, Tomkins II.A.108, MoMa Archives, N.Y., p. 9.

136 *Lady in the Dark*: see Bruce D. McClung's account in *Lady in the Dark: Biography of a Musical* (New York: Oxford University Press, 2007), chap. 1, "Opening Night," pp. 5–34, passim.

138 "Is she good looking?": Allure Manuscript, DVP, Box 35, Folder 2, p. 125.

138 "After I went to work": Vreeland, *D.V.*, p. 90.

139 "Everything is this color around here": DVP, Box 52, Folder 1.

139 "While it looked nothing more": Phyllis Lee Levin, *The Wheels of Fashion* (New York: Oxford University Press, 2007), p. 114.

140 "I *did* love it so much there": Emi-Lu Kinloch, later Astor, to DV, June 1, 1947, DVP, Box 34, Folder 1.

141 "You don't know what it was for a mother": Allure Manuscript, DVP, Box 35, Folder 2, pp. 118–19.

141 "During the War years": Allure Manuscript, DVP, Box 35, p. 93.

141 "They had no exaltation": Allure Manuscript, DVP, Box 35, Folder 2, p. 117.

141 "Can a duck swim?": a favorite expression, but in this instance from Allure Manuscript, DVP, Box 35, Folder 2, p. 129.

141 "He was there for seven years": Allure Manuscript, DVP, Box 35, Folder 2, p. 109.

142 "*One morning, I said 'Betty'*": Allure Manuscript, DVP, Box 35, Folder 2, p. 129.

CHAPTER FIVE: NEW LOOK

143 "I've never taken any side": Weymouth, "A Question of Style," p. 43.

143 "I was no more willing": Snow and Aswell, *The World of Carmel Snow*, p. 145.

144 "Why brilliant fashion-designers": Eric Hobsbawm, *The Age of Extremes: The Short Twentieth Century, 1914–1991* (London: Abacus, 1994), p. 178.

144 a different, more curvaceous silhouette: Arnold, *The American Look*, pp. 173 and 175.

144 "There is no other way": Alexandra Palmer, *Dior: A New Look, A New Enterprise (1947–57)* (London: V&A, 2009), p. 22.

145 "It's quite a revolution": quoted in Rowlands, *A Dash of Daring*, p. 365. Rowlands notes that Carmel Snow said, "This changes everything," though it is not clear whether she used the phrase "the New Look" at the show or later.

145 "I remember *everybody* being so excited": Babs Simpson to Calvin Tomkins, Tomkins II.A.108, MoMA Archives, N.Y., p. 12.

145 "Carmel, it's divine!": quoted in Rowlands, *A Dash of Daring*, p. 369.

145 "Dior saved Paris": Snow and Aswell, *The World of Carmel Snow*, p. 158.

145 "I always call it the guinea hen look": Weymouth, "A Question of Style," p. 48.

146 "Oh I couldn't stand [the clothes] for myself": ibid. The extent to which the New Look suited well-to-do American women more generally was also controversial.

146 "The first thing I asked": Vreeland, *D.V.*, p. 115.

146 "*Of course I look at all of these clothes*": DV to Louise Dahl-Wolfe, September 7, 1951, Louise Dahl-Wolfe Archive, Center for Creative Photography, Tucson, AZ.

147 "You Can't Be A Last-Year Girl": *Harper's Bazaar*, August 1947, p. 95.

147 "Every woman has a waist": *Harper's Bazaar*, September 1947, p. 184.

147 the whole country was in transition: *Harper's Bazaar*, "Anxious Women," October 1946, pp. 203–5.

148 "Look at you": Dwight, *Diana Vreeland*, p. 69.

148 "Reed was always about to make a million dollars": quoted in Kornbluth, "The Empress of Clothes," p. 33.

149 "Diana Vreeland's home": Levin, *The Wheels of Fashion*, p. 113.

149 "I always *looked* rich": Allure Manuscript, DVP, Box 35, Folder 3.

150 "looking as though they had come out of some other world": Billy Baldwin, *Billy Baldwin: an Autobiography* (Boston: Little, Brown, 1985), p. 242.

150 "He was never withered": Allure Manuscript, DVP, Box 35, Folder 1, p. 34.

150 "It must be understood": Baldwin, *An Autobiography*, p. 241.

151 "Geneva isn't inspirational": Elizabeth Vreeland to DV, DVP, Box 32, Folder 1.

152 "Any number of contemporary critics": Beaton, *Glass of Fashion*, p. 2.

152 an affectionate portrait of Diana: Beaton, *Glass of Fashion*, pp. 311–15.

152 "The main point of this letter": Elizabeth Vreeland to DV, DVP, Box 32, Folder 5.

153 "almost an entire winter": Baldwin: *An Autobiography*, p. 244.

153 "Diana attacked the whole apartment": ibid, pp. 244–45.

153 "I raced home": Billy Baldwin, *Billy Baldwin Remembers* (New York: Harcourt Brace Jovanovich, 1974), p. 136.

154 "In it were the most beautifully made shelves": Baldwin: *An Autobiography*, pp. 248–49.

154 "red carpets, red lacquered doors": quoted in Paige Rense (ed.), *Celebrity Homes: Architectural Digest Presents the Private Worlds of Thirty International Personalities* (New York: Penguin, 1979), p. 183.

154 "Piero della Francesca rubs shoulders": Beaton, *Glass of Fashion*, p. 314.

154 "I don't want you to show me one Chippendale chair": Baldwin, *An Autobiography*, p. 245.

155 world of "Va-va" and "Mona" and "the Engelhards": New York society figure Count Va-Va Adlerberg was from "the Swedish side of a White Russian family," according to Diana; Harrison Williams died in 1953, whereupon "Mona" married her longstanding gay companion, "Eddie" von Bismarck and became widely known as Mona Bismarck; the "Engelhards" were the American billionaire mining and minerals tycoon Charles W. Engelhard Jr, and his second wife Jane whom he married in 1947.

155 "outrageous, individual": see Carrie Donovan, *New York Times*, March 28, 1962.

156 Brodovitch's classes at the New School: alongside his work at *Harper's Bazaar*, Brodovitch continued to give classes at the New School in New

York, educating a generation of designers, illustrators, art directors, and photographers in European design, and revolutionizing American graphic design through his influence.

156 "I knew that in Richard Avedon": Snow and Aswell, *The World of Carmel Snow*, p. 155.

156 a new supplementary publication: *Junior Bazaar* was dreamed up by Snow as a way of matching Seventh Avenue advertising to the clothes budgets of affluent young college women. She also used *Junior Bazaar* as a proving ground for much new postwar talent, including art director and photographer Lillian Bassman.

156 "Mrs. Vreeland never looked at me": from Richard Avedon's eulogy at Diana's memorial service, 1989, reprinted here by permission of RAF and in Martin and Koda, *Diana Vreeland: Immoderate Style*, looseleaf.

157 "Boy was I lucky": Richard Avedon in "Richard Avedon: Darkness and Light," directed by Helen Whitney, *American Masters Series*, (PBS), 1996.

157 "It was a three-way vote": Richard Avedon to Calvin Tomkins, Tomkins II.A.108. MoMA Archives, N.Y., p. 4.

157 'A.G.' was pronounced "Agi."

157 "It was a triumvirate": A G. Allen to Dodie Kazanjian, Tomkins II.A.108. MoMA Archives, N.Y., p. 3.

157 "They had each found their look": ibid., p. 9.

157 "Unmarred by a hat": Ballard, *In My Fashion*, p. 285. When actress Ali MacGraw worked for *Bazaar* for a few months in the early 1960s, Diana's look had still scarcely changed at all: "Day after day she looked exactly the same: little black sweater and black Mainbocher skirt, funny little handmade black T-strap pumps, hair so black that it was nearly navy-blue, and a gold wedding ring on a hand whose nails were perfectly manicured a brilliant scarlet, matching her huge mouth." Ali MacGraw, *Moving Pictures* (New York: Bantam Books, 1991), p. 49.

158 "Anyone who had any contact": quoted in Diana DuBois, *In Her Sister's Shadow: An Intimate Biography of Lee Radziwill* (Boston: Little, Brown, 1995), p. 58.

158 "I learned to 'see' ": MacGraw, *Moving Pictures,* p. 49.

158 "D. D. Ryan worshipped her": D. D. Ryan started her career as assistant to Richard Avedon, and as photo editor on *Harper's Bazaar* as Dorinda Dixon Prest.

159 "To Diana Vreeland, I was 'Girl' ": MacGraw, *Moving Pictures,* p. 48.

159 Snow understood and transferred her without comment: Rowlands, *A Dash of Daring,* p. 458.

159 "Once Diana was hooked on a shade of orange": Diana DuBois, *In Her Sister's Shadow,* p. 59.

159 "She was really a wonderful catalyst": Richard Avedon to Calvin Tomkins, interviewed for *Alex: The Life of Alexander Liberman,* Tomkins II.A.108. MoMA Archives, N.Y. p. 4.

160 "Cleopatra was 'the kitten of the nile' ": letter from DV to Richard Avedon with cc Gloria Schiff, "Re: Cleopatra," November 9, 1961, The Richard Avedon Foundation archive, New York.

160 "She just sort of threw your way of thinking": Richard Avedon in "Richard Avedon: Darkness and Light."

160 "She was without exception": From Richard Avedon's eulogy at Diana's memorial service, 1989.

160 "You think, of all the nonsense in the world": Baldwin, *An Autobiography*, p. 243.

161 "Monsieur Balenciaga *likes* a little tummy": quoted in Valerie Steele, *Fifty Years of Fashion: New Look to Now* (New Haven: Yale University Press, 1997), p. 24.

161 "It was a satisfaction": Snow and Aswell, *The World of Carmel Snow*, p. 172.

162 "It was always very interesting to me": A. G. Allen to Amanda Mackenzie Stuart and to Dodie Kazanjian, Tomkins, II.A.108. MoMA Archives, N.Y., p. 9.

162 did in fact 'gnaw'" at Diana: Richard Avedon to Calvin Tomkins, Tomkins, II.A.108. MoMA Archives, N.Y., p.3.

162 "In a curious way": Vreeland, *D.V.*, p. 121.

162 "How can you work in this confusion" Ballard, *In My Fashion*, p. 288.

163 "*the best* in every field": Snow and Aswell, *The World of Carmel Snow*, p. 172.

163 "Wise Men, or Disraeli": Ballard, *In My Fashion*, p. 284.

163 "Diana was not then in the habit": Bill Blass, *Bare Blass* (New York: HarperCollins, 2002), p. 28.

164 Diana was known to go back to advertisers: see Rowlands, *A Dash of Daring*, p. 417.

164 "She does not indulge in cruelty": Baldwin, *An Autobiography*, p. 243.

165 "My dear": quoted in Ballard, *In My Fashion*, p. 284.

165 "You must always give ideas away": Kenneth Jay Lane, *Faking It* (New York: Harry N. Abrams, 1996), p. 117.

165 he built a very good business: Vreeland, *D.V.*, p. 111.

165 "took care of women's hands just for *love*": Vreeland, *D.V.*, p. 112.

165 "I . . . knew that *he* knew that I knew": Vreeland, *D.V.*, p. 113.

166 "You know in the whole city of New York": Lane, *Faking It*, p. 116.

166 "Yes! *Daunkey*": ibid., p. 117.

166 "There's never been a blue like the blue of the Duke of Windsor's eyes": Vreeland, *D.V.*, pp. 103–106.

166 "Last night we went to the Russian Tea Room": Lane, *Faking It*, p. 117.

166 "eyes far off": Ballard, *In My Fashion*, p. 287.

167 "With pure Dianaism": ibid.

168 "There is at this moment": Elizabeth Vreeland to Diana Vreeland, May 1956, DVP, Box 32, Folder 9.

169 language captured by *Bazaar*'s copywriters: *Harper's Bazaar*, misc., 1956–59.

170 "One doesn't talk to Maggie Prescott": *Funny Face*, directed by Stanley Donen, Paramount Pictures, 1957.

170 "Mrs. Vreeland marched out": quoted in Rowlands, *A Dash of Daring*, p. 460.

170 "I'm too real for teasing": to Leo Lerman on February 26, 1984, *The Grand Surprise: The Journals of Leo Lerman* (New York: Alfred A. Knopf, 2007), p. 502.

170 "The inevitable was coming": Rowlands, *A Dash of Daring*, p. 457.

170 "She had bones showing": quoted in ibid., p. 451.

170 "She was pickled in alcohol": ibid., pp. 451 and 462.

171 "faceless Freddy": nicknamed thus by Hearst because Bérard often sketched people without their faces.

171 "The time that followed": Rowlands, *A Dash of Daring*, p. 466.

172 "When Mrs. Snow got the word": quoted in ibid., p. 465.

172 "She was impossible with advertisers": ibid.

172 "We needed an artist and they sent us a housepainter": quoted in Calvin Tomkins, "The World of Carmel Snow," p. 158.

173 "She's . . . open minded": unattributed note, "Diana Vreeland, RE: Nancy White," undated (The Richard Avedon Foundation archive, New York).

173 "I am slowly, I believe": DV to Cecil Beaton, PCB, June 27, 1958.

173 "Vreeland had this annoying posture": Melvin Sokolsky, *Seeing Fashion*, with text by Martin Harrison (Santa Fe, NM: Arena Editions, 2000), p. 16.

173 she wanted the green of a billiard table: there are many different versions of this story, including Diana's own account in *D.V.*, pp. 105–6. She thought the story was apocryphal and that if it happened at all it involved a photographer, not Henry Wolf.

174 "If her husband reaches the White House": quoted in Hamish Bowles, *Jacqueline Kennedy: the White House Years* (New York: Metropolitan Museum of Art; Boston: Bullfinch Press, 2001), p. 37.

174 In July 1960 Fairchild proclaimed: ibid, p. 27.

174 "I buy most of my clothes off the racks": ibid.

175 "I must start to buy American clothes": quoted in ibid. p.28. Apart from this one, all letters to DV from Jacqueline Kennedy quoted in this chapter are in DVP, Box 18, Folders 27–30. Jacqueline Kennedy's letters to Diana were often written in great haste on yellow lined paper, with many dashes, missing apostrophes and '+' for an ampersand. In these transcriptions the apostrophes have been left off as written, but the ampersands restored.

176 Hamish Bowles points out: Hamish Bowles is currently international editor-at-large for *Vogue*, and an authority on design and couture. In addition to writing a number of books on fashion, designers, and *Vogue*, he

has curated a number of fashion exhibitions including *Jacqueline Kennedy: the White House Years* at the Metropolitan Museum of Art, New York, to which this passage is indebted.

176 "line for line copy": Bowles, *Jacqueline Kennedy*, p. 29.

177 "Cassini approached each project": ibid., p. 31.

178 "Now I know how poor Jack feels": quoted in Oleg Cassini, *In My Own Fashion: an Autobiography* (New York: Simon and Schuster, 1987), p. 308.

179 "I think the chances of an increase": DVP, Box 1, Folder 9.

179 Diana was furious: this version of her reaction from Weymouth, "A Question of Style," p. 49.

180 The Hearst organization dripped with tears: for these and other reactions see DVP, Box 1, Folder 13.

CHAPTER SIX: YOUTHQUAKE

181 "Suddenly a rumour was buzzing": Nicholas Haslam, *Redeeming Features: A Memoir* (London: Jonathan Cape, 2009), p. 171.

181 "It was said that her maid": Grace Mirabella, *In and Out of Vogue* (New York: Doubleday, 1995), p. 103.

182 "He had a great gift": former travel editor Despina Messinesi, quoted in Francine du Plessix Gray, *Them: A Memoir of Parents* (New York: Penguin—2005), p. 258.

182 a Jekyll and Hyde character: see, for instance, ibid. pp. 405–409.

183 "We had to touch out navels": Haslam, *Redeeming Features*, p. 172.

183 she was mystifyingly badly dressed: sometimes Daves's forgetfulness about what she was wearing was remarkable by any standard, let alone in the world of fashion. "Jessica used to absentmindedly chew canapés through the veils of the little black hats she always wore, creating a gooey mess of tuna fish or chopped liver, her hat gradually descending upon her face until she realized her gaffe and ran into the nearest bathroom, moaning, to clean up," writes Gray, *Them*, p. 329.

183 "NO to a skirt": *Vogue*, March 15, 1962, p. 93.

183 "She believed in elegance": Valentine Lawford, *Horst: His Work and His World* (Harmondsworth: Viking, 1985), p. 112.

184 "the sort of woman": *Vogue*, October 15, 1961, p. 112.

184 "You've cased the collections": ibid., p. 75.

184 "We have thought of you so much": Elizabeth Vreeland to DV, April 14, 1962, DVP, Box 32, Folder 10.

185 "I worried that you with your birdlike legerté": quoted in Dwight, *Diana Vreeland*, p. 127.

185 "My goodness we are so proud": Elizabeth Vreeland to DV, DVP, Box 32, Folder 6.

185 "What is fashion?": DVP, Box 7, Folder 13. offprint dated November 20, 1962.

186 "*My God, when I think of my years*": Allure Manuscript, DVP, Box 35, Folder 2, p. 151.

187 "Diana Vreeland didn't just sweep": Mirabella, *In and Out of Vogue,* p. 103.

187 "The steam started coming out of my ears": quoted in Dodie Kazanjian and Calvin Tomkins, *Alex: The Life of Alexander Liberman* (New York: Alfred A. Knopf, 1993), p. 237.

188 "My mind drifts around a lot": Allure Manuscript, DVP, Box 35, Folder 2, p. 151.

188 "Whereas the entire chain": Mirabella, *In and Out of Vogue*, p. 116.

188 "Sometimes she paid attention": Carol Phillips to DK, DKP, p. 12.

188 "At my first run-through": Mirabella, *In and Out of Vogue*, pp. 107–8.

189 "Her tastes were as aristocratic": ibid., p. 108.

189 "It seemed the perfect antidote": ibid., pp. 110–13, passim.

190 "From the moment she came to *Vogue*": *Vogue*, December 1989, p. 307.

191 "We are talking about a snake pit": comment from someone who prefers to remain anonymous.

192 "Editing is four walls of work": Levin, *The Wheels of Fashion*, p. 106.

192 "Those were terrible pictures": Hugo Vickers, ed. *Beaton in the Sixties: More Unexpurgated Diaries* (London: Weidenfeld & Nicolson, 2003), p. 205.

192 "*At* Vogue *I was what you might call an enfant terrible*": Vreeland, *Allure*, p. 134.

193 "free-wheeling school of collectors": *Vogue*, August 1, 1962, pp. 66–76.

194 "*In this stillness*": *Vogue*, January 1, 1963, p. 77.

195 "*The image she presents*": *Vogue*, August 1, 1964, p. 43.

196 "A funny thing has happened": ibid., p. 93.

196 "What fires his imagination": *Vogue*, June 1, 1964. p. 68.

196 "Chanel started it": *Vogue*, January 15, 1965, p. 45.

196 "Isn't that life": Weymouth, "A Question of Style," p. 54.

197 "Being from Lancashire himself": Haslam, *Redeeming Features*, p. 173.

198 "No one knew more about fashion": Jean Shrimpton, *Jean Shrimpton: An Autobiography* (London: Sphere Books Ltd., 1991), p. 84.

198 "I think we are frightfully missing": memo to Allene Talmey, n.d. but probably early 1964, DVP, Box 3, Folder 2.

198 "To women, Jagger looks fascinating": *Vogue*, July 1, 1964, p. 73.

198 "I've known two great decades": "Jet Setting," DVP, Box 3, Folder 3.

199 "against everything expected of them": *Vogue*, August 1, 1963, p. 75.

200 "I didn't go much for this street-up business": Weymouth, "A Question of Style," p. 51.

200 "*That* was something": Vreeland, *D.V.*, p. 150.

201 "It's possible to feel on your cheek": *Vogue*, January 1, 1963, p. 77.

201 "I blurted out": Haslam, *Redeeming Features*, p. 174.

202 "Aside from new topics": *Vogue*, September 1, 1964, pp. 60, 82, 83, 100.

202 "There is a marvellous moment": *Vogue*, January 1, 1965, p. 112.

203 "Now the body itself": *Vogue*, January 1, 1965, p. 76.

203 "the body that *is* fashion": *Vogue*, January 1, 1965, p. 73.

204 liberating women from unnatural permanents: though in reality many women still had to make frequent visits to the hair salon to have their hair straightened, blow-dried, and trimmed incessantly to keep the new geometric shapes.

204 "As I walked into her office": Vidal Sassoon, *Vidal: The Autobiography*, (Basingstoke: Macmillan, 2010), p. 171.

205 "the spy system was incredible": R. Avedon to DK, DKP, p. 13. Letters in the Richard Avedon Foundation files suggest that it was known he would make the move by November 1965. He wrote to one friend on December 16, 1965, that he did not have time to meet her in Paris because he was saying good-bye to people and trying to stick to a list of *Vogue* priorities.

205 revolutionizing the distance between photographer and model: see Jane Mulvagh, *Vogue History of 20th Century Fashion* (London: Bloomsbury Books, 1992), p. 240.

206 "I had this baby face": Vera Lehndorff and David Wills, *Veruschka* (New York: Assouline, 2008), p. 12.

206 " 'Vera' was not the person": ibid., p. 12.

207 "Our sessions together were very intense": ibid., p. 22.

207 "What Antonioni was saying": ibid.

207 "Veruschka's bones, her body": ibid., pp. 5–7. By permission of RAF. Richard Avedon's observations on Veruschka first appeared in "Veruschka is the Most Beautiful Woman in the World" in *Vogue*, June 1972.

207 "Veruschka is the only woman": ibid., pp. 6–7. By permission of RAF.

208 "the land of Style": See Holly Brubach, tmagazine.blogs.nytimes.com 2010/02/12.

208 "He made hair expressive": ibid.

208 "Some of the conditions were very harsh": quoted in David Wills, *Ara Gallant* (Bologna: Damiani, 2010), p. 129.

208 "I said to Mrs. Vreeland": Martin and Koda, *Diana Vreeland: Immoderate Style*, looseleaf.

208 a hallucinogenic fashion spread: *Vogue*, October 15, 1966, pp. 88–175.

209 "a Heian beauty": in Japanese history, the Heian period ran from 794 to 1185, when the Imperial capital was based at Heian-kyo, modern day Kyoto.

210 "She has the concentration of a child": Lehndorff and Wills, *Veruschka*, p. 5. By permission of RAF.

210 "There are times during a sitting": ibid., p. 7. By permission of RAF.

210 "It's without content": Richard Avedon to DK, DKP, p. 16.

210 "You looked like a victim": DV to Veruschka, DVP, Box 9, Folder 5.

211 "Jets were brand new": Allure Manuscript, DVP, Box 35, Folder 2, p. 151.

211 "All over the world": "Jet Setting," DVP, Box 3, Folder 3.

211 "Flaunting bare feet and legs": Valerie Steele, *Fashion, Italian Style* (New York: Fashion Institute of Technology), 2003, p. 27.

212 "an oasis of high style": ibid., p. 36.

212 Diana appointed Consuelo Crespi: Countess Consuelo Crespi (1928–2010) was twin sister of Gloria Schiff, and a New York model before she married Count Rodolfo Crespi in 1948. An elegant society figure, she became an important tastemaker in her own right as a fashion PR and editor of Italian *Vogue*, with considerable impact on the careers of Italian couturiers such as Fendi, Missoni, and Valentino.

212 "India has given a new freedom": *Vogue*, December 1, 1964, p. 195. The article ran on pp. 194–215, 277–80, and 282–85.

213 "Vreeland made fashion out of her dreams": Mirabella, *In and Out of Vogue*, p. 117.

213 "The impressionable manufacturers are wooed": Marilyn Bender, *Beautiful People: A Candid Examination of a Cultural Phenomenon—the Marriage of Fashion and Society in the 60's* (New York: Coward-McCann, 1967), pp. 215–16.

214 "The East drew them": quoted in Anne Boston, *Lesley Blanch: Inner Landscapes, Wilder Shores* (London: John Murray, 2010), p. 120.

214 "*Wilder Shores* opened up far horizons": ibid., p. 121.

214 "At last I have visited your Liotards": Elizabeth Vreeland, postcard of a Liotard to DV, March 1956, DVP, Box 32, Folder 6.

214 "my complete inspiration": DV, *Vogue* memo, April 15, 1965, DVP, Box 6, Folder 11.

215 "in the East": Lesley Blanch quoting Gérard de Nerval in *Vogue*, April 15, 1965, p. 107.

215 "it follows that both the home and the woman": ibid., p. 111.

215 "You will notice": DV, *Vogue* memo, April 15, 1965, DVP, Box 6, Folder 11.

215 "to charm the sheik at home": *Vogue*, April 15, 1965, p. 101.

215 In 1964 Freck was posted to Rabat: he eventually became Deputy Assistant Secretary of State for the Near East (1991–92) and then U.S. Ambassador to Morocco (1992–93) by which time he had ceased all contact with the CIA.

215 "Women relaxing into caftans": *Vogue*, July 1, 1966, p. 67.

216 "All float, nothing static": *Vogue*, September 15, 1966, p. 330.

216 "She was the first editor to say to me": Alexander Liberman to DK, DKP.

216 "You have no idea": Allure Manuscript, DVP, Box 35, Folder 2, pp. 151 and 152.

216 seeing the vaudeville performer Joe Frisco on a train: Vreeland, *D.V.*, p. 153.

216 "'Use all the Dynel you want'": Norman Parkinson, *Lifework* (London: Weidenfeld & Nicolson, 1983), p. 112.

217 "For inspiration Mrs. Vreeland showed me an 18th century French picture": quoted in Amy Fine Collins, "It Had to Be Kenneth," *Vanity Fair,* June 2003, p. 153.

217 "I was in the middle of my Dynel period then": Vreeland, *D.V.,* pp. 153–54.

217 In Parkinson's version of what happened next: Parkinson, *Lifework.* p. 113.

217 "Now, apparently, if you go near a certain part of the anatomy": Vreeland, *D.V.,* p. 152.

218 "hadn't seen a lady in eight years": quoted in Collins, "It Had to Be Kenneth," p. 153.

218 "Mrs. Vreeland was always in there": Parkinson, *Lifework,* p. 114.

218 "creative and warm-hearted human beings": Horst and Valentine Lawford, *Vogue's Book of Houses, Gardens, People* (London: The Bodley Head, 1968), introduction by Diana Vreeland, p. i.

219 all the costs of running the apartment: Discovery Proceeding, In the Matter of the Application of Fiduciary Trust Company of New York as executor of the Last Will and Testament of T. Reed Vreeland, Surrogate's Court: County of New York, February 27, 1968, testimony of Madeleine E. Wilson, pp. 14–16.

219 "It's always been men with feminine streaks": Allure Manuscript, DVP, Box 35, Folder 3.

220 "A highly emotional French lady": Vreeland, *D.V.,* pp. 163–64.

220 "Woman should be a creature": Florence Pritchett Smith, *These Entertaining People* (New York: Macmillan, 1966), p. 1.

220 "Arrange a quiet room": Florence Pritchett Smith, *These Entertaining People,* pp. 50-51.

221 *I said, 'What do you take my husband for':* Vreeland, *D.V.,* p. 169.

222 "Reed died loving Yvonne more than anything": Allure Manuscript, DVP, Box 35, Folder 2, p. 169.

222 "The terrible thing was": ibid.

<center>CHAPTER SEVEN: WILDER SHORES</center>

223 "She was so brave": Carol Phillips to DK, DKP, p. 13.

223 "She was the wife": Weymouth, "A Question of Style," p. 54.

223 "Some may see Charles Engelhard": Vickers, *Beaton in the Sixties,* p. 205.

224 "the fantasy of foreign lands": FIT exhibition, 2009.

225 "Astonishingly friendly": Blass, *Bare Blass,* p. 95. Nicholas Haslam also remembered Reed's kindness: "You'd be feeling uncomfortable at some rather grand and intimidating party—and then you'd see Reed winking at you across the room."

225 "Those were the evenings I loved most with her": Blass, *Bare Blass,* p. 95.

225 "She never had a sense of time": ibid.

225 a "knuckle sandwich": ibid., p. 58.

225 *"She was an amalgam of stories"*: ibid., p. 96.

227 boutique design: "Quant sold well in New York, Tuffin & Foale was stocked in Paraphernalia, Betsey Johnson was available in Bazaar. In London Barbara Hulanicki opened a new boutique called Biba, a treasure chest of the new romanticism. In Paris Khanh was designing for the ready-to-wear house Cacharel, and the nautical theme launched by Saint Laurent in the spring—reefer coats, more pea jackets, bell-bottom trousers, and T-shirt dresses—was copied for the ready-to-wear by Bagatel." Mulvagh, *Vogue History of Twentieth-Century Fashion*, p. 291.

229 "kind of fashion American women live in": *Vogue*, May 1, 1967, p. 198.

229 a wider process of liberalization: see Alan Petigny, *The Permissive Society: America, 1941–1965*, (New York: Cambridge University Press, 2009), p. 282.

229 "On the whole, fashion had become less a matter of designer diktat": Valerie Mendes and Amy de la Haye, *20th Century Fashion* (London: Thames & Hudson, 1999), p. 192.

229 "It's your show": *Vogue*, July 1968, p. 35.

229 "You take the most discreet black sweater": ibid.

230 "Invent yourself": *Vogue*, January 1, 1969, p. 79.

230 "I was saved by the 60s": Richard Avedon to DK, DKP, p. 16.

230 "The girl herself is the extravaganza": *Vogue*, March 15, 1967, p. 63.

230 "a broad": Richard Avedon to DK, DKP, p. 16.

230 a stepfather who wanted her out of the house : interview in *Venice Magazine*, November 2007/http://thehollywoodinterview.blogspot.com.

231 "You. You have quite a presence": Derek Blasberg, *Harper's Bazaar*, January 13, 2011. www.harpersbazaar.com.

232 Truman Capote's Black and White Ball: Diana's invitation to Truman Capote's Black and White Ball was, of course, never in doubt, though reports vary as to how long she was there, with at least one friend insisting that she slipped away after the Trees' dinner party and never went at all because she missed Reed so badly that evening. Ostensibly thrown by Capote to celebrate the success of *In Cold Blood*, he turned the ball into one of New York's great who's-in-who's-out events. He changed the guest list incessantly, making, as he later said, five hundred friends and fifteen hundred enemies.

232 "She was gawky": quoted in Kennedy Fraser, introd. *On the Edge: Images from 100 Years of Vogue* (New York: Random House), 1992, p. 148.

232 "I am really fascinated by how beautifully built she is": memo from Diana Vreeland to Richard Avedon with cc. Polly Mellen. "RE: Penelope Tree." June 12, 1967 (The Richard Avedon Foundation archive, New York).

232 "She projects the spirit of the hour": *Vogue*, October 1, 1967, p. 163.

233 "Penelope Tree is the girl of her dreams": *Vogue*, January 15, 1968, p. 38.

233 Tree's upbringing was almost as unhappy as Diana's: Louise France, interview with Penelope Tree: "People thought I was a freak; I kind of liked that," *The Observer*, August 3, 2008.

234 "The call from Vreeland": Twiggy Lawson, *Twiggy in Black and White* (London: Simon & Schuster, 1997), p. 68.

234 Mona Bismarck: Mona Harrison Williams married her long-standing gay friend Count Edward von Bismarck, known as Eddie, after the death of Harrison Williams in 1953.

234 "Mona didn't come out of her room": quoted in Lesley Ellis Miller, *Cristóbal Balenciaga: The Couturiers' Couturier* (London: V&A, 2007), p. 87.

235 Diana dispatched Veruschka: Diana, unusually, was with them in the North African desert in 1967 when Ara Gallant wove a colossal silver-and-green wig of Dynel braids around and around Veruschka's face for specially designed fashions by Strega. After that Diana trusted the team implicitly.

235 Exuberantly original, he liked to ornament the body: see Caroline Rennolds Milbank, *New York Fashion: The Evolution of American Style*, (New York: Harry N. Abrams, 1989), p. 231.

235 "We took fabrics, cords, tools, pins": Lehndorff and Wills, *Veruschka*, p.19.

235 "At some point, I fainted": ibid.

236 "There was a time": quoted in *Vogue*, August 1, 1966, p. 86.

236 "For [many] people": Petigny, *The Permissive Society*, p. 221.

236 "The fact is": See *Vogue*, May 1, 1967, p. 159.

237 "I think people who lunch don't work": DV to DK, DKP, p. 2.

238 Memos streamed in: the memos quoted here come from someone who prefers to remain anonymous, Grace Mirabella, *Visionaire 37: Vreeland Memos* (New York: Visionaire, 2001) (no page numbers) and DVP, Box 6, Folder 17. Several memos quoted here are duplicated across these sources.

238 "these pieces of hair dipped in salad oil": memo from Diana Vreeland to Richard Avedon, with cc Polly Mellen, July 14, 1967 (The Richard Avedon Foundation archive, New York).

239 "There are only a handful of magazines": Meriel McCooey, "Why don't you knit yourself a little skullcap?" *Sunday Times*, March 17, 1968.

241 "The Americans have created Viet Nam anew": *Vogue*, May 1, 1967, p. 260. The other two articles by FitzGerald appeared in the January 1, 1967, issue ("The Long Fear: Fresh Eyes On Viet Nam") and the February 1, 1967, issue ("The Power Set: The Fragile But Dominating Women of Viet Nam").

241 "Black nationalism was wonderful afros": Mirabella, *In and Out of Vogue*, p. 129.

241 "You read revolution in clothes": Weymouth, "A Question of Style," p. 49

241 "People Are Talking About": *Vogue*, June 1, 1965, p. 94.

242 "To roam the earth": *Vogue*, April 15, 1969, p. 52.

242 "You go your own way": *Vogue*, July 1, 1970, p. 51.

242 an exceptional wardrobe of couture clothes: an exhibition of ensembles and accessories from Mrs. Taylor's wardrobe, *Fashion Independent: The Original Style of Ann Bonfoey Taylor*, took place at the Phoenix Art Museum from February to May 2011.

242 "It's all very confusing": transcript of the conversation between DV and Mrs. Vernon Taylor, DVP, Box 6, Folder 2.

244 "Oh Betty Friedan": *Vogue*, March 15, 1966, pp. 92–93.

245 "I believe women are naturally dependent on men": Allure Manuscript, DVP, Box 35, Folder 3.

245 "The feminine side of *so many* men": Ibid.

245 "How free can you get?": Lieberson, "Empress of Fashion," p. 25.

245 "If that's the case, my dear": Allure Manuscript, DVP, Box 35, Folder 3.

246 "Rosemary, don't forget": telegram from DV to Rosemary Blackmon, "RE Accompanying text in March 15," February 2, 1968 (The Richard Avedon Foundation archive, New York).

246 "Pride of body": *Vogue*, September 15, 1967, p. 131.

247 "Nureyev, here in an agony of action": *Vogue*, December 1967, p. 210.

247 captured at a memorable shoot: the December 1967 spread contained photos of Nureyev by Richard Avedon from sittings in 1961/2 and 1967. Avedon took nude photographs of Nureyev at both of them. It is not clear when Diana visited the studio, but it was most unusual and more likely to have happened while she was still at *Bazaar* in 1961/2.

247 "You know how it is with men": Andrew Solomon, "Invitation to the Dance," *Vogue*, November 2007, p. 114.

247 "To me, the Pill was the turning point": Lieberson, "Empress of Fashion," p. 28.

248 changing female identiy: see, for instance, *Vogue*, January 1, 1967, pp. 128–33.

248 Women who saw sexual liberation differently: see Carolyn Bronstein, *Battling Pornography: The American Feminist Anti-Pornography Movement, 1976–1986* (New York: Cambridge University Press, 2011), pp. 30–31.

249 "Who's So Liberated?": *Vogue*, September 1, 1970, pp. 382, 383, 422, 423.

249 "the true impact of an unforgettable woman": ibid., p. 390.

250 "In my opinion in the year 2001": DVP, Box 6, Folder 17, and *Visionaire* 37, no page numbers.

251 "I mean [at *Vogue*], we're asked to help": transcript of the conversation between DV and Mrs. Vernon Taylor, DVP, Box 6, Folder 2.

251 "exacting in her facts and her purposes": *Vogue*, May 1, 1967, p. 174.

251 "They've been to the best schools": transcript of the conversation between DV and Mrs. Vernon Taylor, DVP, Box 6, Folder 2.

252 "She never wants to be first": ibid.

252 "can easily be compared": *Visionaire 37: Vreeland Memos.*

253 *Vogue*'s losses became catastrophic: midmarket magazines fared better, but *Bazaar* did badly too, with a drop of 37 percent.

253 "In a funny way": Carol Phillips to DK, DKP, p. 9.

254 *"Vogue* was high drama": Mirabella, *In and Out of Vogue*, p. 120.

254 "She should have taken more *care*, George": Diana to George Plimpton, Diana Vreeland Tapes, Tape 6.

254 "She wouldn't listen": Alexander Liberman to DK, DKP, p. 694.

254 "You never had any peace": Carrie Donovan to DK, DKP, p. 9.

255 "Inventing a look like . . . 'Scheherazade'": Mirabella, *In and Out of Vogue*, pp. 131–2.

255 "The next morning they found the Peruvian army waiting": ibid., p. 133.

255 'Oh, I know how to handle those boys': Carrie Donovan to DK, DKP, p. 9.

256 "*Her* world": quoted in *D.V.*, p. 173.

256 "I used to beg her": Mirabella, *In and Out of Vogue*, p. 138.

256 Alex and Si Newhouse: Alex Liberman and Samuel Irving Newhouse Jr. The latter, known as "Si," was son of the newspaper tycoon Samuel Irving Newhouse Sr. who bought Condé Nast Publications in 1959. Si Newhouse became Publisher of *Vogue* in 1964.

256 "whole sort of court of admirers": Alexander Liberman to DK, DKP, p. 692 and p. 852.

257 Avedon took a tough line: Richard Avedon to DK, DKP, pp. 15–16.

257 "Frankly, they're both very strong personalities": Alexander Liberman to DK, DKP, p. 852.

257 "I think it struck her as an efficiency": Carol Philips to DK, DKP, p. 13.

257 "She was given too much power": Kazanjian and Tomkins, *Alex*, p. 281

257 "were stronger than they should be": Alexander Liberman to DK, DKP, p. 884.

257 "The extremes of her taste": Alexander Liberman to DK, DKP, p. 691.

258 "I tell you the truth": Carol Phillips to DK, DKP, pp. 13–14.

259 "And we sat there": Si Newhouse to DK, DKP, p. 43.

259 "a yellow rat": Lerman, *The Grand Surprise*, p. 405.

260 "My recollection of Dianne": Si Newhouse to DK, DKP, p. 45.

260 A fashion editor should be "much, much younger": Babs Simpson to DK and to Amanda Mackenzie Stuart.

260 "She herself was becoming older": Mirabella, *In and Out of Vogue*, p. 129 and p. 138.

263 Rumors flew: Cecil Beaton was convinced that Margaret Case was "dreadfully upset at the sacking of Diana and the direction in which

Vogue was going, headed by a lot of ghastly go-getting animals" and that it sent her into a depression from which she never recovered. See Hugo Vickers, ed., *The Unexpurgated Beaton: The Cecil Beaton Diaries as They Were Written* (London: Weidenfeld & Nicolson, 2002), p. 195.

263 "ashamed and afraid": Mirabella, *In and Out of Vogue*, p. 141.

264 "I was so frightened I could hardly speak": Colin McDowell, *Manolo Blahnik* (New York: HarperCollins, 2000), p. 84. Manolo Blahnik was always grateful to Diana. He visited her at 550 Park Avenue whenever he was in New York and long after he became successful. However, he never quite got over his awe of her. "Don't be terrified! This isn't *Vogue* any more, you know," she was wont to say (McDowell, *Manolo Blahnik*. p. 86).

264 She continued to write memos: Grace Mirabella, *Visionaire 37: Vreeland Memos*, and DVP, Box 6, Folder 17. Again, memos quoted here are from more than one source.

264 "I am not proud": Mirabella, *In and Out of Vogue*, p. 141.

265 "This has been a very curious autumn": DVP, Box 5, Folder 2.

265 "ingenious, clever little bug": DV to Mr. and Mrs. Herbert Patterson, April 27, 1972, DVP, Box 4, Folder 21.

265 "To hear someone say that Diana Vreeland is a positive thinker": Lieberson, "Empress of Fashion," p. 28. Norman Vincent Peale was a preacher and author of *The Power of Positive Thinking*, which has sold millions of copies since its publication in 1952 and is still in print.

265 "It seems to be a long Valentino parade": DVP, Box 6, Folder 15. "Jackie, Audrey, and Babe" were, of course, Jacqueline Kennedy Onassis, Audrey Hepburn, and Babe Paley.

266 "I happen to have a very beautiful room": DV to Norman Norell, thanking him for "dozens of perfectly beautiful white roses," April 20, 1972, DVP, Box 4, Folder 17.

CHAPTER EIGHT: OLD CLOTHES

267 "moribund," "gray" and "dying": Thomas Hoving, *Making the Mummies Dance: Inside the Metropolitan Museum of Art* (New York: Simon & Schuster, 1993), p. 32.

267 He caused a stir: ibid., p. 275.

268 he hired . . . Eleanor Lambert: ibid., p. 49.

268 He soon discovered that this was not a good idea: ibid., p. 133.

269 "He came to see me": Vreeland, *D.V.*, p. 175.

269 a group of Diana's most powerful friends: DVP, Box 11, Folder 6.

270 all Diana's friends who agreed to support her paid up: ibid.

270 For all this she would receive: ibid.

270 "I have been rebuilding my life": DVP, Box 4, Folder 7.

270 "I am ecstatically happy": DVP, Box 10, Folders 4.

270 "Life is a fine performance": Diana"s engagement diary, August 13, 1972, DVP, Box 48, Folder 3.

271 As she recollected the affair: DVP, Box 14, Folder 3.

271 "It was like a small court": Hugo Vickers, *Behind Closed Doors: The Tragic Untold Story of the Duchess of Windsor* (London: Hutchinson, 2011), p. 45.

272 "Please forgive me tracking you down": DVP, Box 12, Folder 2.

273 "Please Pauline do not be bored": DVP, Box 12, Folder 2.

273 "Everyone loves and adores Balenciaga": DV to Cecil Beaton, October 6, 1972, DVP, Box 12, Folder 2.

274 "I am now beginning to wonder": ibid.

274 "Things moving very slowly in Europe": DVP, Box 10, Folder 4.

274 a "baby-doll" dress: see Miller, *Balenciaga*, p. 39. Diana may have misdated her "baby-doll" dress. Miller suggests the design appeared from 1958.

275 Curatorial staff looked on appalled: See Dwight, *Diana Vreeland*, p. 210.

276 "She'd never say what it needed": Jesse Kornbluth, "The Empress of Clothes," p. 35.

276 Press reaction was favorable: see for instance "The Era of Balenciaga: It Seems So Long Ago," Bernadine Morris, *New York Times*, March 23, 1973.

277 making the CFDA a benefactor: Michael Gross, *Rogues' Gallery: The Secret History of the Moguls and Money That Made the Metropolitan Museum* (New York: Broadway Books, 2009), pp. 375–76.

277 "It was basically Seventh Avenue": ibid., p. 209.

278 costs were covered before it opened: figures from the Metropolitan Museum of Art Archives.

279 managed to tear their eyes away: see Bernadine Morris "This Show Will have the Most Shattering Effect on Fashion," *New York Times*, December 14, 1973.

280 stunned by the Vionnet dresses: ibid.

280 "The foremost accomplishments of Halston": Martin and Koda, *Diana Vreeland: Immoderate Style*, p. 17.

280 "She uttered one word": Hoving, *Making the Mummies Dance*, p. 355.

281 "The basis was perfect designing": *Romantic and Glamorous Hollywood Design*, exhibition catalog (Metropolitan Museum of Art, 1974), n.p.

282 "That's the best advice": *Romantic and Glamorous Hollywood Design*, audioguide (Metropolitan Museum of Art, 1974).

282 "It is about the dreams": quoted in *Vogue*, December 1974, p. 169.

284 Tonne Goodman and André Leon Talley: at the time of going to press in 2012, Goodman is fashion director of American *Vogue*, and Talley is a contributing editor.

284 "She was a solo pageant": André Leon Talley, *A.L.T.: A Memoir* (New York: Villard Books, 2003), p. 156.

285 "*Well,* first *of all we knock off all the bosoms*": George Trow, "Haute, Haute Couture," *The New Yorker*, May 26, 1975.

286 "No curator in the history of the Met": Hoving, *Making the Mummies Dance*, p. 354.

286 "When people ask me": Allure Manuscript, DVP, Box 35, Folder 2, p. 108.

286 They set off to the cinema: as recounted in Andy Warhol's diaries, in Kornbluth, "Empress of Style," and Kenneth Jay Lane to Amanda Mackenzie Stuart.

287 "This is a working man's town": Diana in conversation with Henry Geldzahler in "The Empress and the Commissioner."

287 "In the space of twenty minutes": draft of an anonymous article, DVP, Box 63, Folder 6.

287 "I was *never* an embassy girl": George W. S. Trow and Alison Rose, "Eclectic, Reminiscent, Amused, Fickle, Perverse," *The New Yorker*, June 5, 1978, p. 77.

288 "He had lots of liquor": *The Andy Warhol Diaries*, ed. Pat Hackett (London: Simon and Schuster, 1989), Friday, January 6, 1978, p. 94.

288 "It really becomes more like pagan Rome": quoted in Bob Colacello, *Holy Terror: Andy Warhol Close Up* (New York: HarperCollins, 1990), p. 352.

288 "Supplicating figures": Lerman, *The Grand Surprise*, p. 437.

288 "Mick is the most attractive man in New York": Trow and Rose, "Eclectic, Reminiscent, Amused, Fickle, Perverse," *The New Yorker*, p. 81.

288 "You're so lucky you're a *wop*": Colacello, *Holy Terror*, p. 291.

289 found Diana's anti-Semitic tone extremely distasteful: see Richard Avedon to Calvin Tomkins, Tomkins, II.A.108. MoMa Archives, N.Y., p. 4.

290 the interior designer Sister Parish: "Sister" was a nickname. She was not a nun with a talent for interior decoration.

291 "Despite the underlying ambivalence": Colacello, *Holy Terror*, p.292.

293 "a true expression of her own": Talley, *A.L.T.*, p. 171.

293 "on the common ground of excellence": *American Women of Style*, exhibition catalog (Metropolitan Museum of Art, 1975), n.p.

293 "When I'd been in Russia": Vreeland, *D.V.*, p. 184.

294 "A minute before eleven": Hoving, *Making the Mummies Dance*, p. 355.

294 "The Russians blinked first." Hoving, ibid. p. 356.

294 "She would praise lavishly": ibid.

295 "We have to—ummm—*consult*": George Trow, "Notes and Comment," *The New Yorker*, December 20, 1976, p. 27.

296 "the biggest one of these things": *Warhol Diaries*, Monday, December 6, 1976, p. 5.

296 "The trick of having a regal New York social life": Trow, "Notes and Comment," Dec. 20, 1976, p. 27.

CHAPTER NINE: ENDGAME

297 *"This thing about being recognized"*: Allure Manuscript, DVP, Box 35, Folder 2, p. 191. An edited version appears in *D.V.*, pp. 193-94.

297 "society, with its foibles": *Vanity Fair*, exhibition catalog (Metropolitan Museum of Art, 1977), n.p.

297 "was what she believed a magazine should be": Martin and Koda, *Diana Vreeland: Immoderate Style*, p. 21.

298 "Why? Because we are not presenting an anthology": *Vanity Fair*, ibid., n.p.

298 "These incredibly beautiful things": ibid.

298 "The truest reflection of Vreeland's commitment": Martin and Koda, *Diana Vreeland: Immoderate Style*, p. 22.

298 "from a rarefied world": *Vanity Fair*, n.p.

299 *"Do not be too hard on vanity"*: ibid.

299 media magnate Jocelyn Stevens: in the early part of his newspaper career (1957–8) Sir Jocelyn Stevens CVO was chairman of Stevens Press and editor of *Queen Magazine* (UK), while Diana was at *Harper's Bazaar* and editor in chief of *Vogue*.

299 "We all have our dreams": Allure Manuscript, DVP, Box 35, Folder 2, pp. 192–93.

299 "I take my cue": George Trow, "Women of Style" *The New Yorker*, December 29, 1975, p. 15.

300 "My first impression of Mrs. Vreeland": Vreeland, *Allure*, p. 7.

300 "Once, during a rare conversational lapse": ibid., p. 9.

301 "Never say I": ibid., p. 7.

301 "Does anyone read a picture book from the beginning?": Vreeland, *Allure*, p. 13.

301 "This has got to be": ibid., p. 89.

301 *Allure* captured Diana's views: ibid.: "A good photograph," p. 24; "They catch something unintended," p. 24; "A nose without strength," p. 60; "the only avant-garde," p. 50; "Blue jeans are the only things" p. 202; "don't let me go grand on you," p. 33; "The two greatest mannequins," p. 127; "Elegance is refusal," p. 203; Deborah Turbeville's "worn-out" girls, p. 56; "Really we should forget all this nonsense," p. 207.

302 "Diana Vreeland called": *Warhol Diaries*, Tuesday, December 2, 1980, p. 346.

303 Diana was much less pleased: Diana Vreeland Tapes, Tape 19.

303 MacBride was ill suited to the task: "Of course I understand that it is impossible for you to write about someone that doesn't quite come through to you," wrote Diana politely on January 26, 1973 (private collection). But she was still annoyed in March when she spoke to Leo Lerman just

before the opening of the Balenciaga exhibition, inadvertently clarifying a relationship about which Lerman had been curious. "How can he do that to a friend? Twenty years of friendship—sending that man to work with me—such a middle-class man—not anywhere in the limits of Truman's world—so dull—the father of five children—and Truman taking him away—in love with him!" Lerman, *The Grand Surprise*, p. 383.

304 "Did I tell you": Vreeland, *D.V.*, pp. 195–96.

304 "Also a book for Queen Elizabeth": DVP, Box 14, Folder 10.

305 "should talk to Fred": *Warhol Diaries*, Sunday, September 25, 1977, p. 73.

305 "All the way down in the cab": *Warhol Diaries*, Wednesday, November 9, 1977, p. 88.

305 "She thinks Fred's making it with Lacey": *Warhol Diaries*, Sunday, May 28, 1978, p. 137. Lacey Neuhaus was an outstandingly beautiful model and actress who was close to the Warhol inner circle. She appeared on the cover of *Interview* in November, 1979.

305 "She and I had had several talks": Colacello, *Holy Terror*, p. 432.

306 "Style was more than surface": ibid., p. 433.

306 "She started screaming and belting me": *Warhol Diaries*, Wednesday, February 15, 1978, p. 111.

306 "running and jumping": ibid., Saturday, February 25, 1978, p. 113.

307 "I never thought": quoted in Colacello, *Holy Terror*, p. 454.

307 She caused a sensation: story told by Oscar de la Renta at Diana's memorial service 1989 and reproduced in Martin and Koda, *Diana Vreeland: Immoderate Style*, looseleaf.

308 *Her glass of neat vodka*: Bruce Chatwin, *What Am I Doing Here?* (London: Jonathan Cape, 1989), p. 79.

308 "the grandest memory": Martin and Koda, *Diana Vreeland: Immoderate Style*, pp. 7–8.

309 "Diaghilev created theatrical magic": Nesta Macdonald, "Diaghilev Retrieved," *Dance Magazine*, March 1979, p. 79.

309 "What Mrs. Vreeland likes": George Trow, "Turnout," *The New Yorker*, December 17, 1979, p. 38.

309 "The thing that unites the textile department": Roy Strong quoted in Suzy Menkes, "Stripping Off for Dressing Up," *The Times*, May 31, 1983.

310 There were further objections: the criticisms outlined in this article provoked a letter to the editor of *The Times* from Elizabeth Daubeny on June 13, 1983. She had worked for several years as a volunteer at the Costume Institute, cited the scholarship of Stella Blum, Elizabeth Lawrence, and Judith Jerde and said it was unthinkable that eighteenth-century petticoats or any other garment would ever be treated in the manner implied.

311 "her vision of Diana Vreeland": Liz Smith, *New York Daily News*, December 10, 1986.

311 "nourished fantasies": Silverman, *Selling Culture*. p. 45.

312 "the leader in all fashion today": *Yves Saint Laurent* (London: Thames & Hudson, 1984), published on the occasion of the Costume Institute exhibition, 1983, p. 8.

313 "I"ve never understood that—about art forms": Trow and Rose, "Eclectic, Reminiscent, Amused, Fickle, Perverse," *The New Yorker,* p. 79.

313 a photograph she took of Marina Schiano: Martin and Koda, *Diana Vreeland: Immoderate Style,* looseleaf.

313 "The curious thing": Allure Manuscript, DVP, Box 35, Folder 2, p. 192.

314 "On my arrival": DVP, Box 53, Folder 1.

315 "Water, flowers, moonlight": DVP, Box 12, Folder 9.

315 "André, I've had such a wonderful life": Talley, *A.L.T.* p. 194.

316 "Great dance dresses": *Vogue* (UK), December 1986, p. 32.

316 "She came in one day": Andrew Solomon, "Invitation to the Dance," *Vogue,* November 2007, p. 114.

317 "I need a great deal of fanfare": Kornbluth, "The Empress of Clothes," p. 36.

318 "I think we"ll have a telephone relationship": Lerman, *The Grand Surprise,* p. 574.

318 "She seems more relaxed": DVP, Box 55, Folder 5.

320 "The last details of any story": Vreeland, *Allure,* p. 107.

320 "Before her it was society ladies": by permission of RAF, and quoted in Martin and Koda, *Diana Vreeland: Immoderate Style,* looseleaf.

321 "stumped over how to sum her up": Cathy McGuigan, "The Style Maker's Best Creation Was Herself," *Newsweek,* September 4, 1989., p. 62.

321 "an entomologist of style": Martin and Koda, *Diana Vreeland: Immoderate Style,* pp. 8 and 9.

322 "Mrs. Vreeland was a genius for understanding": John Ross, Metropolitan Museum of Art Archives.

323 "Whatever their shortcomings": Elizabeth Wilson, *Adorned in Dreams: Fashion and Modernity* (London: I.B. Tauris, 2010), p. 268.

324 "Should we spend this much time on ourselves?": quoted in Lieberson, "Empress of Fashion," p. 22.

324 "I'm an idearist": quoted in ibid., p. 26.

324 "The day you give a dinner": quoted in ibid., p. 25.

325 "We can only see her": Martin and Koda, *Diana Vreeland: Immoderate Style,* p. 28.

325 "I don't like to work": remembered by Stephen Jamail in ibid., looseleaf.

325 " I can't stand a dream that's stronger than my own day": Allure Manuscript, DVP, Box 35, Folder 2, p. 177.

325 Diana's greatest feat: *The Eye Has to Travel,* documentary directed by Lisa Immordino Vreeland, 2012.

326 "haikus": Harold Koda's word for Diana's more mystifying instructions in ibid.

326 "I call it a 'dream' ": Allure Manuscript, DVP, Box 35, Folder 2, p. 165.

326 "I'm looking for something else" : Vreeland, *Allure*, p. 13.

327 "Vreeland understood that": Carol Phillips to DK, DKP, p. 9.

327 "Editing is *not* just in magazines": quoted in Lieberson, "Empress of Fashion," p. 25.

328 "I think I've been a realist": Allure Manuscript, DVP, Box 35, Folder 2, p. 191.

328 life had its up-and-down trips: quoted in Cathy McGuigan, "The Style Maker's Best Creation Was Herself," *Newsweek*, September 4, 1989, p. 62.

328 "Socially determined we may be": Wilson, *Adorned in Dreams*, p. 244.

328 "There will . . . never be": ibid., p. 246.

329 *"you've got to look in the mirror"*: Allure Manuscript, DVP, Box 35, Folder 2, p. 190.

SELECTED BIBLIOGRAPHY

WORKS BY DIANA VREELAND

Vreeland, Diana. *D.V.*, ed. George Plimpton and Christopher Hemphill. New York: Knopf, 1984. Reprint, New York: Da Capo, 1997.
———. *Allure*, with Christopher Hemphill. Boston: Bulfinch, 1980. Reprint, 2002.
———. *Vreeland Memos: Visionaire 37*. New York: Visionaire, 2001.

SELECTED PRIMARY SOURCES

Diana Vreeland Papers. Manuscript and Archives Division, the New York Public Library and Estate of Diana Vreeland.
Diana Vreeland Tapes. Estate of Diana Vreeland.
Correspondence between Diana Vreeland and Mona Bismarck. Filson Historical Society Special Collections Department. Louisville, Kentucky.
The Richard Avedon Foundation archive, New York.
Papers of Sir Cecil Beaton, St. John's College Library, University of Cambridge.
Costume Institute Archives, Metropolitan Museum of Art.
Louise Dahl-Wolfe Archive, Center of Creative Photography, University of Arizona, Tucson.
Hoffman and Dalziel Family Albums.
Dodie Kazanjian Papers. Archives of American Art, Smithsonian Institution, Washington, DC.
Metropolitan Museum of Art Archives.
Calvin Tomkins Papers, Series 11. Museum of Modern Art Archives, New York.

SELECTED ARTICLES

Collins, Amy Fine. "It Had to Be Kenneth." *Vanity Fair*, June 2003.
———. "The Cult of Diana." *Vanity Fair*, November 1993.
Dalziel, Emily Hoffman. "Ten Thousand Miles from Fifth Avenue." *Harper's Bazaar*, February 22, 1922.

Donovan, Carrie. "Diana Vreeland, Dynamic Fashion Figure, Joins *Vogue*." *New York Times*, March 28, 1962.

Druesedow, Jean L. "In Style: Celebrating Fifty Years of the Costume Institute." *The Metropolitan Museum of Art Bulletin*, fall 1987.

Fraser, Kennedy. "On and Off the Avenue: Feminine Fashions." *The New Yorker*, June 16, 1973.

Kornbluth, Jesse. "The Empress of Clothes." *New York* magazine, November 29, 1982.

Lieberson, Jonathan. "Empress of Fashion: Diana Vreeland." *Interview*, December 1980.

———. "Embarras de Richesse: The Life of Diana Vreeland." *New York Review of Books*, June 28, 1984.

Macdonald, Nesta. "Diaghilev Retrieved." *Dance Magazine*, March 1979.

McCooey, Meriel. "Why Don't You Knit Yourself a Little Skullcap?" *Sunday Times*, March 17, 1968.

McGuigan, Cathy. "The Style Maker's Best Creation Was Herself," *Newsweek*, September 4, 1989.

Menkes, Suzy. "Stripping Off for Dressing Up." *The Times*, May 31, 1983.

Morris, Bernadine. "The Era of Balenciaga: It Seems So Long Ago." *New York Times*, March 23, 1973.

———. "This Show Will Have the Most Shattering Effect on Fashion," *New York Times*, December 14, 1973.

———. "Metropolitan Toasts a Dazzling Russia of Old." *New York Times*, December 7, 1976.

Perelman, S. J. "Frou-Frou, or the Future of Vertigo." *The New Yorker*, April 16, 1938.

Pumphrey, Martin. "The Flapper, the Housewife and the Making of Modernity." *Cultural Studies*, Vol. 1, No. 2, (May 1987).

Solomon, Andrew. "Invitation to the Dance," *Vogue*, November 2007.

Tomkins, Calvin. "The World of Carmel Snow." *The New Yorker*, November 7, 1994.

Trow, George W. S. "Inventive." *The New Yorker*, December 24, 1973.

———. "Haute, Haute Couture." *The New Yorker*, May 26, 1975.

———. "Women of Style." *The New Yorker*, December 29, 1975.

———. "Turnout." *The New Yorker*, December 17, 1979.

———, and Alison Rose. "Eclectic, Reminiscent, Amused, Fickle, Perverse." *The New Yorker*, June 5, 1978.

———."Notes and Comment." *The New Yorker*, December 20, 1976.

Weymouth, Lally. "A Question of Style: A Conversation with Diana Vreeland." *Rolling Stone*, August 11, 1977.

"How to Get into the Fashion Business." *Harper's Bazaar*, August 1939.

SELECTED COSTUME INSTITUTE EXHIBITION PUBLICATIONS

The publications listed here were produced by the Metropolitan Museum of Art to accompany Diana Vreeland's costume exhibitions. Books produced by other publishers in conjunction with her exhibitions are listed under "Selected Books" below.

The World of Balenciaga. New York: Metropolitan Museum of Art, 1973.

The Tens, the Twenties, the Thirties: Inventive Clothes 1909–1939. Checklist. New York: Metropolitan Museum of Art, 1973.

The Tens, the Twenties, the Thirties: Inventive Clothes 1909–1939. Catalog. New York: Metropolitan Museum of Art, 1973.

Romantic and Glamorous Hollywood Design. New York: Metropolitan Museum of Art, 1974.

American Women of Style. New York: Metropolitan Museum of Art, 1975.

Vanity Fair. New York: Metropolitan Museum of Art, 1977.

Diaghilev: Costumes and Designs of the Ballets Russes. Checklist. New York: Metropolitan Museum of Art, 1978.

Diaghilev: Costumes and Designs of the Ballets Russes. Catalog. New York: Metropolitan Museum of Art, 1978.

The Fashions of the Hapsburg Era: Austria-Hungary. Checklist. New York: Metropolitan Museum of Art, 1978.

The Eighteenth-Century Woman. New York: Metropolitan Museum of Art, 1981.

La Belle Époque. Checklist. New York: Metropolitan Museum of Art, 1983.

Jullian, Philippe, with illustrations selected by Diana Vreeland. *La Belle Époque.* New York: Metropolitan Museum of Art, 1982.

Yves Saint Laurent. Checklist. New York: Metropolitan Museum of Art, 1983.

Yves Saint Laurent. Essays to accompany the exhibition by Yves Saint Laurent and others, introduction by Diana Vreeland. New York: Metropolitan Museum of Art, 1984.

Martin, Richard, and Harold Koda. *Diana Vreeland: Immoderate Style.* Metropolitan Museum of Art, 1993.

Chanel. Metropolitan Museum of Art, 2005.

SELECTED COSTUME INSTITUTE ACOUSTIGUIDES

The Tens, the Twenties, the Thirties: Inventive Clothes 1909–1939. Metropolitan Museum of Art, 1973.

Romantic and Glamorous Hollywood Design. Metropolitan Museum of Art, 1974.

The Glory of Russian Costume. Metropolitan Museum of Art, 1976.

Dance. Metropolitan Museum of Art, 1986.

SELECTED BOOKS

Adler, Kathleen, Erica Hirshler, and Barbara H. Weinberg. *Americans in Paris, 1860–1900*. London: National Gallery Company, 2006.

Albrecht, Donald. *Cecil Beaton: The New York Years*. New York: Skira Rizzoli, 2011.

Angeletti, Norberto, and Alberto Oliva. *In Vogue: The Illustrated History of the World's Most Famous Fashion Magazine*. New York: Rizzoli, 2006.

Arnold, Rebecca. *Fashion, Desire and Anxiety: Image and Morality in the 20th Century*. London: I. B. Tauris, 2001.

———. *The American Look: Fashion, Sportswear and the Image of Women in 1930s and 1940s New York*. London: I. B. Tauris, 2009.

Bacall, Lauren. *By Myself and Then Some*. New York: HarperEntertainment, 2005.

Bailey, David, with notes by Francis Wyndham. *David Bailey's Box of Pin-Ups*. London: Weidenfeld & Nicolson, 1965.

———, with text by Martin Harrison. *Black and White Memories: Photographs 1948–1969*. London: Dent, 1983.

Bailey, David, and Peter Evans *Goodbye Baby & Amen: A Saraband for the Sixties*. London: Condé Nast; Coward-McCann, 1969.

Baldwin, Billy. *Billy Baldwin Remembers*. New York: Harcourt Brace Jovanovich, 1974.

———, with Michael Gardine. *Billy Baldwin: An Autobiography*. Boston: Little, Brown, 1985.

Ballard, Bettina. *In My Fashion*. London: Secker & Warburg, 1960.

Bassman, Lillian. *Lillian Bassman*. Boston: Bulfinch, 1997.

Beaton, Cecil. *Cecil Beaton's Scrapbook*. London: B. T. Batsford Ltd, 1937.

———. *Cecil Beaton's New York*. London: B. T. Batsford, 1938.

———. *The Glass of Fashion*. London: Weidenfeld & Nicolson, 1954.

Beaton, Cecil, introduction by Hugo Vickers. *The Unexpurgated Beaton: The Cecil Beaton Diaries as They Were Written*. London: Weidenfeld & Nicolson, 2002.

———. *Beaton in the Sixties: More Unexpurgated Diaries*. London: Weidenfeld & Nicolson, 2003. Hugo Vickers, ed.

Bender, Marilyn. *The Beautiful People: A Candid Examination of a Cultural Phenomenon—the Marriage of Fashion and Society in the 60's*. New York: Coward-McCann, 1967.

Berenson, Marisa, with a foreword by Diana Vreeland. *Dressing Up: How to Look and Feel Absolutely Perfect for Any Social Occasion*. New York: Putnam, 1984.

Birchfield, James D. *Kentucky Countess: Mona Bismarck in Art & Fashion*. Lexington: University of Kentucky Art Museum, 1997.

Blanch, Lesley. *The Wilder Shores of Love*. London: John Murray, 1954, Reprint, London: Orion, 1993, reissued in 2010.

Blass, Bill. Ed. Cathy Horyn. *Bare Blass.* New York: HarperCollins, 2002.

Bloom, Alexander, ed. *Long Time Gone: Sixties America Then and Now (Viewpoints on American Culture).* New York: Oxford University Press, 2001.

Bockris, Victor. *Warhol.* London: Penguin, 1990.

Boston, Anne. *Lesley Blanch: Inner Landscapes, Wilder Shores.* London: John Murray, 2010.

Bowles, Hamish. *Jacqueline Kennedy: The White House Years.* Boston: Bulfinch, 2001.

————. *Balenciaga and Spain.* New York: Skira Rizzoli, 2011.

————, ed. Alexandra Kotur. *The World in Vogue: People Parties Places.* New York: Alfred A. Knopf, 2009.

Breward, Christopher. *Fashion.* Oxford: Oxford University Press, 2003.

————, and Caroline Evans, eds., *Fashion and Modernity.* London: Berg, 2005.

Bronstein, Carolyn. *Battling Pornography: The American Feminist Anti-Pornography Movement, 1976–1986.* New York: Cambridge University Press, 2011.

Campbell, Nina, and Caroline Seebohm. *Elsie de Wolfe: A Decorative Life.* London: Aurum, 1993.

Capstick, Fiona Claire. *The Diana Files: The Huntress-Traveller Through History.* Johannesburg: Rowland Ward, 2004.

Carter, Ernestine, introduction by Diana Vreeland. *The Changing World of Fashion.* London: Weidenfeld & Nicolson, 1977.

Carter, Robert A. *Buffalo Bill Cody: The Man Behind the Legend.* New York: John Wiley, 2000.

Cassini, Oleg. *A Thousand Days of Magic: Dressing Jacqueline Kennedy for the White House.* New York: Rizzoli, 1995.

————. *In My Own Fashion: An Autobiography.* New York: Simon and Schuster, 1987.

Chase, Edna Woolman, and Ilka Chase. *Always in Vogue.* London: Victor Gollancz, 1954.

Chatwin, Bruce. *What Am I Doing Here?* London: Jonathan Cape, 1989.

Chaney, Lisa. *Chanel: An Intimate Life.* London: Fig Tree, 2011.

Clarke, Gerald. *Capote: A Biography.* New York: Simon & Schuster, 1988.

Colacello, Bob. *Holy Terror: Andy Warhol Close Up.* New York: HarperCollins, 1990.

Collins, Gail. *When Everything Changed: The Amazing Journey of American Women from 1960 to the Present.* Boston: Back Bay, 2009.

Coontz, Stephanie. *A Strange Stirring: The Feminine Mystique and American Women at the Dawn of the 1960s.* New York: Basic, 2011.

Coudert, Thierry. *Café Society: Socialites, Patrons and Artists, 1920–1960.* Paris: Flammarion, 2010.

Courcy, Anne de. *1939: The Last Season.* London: Thames and Hudson, 1989.

Craik, Jennifer. *The Face of Fashion: Cultural Studies in Fashion*. London: Routledge, 1994.

Cyrulnik, Boris. Trans. David Macey. *Resilience: How Your Inner Strength Can Set You Free From the Past*. London: Penguin, 2009.

Dahl-Wolfe, Louise. *A Photographer's Scrapbook*. London: Quartet, 1984.

Daves, Jessica. *Ready-Made Miracle: The Story of American Fashion for the Millions*. New York: G. P. Putnam's Sons, 1967.

Devlin, Polly. *Vogue Book of Fashion Photography*. London: Thames & Hudson, 1979.

Douglas, Ann. *Terrible Honesty: Mongrel Manhattan in the 1920s*. London: Picador, 1996.

Drehle, David Von. *Triangle: The Fire That Changed New York*. New York: Atlantic Monthly Press, 2003.

DuBois, Diana. *In Her Sister's Shadow: An Intimate Biography of Lee Radziwill*. Boston: Little, Brown, 1995.

Dwight, Eleanor. *Diana Vreeland*. New York: William Morrow, 2002.

Esten, John. *Diana Vreeland: Bazaar Years*. New York: Universe, 2001.

Ewing, William A. *The Photographic Art of Hoyningen-Huene*. London: Thames & Hudson, 1986.

Faucigny-Lucinge, Jean-Louis de. *Legendary Parties*. New York: Vendome, 1987.

Friedan, Betty. *The Feminine Mystique*, with an introduction by Lionel Shriver. London: Penguin Classics, 2010.

Golbin, Pamela, ed. *Madeleine Vionnet*. New York: Rizzoli, 2009, to accompany *Madeleine Vionnet, Puriste de la Mode*, exhibition at the Musée de la Mode et du Textile (Les Arts Décoratifs), Paris, from June 24, 2009 to January 31, 2010.

Goldberg, Vicki, and Nan Richardson. *Louise Dahl-Wolfe*, with a foreword by Dorothy Twining Globus. New York: Harry N. Abrams, 2000.

Gottlieb, Robert. *Lives and Letters*. New York: Farrar, Straus & Giroux, 2011.

Grant, Linda. *The Thoughtful Dresser*. London: Virago, 2009.

Gray, Francine du Plessix. *Them: A Memoir of Parents*. New York: Penguin, 2005.

Gross, Michael. *Rogues' Gallery: The Secret History of the Moguls and Money That Made the Metropolitan Museum*. New York: Broadway, 2009.

Gundlach, F .C. *Martin Munkácsi*. London: Thames & Hudson, 2006.

Hall, Carolyn. *The Thirties in Vogue*. London: Octopus, 1984.

Hampton, Mark, and Mary Louise Wilson. *Full Gallop*. New York: Dramatists Play Service, 1997.

Harris, Alexandra. *Romantic Moderns: English Writers, Artists and the Imagination from Virginia Woolf to John Piper*. London: Thames & Hudson, 2010.

Harrison, Martin. *David Bailey*. London: Collins, 1984.

Haslam, Nicholas. *Redeeming Features: A Memoir.* London: Jonathan Cape, 2009.

Hawes, Elizabeth. *Fashion Is Spinach: Experiences of a Dress Designer in France and the United States of America.* New York: Random House, 1938.

Heale, M. J. *The Sixties in America: History, Politics and Protest.* Edinburgh: Edinburgh University Press, 2001.

Herzog, Lester W. *150 Years of Service and Leadership: The Story of National Commercial Bank and Trust Company.* New York: Newcomen Society in North America, 1975.

Higham, Charles. *Mrs. Simpson: Secret Lives of the Duchess of Windsor.* London: Pan, 2005.

Hobsbawm, Eric. *The Age of Extremes: The Short Twentieth Century, 1914– 1991.* London: Abacus, 1994.

Holgate, Mark. "Couture and Culture on the News Stand: *Vogue* and *Harper's Bazaar* 1945 to 1960." Thesis submitted to fulfill requirement of M.A. History of Design Course, run jointly by the Royal College of Art and the V & A Museum, 1994.

Homberger, Eric. *Mrs. Astor's New York: Money and Social Power in a Gilded Age.* New Haven: Yale University Press, 2002.

Hoving, Thomas. *Making the Mummies Dance: Inside the Metropolitan Museum of Art.* New York: Simon & Schuster, 1993.

Howell, Georgina. *In Vogue: Six Decades of Fashion.* London: Allen Lane, 1975.

Hutto, Richard Jay. *Their Gilded Cage: The Jekyll Island Club Members.* Macon, GA: Henchard, 2006.

Jowitt, Deborah. *Time and the Dancing Image.* Berkeley: University of California Press, 1989.

Kazanjian, Dodie, and Calvin Tomkins. *Alex: The Life of Alexander Liberman.* New York: Alfred A. Knopf, 1993.

Keenan, Brigid. *The Women We Wanted to Look Like.* London: Macmillan, 1977.

Lane, Kenneth Jay. *Kenneth Jay Lane: Faking It.* New York: Harry N. Abrams, 1996.

Lawford, Valentine. *Horst: His Work and His World.* New York: Knopf, 1984.

———, photographed by Horst, introduction by Diana Vreeland. *Vogue's Book of Houses, Gardens, People.* London: Bodley Head, 1968.

Lawson, Twiggy, with contributions by Terence Pepper, Robin Muir, and Melvin Sokolsky. *Twiggy: A Life in Photographs.* London: National Portrait Gallery, 2009, to accompany the exhibition *Twiggy: A Life in Photographs*, London, from September 18, 2009, to March 24, 2010.

Lawson, Twiggy, with Penelope Dening. *Twiggy in Black and White.* London: Simon & Schuster, 1997.

Lee, Sarah Tomerlin, ed. *American Fashion: The Life and Times of Adrian,*

Mainbocher, McCardell, Norell, Trigère. New York: Quadrangle/New York Times, 1975.

Lehndorff, Vera, and David Wills. *Veruschka.* New York: Assouline, 2008.

Lerman, Leo. *The Museum: One Hundred Years and the Metropolitan Museum of Art.* New York: Viking, 1969.

————. *The Grand Surprise: The Journals of Leo Lerman,* ed. Stephen Pascal. New York: Alfred A. Knopf, 2007.

Levin, Phyllis Lee. *The Wheels of Fashion.* New York: Doubleday, 1965.

MacGraw, Ali. *Moving Pictures.* New York: Bantam, 1991.

Manzoni, Pablo, introduction by Diana Vreeland. *Instant Beauty: The Complete Way to Perfect Make-Up.* New York: Simon & Schuster, 1978.

McClung, Bruce D. *Lady in the Dark: Biography of A Musical.* New York: Oxford University Press, 2007.

McConathy, Dale, with Diana Vreeland. *Hollywood Costume: Glamour, Glitter, Romance.* New York: Harry N. Abrams, 1976.

McDowell, Colin. *Manolo Blahnik.* New York: HarperCollins, 2000.

Mears, Patricia. *American Beauty: Aesthetics and Innovation in Fashion.* New Haven: Yale University Press in association with Fashion Insitute of Technology, New York, 2009.

Mendes, Valerie, and Amy de la Haye. *20th Century Fashion.* London: Thames & Hudson, 1999.

Milbank, Caroline Rennolds. *New York Fashion: The Evolution of American Style.* New York: Harry N. Abrams, 1989.

Miller, Lesley Ellis. *Christobal Balenciaga (1895–1972): The Couturiers' Couturier.* London: V&A, 2007.

Mirabella, Grace. *In and Out of Vogue.* New York: Doubleday, 1995.

Moore, Lucy. *Anything Goes: A Biography of the Roaring Twenties.* London: Atlantic, 2009.

Morano, Elizabeth (introduction), foreword by Diana Vreeland. *Sonia Delaunay.* New York: George Braziller, 1986.

Morgan, Maud. *Maud's Journey: A Life from Art.* Berkeley: New Earth, 1995.

Mower, Sarah. *Oscar: The Style, Inspiration and Life of Oscar de la Renta.* New York: Assouline, 2002.

Mulvagh, Jane. *Vogue History of 20th Century Fashion.* London: Bloomsbury, 1992.

Onassis, Jacqueline, ed. *In the Russian Style.* New York: Viking, 1976.

On the Edge: Images from 100 Years of Vogue, introduction by Kennedy Fraser. New York: Random House, 1992.

Palmer, Alexandra. *Dior: A New Look, A New Enterprise (1947–57).* London: V&A, 2009.

Parkinson, Norman. *Lifework, 2003.* London: Weidenfeld & Nicolson, 1983.

Penn, Irving, and Diana Vreeland. *Inventive Paris Clothes 1909–1939: A Photographic Essay by Irving Penn with Text by Diana Vreeland.* New York: Viking, 1977.

Petigny, Alan. *The Permissive Society: America, 1941–1965.* New York: Cambridge University Press, 2009.

Picardie, Justine. *Coco Chanel: The Legend and the Life.* London: HarperCollins, 2010.

Plimpton, George. *Truman Capote: In Which Various Friends, Enemies, Acquaintances, and Detractors Recall His Turbulent Career.* New York: Doubleday, 1997.

Pritchard, Jane, ed. *Diaghilev and the Golden Age of the Ballets Russes, 1909–1929.* London: V&A, 2010.

Purcell, Kerry William. *Alexey Brodovitch.* London: Phaidon, 2002.

Quant, Mary. *Autobiography.* London: Headline, 2012.

Rense, Paige, ed. *Celebrity Homes: Architectural Digest Presents the Private Worlds of Thirty International Personalities.* New York: Penguin, 1979.

Ross, Josephine. *Beaton in Vogue.* London: Thames & Hudson, 1986.

———. *Society in Vogue: The International Set between the Wars.* London: Condé Nast, 1992.

Rowlands, Penelope. *A Dash of Daring: Carmel Snow and Her Life in Fashion, Art, and Letters.* New York: Atria, 2005.

Sassoon, Vidal. *Vidal: The Autobiography.* London: Macmillan, 2010.

Schlumberger, Jean, with Diana Vreeland. *Jean Schlumberger.* Milano: Franco Maria Ricci, 1976.

Schulenberg, Fritz von der. *Balnagown: Ancestral Home of the Clan Ross: A Scottish Castle through Five Centuries.* London: Brompton, 1997.

Seebohm, Caroline. *The Man Who Was Vogue: The Life and Times of Condé Nast.* New York: Viking, 1982.

Shrimpton, Jean. *Jean Shrimpton: An Autobiography.* London: Sphere, 1991.

Silverman, Debora. *Selling Culture: Bloomingdale's, Diana Vreeland, and the New Aristocracy of Taste in Reagan's America.* New York: Pantheon, 1986.

Smith, Florence Pritchett. *These Entertaining People.* New York: Macmillan, 1966.

Smith, Jane S., introduction by Diana Vreeland. *Elsie de Wolfe: A Life in the High Style.* New York: Atheneum, 1982.

Snow, Carmel, and Mary Louise Aswell. *The World of Carmel Snow.* New York: McGraw-Hill, 1962.

Sokolsky, Melvin, text by Martin Harrison. *Seeing Fashion.* Santa Fe, NM: Arena, 2000.

Sotheby's. *The Diana Vreeland Collection of Fashion Jewelry.* New York: Sotheby's, 1987.

———. *Property from the Estate of Diana D. Vreeland.* New York: Sotheby's, 1990.

Steele, Valerie. *Women of Fashion: Twentieth-Century Designers.* New York: Rizzoli International, 1991.

———. *Fifty Years of Fashion: New Look to Now.* New Haven: Yale University Press, 1997.

———. *Fashion, Italian Style.* New Haven: Yale University Press, 2003.

Steinhart, Edward I. *Black Poachers, White Hunters: A Social History of Hunting in Colonial Kenya.* Oxford: James Currey, 2006.

Stern, Bert. *The Last Sitting.* London: Orbis, 1982.

Talley, André Leon. *A.L.T: A Memoir.* New York: Villard, 2003.

Tapert, Annette, and Diana Edkins. *The Power of Style.* New York: Crown, 1994.

Trahey, Jane, ed. *Harper's Bazaar: 100 Years of the American Female.* New York: Random House, 1967.

Vickers, Hugo. *Cecil Beaton: The Authorized Biography.* London: Weidenfeld & Nicolson, 1985.

———. *Behind Closed Doors: The Tragic, Untold Story of the Duchess of Windsor.* London: Hutchinson, 2011.

Vreeland, Lisa Immordino. *Diana Vreeland: The Eye Has to Travel.* New York: Abrams, 2011.

Walz, Barbra, with photographs by Barbra Walz and text by Bernadine Morris. *The Fashion Makers.* New York: Random House, 1978.

Warhol, Andy. Ed. Pat Hackett. *The Andy Warhol Diaries.* London: Simon & Schuster, 1989.

Welters, Linda, and Abby Lillethun, eds. *The Fashion Reader.* Oxford, New York: Berg, 2007.

Wilcox, Claire, ed. *The Golden Age of Couture: Paris and London 1947–57.* London: V&A, 2007.

Wills, David. *Ara Gallant.* Bologna: Damiani, 2010.

Wilson, Elizabeth. *Adorned in Dreams: Fashion and Modernity.* London: Virago, 1985, new edition updated and revised, reprinted 2010, London: I. B. Tauris.

Yohannan, Kohle, and Nancy Nolf. *Claire McCardell: Redefining Modernism.* New York: Harry N. Abrams, Inc., 1998.

The 1972 World Book Year Book: The Annual Supplement to the World Book Encylopedia. Chicago: Field Enterprises, 1972.

SELECTED FILMS AND TV PROGRAMS

Feature Films

Funny Face, directed by Stanley Donen. Paramount Pictures, 1957.

Who Are You, Polly Magoo? directed by William Klein, 1966.

Documentaries

Richard Avedon: Darkness and Light, directed by Helen Whitney, *American Masters Series*, PBS, 1996.

Bailey on Beaton, directed by Bill Verity, ATV, 1971.

Chop Suey, directed by Bruce Weber, 2001.

Diana Vreeland: The Eye Has to Travel, directed by Lisa Immordino Vreeland, 2011.

Television programs

"At the Met: the Eighteenth-Century Woman." Arts Cable, 1982.

"At the Met: La Belle Epoque 1890–1914." Arts Cable, 1983.

"Degas, Erté, and Chagall." *Mastervision Arts Series*, 1977.

'The Empress and the Commissioner," directed by Don Monroe for Andy Warhol TV, Manhattan Cable, 1980.

Theater Production Recording

Full Gallop, by Mark Hampton and Mary Louise Wilson, starring Mary Louise Wilson. Videotaped by The New York Public Library's Theater on Film and Tape Archive at the Waterside Theater (Downstairs), New York, N.Y., August 13, 1997.

PERMISSIONS

The author gratefully acknowledges the following for permission to quote from copyrighted material:

Assouline Publishing for permission to quote from *Veruschka* by Vera Lehndorff and David Wills, © 2008 Assouline Publishing.

Mrs. Hugh Astor for permission to quote from the albums of Emily Hoffman Dalziel and Alexandra Dalziel.

The Richard Avedon Foundation for permission to quote from The Richard Avedon Foundation archive, and other works by Richard Avedon.

Bob Colacello for permission to reprint extracts from *Holy Terror* © 1990 by Bob Colacello. Reprinted by permission of the author.

Condé Nast Publicatons for permission to quote from *Vogue, The New Yorker, Women's Wear Daily,* and *Vanity Fair.*

Dr. Mary Aswell Doll for permission to quote from *The World of Carmel Snow* by Carmel Snow with Marie Louise Aswell.

Doubleday for permission to quote from *In and Out of Vogue: A Memoir* by Grace Mirabella, Judith Warner © 1995 by Grace Mirabella. Used by permission of Doubleday, a division of Random House, Inc.; and *The Wheels of Fashion* by Phyllis Lee Levin.

Field Enterprises Corporation for permission to quote from *The 1972 World Book Year Book: The Annual Supplement to the World Book Encyclopedia.*

HarperCollins Publishers Inc. for permission to quote from *By Myself and Then Some* by Lauren Bacall; *Diana Vreeland* by Eleanor Dwight; and *Bare Blass* by Bill Blass and Cathy Horyn.

The Hearst Corporation for permission to quote from *Harper's Bazaar.*

Dodie Kazanjian for permission to quote from The Dodie Kazanjian Papers, Archives of American Art, Smithsonian Institution.

Caroline Kennedy for permission to quote from letters written by her mother, Jacqueline Kennedy Onassis, to Diana Vreeland, 1960–61.

Little, Brown & Company for permission to quote from *Billy Baldwin: An Autobiography* by Billy Baldwin and Michael Gardine.

The Metropolitan Museum of Art to quote work excerpted from *Romantic and Glamorous Hollywood Design*, Copyright © 1974 by The Metropolitan Museum of Art, New York. Reprinted by permission. Work excerpted from *Vanity Fair* © 1977 by The Metropolitan Museum of Art, New York. Reprinted by permission. Work excerpted from *Diana Vreeland: Immoderate Style* by Richard Martin and Harold Koda. Copyright © 1993 by The Metropolitan Musuem of Art, New York. Reprinted by permission.

Peters Fraser & Dunlop for permission to quote a parody of Diana Vreeland from "Why Don't You Parody" by S. J. Perelman. Reprinted by permission of Peters Fraser and Dunlop [www.petersfraserdunlop.com] on behalf of the Estate of S. J. Perelman.

The Random House Group Ltd. for permission to quote from *Redeeming Features: A Memoir* by Nicholas Haslam, published by Jonathan Cape. Reprinted by permission of the Random House Group Ltd; and from *What Am I Doing Here?* by Bruce Chatwin, published by Jonathan Cape. Reprinted by permission of the Random House Group Ltd and Aitken Alexander Associates.

Rolling Stone for permission to use material excerpted from *Rolling Stone*, August 11, 1977 © 1977 Rolling Stone LLC.

Penelope Rowlands for permission to quote from *A Dash of Daring: Carmel Snow and Her Life in Fashion, Art, and Letters* © 2005 by Penelope Rowlands.

Calvin Tomkins for permission to quote from the Calvin Tomkins Papers, Series II, The Museum of Modern Art Achives, New York; from "The World of Carmel Snow," *The New Yorker*, November 7, 1994; and, with Dodie Kazanjian, from *Alex: The Life of Alexander Liberman.*

Hugo Vickers for permission to quote from the works and letters of Sir Cecil Beaton, and the Papers of Sir Cecil Beaton, St. John's College Library © The Literary Executors of the late Sir Cecil Beaton.

The estate of Diana Vreeland for permission to quote from The Diana Vreeland Papers, Manuscripts and Archives Division, The New York Public Library, Astor, Lenox, and Tilden Foundations; *D.V.* by Diana Vreeland; *Allure* by Diana Vreeland; the Diana Vreeland Tapes; and other works by Diana Vreeland.

PHOTO CREDITS

Page 4: Left and bottom right: Photographs by Franco Rubartelli. Copyright © Condé Nast Archive/Corbis. Top right: Photograph by Henry Clarke. Copyright © Condé Nast Archive/Corbis.

Page 5: Top: Photograph by Bert Stern. Stern/*Vogue*/Condé Nast Archive. Copyright © Condé Nast.

Bottom: Photograph by Bert Stern. Copyright © Condé Nast Archive/Corbis.

Page 6: Photograph by Cecil Beaton. Courtesy of the Cecil Beaton Archive at Sotheby's.

Page 7: Top: The Metropolitan Museum of Art. Photograph by Al Mozell. Image © The Metropolitan Museum of Art.

Bottom: The Metropolitan Museum of Art. Photograph by Al Mozell. Image © The Metropolitan Museum of Art.

Page 8: Photograph by Richard Avedon © The Richard Avedon Foundation.

INDEX